DRAWING ON THE RIGHT SIDE OF THE BRAIN

Drawing on the Right side of the Brain

Betty Edwards

The Definitive, 4th Edition

Souvenir Press

Drawing on the right side of the brain – Definitive, 4th edition.
Revised and expanded edition of: New drawing on the right side of the brain. 1999.

The definitive, 4th edition first published in the USA
by Jeremy P. Tarcher/Penguin 2012

First published in Great Britain in 2013 by Souvenir Press Ltd
43 Great Russell Street, London WC1B 3PD

Reprinted 2013, 2014, 2015, 2016

ISBN 9780285641778

Book design by Joe Molloy

Printed and bound by TJ International Ltd, Padstow, Cornwall

Dedication

To my granddaughters, who
have taken to drawing the
way fish take to swimming
and birds to flying, simply by
sometimes sitting in on their
Dad's drawing workshops.

Dear Sophie and Francesca,

this book is for you,

with thanks for all the joy

you have brought into my world.

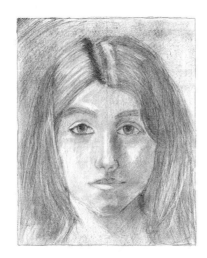

Self-portrait by Sophie Bomeisler, July 29,
2011, when she was 11.

Self-portrait by Francesca Bomeisler, July 29,
2010, when she was 8.

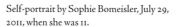

CONTENTS

ACKNOWLEDGMENTS

I shall be forever grateful to Dr. Roger W. Sperry (1913–1994), neuropsychologist, neurobiologist, and Nobel laureate, for his generosity and kindness in discussing the original text with me. At a time in 1978 when I was most discouraged and doubtful about the manuscript I was writing, I summoned the courage to send it to him. Not long after that, I was filled with gratitude to receive his kind response in a letter that began, "I have just read your splendid manuscript." He suggested that we meet to review and clarify some errors in my layperson's effort to write about his research. That invitation began a series of once-a-week meetings in his office at the California Institute of Technology, resulting in revision after revision of Chapter Three of the manuscript, the chapter in which I attempted to describe the "split-brain" studies.

Most gratifyingly, when *Drawing on the Right Side of the Brain* was finally published in 1979, Dr. Sperry wrote a statement for the back cover:

> "…her application of the brain research findings to drawing conforms well with the available evidence and in many places reinforces and advances the right hemisphere story with new observations."

I asked him why he had used the "…" to begin his statement. He replied, with his usual sly humor, that if any of his colleagues objected to his approval of this nonscientific book, he could always say that something was left out. At that time, objections

to Dr. Sperry's findings were frequent, especially regarding his demonstrations that the right-brain hemisphere was capable of fully human, high-level cognition. These objections diminished over the years, as corroboration of his insights became undeniable. The Nobel Prize in Medicine in 1981 ensured Dr. Sperry's eminent position in the history of science.

Many other people have contributed greatly to my book. In this brief acknowledgment, I wish to thank at least a few.

My publisher, Jeremy Tarcher, for his enthusiastic support over more than thirty years.

My representative, Robert B. Barnett of the law firm Williams & Connolly, Washington, DC, for always being a great advocate and friend.

Joel Fotinos, Vice-President and Publisher of Tarcher/Penguin, for setting this project in motion and for his longtime friendship.

Sara Carder, my Tarcher/Penguin Executive Editor, for her enthusiastic support, help, and encouragement.

Dr. J. William Bergquist, for his generous assistance with the first edition of the book and with my doctoral research that preceded it.

Joe Molloy, my longtime friend, who has designed all of my books for publication. Somehow, he makes superb design appear to be effortless, and it isn't.

Anne Bomeisler Farrell, my daughter, who as editor has brought her great writing skills to help me with this project. Throughout, she has been my anchor and support.

Brian Bomeisler, my son, for his long years of work helping me to revise, refine, and clarify these lessons in drawing. His skills as an artist and as our lead workshop teacher have enabled countless students to succeed at drawing.

Sandra Manning, who so ably manages the Drawing on the Right Side of the Brain office and workshops. Her wonderful contribution was in researching and obtaining international per-

missions to reproduce the many new illustrations found in this edition.

My son-in-law, John Farrell, and my granddaughters Sophie Bomeisler and Francesca Bomeisler, who have been my enthusiastic cheerleaders.

My thanks also go to the many art teachers and artists across the country and in many other parts of the world who have used the ideas in my book to help bring drawing skills to their students.

And last, I wish to express my gratitude to all of the students whom I have been privileged to know over the decades. It was they who enabled me to form the ideas for the original book and who have since guided me in refining the teaching sequences. Most of all, it has been the students who have made my work so personally rewarding. Thank you!

INTRODUCTION

Drawing used to be a civilized thing to do, like reading and writing.

It was taught in elementary schools. It was democratic.

It was a boon to happiness.[1]

—MICHAEL KIMMELMAN

For more than thirty years, *Drawing on the Right Side of the Brain* has been a work in progress. Since the original publication in 1979, I have revised the book three times, with each revision about a decade apart: the first in 1989, the second, 1999, and now a third, 2012 version. In each revision, my main purpose has been to incorporate instructional improvements that my group of teachers and I had gleaned from continuously teaching drawing over the intervening years, as well as bringing up-to-date ideas and information from education and neuroscience that relate to drawing. As you will see in this new version, much of the original material remains, as it has passed the test of time, while I continue to refine the lessons and clarify instructions. In addition, I make some new points about emergent right-brain significance and the astonishing, relatively new science called neuroplasticity. I make a case for my life's goal, the possibility that public schools will once again teach drawing, not only as a civilized thing to

1. From "An Exhibition About Drawing Conjures a Time When Amateurs Roamed the Earth," *New York Times*, July 19, 2006. Michael Kimmelman is an author and chief art critic for the *New York Times*.

do and a boon to happiness, but also as perceptual training for improving creative thinking.

The power of perception

Many of my readers have intuitively understood that this book is not only about learning to draw, and it is certainly not about Art with a capital A. The true subject is *perception*. Yes, the lessons have helped many people attain the basic ability to draw, and that is a main purpose of the book. But the larger underlying purpose was always to bring right hemisphere functions into focus and to teach readers how to *see* in new ways, with hopes that they would discover how to transfer perceptual skills to thinking and problem solving. In education, this is called "transfer of learning," which has always been regarded as difficult to teach, and often teachers, myself included, hope that it will just happen. Transfer of learning, however, is best accomplished by direct teaching, and therefore, in Chapter 11 of this revised edition, I encourage that transfer by including some direct instruction on how perceptual skills, learned through drawing, can be used for thinking and problem solving in other fields.

The book's drawing exercises are truly on a basic level, intended for a beginner in drawing. The course is designed for persons who cannot draw at all, who feel that they have no talent for drawing, and who believe that they probably can never learn to draw. Over the years, I have said many times that the lessons in this book are not on the level of art, but are rather more like learning how to read—more like the ABCs of reading: learning the alphabet, phonics, syllabification, vocabulary, and so on. And just as learning basic reading is a vitally important goal, because the skills of reading transfer to every other kind of learning, from math and science to philosophy and astronomy, I believe that in time learning to draw will emerge as an equally vital skill, one that provides equally transferrable powers of perception to guide and promote insight into the *meaning* of visual and verbal information. I will even go out on a limb and say that we mistakenly

may have been putting all our educational eggs into one basket only, while shortchanging other truly valuable capabilities of the human brain, namely perception, intuition, imagination, and creativity. Perhaps Albert Einstein put it best: "The intuitive mind is a sacred gift, and the rational mind is a faithful servant. We have created a society that honors the servant and has forgotten the gift."

The hidden content

About six months after publication of the original book in 1979, I had the odd experience of suddenly realizing that the book I thought I had written contained another content of which I was unaware. That hidden content was something I didn't know I knew: I had inadvertently defined the basic component skills of the global skill of drawing. I think part of the reason this content was hidden from me was the very nature of art education at the time, where beginning drawing classes focused on subject matter, such as "Still Life Drawing," "Landscape Drawing," or "Figure Drawing," or on drawing mediums, such as charcoal, pencil, pen and ink, ink wash, or mixtures of mediums.

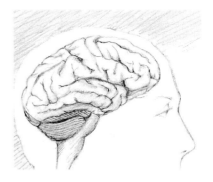

But my aim was different: I needed to provide my readers with exercises that would cause a cognitive shift to the right hemisphere—a shift similar to that caused by Upside-Down Drawing: "tricking" the dominant left hemisphere into dropping out of the task. I settled on five subskills that seemed to have the same effect, but at the time, I thought that there must be other basic skills—maybe dozens of them.

Then, months after the book had been published, in the midst of teaching a class, it hit me as an *aha!* that for learning to draw realistic images of observed subjects, the five subskills were it—there weren't more. I had inadvertently selected from the many aspects of drawing a few fundamental subskills that I thought might be closely aligned to the effect of Upside-Down Drawing. And the five skills, I realized, were not drawing skills in the usual sense; they were rock-bottom, fundamental *seeing* skills:

how to perceive edges, spaces, relationship, lights and shadows, and the *gestalt*. As with the ABCs of reading, these were the skills you had to have in order to draw *any* subject.

I was elated by this discovery. I discussed it at length with my colleagues and searched through old and new textbooks on drawing, but we did not find any additional *fundamental* basic components of the global skill of basic realistic drawing—drawing one's perceptions. With this discovery, it occurred to me that perhaps drawing could be quickly and easily taught and learned—not strung out over years and years, as was the current practice in art schools. My aim suddenly became "drawing for everyone," not just for artists in training. Clearly, the basic ability to draw does not necessarily lead to the "fine art" found in museums and galleries any more than the basic ability to read and write inevitably leads to literary greatness and published works of literature. But learning to draw was something I knew was valued by children and adults. Thus, my discovery led me in new directions, resulting in a 1989 revision of *Drawing on the Right Side of the Brain*, in which I focused on explaining my insight and proposing that individuals who had never been able to draw could learn to draw well very rapidly.

Subsequently, my colleagues and I developed a five-day workshop of forty hours of teaching and learning (eight hours a day for five days), which proved to be surprisingly effective: students acquired quite high-level basic drawing skills in that brief time, and gained all the information they needed to go on making progress in drawing. Since drawing perceived subjects is always the same task, always requiring the five basic component skills, they could proceed to any subject matter, learn to use any or all drawing mediums, and take the skill as far as they wished. They could also apply their new visual skills to thinking. The parallels to learning to read were becoming obvious.

Over the next decade, from 1989 to 1999, the connection of perceptual skills to general thinking, problem solving, and creativity became a more central focus for me, especially after pub-

lication of my 1986 book, *Drawing on the Artist Within*. In this book, I proposed a "written" language for the right hemisphere: the language of line, the expressive language of art itself. This idea of using drawing to *aid thinking* proved to be quite useful in a class on creativity that I developed for university students and in small corporate seminars on problem solving.

Then, in 1999, I again revised *Drawing on the Right Side of the Brain*, again incorporating what we had learned over the years of teaching the five basic skills and refining the lessons. I especially focused on the skill of sighting (proportion and perspective), which is perhaps the most difficult component skill to teach in words, because of its complexity and its reliance on students' acceptance of paradox, always anathema to the logical, concept-bound left brain. In addition, I urged using perceptual skills to "see" problems.

Now, with this third revision in 2012, I want to clarify to the best of my ability the global nature of drawing and to link drawing's basic component skills to thinking in general and to creativity in particular. Throughout many cultures, both in the United States and worldwide, there is much talk of creativity and our need for innovation and invention. There are many suggestions to try this or try that. But the nitty-gritty of precisely *how* to become more creative is seriously lacking. Our education system seems bent on eliminating every last bit of creative perceptual training of the right side of the brain, while overemphasizing the skills best accomplished by the left side of the brain: memorizing dates, data, theorems, and events with the goal of passing standardized tests. Today we are not only testing and grading our children into the ground, but we are not teaching them how to see and understand the *deep meaning* of what they learn, or to perceive the connectedness of information about the world. It is indeed time to try something different.

Fortunately, the tide seems to be turning, according to a recent news report. A small group of cognitive scientists at the University of California at Los Angeles is recommending something

"The noblest pleasure
is the joy of understanding."
— Leonardo da Vinci

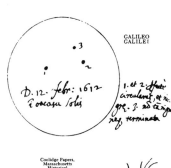

GALILEO GALILEI

D. 12. febr: 1612
é oscusa solis

1. et 2. stelle circulares, et nigre. 3. 2ò ta nigr nig, terminata

Coolidge Papers, Massachusetts Historical Society

THOMAS JEFFERSON

MICHAEL FARADAY

2.
SUGGESTED DESIGN
FOR U.S. CAPITOL

Thomas Alva Edison
Foundation Museum
West Orange, N.J.

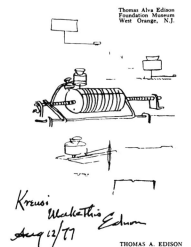

THOMAS A. EDISON

3. WORKING DRAWING FROM
WHICH THE ORIGINAL
PHONOGRAPH WAS BUILT

In the history of inventions, many creative ideas began with small sketches. The examples above are by Galileo, Jefferson, Faraday, and Edison.
— Henning Nelms, *Thinking with a Pencil* (New York: Ten Speed Press, 1981), p. xiv

2. Benedict Carey. "Brain Calisthenics for Abstract Ideas," *New York Times*, June 7, 2011

they call "perceptual learning" as a remedy to our failing educational practices. They express hope that such training will transfer to other contexts, and they have had some success with achieving transfer. Discouragingly, however, the news report ended: "In an education awash with computerized learning tools and pilot programs of all kinds, the future of such perceptual learning efforts is far from certain. Scientists still don't know the best way to train perceptual intuition, or which specific principles it's best suited for. And such tools, if they are incorporated into curriculums in any real way, will be subject to the judgment of teachers."[2]

I would like to suggest that we already have a best way to train perceptual skills: it has been staring us in the face for decades, and we haven't (or wouldn't, or couldn't) accept it. I think it is not a coincidence that as drawing and creative arts in general have steadily diminished in school curricula since the mid-twentieth century, the educational achievement of students in the United States has likewise diminished, to the point that we now rank behind Singapore, Taiwan, Japan, the Republic of Korea, Hong Kong, Sweden, the Netherlands, Hungary, and Slovenia.

In 1969, perceptual psychologist Rudolf Arnheim, one of the most widely read and respected scientists of the twentieth century, wrote:

> *"The arts are neglected because they are based on perception, and perception is disdained because it is not assumed to involve thought. In fact, educators and administrators cannot justify giving the arts an important position in the curriculum unless they understand that the arts are the most powerful means of strengthening the perceptual component without which productive thinking is impossible in every field of academic study.*

> *"What is most needed is not more aesthetics or more esoteric manuals of art education but a convincing case made for visual thinking quite in general. Once we understand in*

theory, we might try to heal in practice the unwholesome split which cripples the training of reasoning power."[3]

3. Rudolf Arnheim, *Visual Thinking* (University of California Press, 1969).

Drawing does indeed involve thought, and it is an effective and efficient method for perceptual training. And perceptual knowledge can impact learning in all disciplines. We now know how to rapidly teach drawing. We know that learning to draw, like learning to read, is *not* dependent on something called "talent," and that, given proper instruction, every person is able to learn the skill. Furthermore, given proper instruction, people can learn to *transfer* the basic perceptual components of drawing to other learning and to general thinking. And, as Michael Kimmelman said, learning to draw is a boon to happiness—a panacea for the stultifying and uncreative drudgery of standardized testing that our schools have embraced.

Our two minds and modern multitasking

Today, as research expands and the information-processing styles and proclivities of the hemispheres become ever clearer, respected scientists are recognizing functional differences as evident and real, despite the fact that both hemispheres appear to be involved to a greater or lesser extent in every human activity. And there remains much uncertainty about the reason for the profound asymmetry of the human brain, which we seem to be aware of at the level of language. The expression "I am of two minds about that" clearly states our human situation. Our two minds, however, have not had an equal playing field: until recently, language has dominated worldwide, especially in modern technological cultures like our own. Visual perception has been more or less taken for granted, with little requirement for special concern or education. Now, however, computer scientists who are trying to replicate human visual perception find it extremely complicated and slow going. After decades of efforts, scientists have finally achieved facial recognition by computers, but reading the meaning of changes in facial expression, accomplished instantly and

In his wonderful book *The Master and His Emissary*, psychiatrist and Oxford professor Iain McGilchrist proposes a telling metaphor to describe human history and human culture:
"Over the centuries of history, The Master (the right hemisphere) has seen his empire and powers usurped and betrayed by his Emissary (the left hemisphere)."
— Iain McGilchrist, *The Master and His Emissary* (Yale University Press, 2009), p. 14

An example of extreme multitasking:
For 12 hours a day, a young intelligence officer monitors 10 overhead television screens, types computer responses to 30 different chats with commanders, troops, and headquarters, has a phone in one ear, and communicates with a pilot on a headset in the other ear. "It's intense," he says.

Reported in the *New York Times* by Thom Shanker and Matt Richtel, "In New Military, Data Overload Can Be Deadly," January 17, 2011, p. 1

effortlessly by the right hemisphere, will take much more time and work.

Meanwhile, visual images are everywhere, and visual and verbal information compete for attention. Constant multitasking linked to information overload is challenging the brain's ability to rapidly shift modes, or to simultaneously deal with both modes of input. The recent banning of texting while driving illustrates the problem of the brain's difficulty in simultaneously processing two modes of information. This recognition that we need to find productive ways to use both modes perhaps explains why replicating right hemisphere processes is only now emerging as important and even, perhaps, critical.

A complication: the brain that studies itself

As a number of scientists have noted, research on the human brain is complicated by the fact that the brain is struggling to understand itself. This three-pound organ is perhaps the only bit of matter in the our universe—at least as far as we know—that observes and studies itself, wonders about itself, tries to analyze how it does what it does, and tries to maximize its capabilities. This paradoxical situation no doubt contributes to the deep mysteries that still remain despite rapidly expanding scientific knowledge. One of the most encouraging new discoveries that the human brain has made about itself is that it can physically change itself by changing its accustomed ways of thinking, by deliberately exposing itself to new ideas and routines, and by learning new skills. This discovery has led to a new category of neuroscientists, neuroplasticians, who use microelectrodes and brain scans to track complex brain maps of neuronal communication, and who have observed the brain revising its neuronal maps.

"The mystery is the human faculty of perception, the act of knowing what our senses have discovered."
— Edmund Bolles, *A Second Way of Knowing: The Riddle of Human Perception* (Prentice Hall, 1991)

Brain plasticity: a new way to think about talent

This conception of a plastic brain, a brain that constantly changes with experience, that can reorganize and transmute and even develop new cells and new cell connections, is in direct contrast

to previous judgments of the human brain as being more akin to a hard-wired machine, with its parts genetically determined and unchangeable except for development in early childhood and deterioration in old age. For teachers like myself, the science of brain plasticity is both exciting and reaffirming—exciting because it opens vast new possibilities, and reaffirming because the idea that learning can change the way people live and think has always been a goal of education. Now, at last, we can move beyond the ideas of fixed intelligence limits and special gifts for the lucky few, and look for new ways to enhance potential brain power.

One of the exciting new horizons that brain plasticity opens is the possibility of questioning the concept of *talent*, especially the concepts of artistic talent and creative talent. Nowhere has the idea of the hard-wired brain, with its notion of given or not-given talent, been as widespread as in the field of art, and especially in drawing, because drawing is the entry-level skill for all the visual arts. The common remark, "Drawing? Not on your life! I can't even draw a straight line!" is still routinely announced with full conviction by many adults and even more distressingly, by many children as young as eight or nine, who have tried and sadly judged as failures their attempts to draw their perceptions. The reason given for this situation is often a flat-out statement: "I have no artistic talent." And yet we know now, from knowledge of brain plasticity and from decades of work by me and many others in the field, that drawing is simply a skill that can be taught and learned by anyone of sound mind who has learned other skills, such as reading, writing, and arithmetic.

Drawing, however, is not regarded as an essential skill in the way the three Rs are viewed as necessary life skills. It is seen as perhaps a peripheral skill, nice to have as a pastime or hobby, but certainly not indispensable. And yet, somehow, at some level, we sense that something important is being ignored. Surprisingly, people often equate their lack of drawing skill with a lack of creativity, even though they may be highly creative in other areas of their lives. And the importance of perception often shows up

in the words we speak, phrases that speak of seeing and perceiv-
ing. When we finally understand something, we exclaim, "Now I
see it!" Or when someone fails to understand, we say the person
"can't see the forest for the trees," or "doesn't get the picture." This
implies that perception is important to understanding, and we
hope that we somehow learn to perceive, but it is a skill without a
classroom and without a curriculum. I propose that drawing can
be that curriculum.

Public education and the arts

Drawing, of course, is not the only art that trains perceptual
thinking. Music, dance, drama, painting, design, sculpture, and
ceramics are all vitally important and should all be restored to
public schools. But I'll be blunt: even if there were the will, there
is no way that will happen because it would cost too much in this
era of ever-diminishing resources for public education. Music
requires costly instruments, dance and drama require staging
and costumes, sculpture and ceramics require equipment and
supplies. Although I wish it were otherwise, high-cost visual and
performing arts programs that were terminated long ago will not
be reinstated. And cost is not the only deterrent. Over the last
forty years, many educators, decision-makers, and even some
parents have come to regard the arts as peripheral, and, let's face
it, frivolous—especially the visual arts, with their connotation of
"the starving artist" and the mistaken concept of necessary talent.

The one art subject that we could easily afford is drawing, the
skill that is basic to training visual perception and is therefore
the entry-level subject—the ABCs—of perceptual skill-building.
Among people who oppose arts education, drawing doesn't
escape the frivolity label, but it is affordable to teach. Drawing
requires the simplest of materials—paper and pencils. It requires
a minimum of simple equipment and no special rooms or build-
ings. The most significant requirement is a teacher who knows
how to draw, knows how to teach the basic perceptual skills of

drawing, and knows how to transfer those skills to other domains. Of all the arts, drawing is the one that can fit into today's rapidly shrinking school budgets. And most parents are very supportive if their children acquire real, substantive drawing skills as opposed to the more usual "expressive" manipulation of materials in vogue in recent decades. At around ages seven to nine, children long to learn "how to make things look real" in their drawings, and they are well able to learn to draw, given appropriate teaching. If educators would find the will, there would be a way.

Trying something new

We could at least give it a try. Our American public schools are failing fast. The more we double down on teaching facts and figures, the more we focus on standardized testing, the more left-brained our schools become, the more our children are failing even our own standardized tests, while the dropout rates rise ominously. Albert Einstein once defined insanity as "doing the same thing over and over again and expecting different results." He also said, "We can't solve problems by using the same kind of thinking we used when we created them."

In light of the United States' appalling worldwide standing in reading, math, and science, surely it is time to try something different—namely, to begin purposely educating the other half of the brain in order to maximize the powers of both hemispheres. I believe that the goal of education should be not only to pass necessary standardized tests but also to enable our students to acquire and apply *understanding* to what they have learned. Ideally, of course, students should develop rational, orderly thinking processes—left-hemisphere skills that are compatible with investigation, dissection, reduction, examination, summary, and abstraction. If we also teach students right-hemisphere perceptual skills, they will help students "see things in context," "see the whole picture," "see things in proportion and in perspective," and observe and apprehend—in short, to intuit, to understand and

In December 2010, the Organization for Economic Cooperation and Development released the highly regarded results of its 2009 "Pisa" test, the Program for International Student Assessment test of fifteen-year-old students in sixty-five countries in science, reading, and math.

Alarmingly, American students came in seventeenth in reading, twenty-third in science, and thirtieth in math, far behind China, Singapore, Finland, and Korea. The U.S. Secretary of Education, Arne Duncan, said, "We have to see this as a wake-up call."

Transfer of learning can be "near transfer" or "far transfer." An example of near transfer of drawing skills might be students drawing various types of bird beaks in a science class to memorize and identify them. An example of far transfer might be students extrapolating from that experience to study and understand the evolution of bird beaks.

Alan Kay, famed for his innovative computer science contributions, has stated that the concept of negative spaces is essential to computer programming—an elegant example of "far transfer."

bring *meaning* to the fragmented world of the left hemisphere.

Teaching for transfer of learning

To promote understanding, we could teach our children perceptual skills through drawing in elementary school, starting around the fourth or fifth grade—not with the intention of training future artists, but with the intention of teaching students how to transfer perceptual skills learned through drawing to general *thinking skills* and problem-solving skills. After all, we do not teach children to read and write with the goal of training future poets and authors. With careful teaching for transfer, drawing and reading together can educate *both* halves of the brain.

A further argument for perceptual training is the ameliorative effect that a partial focus on right-hemisphere learning might have on our public school curriculum. To have even a small part of the school day free from continuous left-brain, verbal discourse might provide some welcome quiet time and relief from incessant competitive verbal pressure. In days long past, when I attended ordinary working-class public schools, art classes, cooking classes, sewing classes, ceramics, woodworking, metal working, and gardening provided welcome breaks in the academic day, with time for solitary thought. Silence is a rare commodity in modern classrooms, and drawing is an individual, silent, timeless task.

Two vital global skills: reading and drawing

What are the skills you will learn through drawing, and how do they transfer to general thinking? Drawing, like reading, is a *global* skill made up of component subskills that are learned step by step. Then, with practice, the components meld seamlessly into the smoothly functioning global activities of reading and drawing.

For the global skill of drawing, the basic component skills, as I have defined them, are:

- The perception of edges (seeing where one thing ends and another starts)

- The perception of spaces (seeing what lies beside and beyond)
- The perception of relationships (seeing in perspective and in proportion)
- The perception of lights and shadows (seeing things in degrees of values)
- The perception of the *gestalt* (seeing the whole *and* its parts)

The first four skills require direct teaching. The fifth occurs as an outcome or insight—a visual and mental comprehension of the perceived subject, resulting from the focused attention of the first four. Most students experience these skills as new learning, seeing in ways they haven't seen previously. As one student put it after drawing her own hand, "I never really looked at my hand before. Now I see it differently." Often students say, "Before I learned to draw, I think I was just naming things I saw. Now it's different." And many students remark that seeing negative spaces, for example, is an entirely new experience.

Turning to reading, specialists in teaching reading list the basic component skills of reading, mainly taught in elementary school, as:

- Phonetic awareness (knowing that alphabet letters represent sounds)
- Phonics (recognizing letter sounds in words)
- Vocabulary (knowing the meanings of words)
- Fluency (being able to read quickly and smoothly)
- Comprehension (grasping the meaning of what is read)

As in drawing, the last skill of comprehension ideally occurs as an outcome or result of the preceding skills.

I am aware, of course, that many additional skills are required for drawing that leads to "Art with a capital A," the world of artists, galleries, and museums. There remain countless materials and mediums along with endless practice to achieve mastery, as well as that unknown spark of originality and genius that marks

I am not an expert in reading instruction, but it worries me that "fluency" is consistently listed in educational literature as a *basic component* of reading. It seems to me that fluency is better described as an *outcome* of learning to read. It also worries me that learning syllabification of words is rarely listed by reading experts as a basic component, nor is basic sentence structure—that is, finding the subject and verb in a sentence.

The listing of fluency as a basic reading component calls to mind the very common practice of art teachers insisting that beginners in drawing, even before they have learned the most basic components of the skill, draw a perceived subject very, very rapidly (this is often called "scribble drawing"), which can leave students baffled and frustrated. After the fifth or sixth—or tenth—scribble drawing, the left brain will have dropped out and students may come up with a "good" drawing, usually so designated by the teacher. They don't know why it happened, how to replicate it, or why the teacher likes it. It does seem that often in American education, *fast* is judged to be better, even when it isn't.

the truly great artist of any time. Once you have learned basic drawing skill, you can move on, if you wish, to drawing from memory, drawing from imagined images, and creating abstract or nonobjective images. But for skillful realistic drawing of one's perceptions using pencil on paper, the five skills I will teach you in this book provide adequate basic perceptual training to enable you to draw what you see.

The same is true of basic reading, of course. There are many refinements of reading abilities, depending on subject matter and formats other than print on paper. But for both skills, the basic components are the foundation. Once you can read, your plastic brain has been forever changed. You can read anything, at least in your native language, and you can read for life. Likewise, once you have learned to draw, your brain has again been changed: you can draw anything that you see with your own eyes, and the skill stays with you for life.

Twin skills and their transfer: L-mode and R-mode

Thus, in a sense, reading and drawing might be thought of as twin skills: verbal, analytical L-mode skills as a major function of the left brain, and visual, perceptual R-mode skills as a major function of the right brain. Moreover, human history tells us that, like written language, portraying perceptions in drawings has been singularly important in human development. Consider the fact that the astoundingly beautiful prehistoric cave drawings and paintings preceded written languages by more than twenty-five thousand years. Moreover, writing grew out of pictographs or word pictures representing, for example, bird, fish, grain, and ox, thus illustrating the profoundly significant role of drawing in human development. And consider the fact that human beings are the only creatures on our planet that write things down and make images of things seen in the world.

Language dominates

These two cognitive twins, however, are not equal. Language is extremely powerful, and the left hemisphere does not easily share its dominance with its silent partner. The left hemisphere deals with an explicit world, where things are named and counted, where time is kept, and step-by-step plans remove uncertainty from the future. The right hemisphere exists in the moment, in a timeless, implicit world, where things are buried in context, and complicated outlooks are constantly changing. Impatient with the right hemisphere's view of the complex whole, the competitive left hemisphere tends to jump quickly into a task, bringing language to bear, even though it may be unsuited to that particular task.

This is true in drawing: using symbols from childhood to quickly draw an abstracted, notational image, the left brain will rush in to take over a drawing task that is best accomplished by the visual right hemisphere. When writing the original book, I needed to find a way to keep this from happening—a way to enable the right hemisphere to "come forward" to draw. This required finding a strategy to set aside the left hemisphere. Taking my cue from Upside-Down Drawing, and thinking hard, I laboriously arrived at a solution and stated it this way:

> *In order to gain access to the right hemisphere, it is necessary to present the left hemisphere with a task that it will turn down.*

In other words, it is no use going up against the strong, verbal, domineering left brain to try to keep it out of a task. It can be *tricked*, however, into not wanting to do the task, and, once tricked, it tends to "fade out," and will stay out, ending its interfering and usurping. As a side benefit, this cognitive shift to a different-from-usual mode of thinking results in a marvelous state of being, a highly focused, singularly attentive, deeply engaging, wordless, timeless, productive, and mentally restorative state.

If an art student says, "Well, I am good at drawing still life, and I am fairly good at figure drawing, but I am not good at landscape, and I can't do portraits at all," it means that one or more of the basic component skills has not been learned. A comparable statement about reading would be, "I am good at reading magazines, and I am fairly good at instruction manuals, but I'm not good at newspapers, and I can't read books at all." Hearing this, one would know that some reading components were not learned.

I once saw a video of an elephant that had been trained to paint a rough image of an elephant by holding a paintbrush in its trunk and painting line by line on paper. This is the nearest nonhuman approximation of human drawing skills I am aware of. But, as far as I know, there are no elephants out in the wild spontaneously drawing images of other animals on stone surfaces or in the sand.

Paleolithic cave painting from Altamira, Spain.

Recently this strategy has been corroborated scientifically. Norman Doidge, in his fascinating book on human brain plasticity, *The Brain That Changes Itself* (Penguin Books, 2007), cites Dr. Bruce Miller, a professor of neurology at the University of California, San Francisco, who has shown that people who lose language abilities due to left-brain dementia damage spontaneously develop unusual artistic, musical, and rhyming abilities, including drawing abilities—skills attributed to the right hemisphere. Doidge reports that Miller argues that "the left hemisphere normally acts like a bully, inhibiting and suppressing the right. As the left hemisphere falters, the right's uninhibited potential can emerge."

Doidge goes on to say of my main strategy: "Edwards's book, written in 1979, years before Miller's discovery, taught people to draw by developing ways to stop the verbal, analytical left hemisphere from inhibiting the right hemisphere's artistic tendencies. Edwards's primary tactic was to deactivate the left hemisphere's inhibition of the right by giving students a task the left hemisphere would be unable to understand and so 'turn down.'"

How the strategy works in the drawing exercises

‣ The Vase/Faces exercise in Chapter 4 is designed to acquaint students with the possibility of conflict between the hemispheres as they compete for the task. The exercise is set up to strongly activate the verbal hemisphere (L-mode), but completion of the exercise requires the abilities of the visual hemisphere (R-mode). The resulting mental conflict is perceptible and instructive for students.

‣ The Upside-Down Drawing exercise in Chapter 4 is rejected by the left hemisphere because it is too difficult to name parts of an image when it is upside down, and, in left-brain terms, an inverted image is too unusual—that is, useless—to bother with. This rejection enables the right hemisphere to jump into the task (for which it is well suited) without competition from the left hemisphere.

• The Perception of Edges exercise (seeing complex edges) in Chapter 6 forces extreme slowness and extreme perception of tiny, inconsequential (in left-brain terms) details, where every detail becomes a fractal-like whole, with details within details. The left hemisphere quickly becomes "fed up" because it is "too slow for words" and drops out, enabling the right hemisphere to take up the task.

• The Perception of Spaces exercise (negative spaces) in Chapter 7 is rejected by the left hemisphere because it will not deal with "nothing," that is, negative spaces that aren't objects and can't be named. In its view, spaces are not important enough to bother with. The right hemisphere, with its recognition of the whole (shapes *and* spaces), is then free to pick up the task and seems to take antic delight in drawing negative spaces.

• The Perception of Relationships exercise (perspective and proportion in buildings or interiors) in Chapter 8 forces the left hemisphere to confront *paradox* and *ambiguity*, which it dislikes and rejects ("this is not how I know things to be"), and which are abundant in perspective drawing, with its angular and proportional spatial changes. Because the right hemisphere is willing to acknowledge perceptual reality, it accepts and will draw what it sees ("it is what it is").

• The Perception of Lights and Shadows exercise (values from dark to light) in Chapter 10 presents shapes (of lights and shadows) that are infinitely complex, variable, unnamable, and not useful in terms of language. The left hemisphere refuses the task, which the complexity-loving right hemisphere then picks up, delighting in the three-dimensionality that lights and shadows reveal.

• The Perception of the *Gestalt* occurs during and at the close of a drawing. The main effect is a right-hemisphere *aha*, as though in recognition of the whole that emerges from careful perception and recording of the parts, all in relationship to each other and to the whole. This initial perception of the *gestalt* occurs largely without verbal input or response from the left hemisphere, but

This set of drawings by workshop participant James Vanreusel resulted from his work in a five-day class, November 13–17, 2006. His Vase/Faces drawing and his Pure Contour drawing, both done on the Day 1 of the workshop, were not available. Each workshop day begins with an explanation of the component skill to be explored and a demonstration drawing by the instructor, after which the students apply the instructions to their own drawings. James Vanreusel's drawings illustrate the instructional strategies described on pages xxviii to xxxii.

(See additional Pre- and Post-instruction student drawings, pages 19 to 20.)

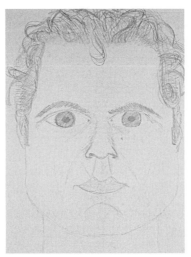

Day 1: James's Pre-instruction "Self-Portrait." November 13, 2006

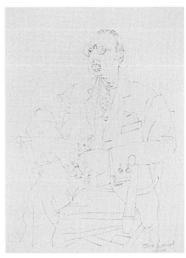

Day 1: His "Upside-Down drawing of Picasso's *Stravinski.*" November 13, 2006

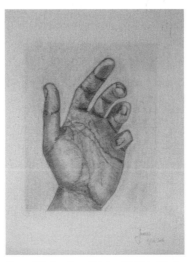

Day 2: His drawing of his hand in "Modified Contour" (edges). The fine detail of edges and wrinkles in this drawing derives from the Pure Contour Drawing exercise. November 14, 2006

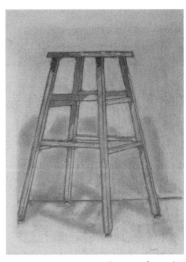

Day 2: His negative space drawing of a stool. November 14, 2006

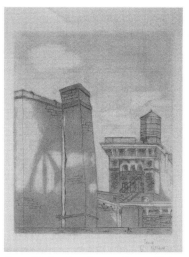

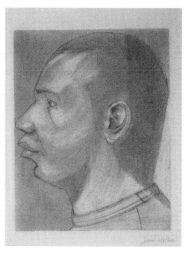

Day 3: His drawing of an outside view, "Sighting Perspective and Proportion." November 15, 2006

Day 4: James's profile drawing of a fellow student, summarizing edges, spaces, and sighting relationships. November 16, 2006

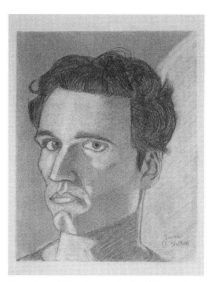

Day 5: James's Post-instruction "Self-Portrait," summarizing edges, spaces, lights and shadows, and the *gestalt*. November 17, 2006

later the left brain may put into words a response that expresses the right brain's *aha*. I believe that the perception of the *gestalt* closely resembles the "aesthetic response," our human delight in beauty.

This, then, is the essence of *Drawing on the Right Side of the Brain:* five basic component perceptual skills of drawing, and an overall strategy to enable your brain to bring to bear the brain mode appropriate for drawing. In a new Chapter 11, I suggest specific ways you can apply the five basic skills to general thinking and problem solving. Incidentally, for this edition, I have rewritten the chapter on the Perception of Relationships (perspective and proportion, also called "sighting," Chapter 8) with hopes of simplifying and clarifying this skill. Because the perceptions are complicated with aspects that seem "left-brained," putting this skill into words is something like trying to teach someone in words how to dance the tango. Once sighting is understood, however, it is purely perceptual and most engaging because it unlocks three-dimensional space.

The Great Saboteur

A caution: as all of our students discover, sooner or later, the left hemisphere is the Great Saboteur of endeavors in art. When you draw, it will be set aside—left out of the game. Therefore, it will find endless reasons for you *not* to draw: you need to go to the market, balance your checkbook, phone your mother, plan your vacation, or do that work you brought home from the office.

What is the strategy to combat that? The same strategy. Present your brain with a job that your left hemisphere will turn down. Copy an upside-down photograph, regard a negative space and draw it, or simply start a drawing. Jogging, meditation, games, music, cooking, gardening—countless activities also produce a cognitive shift. The left hemisphere will drop out, again tricked out of its dominance. And oddly, given the great power and force of the left hemisphere, it can be tricked over and over with the same tricks.

Over time, probably due to brain plasticity, the sabotage will lessen and the need for trickery will diminish. I have sometimes wondered whether the left hemisphere becomes alarmed when it is first set aside for a period of time. The right hemisphere state of mind is notably desirable and productive—sometimes called the "zone" in athletic terms. I think it is possible that the left hemisphere may worry that if you get "over there" long enough, you may not come back. But this is a needless concern. The right-hemisphere state is extremely fragile, ending the instant the cell phone rings or someone asks you what you are doing or calls you to dinner. Immediately it is over, and you are back to your more usual mental state.

Teaching methods that work

Over the years, I have been rebuked occasionally by various scientists for overstepping the bounds of my field. In each edition, however, I have made the following statement: The methods presented in my book have proven empirically successful. From my own work with students and letters sent to me by thousands of readers and countless art teachers, I know that my methods work in a variety of environments, taught by teachers with undoubtedly varied teaching styles. Science has corroborated some of my ideas, but we must depend on future science to confirm more exactly the explanations and uses of our still-mysterious and asymmetrical, divided brain.

Meanwhile, I venture to say that learning to draw always seems to help and never to harm. My students' most frequent comment after learning to draw is "Life seems much richer now that I am seeing more." That may be reason enough to learn to draw.

Chapter 1
Drawing and the Art of Bicycle Riding

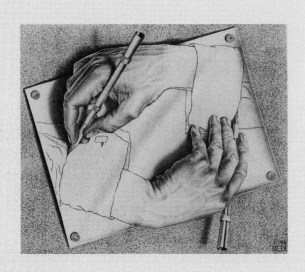

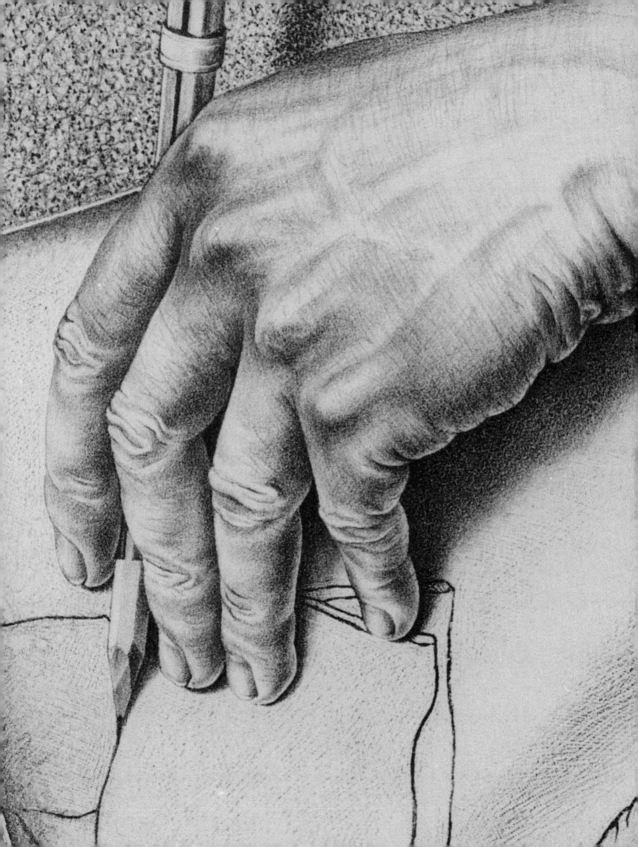

Drawing is a curious process, so intertwined with seeing that the two can hardly be separated. The ability to draw depends on one's ability to see the way an artist sees. This kind of seeing, for most people, requires teaching, because the artist's way of seeing is very specific and very different from the ways we ordinarily use vision to navigate our lives.

Because of this unusual requirement, teaching someone to draw has some special problems. It is very much like teaching someone to ride a bicycle: both skills are difficult to explain in words. For bicycle riding, you might say, "Well, you just get on, push the pedals, balance yourself, and off you'll go." Of course, that doesn't explain it at all, and you are likely to finally say, "I'll get on the bike and show you how. Watch and see how I do it."

And so it is with drawing. An art teacher may exhort students to "look more carefully," or to "check the relationships," or to "just keep trying and with practice, you will get it." This does not help students solve the problems of drawing. And it is fairly rare today for teachers to help by demonstrating a drawing, which *is* extremely effective. A well-kept secret of art education is that many art teachers, having come up through the same system that prevails today, where real skills in drawing are rarely taught, cannot themselves draw well enough to demonstrate the process to a group of students.

Drawing as a magical ability

As a result, few people are skilled at drawing in twenty-first-century American culture. Since it is rare now, many people regard drawing as mysterious and even somewhat magical. Artists who *can* draw often do little to dispel the mystery. If you ask, "How do you draw something so that it looks real—say a portrait or a landscape?" an artist is likely to reply, "Well, it is hard to explain. I just *look* at the person or the landscape and I draw what I see." That

> "Learning to draw is really a matter of learning to see—to see correctly—and that means a good deal more than merely looking with the eye."
> — Kimon Nicolaides, *The Natural Way to Draw*, 1941

seems like a logical and straightforward answer, yet, on reflection, doesn't explain the process at all, and the sense persists that drawing is a vaguely magical ability.

This attitude of wonder at drawing skill does little to encourage individuals to try to learn to draw. Often, in fact, people hesitate to take a drawing class because they don't already know how to draw. That is like deciding that you shouldn't take a Spanish class because you don't already speak the language. Moreover, because of changes in today's art world, a person who has never learned to draw nevertheless can become a successful university art student or even a famous artist.

Drawing as a learnable, teachable skill

I firmly believe that given good instruction, drawing is a skill that can be learned by every normal person with average eyesight and average eye-hand coordination. Someone with sufficient ability, for example, to sign a receipt or to type out an e-mail or text message can learn to draw. Clearly, the long history of humans drawing pictures of their perceptions, from prehistoric times to now, demonstrates that drawing perceptions is an innate potential of our plastic, changeable brains.

And learning to draw, without doubt, causes new connections in the brain that can be useful over a lifetime for general thinking. Learning to see in a different way requires that you use your brain differently. At the same time, you will be learning something about how your individual brain handles visual information and about how to better control the process. One aspect of that control is learning to shift away from our more usual way of thinking—mainly in words.

Drawing attention to states of consciousness

I have designed the exercises and instructions in this book specifically for people who cannot draw at all, who may feel that they have little or no talent for drawing, and who may feel doubtful

"The painter draws with his eyes, not with his hands. Whatever he sees, if he sees it *clearly*, he can put down. The putting of it down requires, perhaps, much care and labor, but no more muscular agility than it takes for him to write his name. Seeing *clear* [sic] is the important thing."
— Maurice Grosser, *The Painter's Eye*, 1951

"If a certain kind of activity, such as painting, becomes the habitual mode of expression, it may follow that taking up the painting materials and beginning work with them will act suggestively and so presently evoke a flight into the higher state."
— Robert Henri, *The Art Spirit*, 1923

that they could ever learn but who think they might like to learn to draw.

Given proper instruction, drawing is not very difficult. It almost seems that your brain already knows how to draw. You just don't realize it. Helping people move past the blocks to drawing is, however, the difficult part. The brain, it seems, doesn't easily give up its accustomed way of seeing things. It helps, I think, to know that the slight change in awareness or consciousness that occurs in drawing is not that unusual. You may have observed in yourself other slightly altered states. For example, most people are aware that they occasionally slip from alert consciousness to a state of daydreaming. As another example, people often say that reading a good novel takes them "out of themselves." Other kinds of activities that apparently produce a shift in consciousness are meditation, jogging, video games, sports of all varieties, and listening to music.

An interesting example of this slightly altered state, I believe, is driving on the freeway. In freeway driving, we deal with visual information, keeping track of relational, spatial changes, sensing complicated configurations of traffic. These visual mental operations may activate some of the same parts of the brain used in drawing. Many people find that they also do a lot of creative thinking while driving, often losing track of time. Of course, if driving conditions are difficult, if we are late for an appointment, or if someone sharing the ride talks with us, the shift to an alternative state doesn't occur. And that nonverbal alternative state is the appropriate one for driving. Verbal distractions, like cell phone conversation or texting while driving, are proving to be so distracting and dangerous that they are banned in some cities and states.

The shift to the drawing state, therefore, is not entirely unfamiliar, but it is strikingly different in some ways from, say, daydreaming. The drawing state is one of high alertness, engagement, and acute, focused attention. It is also a state without a sense of time passing or awareness of one's surroundings. Because the state is fragile and easily broken, an important key to learning to

draw is learning how to set up conditions that allow this mental shift that enables you to see and draw. In addition to teaching you *what* and *how* to see, the exercises and strategies in this book are designed specifically for that purpose.

The original 1979 edition of *Drawing on the Right Side of the Brain* was based on my teaching experiences in the art departments of Venice High School in West Los Angeles, Los Angeles Trade Technical Community College, and California State University, Long Beach. Subsequent editions benefitted from experiences teaching an intensive five-day, eight-hour-a-day workshop, conducted in many locations across the United States, as well as in countries overseas. Workshop students range widely in ages and occupations. Most of the participants begin a workshop with low-level drawing skills and with high anxiety about their potential drawing ability.

Almost without exception, workshop students achieve quite a high level of skill in drawing and gain confidence to go on developing their skills in further art courses or by practice on their own. One of the most intriguing findings of the *Drawing on the Right Side of the Brain* five-day workshop is that people can actually achieve those high-level drawing skills in that forty-hour time period. It is hard work, for both students and teachers, but it does reinforce my belief that our teaching and our instruction have more to do with *releasing* inborn skills than teaching new skills.

To put it another way, it seems probable that you have all the brain power needed for drawing, but old habits of seeing interfere with that ability and block it. The exercises in this book are designed to remove that interference and unblock it.

Realism as a means to an end

The drawing exercises focus on what is known in the art world as *realism*, the art of realistically portraying actual things seen "out there" in the world. Unexpectedly, perhaps, the subjects I have chosen for the exercises are usually considered in drawing terms

to be the most difficult: the human hand, a chair, a landscape or an interior of a building, a profile portrait, and a self-portrait.

I have not selected these drawing tasks to torture our students but rather to provide them with the satisfaction of being able to draw the really "hard" subjects. Famed psychologist Abraham Maslow once said, "The greatest satisfaction comes from mastering something that is truly difficult." Another reason for my subject choices is that *all drawing is the same*, broadly speaking, always involving the same ways of seeing and the same skills, the basic components of drawing. You might use different mediums, different papers, large or small formats, but for drawing still-life setups, the figure, random objects, portrait drawings, and even imaginary subjects or drawing from memory, *it is all the same task*, always requiring the same basic component skills—just as it is in reading! Drawing requires that you see what is out there (imaginary subjects and images from memory are "seen" in the "mind's eye") and you draw what you see. Since it is all the same task, it seems to me that we might as well go for peak accomplishment. One subject is not "harder" than another, once you understand the basics of drawing.

Moreover, in the case of drawing a profile portrait or a self-portrait, students are highly motivated to see clearly and to draw correctly what they see. This high motivation might be lacking if the subject is a potted plant, where a viewer of the finished drawing might have a less critical eye for verisimilitude. Beginning students often think that portrait drawing must be the hardest of all kinds of subjects. Thus, when they see that they *can* successfully draw a portrait that actually looks like the sitter, their confidence soars and progress is enhanced.

A second important reason for using portraits as subject matter is that the right hemisphere of the human brain is specialized for recognition of faces. Since the right hemisphere is the one we are trying to access, it makes sense to choose a subject that fits the functions of the right brain. And third, faces are fascinating! In drawing a portrait, you see a face as you have never seen one

"I have learned that what I have not drawn, I have never really seen, and that when I start drawing an ordinary thing, I realize how extraordinary it is, sheer miracle."
— Frederick Franck, *The Zen of Seeing*, 1973

before, in all its complexity and expressive individuality. As one of my students said, "I don't think I ever actually *saw* anyone's face before I started drawing. Now, the oddest thing, I find I am really seeing people instead of just making verbal tags, and the unusual faces are the ones I find the most interesting."

My approach: A path to creativity

I recognize that you may have no interest whatsoever in becoming a full-time working artist, but there are many reasons for learning to draw. I see you as an individual with creative potential for expressing yourself through drawing. My aim is to provide the means for releasing that potential, for gaining access *at a conscious level* to your inventive, intuitive powers that may have been largely untapped by our verbal, technological culture and education system.

Creative persons from fields other than art who want to get their working skills under better control and learn to overcome blocks to creativity will also benefit from working with the techniques presented here. Teachers and parents will find the theory and exercises useful in helping children develop their creative abilities.

The exercises will also provide insights into the way your mind works—that is, your two minds—singly, cooperatively, or one against the other. A reasonable goal that you might pursue in learning to draw is simply to enhance confidence in your critical thinking ability and your decision making. With our new knowledge of brain plasticity, the possibilities seem almost limitless.

Learning to draw may uncover potentialities that are unknown to you right now. The German artist Albrecht Dürer said, "From this, the treasure secretly gathered in your heart will become evident through your creative work."

Summing up

Drawing is a teachable, learnable skill that can provide a twofold advantage. First, by gaining access to the part of your mind that

In a letter to his brother, Theo, who had suggested that Vincent become a painter, Vincent van Gogh wrote:

"...at the time when you spoke of my becoming a painter, I thought it very impractical and would not hear of it. What made me stop doubting was reading a clear book on perspective, Cassange's *Guide to the ABC of Drawing,* and a week later I drew the interior of a kitchen with stove, chair, table and window—in their places and on their legs—whereas before it had seemed to me that getting depth and the right perspective into a drawing was witchcraft or pure chance."
— *Complete Letters of Vincent van Gogh,* Letter 184, p. 331

works in a style conducive to creative, intuitive thought, you will learn a fundamental skill of the visual arts: how to put down on paper what you see in front of your eyes. Second, you will enhance your ability to think more creatively in other areas of your life.

How far you go with these skills will depend on your other traits, such as energy, curiosity, and discipline. But first things

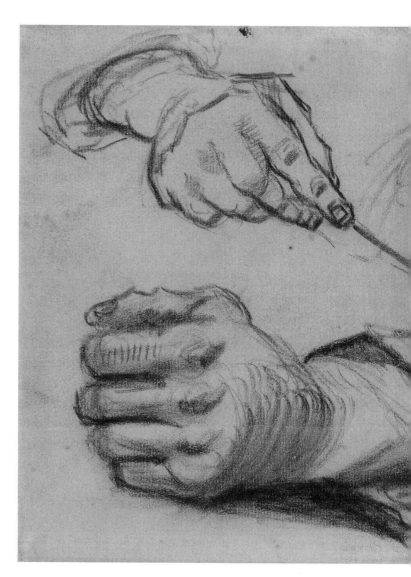

first! The potential is there. Sometimes it is necessary to remind ourselves that Shakespeare at some point learned to write a line of prose, Beethoven learned the musical scales, and, as you see in the margin quotation, Vincent van Gogh learned how to draw.

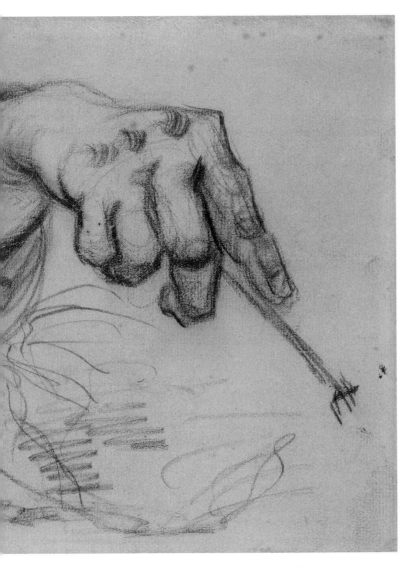

Vincent van Gogh (1853-1890), *Three Hands, Two Holding Forks, Nuenen: March-April, 1885*. Drawing, black chalk on laid paper, Van Gogh Museum Amsterdam (Vincent van Gogh Foundation), The Netherlands

Chapter 2
First Steps in
Drawing

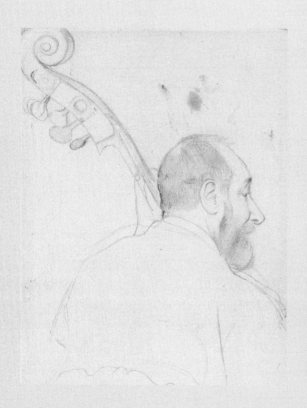

Edgar Degas (1834–1917), *M. Gouffé, the String Bass Player*. Photography: Graham Haber, 2010. The Thaw Collection, The Pierpont Morgan Library, New York. EVT 279/Art Resource, NY.

A sketch by Degas for his painting, *The Orchestra of the Opera*. The artist masterfully used the compositional device of placing the bass player in the extreme foreground of the painting, giving depth to the scene. The viewer looks past Gouffé to the footlit stage.

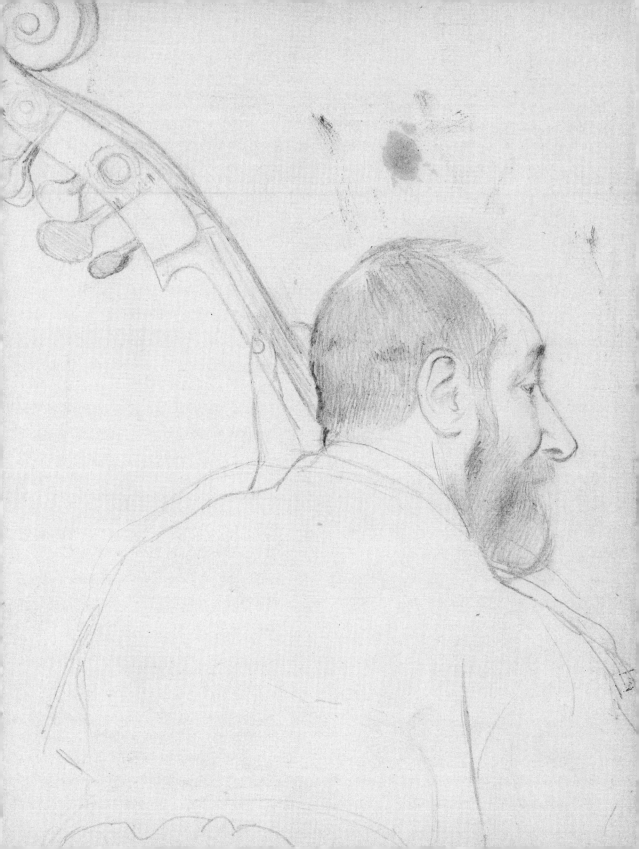

Drawing materials

Art supply stores can be rather baffling in their profusion of products, but fortunately, the materials required for drawing are simple and limited in number. Essentially, you need paper and a pencil, but for purposes of effective instruction, I have added a few more items.

Paper:	Some inexpensive plain bond paper
	A pad of Strathmore Drawing Paper, 80 lb., 11" × 14"
Pencils:	A #2 ordinary yellow writing pencil with an eraser at the top
	A #4 drawing pencil—Faber-Castell, Prismacolor Turquoise, or other brand
Marking pens:	Sharpie (or other brand) fine point non-permanent black
	A second marker, fine point permanent black
Graphite stick:	#4 General's is a good brand, or other brand
Pencil sharpener:	A small handheld sharpener is fine
Erasers:	A Pink Pearl eraser
	A Staedtler Mars white plastic eraser
	A kneaded eraser—Lyra, Design, or other brand
Masking tape:	3M Scotch Low Tack Artist Tape
Clips:	Two 1-inch-wide black clips
Drawing board:	A firm surface large enough to hold your 11" × 14" drawing paper—about 15" × 18" is a good size. This can be improvised from a kitchen cutting board, a piece of foam

board, a piece of Masonite, or thick cardboard.

"I love the quality of pencil. It helps me get to the core of a thing."
— Andrew Wyeth, in *The Art of Andrew Wyeth*, exhibition catalog, The Fine Arts Museum of San Francisco, 1973

Picture plane: This too can be improvised using an 8" × 10" piece of glass (you will need to tape the edges), or an 8" × 10" piece of clear plastic, about ¹⁄₁₆" thick.

Viewfinders: You will make these from black paper— "construction" paper is a good thickness, or you could use thin black cardboard. You will find instructions for making the viewfinders on page 14

A small mirror: About 5" × 7" that can be taped to a wall, or any available wall mirror.

Gathering these materials requires a bit of effort, but they will truly help you learn rapidly. We no longer attempt to teach our students without the help of viewfinders and the plastic picture plane, because these aids are so essential to your understanding of the basic nature of drawing.[4] Once you have learned the basic components of drawing, however, you will no longer need these teaching aids.

4. These materials, as well as my custom-designed Picture Plane and viewfinder and a CD demonstrating the exercises, are available for purchase by mail by contacting Drawing on the Right Side of the Brain at www.drawright.com.

Pre-instruction drawings—a valuable record for later validation of your progress

Now, let's get started. First, you need to make a record of your present level of drawing skills. This is important! You don't want to miss the pleasure of having a real memento of your starting point to compare with your later drawings. I am fully aware of how anxiety-causing this is, but just do it. As the great Dutch artist Vincent van Gogh wrote in a letter to his brother Theo:

> *"You do not know how paralyzing it is, that staring of a blank canvas which says to a painter, 'You don't know anything.'"*

How to construct two viewfinders

Viewfinders are perceptual aids that will help you "frame" your view and compose your drawings. Note that the outside edge of your picture plane, the outside and inside edges of your viewfinders, and the format you draw on your drawing paper are all the same proportion in width to length, differing only in size. This enables you to draw what you see through the viewfinder/picture plane onto the format drawn on your paper—they are all proportionately the same shape, though they differ in size.

Construct two viewfinders as follows:

1. Use black construction paper or thin black cardboard.
2. Cut two 8" × 10" pieces (this is the same size as your picture plane).
3. On both pieces, using pencil, draw diagonal lines from corner to corner, crossing in the middle.
4. On one piece, draw vertical and horizontal lines 2" from the edge, again connecting the lines at points on the diagonals. Cut out the inner rectangle. This is your "small viewfinder."
5. On the second piece, draw vertical and horizontal lines 1" from the edge, connecting the lines at points on the diagonals, forming a new inner rectangle. Using scissors, cut out the inner rectangle. This is your "large viewfinder."

Constructed this way, the inner rectangles have the same proportion width to length as the outer edges of the viewfinders.

You will use your viewfinders by clipping one or the other onto your Picture Plane. Don't forget to draw vertical and horizontal crosshairs on your Picture Plane, using your permanent marking pen.

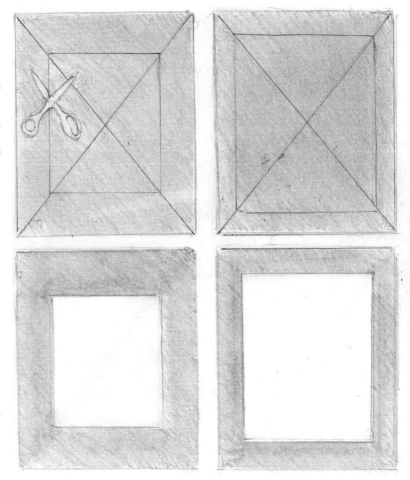

Soon you will "know something," I promise. Just gear yourself up and do the drawings. Later you will be very happy that you did. The pre-instruction drawings have proved invaluable in helping students see and recognize their own progress, because a kind of amnesia seems to set in as drawing skills improve. Students forget what their drawing was like before instruction. Moreover, the degree of criticism keeps pace with progress. Even after considerable improvement, students are sometimes critical of their drawings because "It's not as good as da Vinci could do," as one person put it. The pre-instruction drawings provide a realistic gauge of progress.

After you have finished the drawings, put them carefully away, to be looked at later on in light of your newly acquired skills.

Three pre-instruction drawings

It usually takes students about an hour to do the three pre-instruction drawings, but take as long or as short a time as you wish. I first list the drawing titles, then a list of materials needed for these drawings, followed by instructions for each drawing.

What you will draw:

- "A Person, Drawn from Memory"
- "Self-Portrait"
- "My Hand"

Materials you will use for the three drawings:

- Paper to draw on—plain bond is fine
- Your #2 writing pencil
- Your pencil sharpener
- Your masking tape
- A small 5" × 7" mirror, or any available wall mirror
- Your drawing board
- About an hour of uninterrupted time

For each drawing in turn, tape a stack of three or four sheets of bond paper to your drawing board. Stacking the sheets provides a "padded" surface to draw on—much better than the rather hard surface of the drawing board.

Pre-instruction drawing #1: "A Person, Drawn from Memory"

1. Call up in your mind's eye an image of a person—perhaps someone from the past, or someone you know now. Or you may recall a drawing you did in the past or a photograph of a person well known to you.
2. To the best of your ability, do a drawing of the person. You may draw just the head, a half-figure, or a full-length figure.

3. When you have finished, title, sign, and date your drawing in the lower right-hand corner.

Pre-instruction drawing #2: Your "Self-Portrait"

1. Tape your small mirror to a wall and sit at arm's length (about 2 to 2½ feet) from the wall. Adjust the mirror so that you see your whole head within its edges. Lean your drawing board up against the wall, resting the bottom of the board on your lap. Have a three-sheet stack of paper taped to your board.
2. Look at the reflection of your head in the mirror and draw your "Self-Portrait."
3. When you have finished, title, sign, and date your drawing.

Pre-instruction drawing #3: "My Hand"

1. Seat yourself at a table to draw.
2. If you are right-handed, draw your left hand in whatever position you choose. If you are left-handed, of course, draw your right hand.
3. Title, sign, and date your drawing.

When you have finished the pre-instruction drawings:

Spread the three drawings out on a table and look at them closely. If I were there with you, I would be looking for small areas of the drawings that show that you were looking carefully—perhaps the way a collar turns or a beautifully observed curve of an eyebrow or ear. Once I encounter such signs of careful seeing, I know the person will learn to draw well.

You, on the other hand, may find nothing admirable and perhaps may dismiss the drawings as "childish" or "amateurish." Please remind yourself that these are drawings made before instruction. On the other hand, you may be surprised and pleased with your drawings, or parts of them, perhaps especially the drawing of your hand. The "Drawing from Memory" often elicits the most dismay.

The reason for doing the memory drawing

I'm sure that drawing a person from memory was very difficult for you, and rightfully so. Even a trained artist would find it difficult, because visual memory is never as rich, complicated, and clear as is actual seeing. Visual memory is necessarily simplified, generalized, and abbreviated—frustratingly so for most artists, who often have a fairly limited repertoire of memorized images that they can call up in the mind's eye and draw.

"Then why do it?" you may well ask. The reason is simply this: for a beginning student, drawing a person from memory brings forth a memorized set of symbols, practiced over and over during childhood. While doing the drawing from memory, can you recall that your hand seemed to have a mind of its own? You knew that you weren't making the image you wanted to, but you couldn't keep your hand from making those simplified shapes—perhaps the nose shape, for example. This is caused by the so-called symbol system of early childhood drawing, memorized by countless repetitions.

Now, compare your "Self-Portrait" with your memory drawing. Do you see symbols repeated in both drawings—that is, are the eyes (or the nose or mouth) similar in shape, or even identical? If so, this indicates that your symbol system was controlling your hand even when you were observing the actual shapes in your face in the mirror. You may also find a simplified, repeated symbol for fingernails in your hand drawing.

The "tyranny" of the childhood symbol system

This tyranny of the symbol system explains in large part why people untrained in drawing continue to produce "childish" drawings right into adulthood and even old age. What you will learn is how to set your symbol system aside and accurately draw what you see. This training in perceptual skills—how to see and draw what is actually "out there"—is the rock bottom "ABC" of drawing. It is necessarily (or at least ideally) learned before progressing to imaginative drawing, painting, or sculpture.

With this information in mind, you may want to make a few notes on the backs of your drawings, indicating any repeated symbols, which parts were the most difficult, and which were successful.

Then, put the drawings away for safekeeping. Do not look at them again until you have completed my course and have learned to see and draw.

Drawings before and after instruction

These examples show some of my students' pre-instruction and post-instruction self-portraits. All had attended one of our five-day, eight-hour-a-day workshops. Students drew their images, seen in a mirror, as you have just done with your pre-instruction drawing. Regard the drawings from this standpoint: as a visible record of improvement in perception. The drawings show typical changes in drawing ability from the pre-instruction "Self-Portrait" to the "Self-Portrait" drawn on the fifth day. As you see, the change between each student's two drawings is significant enough that it almost seems as though two different persons have done the drawings.

Learning to perceive is the basic skill that the students acquired, not drawing skill. In our workshops, we actually teach very few skills that could be called "drawing skills," such as setting a toned ground, using an eraser as a drawing tool, crosshatching, shading from light to dark, and so on. The really important teaching/learning is how to *see* differently. Our goal is that every student will make significant progress regardless of their initial skill level.

If you look at the pre-instruction drawings on pages 19 and 20, you will see that people came to the workshop with different levels of existing skills, as is the case with your pre-instruction drawings. These pre-existing skills have nothing to do with potential to draw well. What the pre-instructions drawings represent is *the age at which the person last drew*, often coinciding with the age at which the person gave up on trying to draw.

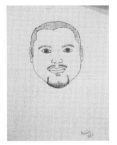

Andres Santiago
Before instruction
April 5, 2011

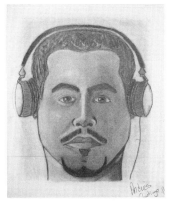

After instruction
April 9, 2011

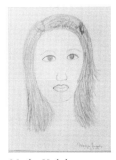

Merilyn Umboh
Before instruction
August 16, 2011

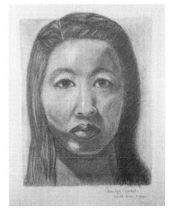

After instruction
August 20, 2011

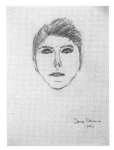

Douglas Hansen
Before instruction
February 8, 2011

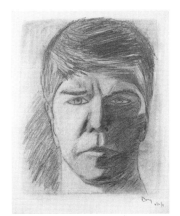

After instruction
February 12, 2011

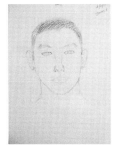

David Caswell
Before instruction
August 16, 2011

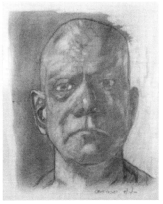

After instruction
August 20, 2011

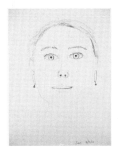

Jennifer Boivin
Before instruction
September 9, 2011

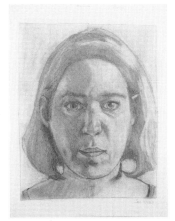

After instruction
September 13, 2011

James Han
Before instruction
June 6, 2011

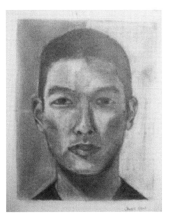

After instruction
June 10, 2011

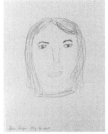

Robin Ruzan
Before instruction
May 16, 2011

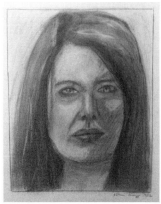

After instruction
May 20, 2011

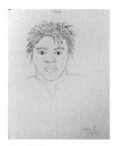

Frank Zvovu
Before instruction
November 29, 2010

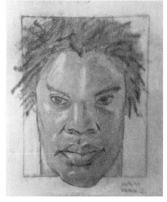

After instruction
December 3, 2010

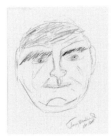

Terry Woodward
Before instruction
January 8, 2007

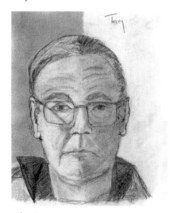

After instruction
January 12, 2007

Peter Lawrence
Before instruction
February 8, 2011

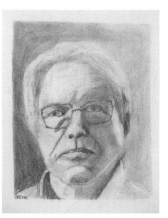

After instruction
February 12, 2011

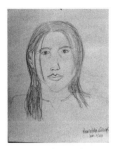

Maria Catalina Ochoa
Before instruction
May 30, 2010

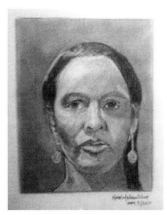

After instruction
June 3, 2010

Derrick Cameron
Before instruction
April 5, 3011

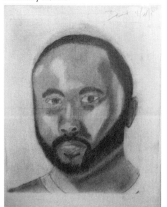

After instruction
April 9, 2011

5. Published by the J. Paul Getty Museum, 2010, p. 104.

Considered this way, the pre-instruction drawings on pages 19 and 20 represent drawing-age ranges from about seven or eight years old to late adolescence, and, occasionally, even near-adult drawing age. For example, Terry Woodward and Derrick Cameron were initially drawing at about age level seven or eight, while Merilyn Umboh's and Robin Ruzan's pre-instruction drawings represent about age-ten-to-twelve drawing level—that is, they were drawing the way most children draw at that age, and it may be that they quit drawing at that point. Several other students were drawing at a later adolescent age: Andres Santiago and Douglas Hansen, on page 19. At an even later adolescent age are Peter Lawrence, Maria Catalina Ochoa, Jennifer Boivin, Frank Zvovu, James Han, and David Caswell.

As a teacher, I am always interested in this aspect of the pre-instruction drawings, as it gives me a sense of each individual's history in terms of drawing. The goal of the lessons is to enable each student, regardless of their starting point, to reach fully adult capability in drawing. And, as you can observe in the post-instruction drawings five days later, students do reach that level, with remarkable gains in skills. We—along with our students—strive for 100 percent success in each of our workshops. Success is defined as the ability to effectively use all five of the basic perceptual skills of drawing: perceiving and drawing edges, spaces, relationships, lights and shadows, and the *gestalt* (in a self-portrait, the *likeness*). With this foundation, only practice is needed to continue progress, to as high a level as desired. Again, it is quite like reading: once you have the basic skill, further achievement just requires practice, and, perhaps, expanding one's vocabulary. For drawing, further progress might be in expanded subject matter and other drawing mediums.

Style, self-expression, and the nonverbal language of drawing

In his outstanding book *Master Drawings Close Up*,[5] Julian Brooks defines style in drawing thusly:

In our workshops, we do not teach how to express yourself in drawing—that is, we do not teach styles of drawing. Your style is your own style, and your expression in drawing is how *you* express yourself in drawing. If you look only casually at the Seattle students' drawings, they have a certain similarity because they are all self-portraits and they are all using the same mediums under the same lighting conditions. But if you look more closely, you will see that each person has his or her own personal *way* of drawing, each a unique style. This is what I value the most. This, to me, is true self-expression in drawing, and it is much more personal than some of the overwhelming expressionism sometimes encouraged in today's art classes.

Style in drawing is similar to the development of an individual's style in handwriting. Once a person moves beyond childhood or adolescent writing styles, the individual's adult style emerges. If, for a moment, we could regard your handwriting as a form of drawing (which it is), we could say that you are already expressing yourself with a fundamental element of art: line.

On a sheet of bond paper, using your #2 yellow pencil, write your signature as you usually sign your name. Next, regard your signature from the following point of view: you are looking at a *drawing* that is your original creation, so unique that it has legal status as being owned by you and no other person in the world. This drawing of your name is shaped, it is true, by the cultural influences of your life, but aren't the creations of every artist shaped by such influences?

Every time you write your name, you have expressed yourself through the use of line, just as Picasso's line in his signature is expressive of him. The line can be "read" because in writing your name, you have used the nonverbal language of art. Let's try read-

ing line. There are five signatures in the margin. All are the same name: Monica Jessup.

What is the first Monica Jessup like? You would probably agree that this Monica Jessup is more likely to be extroverted than introverted, more likely to wear bright colors than muted ones, and at least superficially observed, likely to be outgoing, talkative, even dramatic.

Let's look at the second signature in the margin. What would you expect that Monica Jessup to be like?

Now, regard the third Monica Jessup. What is your guess about that person?

And the fourth signature?

And the fifth and last signature? What does the line style express?

Next, turn back to your own signature and respond to the nonverbal message of the line. Then, on the same page, write your name in three or more *different* styles of line, each time responding to the new image. The name formed by the "drawings" is made up of the same letters forming the same name. What, then, were you responding to?

You were, of course, responding to the *felt* quality of the "drawn" lines: the speed, the size, the spacing, the felt muscle tension or lack of tension, the directional pattern or lack of pattern, the clarity of the signature. All of that is precisely communicated by the line.

Turn back now to your usual, normal signature. It expresses *you*, your individuality, and your creativity. Your signature is true to yourself. In this sense, you are already using the nonverbal language of art. You are using a basic element of art, line, in an expressive way, unique to yourself.

In the chapters that follow, therefore, I don't dwell on what you can already do. Instead, the aim is to teach you how better to see what is out there, so that you can use your expressive, individual style to draw your perceptions more clearly and accurately.

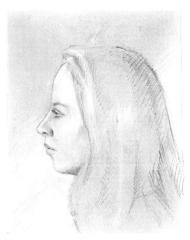

Heather by instructor Brian Bomeisler.

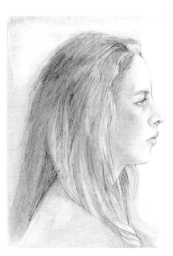

Heather by the author.

"The art of archery is not an athletic ability mastered more or less through primarily physical practice, but rather a skill with its origin in mental exercise and with its object consisting in mentally hitting the mark. "Therefore, the archer is basically aiming for himself. Through this, perhaps, he will succeed in hitting the target—his essential self."
— Eugen Herrigel, *Zen in the Art of Archery*, 1948

Drawing as a mirror and metaphor for you

To illustrate how much personal, individual style is embedded in drawings, look at the two drawings on page 24, drawn at the same time by two persons—myself and artist/teacher Brian Bomeisler. We sat on either side of our model, Heather Allen. We were demonstrating how to draw a profile portrait for a group of students, the same profile drawing you will learn to do in Chapter 9.

We were using identical materials (the ones in your Materials List on page 12), and we both drew for the same length of time, about thirty-five or forty minutes. You can see that the model is the same—that is, both drawings achieve a likeness of Heather Allen. But Brian's portrayal expresses his response to Heather in his more "painterly" style (meaning emphasis on shapes), and my drawing expresses my response in my more "linear" style (emphasis on line).

By looking at my portrait of Heather, the viewer catches sight of me, and Brian's drawing provides an insight into him. Thus, paradoxically, the more clearly you can perceive and, in your personal style, draw what you see in the external world, the more clearly the viewer can see *you*, and the more you can know about yourself. Drawing becomes a metaphor for the artist.

Because the exercises in this book focus on expanding your perceptual powers, not on techniques of drawing, your individual style—your unique, expressive way of drawing—will emerge intact. This is true even though the exercises concentrate on realistic drawings, which tend to "look alike" in a large sense. But a closer look at realistic art reveals subtle differences in line style, emphasis, and intent. In this age of massive self-expression in the arts, this more-subtle communication often goes unnoticed and unappreciated.

As your skills increase, you will see your unique style become firm and recognizable. Guard it, nurture it, and cherish it, for your style expresses you. As with the Zen master-archer, the target is yourself.

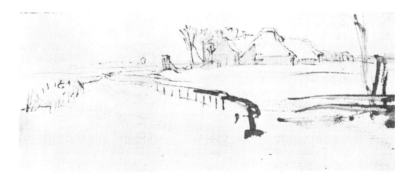

Fig. 2-2. Rembrandt van Rijn (1606–1669), *Winter Landscape* (c. 1649). Courtesy The Fogg Art Museum, Harvard University.

Rembrandt drew this tiny landscape with a rapid calligraphic line. Through it, we sense Rembrandt's visual and emotional response to the deeply silent winter scene. We see, therefore, not only the landscape; we see *through* the landscape to Rembrandt himself.

Artists are known by their unique line qualities, and experts in drawing often base their authentication of drawings on these known line qualities. Styles of line have actually been put into named categories. There are quite a few: the "bold line;" the "broken line" (sometimes called "the line that repeats itself"); the "pure line"—thin and precise, sometimes called "the Ingres line" after the 19th-century French artist Jean-Auguste Dominique Ingres; the "lost-and-found line," which starts out dark, fades away, then becomes dark again. See samples in figure 2-3.

Beginning students most often admire drawings done in a rapid, self-confident style—the "bold" line that is rather like Picasso's, in fact. But an important point to remember is that *every style of line is valued, one not more than another.*

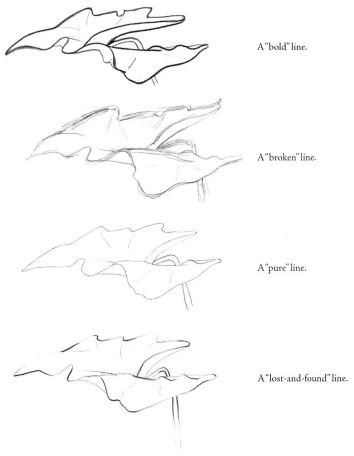

A "bold" line.

A "broken" line.

A "pure" line.

A "lost-and-found" line.

Fig. 2-3. A variety of line styles.

CHAPTER 3
YOUR BRAIN, THE
RIGHT AND LEFT OF IT

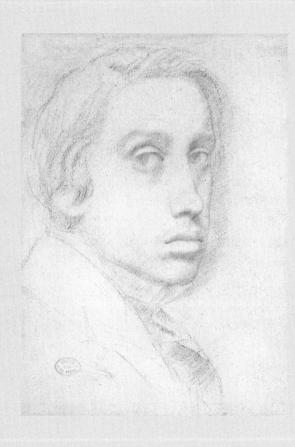

Edgar Degas (1834–1917), *Self-Portrait,*
c. 1855. Red chalk on laid paper. Image cour-
tesy National Gallery of Art, Washington,
D.C., Woodner Family Collection.

Degas was a passionate viewer of "modern"
life in nineteenth-century France. Once,
leaving a café with his friend, English
painter Walter Sickert, Degas objected
when Sickert summoned a closed horse-
drawn cab. "Personally," he said, "I love to
ride on the omnibus. You can look at people.
We were created to look at one another,
weren't we?"
 —From Robert Hughes, *Nothing If*
 Not Critical: Selected Essays on Art
 and Artists (New York: Penguin,
 1992)

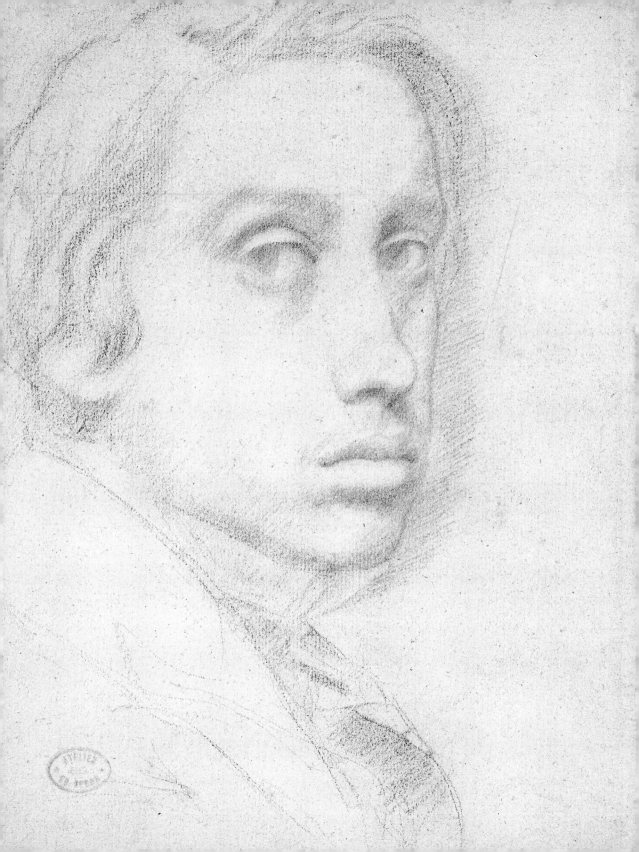

Despite centuries of study and thought and the accelerating rate of knowledge in recent years, the human brain still engenders awe and wonder at its marvelous capabilities, not the least of which is the fact that our plastic brains can grow new brain cells and can form new neural pathways. Scientists have targeted visual perception in particular with highly precise studies, yet vast mysteries still prevail. We simply take for granted many of the brain's capabilities, because they are out of our conscious awareness. Even the most ordinary activities are awe-inspiring, as Francis Crick, co-discoverer of the structure of DNA, so eloquently states.

One of the most amazing capabilities of our human brain is the ability to record our perceptions in drawings. Since I propose that learning how to draw is greatly facilitated by some basic understanding of the role of brain functions in drawing, this is a good place for a brief review before we start on the exercises.

The double brain

Seen from above, the human brain resembles the halves of a walnut—two similar-appearing, convoluted, rounded brain halves, separated by a longitudinal fissure and mainly connected by the corpus callosum, a thick band of nerve fibers (Figure 3-1,). Most people are aware that the left hemisphere controls the right side of the body, the right hemisphere, the left side. Due to this crossing over of the nerve pathways, the right hand is controlled by the left hemisphere, the left hand by the right brain, as shown in Figure 3-2.

As a result of extraordinary work by neuroscientists over the past sixty years, we now know that despite our normal feeling that we are one person—a single being—our mental functions are divided between the two cerebral hemispheres. While the hemispheres are visually similar, each has its own way of knowing, its own way of perceiving external reality. Information passes from one side to the other by means of the corpus callosum, thus preserving our sense of one self, but scientists now recognize that

Fig. 3-1.

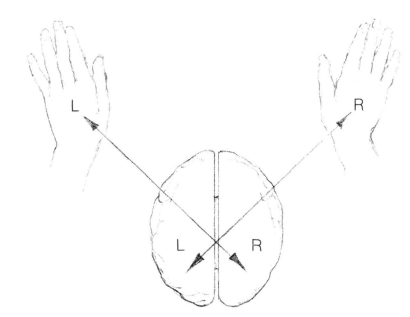

Fig. 3-2. The crossover connections of left hand to right hemisphere, right hand to left hemisphere.

the corpus callosum can also inhibit such passage. It appears that each hemisphere may have a way of keeping knowledge from the other hemisphere. Therefore, it may be true, as the old saying goes, that at times the right hand truly does not know what the left is doing.

From an evolutionary standpoint, the *why* of this asymmetrical design is still largely under study. Scientists once thought that only human brains had separate and different functions located (lateralized) in each hemisphere. Recent studies of birds, fish, and primates, however, suggest that asymmetrical brains are common in many vertebrates, and the animal studies indicate that lateralized brains are more efficient, which may help explain the asymmetrical design. The two human hemispheres can work together in a number of ways. They can cooperate, with each half contributing its special capabilities. At other times, one hemisphere can function more or less as the "leading" hemisphere and the other "following." And research also shows that the hemispheres can

Many creative people seem to have intuitive awareness of the separate-sided brain. For example, Rudyard Kipling wrote the following poem, entitled "The Two-Sided Man," which is happily without bias, more than eighty years ago.

Much I owe to the lands that grew—

More to the Lives that fed—

But most to the Allah who gave me two

Separate sides to my head.

Much I reflect on the Good and the True

In the faiths beneath the sun

But most upon Allah who gave me Two

Sides to my head, not one.

I would go without shirt or shoe,

Friend, tobacco or bread,

Sooner than lose for a minute the two

Separate sides of my head!

— Rudyard Kipling, 1929

conflict, one half attempting to do what the other half "knows" it can do better.

For the past two hundred years or so, scientists have known that language and language-related capabilities are mainly located in the left hemispheres of the majority of individuals—for approximately 98 percent of right-handers and about two-thirds of left-handers. This knowledge was largely derived from observations of the effects of brain injuries. It was apparent, for example, that an injury to the left side of the brain was more likely to cause a loss of speech capability than an injury of equal severity to the right side.

Because speech and language are such vitally important human capabilities, nineteenth-century scientists named the left hemisphere the "dominant" or "major" hemisphere, and named the right brain the "subordinate" or "minor" hemisphere. Reflecting these labels, the general view, which prevailed until fairly recently, was that the right half of the brain was less advanced,

Fig. 3-3. A diagram of the left half of a human brain, showing the corpus callosum and a related commissure.

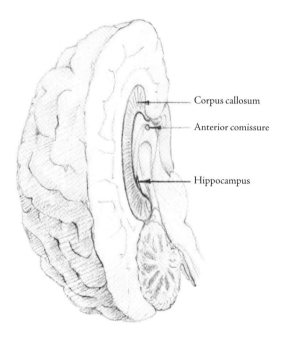

Corpus callosum

Anterior comissure

Hippocampus

less evolved than the left half—a mute twin with lower-level capabilities, directed and carried along by the verbal left hemisphere. Among some scientists, the bias against the right hemisphere went even deeper. They considered the right brain to be more on the level of animals and not capable of high, human-level cognition—a sort of "stupid" brain half.

Today, that biased view has changed, largely due to groundbreaking and brilliant Nobel Prize–winning research (the 1950s animal studies and the 1960s human "split-brain" studies[6]) by Roger W. Sperry and his students Ronald Myers, Colwyn Trevarthen, Michael Gazzaniga, Jerre Levy, Robert Nebes, and others at the California Institute of Technology. Neuroscientists, somewhat reluctantly at first, came to recognize that *both* hemispheres are involved in high, human-level cognition, with each half of the brain specialized for different modes of thinking, both highly complex.

But what, you might well ask, does this have to do with learning how to draw? Research on brain-hemisphere aspects of visual perception indicates that drawing a complex realistic image of a perceived form is mainly a function of the right hemisphere of the brain. (As I have mentioned, to avoid the so-called location controversy, I have termed right-brain functions "R-mode," and left-brain functions "L-mode," no matter where located in the individual brain.) Learning to draw well may depend on whether you can find a way to access the "minor" or subdominant R-mode. (Yes, in 2012, the right brain is still termed the lesser of the two. Old biases die hard!)

How does this help a person draw? It appears that the right brain perceives—processes visual information—in a mode suitable for drawing, and that the left-brain mode of functioning (L-mode) may be inappropriate for the task. Because of the strength and dominance of the L-mode, the problem we confront is how to "set aside" the L-mode in order to access the R-mode at the conscious level.

6. "Split-brain" is the lay term for a surgical operation to treat intractable epilepsy by severing the corpus callosum and related connections of the two brain hemispheres, thus preventing the spread of seizures. Working with a small group of patients with separated hemispheres enabled Sperry and his group to test for differences in functions of the two hemispheres.

Language clues reflect a long-held bias against the right brain

In hindsight, we realize that human beings perhaps from the beginning have had some sense of the differences between the halves of the brain and have shared the negative bias. Languages worldwide contain numerous words and phrases suggesting that the left side of a person's body, linked to and controlled by the right brain, has characteristics that are inferior to the right side of the body. Most of these phrases speak of hands, not of brain halves, but because of the crossover connections of hands and hemispheres, the terms must be inferred to also mean the hemispheres that control the hands. Therefore, the examples of familiar terms for hands in the next section refer specifically to the left and right hands but actually also refer inferentially to the opposite brain halves—the left hand controlled by the right hemisphere, the right hand by the left brain.

Parallel Ways of Knowing	
intellect	intuition
convergent	divergent
digital	analogic
secondary	primary
abstract	concrete
directed	free
propositional	imaginative
analytic	relational
lineal	nonlineal
rational	intuitive
sequential	multiple
analytic	holistic
objective	subjective
successive	simultaneous

—J. E. Bogen, "Some Educational Aspects of Hemisphere Specialization," in UCLA *Educator*, 1972

The Duality of *Yin* and *Yang*	
Yin	*Yang*
feminine	masculine
negative	positive
moon	sun
darkness	light
yielding	aggressive
left side	right side
cold	warm
autumn	spring
unconscious	conscious
right brain	left brain
emotion	reason

— *I Ching, Book of Changes*, a Taoist work

The bias of language and customs

Words and phrases referring to left and right hands indicate not just bodily location, but deep differences in fundamental traits or qualities as well. The right hand (inferring also the left hemisphere) is strongly connected with what is good, just, moral, and proper. The left hand (therefore also the right hemisphere) is strongly linked with concepts of anarchy and feelings that are out of verbal control—and somehow bad, immoral, and dangerous. In religious literature, the Devil is said to be left-handed, but, in Ephesians 3:11, "Christ sits at the right hand of God." From ordinary life, a "left-handed compliment," meaning a sly dig, refers to the pejorative qualities assigned to left hand/right brain. A "right-handed compliment" would be to call someone "My right-hand man (or woman)," meaning "My good, strong helper."

Hand phrases can indicate conflict or disagreement between the two sides. For example, if we want to compare conflicting ideas, we say, usually with gestures, "On the one hand…but, on the other hand…" Until very recently, the ancient bias against the left hand/right hemisphere even led some parents and teachers of naturally left-handed children to force the children to use their right hands for writing, eating, and sometimes for sports—a practice that often caused problems lasting into adulthood, such as stammering, difficulty learning to read, and right/left direc-

Aztecs in early Mexico used the left hand for medicine for kidney trouble, the right when curing the liver.

In a rare exception, the Incas of ancient Peru considered left-handedness a sign of good fortune.

Maya Indians favored the right side of the body: the twitching of a soothsayer's left leg foretold disaster.

From *The Left-Handers' Handbook*, J. Bliss and J. Morella, A&W Visual Library, 1980

tional confusion. There is no acceptable justification for teachers or parents to force a change. Reasons proffered run from "Writing with the left hand looks so uncomfortable," to "The world is set up for right-handers and my left-handed child would be at a disadvantage." These are not good reasons, and I believe they often mask an inherent prejudice against left-handedness—a prejudice rapidly disappearing, I'm happy to report. Perhaps the fact that six of our recent American presidents have been left-handed has helped ease prejudice: Harry Truman, Gerald Ford, Ronald Reagan (who possibly was ambidextrous), George W. Bush, Bill Clinton, and Barack Obama.

Worldwide cultural and historical terms of prejudice

Terms with connotations of good for the right hand/left hemisphere and connotations of bad for the left hand/right hemisphere appear in most languages around the world. The Latin word for left is *sinister*, meaning "ominous," or "treacherous." The Latin word for right is *dexter*, from which comes our word "dexterity," meaning "skill" or "adroitness." The French word for left—remember that the left hand is controlled by the right hemisphere—is *gauche*, meaning "awkward," "naïve," or "ill-mannered," from which comes our word "gawky." The French word for right is *droit*, meaning "good," "virtuous," "truthful," and "high-minded."

> "The main theme to emerge…is that there appear to be two modes of thinking, verbal and nonverbal, represented rather separately in left and right hemispheres, respectively, and that our educational system, as well as science in general, tends to neglect the nonverbal form of intellect. What it comes down to is that modern society discriminates against the right hemisphere."
>
> — "Lateral Specialization of Cerebral Function in the Surgically Separated Hemispheres," Roger W. Sperry. In *Neurosciences Third Study Program*, F. Schmitt and F. Worden (Eds.), Cambridge, M.I.T. Press, 1974.

The derogatory meaning of left may reflect a discomfort or suspicion directed by the right-handed majority against a minority of people who were different, that is, left-handed. In English, the word *left* comes from the Anglo-Saxon *lyft*, meaning "weak" or "worthless." The left hand of most right-handed people is in fact weaker than the right, but the original word also implied lack of moral strength. Reinforcing this bias, the Anglo-Saxon word for right, *reht* (or *riht*), meant "straight" or "just." From *reht* and its Latin cognate, *rectus*, we derived our words "correct" and "rectitude."

These ideas are also reflected in our political vocabulary. The political right, for instance, admires national power and individ-

ual responsibility, and resists change. The political left, conversely, admires people power and social responsibility, and favors change. At their most extreme, the political right is fascist, the political left is anarchist.

In the context of cultural customs, the place of honor at a formal dinner is on the host's right-hand side. The groom stands on the right in the marriage ceremony, the bride on the left—a nonverbal message of the relative status of the two participants. We shake hands with our right hands, and it seems somehow wrong to shake hands with our left hands. Under "left-handed," the dictionary lists as synonyms "clumsy," "awkward," "insincere," and "malicious." Synonyms for "right-handed," however, are "correct," "indispensable," and "reliable."

Mind you, it's important to remember that when languages began, these contrasting terms were made up by early humans' left hemispheres—and the left brain gave itself all the best words! The right brain—labeled, skewered, and vilified by the left—was without a verbal language of its own to defend itself.

Two ways of knowing

Along with the opposite connotations of left and right in our language, philosophers, teachers, and scientists from many different times and cultures have postulated concepts of the duality, or two-sidedness, of human nature and thought. The key idea is that there are two parallel "ways of knowing."

You are probably familiar with the following ideas embedded in our languages and cultures. The main divisions are between thinking and feeling, intellect and intuition, and objective analysis and subjective insight. Political writers say that people generally analyze the good and bad points of an issue and then vote on their "gut" feelings. The history of science is replete with anecdotes about researchers who try repeatedly to figure out a problem and then have a dream in which the answer presents itself as a metaphor intuitively comprehended by the scientist. The statement regarding intuition by the nineteenth-century

French mathematician, theoretical physicist, engineer, and philosopher Henri Poincaré described a sudden intuition that gave him the solution to a difficult problem:

"One evening, contrary to my custom, I drank black coffee and could not sleep. Ideas rose in crowds; I felt them collide until pairs interlocked, so to speak, making a stable combination."

[That strange phenomenon provided the intuition that solved the troublesome problem. Poincaré continued:]

"It seems, in such cases that one is present at his own unconscious work, made partially perceptible to the overexcited consciousness, yet without having changed its nature. Then we vaguely comprehend what distinguishes the mechanisms or, if you wish, the working methods of the two egos."

mathematician Henri Poincaré is a vivid example of the process.

In another context, people occasionally say about someone, "The words sound okay, but something tells me not to trust him (or her)." Or "I can't tell you in words exactly what it is, but there is something about that person that I like (or dislike)." These statements are intuitive observations indicating that both sides of the brain are at work simultaneously, processing the same information in two different ways.

Inside each of our skulls, therefore, we have a double brain with two ways of knowing. The dualities and differing characteristics of the two halves of the brain and body, intuitively expressed in our language, have a real basis in the physiology of the human brain, but because the connecting fibers of the corpus callosum are intact in normal brains and can block passage of information, we are often not fully aware of contradictory responses occurring in the two halves.

Two modes of information processing

As our hemispheres gather in the same sensory information, the task may be shared, each handling the part suited to its style. Or one hemisphere, often the dominant left, can "take over" and inhibit the other half. Remember, language dominates! The left hemisphere verbalizes, analyzes, abstracts, counts, marks time, plans step-by-step procedures, makes rational statements based on logic, and looks to past experience to approach a new problem. Here is an example of an L-mode statement: "Given numbers a, b, and c, we can say that if a is greater than b, and b is greater than c, then a is necessarily greater than c." This statement illustrates the mode: it is verbal, analytic, propositional, sequential, symbolic, linear, objective, and provably true. But, we must remember, L-mode can also spin an untrue story to "explain away" a problem situation.

On the other hand, we have a second way of knowing: the right-hemisphere mode. In this mode, we can "see" things in the mind's eye. In the example given just above, did you perhaps visu-

Howard Gardner, Harvard professor of psychology and education, refers to the linkage of art and creativity:
"By a curious twist, the words *art* and *creativity* have become closely linked in our society."
— Howard Gardner, *Creating Minds*, 1993

alize the "*a, b, c*" relationship? If so, that would be an example of the hemispheres agreeing and cooperating in understanding the statement.

In visual R-mode, we see how things exist in space and how parts go together to make up a whole. Using the right hemisphere, we use metaphors and image solutions, and create new combinations of ideas and novel ways to approach problems. Sometimes our visual mode may see things that the L-mode can't or won't see, especially contradictory or ambiguous information. The right hemisphere tends to confront what is "really out there." And there are times when language can be inadequate. When something is too complex to describe in words, we make gestures to communicate meaning. Psychologist David Galin[7] has a favorite example: try to describe a spiral staircase without making a spiral gesture.

This, then, is the right-hemisphere mode: the intuitive, subjective, relational, holistic, time-free, reality-seeing mode. This is also the disdained, disparaged, left-handed mode that in our culture has been generally ignored and virtually neglected by our educational system. Neurobiologist Jerre Levy, who contributed greatly to Roger Sperry's original work, said only half-jokingly at the time of Sperry's studies that she thought "American education up through graduate school probably ablated the right hemisphere."[8]

Drawing and your creative potential

My students often report that learning to draw makes them feel more "artistic" and therefore more creative. One definition of a creative person is someone who can combine information directly at hand—the ordinary sensory data available to all of us—in new, socially productive ways. A writer uses words, a musician notes, an artist visual perceptions, and all need some knowledge of the techniques of their crafts. I do believe that the arts in general are important for liberating your creative potential, and that learning to draw may be one of the more efficient ways.

7. Langley Porter Institute, University of California, San Francisco.

8. Ablated: to have surgically removed diseased or unwanted tissue from the body.

Some famous individuals usually classified as left-handers:

Albert Einstein
Benjamin Franklin
Cary Grant
Charlemagne
Charlie Chaplin
Cole Porter
Jimi Hendrix
John McCain
Judy Garland
Julius Caesar
King George VI of Britain
Lewis Carroll
Marilyn Monroe
Mark Twain
Martina Navratilova
Mohandas Gandhi
Napoleon Bonaparte
Oprah Winfrey
Paul McCartney
Pharaoh Ramses II
Prince Charles
Prince William
Queen Victoria
Ringo Starr
Ted Williams
Tom Cruise

The *aha* response

In the creative mode, we use intuition and have leaps of insight—moments when "everything seems to fall into place" without figuring things out in a logical order. When this occurs, people often spontaneously exclaim, "I've got it" or "Ah, yes, now I see the picture." The classic example of the *Great Aha* is the exultant cry *"Eureka!"* (I have found it!), attributed to the Greek mathematician Archimedes. According to the story, Archimedes was asked by the king to determine whether a certain gold crown had been wrongly alloyed with silver. After long mulling over the difficult problem, Archimedes experienced a flash of insight while bathing: as he got into the tub, he noticed the water level rising. He suddenly "saw" that by submerging the crown in water and measuring the displaced water, he could determine the volume of the irregularly shaped crown and therefore the density of the metal, which would be less than that of pure gold if a cheaper and less dense metal had been added. The story concludes that Archimedes was so elated by this insight that, forgetting to get dressed, he ran naked out into the street shouting "Eureka! Eureka!" This story illustrates the importance of *seeing* connections between things that are seemingly unconnected in order to gain (in a telling word) *insight*.

Handedness, left or right

Students often ask questions about left- and right-handedness. This is a good place to briefly address the subject, before we begin instruction in the basic skills of drawing. I clarify only a few points that relate to drawing, because the extensive research on handedness is difficult and complicated.

A useful way to regard handedness is to recognize that hand preference is the most visible outward sign of how an individual's brain is organized. There are other outward signs: eyedness (most of us have a dominant eye, the one held open when aiming at a target) and footedness (the foot used to step off a curb or to start a dance step). Hand preference is probably genetically

determined, and forcing a change works against natural brain organization. Natural hand preference for writing is so strong that past efforts to change left-handers often resulted in ambidexterity. Children capitulated to pressure (in the old days, even punishment) and learned to use the right hand for writing, but continued to use the left for everything else.

Classifying people as strictly left-handed or right-handed is rarely accurate. People range from being completely left-handed or completely right-handed to being completely ambidextrous—that is, able to do many things with either hand, without a decided preference. Most of us fall somewhere on a continuum, with about 90 percent of humans preferring, more or less strongly, the right hand, and 10 percent preferring the left. The percentage of individuals with left-hand preference for handwriting seems to be rising, from about 2 percent in 1932 to about 8 to 15 percent of the world population today. This change may reflect teachers' and parents' greater tolerance for left-handed writing.

Former United States Vice President Nelson Rockefeller, a changed left-hander, had difficulty reading prepared speeches because of a tendency to read backward from right to left. The cause of this difficulty may have been his father's unrelenting effort to change his son's left-handedness.

"Around the family dinner table, the elder Mr. Rockefeller would put a rubber band around his son's left wrist, tie a long string to the band, and jerk the string whenever Nelson started to eat with his left hand, the one he naturally favored."
— Quoted in *The Left-Handers' Handbook* by J. Bliss and J. Morella, 1980

Eventually, young Nelson capitulated and achieved a rather awkward ambidextrous compromise, but he suffered the consequences of his father's rigidity throughout his lifetime.

A summary description of L-mode and R-mode

L-Mode

Verbal	Using words to name, describe, define.
Analytic	Figuring things out step-by-step and part-by-part.
Symbolic	Using a symbol to stand for something. For example, the 👁 stands for eye, the sign + stands for the process of addition.
Abstract	Taking out a small bit of information and using it to represent the whole.
Temporal	Keeping track of time, sequencing one thing after another: doing first things first, second things second, etc.
Literal	Adhering to factual meaning of words or text: difficulty understanding metaphors.

Rational	Drawing conclusions based on reason and accepted facts.
Digital	Using numbers as in counting.
Logical	Drawing conclusions based on logic: one thing following another in step-by-step order. For example, a mathematical theorem or a well-stated argument.
Linear	Thinking in terms of linked ideas, one thought directly following another, often leading to a convergent conclusion. The linear process can be brought to a halt by missing data.

R-Mode

Nonverbal	Using visual, nonverbal cognition to process perceptions.
Synthetic	Putting parts together to form wholes. Perceiving things in context.
Actual, real	Relating to things as they are, in reality, at the present moment.
Analogic	Seeing likenesses among things; understanding metaphoric relationships.
Nontemporal	Lacking a sense of time passing.
Imaginative	Conjuring mental visual images, real or imagined.
Nonrational	Not requiring a basis of reason or facts; willingness to suspend judgment.
Spatial	Seeing where things are located in space, in relation to other things, and how parts go together to form a whole.
Intuitive	Making leaps of insight, often based on incomplete patterns, hunches, feelings, visual images, or visual

connections. Able to jump across missing data.

Holistic (Meaning "wholistic.") Seeing whole things all at once, in reality, and in all of their complexity; perceiving overall patterns and structures, often leading to divergent conclusions.

Differences between left-handers and right-handers

Putting prejudice aside, there are differences between left-handers and right handers. Specifically, language is mediated in the left hemisphere in about 90 percent of right-handers. Of the remaining 10 percent of right-handers, about 2 percent have language located in the right brain, and about 8 percent mediate language in both hemispheres.

Left-handers can be somewhat less lateralized than right-handers, meaning that functions are less clearly located in one or the other brain half. For example, left-handers more frequently than right-handers process language *and* spatial information in both hemispheres. Some left-handers have language located in the *left* brain, and these individuals often write in the "hooked" position that seems to cause teachers so much dismay. Surprisingly, right-handers with *right hemisphere* language location (which is fairly rare) may also write in hooked fashion.[9]

Do these differences matter? Individuals vary so much that generalizations are risky. Nevertheless, some experts agree in general that a mixture of functions in both hemispheres (that is, mixed dominance or a lesser degree of lateralization) creates the potential for conflict or interference. It is true that left-handers statistically are more susceptible to stammering and to experiencing certain ways of thinking, such as tending to see both sides of every question in making decisions. However, other experts suggest that bilateral distribution of functions may produce superior mental abilities, perhaps because of easier access to both modes. Left-handers seem to excel in mathematics, music, sports, and chess. And the history of art certainly suggests evidence of

9. Neurobiologist Jerre Levy has proposed that hand position in writing may be another outward sign of brain organization, with the "hooked" position "pointing" to the same-side hemisphere for language location, and the upright or "normal" position pointing to the opposite side of the brain for language location.

Sigmund Freud, Hermann von Helmholtz, and the German poet Schiller were afflicted with right/left confusion. Freud wrote to a friend:

"I do not know whether it is obvious to other people which is their own or other's right or left. In my case, I had to think which was my right; no organic feeling told me. To make sure which was my right hand I used quickly to make a few writing movements."
— Sigmund Freud, *The Origins of Psychoanalysis*, 1910

A less august personage had the same problem:

Pooh looked at his two paws. He knew that one of them was the right, and he knew that when you had decided which one of them was the right, that the other one was the left, but he never could remember how to begin. "Well," he said slowly…
— A. A. Milne, *The House at Pooh Corner*, 1928

an advantage for left-handedness in the field of art: Leonardo da Vinci, Michelangelo, and Raphael were all left-handed.

Handedness and drawing

Does left-handedness, then, improve a person's ability to gain access to right-hemisphere functions such as drawing? From my observations as a teacher, I can't say that I have noticed much difference in ease of learning to draw between left- and right-handers. As a child, drawing came easily to me, for example, and I am extremely right-handed—though, like many people, especially women, I have some right/left confusion, perhaps indicating some mixed dominance.[10] But there is a point to be made here. The process of learning to draw can create some degree of mental conflict between the two modes. It's possible that left-handers are more used to that kind of conflict and are therefore better able to cope with the discomfort it creates than are fully lateralized right-handers. Clearly, much more research is needed in this area.

Some art teachers recommend that right-handers shift the pencil to the left hand, presumably to have more direct access to the R-mode. I do not agree. The problems with seeing that prevent individuals from being able to draw do not disappear simply by changing hands; the drawing is just more awkward. Awkwardness, I regret to say, is viewed by some art teachers as being more creative or more interesting. I think this attitude does a disservice to the student and is demeaning to art itself. We do not view awkward language, for instance, or awkward science as being more creative and somehow better.

By trying to draw with their left hand, a small percentage of right-handed students do discover that they actually draw more proficiently that way. On questioning, however, it almost always comes to light that the student has some ambidexterity or was a left-hander who had been pressured to change. It would not occur to a true right-hander like myself (or to a true left-hander) to draw with the less-used hand. But on the chance that a few of you may discover some previously hidden ambidexter-

ity, I encourage you to try both hands at drawing, then settle on whichever hand feels the most comfortable.

In the chapters to follow, I address the instructions to the majority right-handers and thus avoid tedious repetition of instructions specifically for left-handers. Trust me, this indicates no prejudicial "handism" on my part, prejudice that left-handers know all too well.

Setting up the conditions for the L to R shift

The exercises in the next chapters are designed to cause a (hypothesized) mental shift from the L-mode to the R-mode, the brain mode appropriate for drawing. The basic assumption of the exercises is that the nature of the task can influence which hemisphere will "take up" the job while inhibiting the other hemisphere. But the question arises: what factors determine which mode will predominate?

Through studies with animals, split-brain patients, and individuals with intact brains, scientists believe that the control question may be decided mainly in two ways. One is speed: which hemisphere gets to the job the quickest? A second way is motivation: which hemisphere cares most or likes the task the best? And conversely: which hemisphere cares least and likes the job the least?

Since realistically drawing a perceived form is largely an R-mode function, it helps to reduce L-mode interference as much as possible. The problem is that the left brain is dominant and speedy, and is very prone to rush in with words and symbols, even taking over jobs for which it is ill-suited. The split brain studies indicated that the dominant L-mode prefers not to relinquish tasks to its mute partner unless it really dislikes the job— either because the job takes too much time or is too detailed or slow, or because the left brain is simply unable to accomplish the task. That's exactly what we need—tasks that the dominant left brain will turn down. The exercises that follow are designed to present your brain with tasks that the left hemisphere either can't or won't do.

And now if e'er by chance I put
My fingers into glue
Or madly squeeze a right-hand foot
Into a left-hand shoe....
— Lewis Carroll, from "Upon the
Lonely Moor," published in the
British literary journal *The Train*.
1856

CHAPTER 4
CROSSING OVER FROM
LEFT TO RIGHT

Can you find the five hidden profiles?

"Lilies of France," engraving, France, 1815. Publisher unknown. Contains profiles of the French royal family. From *The Playful Eye* (The Redstone Press, 1999).

The Vase/Faces illusion was made famous by Danish psychologist Edgar Rubin in 1915, but many earlier versions appeared in eighteenth-century French prints and engravings.

This figure/ground illusion presents a perceptual choice: either a vase or two facing profiles. Most people cannot see both the vase and the faces at the same time.

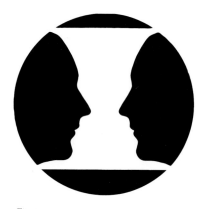

Fig. 4-1.

11. The reason for the left- and right-hand versions of the Vase/Faces pattern is to prevent your drawing hand from covering up the first profile while you are drawing the facing profile.

Vases and faces: an exercise for the double brain

The exercises that follow are designed specifically to help you understand the shift from dominant left-hemisphere mode (L-mode) to subdominant R-mode. I could go on describing the process in words, but only you can experience for yourself this cognitive shift, this slight change in subjective state. As Fats Waller once said, "If you gotta ask what jazz is, you ain't never gonna know."

So it is with R-mode state: you must experience the L- to R-mode shift, observe the R-mode state, and in this way come to know it. As a first step, the exercise below is designed to illuminate the possibility of conflict between the two modes.

What you'll need:

+ Bond paper, or drawing paper, if you prefer
+ Your #2 writing pencil, sharpened
+ Your drawing board and masking tape to tape a stack of 3 or 4 sheets to the board

Figure 4-1 is a famous optical-illusion drawing called "Vase/Faces" because it can be seen as either:

+ two facing profiles

 or

+ a symmetrical vase in the center.

What you'll do:

Before you begin: Please read all the directions for the exercise.

1. First, you will copy one-half of the Vase/Faces illusion. If you are right-handed, draw the profile on the left side, facing toward the center, as shown in Figure 4-2. If you are left-handed, copy the version shown in Figure 4-3, with the profile on the right side of the paper, facing toward the center.[11] (Or you may make up your own version of the profile if you wish.)

2. Next, draw horizontal lines at the top and bottom of your profile, forming the top and bottom of the vase (again, see

Figures 4-2 and 4-3).

3. Now, take your pencil and slowly go back over the line of the profile you have just drawn, naming the parts from top to bottom as you redraw the line, like this: "Forehead…nose…upper lip…lower lip…chin…neck." You might even do that a second time, again redrawing the lines of the profile and really thinking to yourself what those terms mean.

4. Then, go to the other side and start to draw the facing profile that will complete the symmetrical vase in the center.

5. When you get to somewhere around the forehead or nose, you may begin to experience some mental confusion or conflict. Mentally note this as it happens.

6. The purpose of this exercise is for you to self-observe: "How do I solve the problem?"

Fig. 4-2. For right-handers.

Without reading further, begin the exercise now. It should take you about five minutes, but take as much time as you wish.

Why you did this exercise

Nearly all of my students experience some confusion or conflict while doing this exercise. A few people experience a great deal of conflict, even a moment of paralysis. If this happened to you, you may have come to a point where you needed to change direction in the drawing, but didn't know whether the line should go right or left. The conflict may have been so great that you could not make your hand move the pencil to continue the drawing.

Fig. 4-3. For left-handers.

That is the purpose of the exercise: to create mental conflict so that each person can experience in their own mind the "crunch" that can occur when instructions are inappropriate to the task at hand. I believe that the conflict can be explained this way:

I gave you instructions that strongly "plugged in" the verbal system in the brain. Remember, I insisted that you name each part of the profile and I said, "Now, redraw the profile once more and really think what those terms mean," and, referring to the vase, I stressed the word *symmetrical*.

Then, I gave you a task (to complete the second profile and, simultaneously, the symmetrical vase) that can only be done by shifting to the visual, spatial mode of the brain. This is the part of the brain that can perceive and nonverbally assess visual relationships of sizes, curves, angles, and shapes.

The difficulty of making that mental shift causes a feeling of conflict and confusion—and even a momentary mental paralysis.

You may have found a way to solve the problem, thereby enabling yourself to complete the second profile and therefore the symmetrical vase.

How did you solve it?

+ By telling yourself *not* to think of the names of the features?
+ By shifting your focus from the face to the vase?
+ By using a grid (drawing vertical and horizontal lines to help you see relationships)?
+ By marking points where the outermost and innermost curves occurred?
+ By drawing from the bottom up rather than from the top down?
+ By deciding that you didn't care whether the vase was symmetrical or not and drawing any old memorized profile just to finish with the exercise?

With this last decision, the verbal system "won" and the visual system "lost," because the vase will not be symmetrical, something that seems to upset both modes.

Let me ask you a few more questions. Did you use your eraser to "fix up" your drawing? If so, did you feel guilty? If so, why? (The verbal system has a set of memorized rules, one of which may be "You can't use an eraser unless the teacher says it's okay.") The visual system, which is largely without language or verbal rules, just keeps looking for ways to solve the problem according to another kind of logic—visual logic.

"The development of an Observer can allow a person considerable access to observing different identity states, and an outside observer may often clearly infer [a] different identity state, but a person himself who has not developed the Observer function very well may never notice the many transitions from one identity state to another."
— Charles Tart, *Altered States of Consciousness*, 1977

To sum up, this is the point of the seemingly simple Vase/Faces exercise:

 ✦ In order to draw a perception—something that you see with your eyes—you must make a mental shift to the visual spatial brain mode that is specialized for this task.

 ✦ The difficulty of making the shift from verbal to visual mode often causes a "crunch" of conflict. Didn't you feel it?

 ✦ To reduce the discomfort of the conflict, you stopped (do you remember feeling stopped short?) to make a new start. Perhaps at that point, you gave yourself instructions—that is, you gave your brain instructions—to "shift gears," or "change strategy," or "don't do this; do that," or whatever terms you may have used to cause a cognitive shift to a different mode. [12]

There are numerous solutions to the mental "crunch" of the Vase/Faces exercise. Perhaps you found a unique or unusual solution. To capture your personal solution in words, you might write down what occurred on the back of your drawing.

Navigating a drawing in right-hemisphere mode

When you did your drawing of the Vase/Faces, you probably drew the first profile mainly in left-hemisphere mode, like the European navigator, taking one step at a time and naming the parts one by one. The second profile needed to be drawn in right-hemisphere mode. Like the navigator from the South Sea Islands of Truk, you needed to scan constantly to adjust the direction of the line.

 You probably found that naming the parts such as forehead, nose, or mouth seemed to confuse you. It was better not to think of the drawing as a face. It was easier to use the shape of the space between the two profiles as your guide. Stated differently, it was easiest not to think at all—that is, *not to think in words*. In right-hemisphere-mode drawing, the mode of the artist, if you do use words to think, you ask yourself only such things as:

"Where does that curve start?"

Thomas Gladwin, an anthropologist, contrasted the ways that a European and a native sailor from the island group of Truk navigated small boats between many tiny islands in the vast Pacific Ocean.

The European navigator uses the left-hemisphere mode.

Before setting sail, the European begins with a plan that can be written in terms of directions, degrees of longitude and latitude, [and] estimated time of arrival at separate points on the journey. Once the plan is conceived and completed, the sailor has only to carry out each step consecutively, one after another, to be assured of arriving on time at the planned destination. The sailor uses all available tools, such as a compass, a sextant, a map, etc., and if asked, can describe exactly how he got where he was going.

The Trukese navigator uses the right-hemisphere mode.

In contrast, the native Trukese sailor starts his voyage by *imaging the position* of his destination *relative to the position* of other islands. As he sails along, he constantly adjusts his direction according to his awareness of his position *thus far*. His decisions are improvised continually by checking relative positions of landmarks, sun, wind direction, etc. He navigates with reference to where he started, where he is going, and the space between his destination and the point *where he is at the moment*. If asked how he navigates so well without instruments or a written plan, he cannot possibly put it into words. This is not because the Trukese are unaccustomed to describing things in words, but rather because the process is too complex and fluid to be put into words.

 —J. A. Paredes and M. J. Hepburn, "The Split-Brain and the Culture-Cognition Paradox," in *Current Anthropology* 17, 1976

12. The part of the brain hypothesized as the "executive" or the "observer" of the brain is the source of instructions about how to solve the problem.

"How deep is that curve?"

"What is that angle relative to the vertical edge of the paper?"

"How long is that line relative to the one I've just drawn?"

"As I scan across to the other side, where is that point relative to the distance from the top (or bottom) edge of the paper?"

These are R-mode questions: spatial, relational, and comparative. Notice that no facial features are named. No statements are made, no conclusions drawn, such as, "The chin must come out as far as the lips," or "Noses are curved."

What is learned in "learning to draw"?

Obviously, in daily life and for most tasks, the two modes largely work together. Realistic drawing of a perceived image, however, requires a shift to a mode of thinking that is fundamentally different from the one we rely on nearly all of our waking hours. This kind of drawing may be one of the relatively few activities that require mainly one mode: the visual mode mostly unassisted by the verbal mode. There are other examples: athletes and dancers, for instance, seem to perform best by quieting their verbal system during performances, often called being "in the zone." Interestingly, however, a person who needs to shift in the other direction, from visual to *verbal* mode, can also experience conflict. A surgeon once told me that while operating on a patient (mainly a visual task, once a surgeon has acquired the knowledge and technical experience needed), he would find himself unable to name the instruments. He would hear himself saying to an attendant, "Give me the…the…you know, the…thingamajig!"

The first step in learning to draw, therefore, turns out *not* to be "learning to draw." Paradoxically, it means learning to access at will that system in the brain that is the appropriate one for drawing. Putting it another way, accessing the visual mode of the brain—the appropriate mode for drawing—causes you to see in the special way an artist sees. The artist's "way of seeing" is different from ordinary seeing and requires an ability to make mental shifts by conscious volition. Perhaps more accurately, an artist

Fig. 4-4. Upside-down photograph by Philippe Halsman.

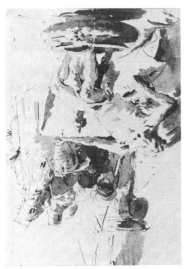

Fig. 4-5. Giovanni Battista Tiepolo (1696–1770), *The Death of Seneca*. Courtesy of the Art Institute of Chicago, Joseph and Helen Regenstein Collection.

sets up conditions that cause a cognitive shift to "happen." That is what a person who is trained in drawing does, and that is what you are about to learn.

Again, this ability to see things differently and to enable insight to rise to conscious level (as in the Archimedes story) has many uses in life aside from drawing—not the least of which is creative problem solving.

Keeping the conflict-causing Vase/Faces lesson in mind, please try the next exercise, one that I designed to reduce conflict between the two brain modes. The purpose of this exercise is just the reverse of the previous one.

Upside-Down Drawing: making the shift to R-mode

Familiar things do not look the same when they are upside down. We automatically assign a top, a bottom, and sides to the things we perceive, and we expect to see things oriented in the usual way—that is, right side up. In upright orientation, we can recognize familiar things, name them, and quickly categorize them by matching what we see with our stored memories and concepts.

When an image is upside down, the visual clues don't match. The message is strange, and the brain becomes confused. We see the shapes and the areas of light and shadow, but the image doesn't call forth the immediate naming that we are used to. We don't particularly object to looking at upside-down pictures unless we are called on to name the image. Then the task becomes exasperating.

Seen upside down, even well-known faces are difficult to recognize and name. For example, the photograph in Figure 4-4 is of a famous person. Do you recognize who it is?

You may have had to turn the photograph right side up to see that it is Albert Einstein, the famous theoretical physicist. Even after you know who the person is, the upside-down image probably continues to look strange.

Inverted orientation causes recognition problems with other images. Your own handwriting, turned upside down, is probably

difficult for you to figure out, although you've been reading it for years. To test this, find an old shopping list or letter in your handwriting and try to read it upside down.[13]

A complex drawing, such as the one shown upside down in the Tiepolo drawing, Figure 4-5, is almost indecipherable. The mind just gives up on it.

Upside-Down Drawing: an exercise that reduces mental conflict

We shall use this gap in the recognition and naming abilities of the left hemisphere to allow the R-mode to have a chance to take over for a while.

Figure 4-8, on page 55, is a reproduction of a 1920 line drawing by Pablo Picasso of the Russian composer Igor Stravinsky (1948–1971). The image is upside down—do not turn it right side up! You will be copying the upside-down image. Your drawing, therefore, will also be done upside down—that is, you will copy the Picasso drawing *just as you see it*. (Figure4-7.)

What you'll need:

+ The reproduction of the Picasso drawing, Figure 4-8, page 55
+ Your #2 writing pencil, sharpened
+ Your drawing board and masking tape to tape a stack of bond paper to the board[14]
+ Forty minutes to an hour of uninterrupted time

What you'll do:

Before you begin, please read through all of the following instructions.
1. Find a place where you can be alone for an hour.
2. Play music if you like, something without lyrics, or you may prefer silence. As you shift into R-mode, you may find that the music fades out. Finish the drawing in one sitting, allowing yourself at least forty minutes—more if possible. And most important, *do not turn either your drawing or the Picasso*

Fig. 4-6. Photograph by Philippe Halsman, 1947. © Yvonne Halsman, 1989. This is the full photograph shown upside down on page 51. We are indebted to Yvonne Halsman for allowing this unorthodox presentation of Philippe Halsman's famous image of Einstein.

13. Forgers, in order to copy a signature accurately, turn the target signature upside down.

14. If you prefer to use your drawing paper, use a piece of bond paper as a template to draw an 8½" × 11" border (a format edge) for your drawing.

drawing right-side up until you have finished. Turning the drawing would cause a shift back to L-mode, which we want to avoid while you are learning to experience the focused R-mode state of awareness.

3. You may start anywhere you wish—the bottom, either side, or the top. Most people tend to start drawing at the top of the paper. Try not to figure out what you are looking at in the upside-down image. It is better not to know. Simply start copying the lines, but remember: don't turn the drawing right-side up!

4. I recommend that you not try to draw the entire outline of the form and then "fill in" the parts. The reason is that if you make any small error in the outline, the parts inside won't fit.[15] One of the great joys of drawing is the discovery of how the parts fit together. Therefore, I recommend that you move from line to adjacent line, space to adjacent shape, working your way through the drawing, fitting the parts together as you go.

5. If you talk to yourself at all, use only the language of vision, such as: "This line bends this way," or "That shape has a curve there," or "Compared to the edge of the paper (vertical or horizontal), this line angles like that," and so on. What you do not want to do is to name the parts.

6. When you come to parts that seem to force their names on you—the H-A-N-D-S and the F-A-C-E—try to focus on these parts just as shapes. You might cover up with one hand or finger all but the specific line you are drawing and then uncover each adjacent line. Alternatively, you might shift briefly to another part of the drawing.

7. You may even want to cover most of the reproduced drawing with another piece of paper, slowly uncovering new areas as you work your way down through the drawing. A note of caution, however: some of my students find this ploy helpful, while some find it distracting and unhelpful.

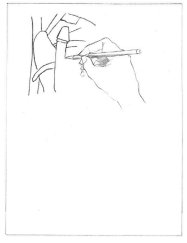

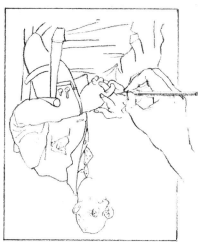

Figs. 4-7. To draw the Picasso upside down, move from line to adjacent line, space to adjacent shape and work your way through the drawing.

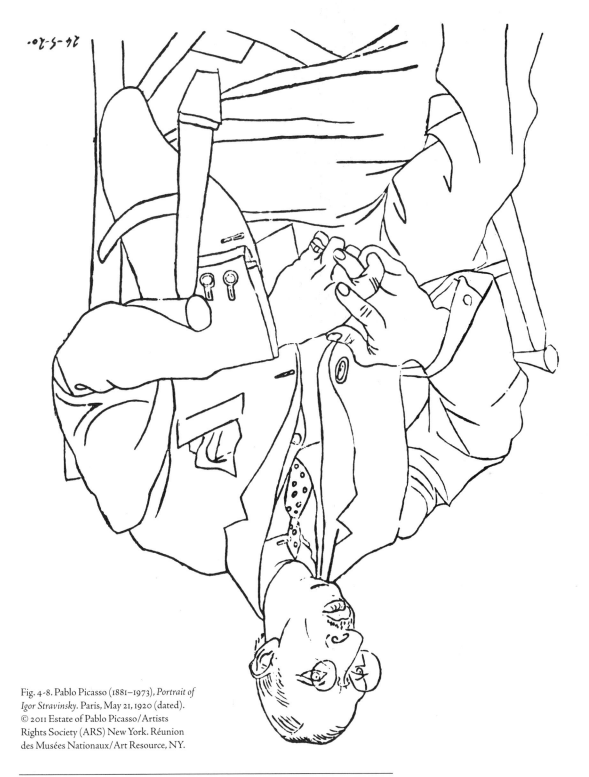

Fig. 4-8. Pablo Picasso (1881–1973), *Portrait of Igor Stravinsky*. Paris, May 21, 1920 (dated). © 2011 Estate of Pablo Picasso/Artists Rights Society (ARS) New York. Réunion des Musées Nationaux/Art Resource, NY.

8. At some point, the drawing may begin to seem like an interesting, even fascinating, puzzle, rather like a jigsaw puzzle. When this happens, you will be "really drawing," meaning that you have successfully shifted to R-mode and you are seeing clearly. This state is easily broken. For example, if someone were to come into the room and ask, "What are you doing?" your verbal system would be reactivated and your focus and concentration would be instantly over.

9. Remember that everything you need to know to draw the image of Stravinsky is right in front of your eyes. All the information is right there, making it easy for you. Don't make it complicated. It really is as simple as that.

Begin your Upside-Down Drawing now.

After you have finished

Turn both of the drawings—the reproduction in the book and your copy—right side up. See what you have accomplished, drawing upside down! This Picasso drawing is considered quite challenging to copy right side up, but I can confidently predict that you will be pleased with your drawing, especially if you have thought in the past that you would never be able to draw.

I can also confidently predict that the most difficult parts are beautifully drawn, creating a spatial illusion. In your drawing of Igor Stravinsky seated in a chair, you drew the crossed legs in foreshortened view.[16] For most of my students, this is the finest part of their drawing, despite the challenge of foreshortening. How could they draw this difficult part so well? Because they didn't know what they were drawing! They simply drew what they saw, just as they saw it—one of the most important keys to drawing well.

When you came to the hands and face of Stravinsky, however, knowledge of what you were drawing was probably inescapable, and for most people, this is where erasing and redrawing becomes the most intense. The reason, of course, is that you knew what you were drawing, and perhaps you began talking to

Fig. 4-9. "I Want You for U. S. Army" by James Montgomery Flagg, 1917 poster. Permission: Trustees of the Imperial War Museum, London, England.

Uncle Sam's arm and hand are "foreshortened" in this Army poster. Foreshortening means that, in order to give the illusion of forms advancing or receding in space, the forms must be drawn just as they appear in that position, not depicting what we know about their actual length. Learning to "foreshorten" is often difficult for beginners in drawing.

yourself, saying such things as, "That thumb is a weird shape. It can't be right," or, "Why is one side of the eyeglasses bigger than the other? That can't be right." I'm sure you found that verbalizing didn't help, and, as you will learn from the coming exercises, the solution in drawing is always: if you see it, you draw it, just as it is.

A logical box for the L-mode

Figure 4-10 and Figure 4-11 show two drawings by the same university student. The student had misunderstood my instructions to the class and did the drawing right side up. When he came to class the next day, he showed me his drawing and said, "I misunderstood. I just drew it the regular way." I asked him to take a seat and do the drawing again, this time upside down. He did, and Figure 4-11 was the result.

It goes against common sense that the upside-down drawing is so far superior to the drawing done right-side up. The student himself was astonished. No instruction had intervened between the two drawings.

This puzzle puts the L-mode into a logical box: how to account for this sudden ability to draw well, when the only change is that the verbal mode has been eased out of the task. The left brain, ever the critic, but an admirer of a job well done, must now consider the possibility that the disdained right brain is good at drawing.

Why upside-down drawing works

For reasons that are still unclear, the verbal system immediately rejects the task of "reading" and naming upside-down images. The L-mode seems to say, in effect, "I don't do upside down. It's too hard to name things seen this way, and, besides, the world isn't upside down. Why should I bother with such stuff?"

Well, that's just what we want! On the other hand, the R-mode seems not to care. Right-side up, upside down, it's all interesting, perhaps even more interesting upside down because

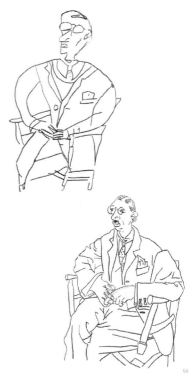

Fig. 4-10; top: A university student's copy of Picasso's *Stravinsky*, mistakenly copied right-side up.

Fig. 4-11; bottom: The next day, the same student made this copy of Picasso's drawing, this time upside down.

the R-mode is free of interference from its verbal partner, which is often in a "rush to judgment" or, at least, a rush to recognize, name, and move on.

Why you did this exercise:

The reason you did this exercise, therefore, is to experience escaping the clash of conflicting modes—the kind of conflict and even mental paralysis that the Vase/Faces exercise may have caused. When the L-mode drops out voluntarily, conflict is avoided and the R-mode quickly takes up the task that is appropriate for it: drawing a perceived image.

Getting to know the L-to-R shift

Two important points of progress emerge from the Upside-Down Drawing exercise. The first is your conscious recall of the cognitive shift. The quality of the R-mode state of consciousness is different from the L-mode state. One can detect those differences and begin to recognize *after the fact* when the cognitive shift has occurred. Oddly, the moment of shifting between states of consciousness always remains out of awareness. For example, one can be aware of being alert and then of having been daydreaming, but the moment of shifting between the two states remains elusive. Similarly, the moment of the shift from L-mode to R-mode remains out of awareness, but once you have made the shift, the difference in the two states is accessible to knowing after the fact. This knowing will help bring the shift under conscious control—a main goal of these lessons.

The second insight gained from the exercise is your awareness that shifting to R-mode enables you to see in the way a trained artist sees, and therefore to draw what you perceive. Now, it's obvious that we can't always be turning things upside down. Your models are not going to stand on their heads for you, nor is the landscape going to turn itself upside down. Our goal, then, is to teach you how to make the cognitive shift when perceiving things in their normal right-side-up positions. You will learn the

-mode

The L-mode is the "right-handed," left-hemisphere mode. The L is foursquare, upright, sensible, direct, true, hard-edged, unfanciful, forceful.

-mode

The R-mode is the "left-handed," right-hemisphere mode. The R is curvy, flexible, more playful in its unexpected twists and turns, more complex, diagonal, fanciful.

artist's "gambit": to direct your attention toward visual information that the L-mode cannot or will not process. In other words, you will always try to present your brain with a task the language system will refuse, thus allowing the R-mode to use its capability for drawing. Exercises in the coming chapters will show you some ways to do this.

A review of the R-mode

It might be helpful to review what the R-mode feels like. Think back. You have made the shift several times now—slightly, perhaps, while doing the Vase/Faces drawings and more intensely just now while drawing the Stravinsky. In the R-mode state, did you notice that you were somewhat unaware of the passage of time—that the time you spent drawing may have been long or short, but you couldn't have known until you checked it afterward? If there were people near, did you notice that you couldn't listen to what they said—in fact, that you didn't want to hear? You may have heard sounds, but you probably didn't care about figuring out the meaning of what was being said. And were you aware of feeling alert but relaxed—confident, interested, absorbed in the drawing and clear in your mind?

Most of my students have characterized the R-mode state of consciousness in these terms, and the terms coincide with my own experience and accounts related to me of artists' experiences. One artist told me, "When I'm really working well, it's like nothing else I've experienced. I feel at one with the work: the painter, the painting, the model, it's all one. I feel alert, but calm—fully engaged, and in full control. It's not exactly happiness; it's more like bliss. I think it's what keeps me coming back and back to painting and drawing."

The R-mode state is indeed pleasurable, and in that mode you work well. But there is an additional advantage: shifting to the R-mode releases you for a time from the verbal, symbolic domination of the L-mode, and that is a welcome relief. The pleasure may come from resting the left hemisphere, stopping its chatter,

"Our normal waking consciousness, rational consciousness, as we call it, is but one special type of consciousness, whilst all about it, parted from it by the filmiest of screens, there lie potential forms of consciousness entirely different. We may go through life without suspecting their existence; but apply the requisite stimulus, and at a touch they are there in all their completeness, definite types of mentality which probably somewhere have their field of application and adaptation."
— William James, *The Varieties of Religious Experience*, 1902

Fig. 4-12. Another upside-down image to draw: Spider-Man in a strongly foreshortened view.

keeping it quiet for a change. This yearning to quiet the L-mode may partially explain centuries-old practices such as meditation and self-induced altered states of consciousness achieved through fasting, chanting, drugs, or alcohol. Drawing induces a focused, alert state of consciousness that can last for hours, bringing significant satisfaction, and, unlike some self-induced altered states, is productive in terms of work output. You have a drawing to show for the time spent.

Fig. 4-13. This sixteenth-century drawing by an unknown German artist offers a wonderful opportunity to practice upside-down drawing.

Fig. 4-14. A line drawing copy of the German horse and rider. Be certain before starting your copy that your format is the same proportion as this line drawing copy. The format controls all the shapes and spaces of the drawing, and if you start with a different format, the shapes and spaces will become distorted.

Before you read further, do at least one more drawing upside down. Spider-Man is a good image to draw, Figure 4-12, as is the German horse and rider, Figure 4-13, or find other line drawings (even photographs) to copy upside down. After each time you draw, try to consciously review the R-mode shift, so that you become familiar with how it feels to be in that mode.

CHAPTER 5
DRAWING ON YOUR CHILDHOOD ARTISTRY

This amazing drawing was made by Paul Cannon, now an adult, when he was five years old. His father, British artist and educator Colin Cannon, wrote on the back of the drawing: "Paul, age 5. He used to cover large sheets of paper with figures: knights, warriors, horses, etc., against appropriate backgrounds. He did this before he had seen the Bayeux Tapestry."(The Bayeux Tapestry is an eleventh-century linen embroidery recording the events and battles of the Norman conquest of England in 1066.)

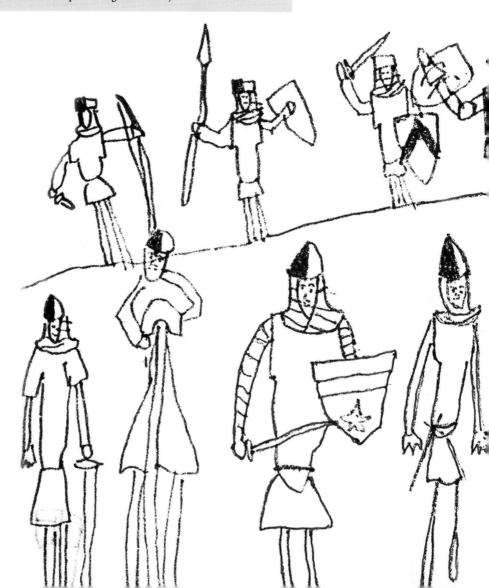

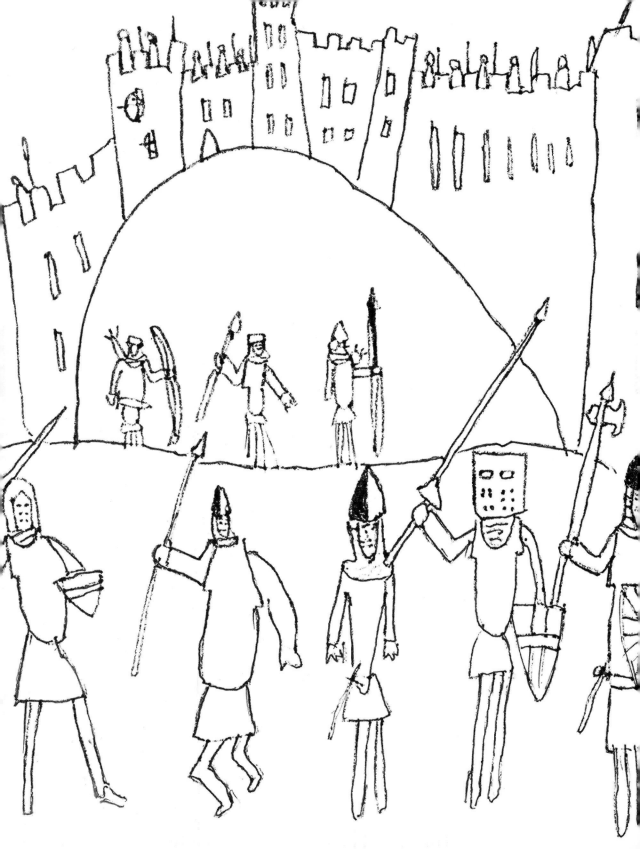

An expert in children's art, Miriam Lindstrom of the San Francisco Art Museum, described the crisis in early adolescent art:

"Discontented with his own accomplishments and extremely anxious to please others with his art, he tends to give up original creation and personal expression....Further development of his visualizing powers and even his capacity for original thought and for relating himself through personal feelings to his environment may be blocked at this point. It is a crucial stage beyond which many adults have not advanced."
— Miriam Lindstrom, *Children's Art*, 1957

These drawings by an adult show the persistence of childlike forms.

Fig. 5-1.

Fig. 5-2.

Age nine or ten seems to mark the abrupt end of children's artistic development in terms of drawing skills. At this age, children confront an artistic crisis, a conflict between their increasingly complex perceptions of the world around them and their current level of drawing skills to depict what they see.

The development of children's art is linked to developmental changes in the brain. In the early stages, infants' brain hemispheres are not clearly specialized for separate functions. Lateralization—the consolidation of specific functions into one hemisphere or the other—progresses gradually through the childhood years, paralleling the acquisition of language skills and the symbols of childhood art.

Lateralization is usually complete by around age ten, and this coincides with the period of conflict in children's art, when the symbol system seems to override perceptions and to interfere with accurate drawing of those perceptions. One could speculate that conflict arises because children may be using the "wrong" brain mode—the L-mode—to accomplish a task best suited for the R-mode. Perhaps they simply cannot work out a way to shift to the visual mode. By age ten, language dominates, adding further complication as names and symbols overpower visual, spatial perceptions.

Figures 5-1 and 5-2 illustrate the persistence of childlike forms in drawings by a brilliant young professional man who was just completing a doctoral degree at a major university. He joined one of my classes because, he said, he had always wondered if he could learn to draw. I watched the young man as he did two pre-instruction drawings: one of himself (Figure 5-1) and one of another student (Figure 5-2). He first drew himself as seen in a mirror and then he drew a student who posed for him. He would draw a bit, erase, and draw again, persisting for about twenty minutes. During this time, he became restless and seemed tense and frustrated. Later he told me that he hated his drawings and that he hated drawing, period.

If we were to attach a label to this learning disability the way educators have attached the label *dyslexia* to reading problems, we might call the problem *dyspictoria* or *dysartistica* or some such term, and we would seek a remedy. But no one has done so because drawing is not considered a vital skill for survival in our culture, whereas speech and reading are. Therefore, hardly anyone seems to notice that most children give up drawing at age nine or ten. These children grow up to become the adults who say that they never could draw and can't even draw a straight line. The same adults, however, if questioned, often say that they would have liked to learn to draw, just for their own satisfaction at solving the drawing problems that plagued them as children. But they felt that they had to stop drawing because they simply couldn't figure out how to do it.

A consequence of this early cutting off of artistic development is that fully competent and self-confident adults often become suddenly self-conscious, embarrassed, and anxious if asked to draw a picture of anything, but especially a human face or figure. In this situation, individuals often say such things as "No, I can't! Whatever I draw is always terrible. It looks like a kid's drawing." Or "I don't like to draw. It makes me feel so stupid." You yourself may have felt a twinge or two of those feelings when you did the pre-instruction drawings.

The crisis period

At nine or ten, children develop a passion for realistic drawing, especially the depiction of space—how things go back in space and look three-dimensional. They become sharply critical of their earlier childhood drawings and begin to draw certain favorite subjects over and over again, attempting to perfect the image. They may regard as failure anything short of perfect realism.

Perhaps you can remember your own attempts at that age to make things "look right" in your drawings, and your feeling of disappointment with the results. Drawings that might have made you proud at an earlier age perhaps seemed hopelessly

"When my daughter was about seven years old, she asked me one day what I did at work. I told her that I worked at the college—that my job was to teach people how to draw. She stared back at me, incredulous, and said, "You mean, they forgot?"
— Howard Ikemoto, artist and teacher, Cabrillo College, Aptos, California

"The scribblings of any child clearly indicate how thoroughly immersed he is in the sensation of moving his hand and crayon aimlessly over a surface, depositing a line in his path. There must be some quantity of magic in this alone."
— Edward Hill, *The Language of Drawing,* 1966

wrong and childish and embarrassing. Regarding your drawings, you may have said, as many children this age say, "This is terrible! I'm awful at drawing and I'm not doing it anymore."

There is another unfortunately frequent reason that children stop drawing. Unthinking individuals sometimes make sarcastic or derogatory remarks about children's art. The thoughtless person may be a teacher, a parent, another child, or perhaps an admired older brother or sister. Many adults have related to me their painfully clear memories of someone ridiculing their attempts at drawing. Sadly, children often blame themselves and the drawing for causing the hurt, rather than blaming the careless critic. Therefore, to protect the ego from further damage, children react defensively, and understandably so: they seldom ever attempt to draw again.

Art in school

Even sympathetic middle school art teachers (a rapidly disappearing group, I regret to say) who may feel dismayed by unfair criticism of children's art and who want to help, become discouraged by the style of drawing that young adolescents prefer—complex, detailed scenes, labored attempts at realistic drawing, endless repetitions of favorite themes such as racing cars (boys) or rearing horses (girls). Teachers recall the beguiling freedom and charm of younger children's work and wonder what happened. They deplore what they see as "tightness" and "lack of creativity" in students' drawings, and the children themselves often become their own most unrelenting critics. Consequently, teachers frequently resort to crafts projects because they seem safer and cause less anguish—projects such as paper mosaics, string painting, drip painting, and other manipulations of materials.

As a result, most students do not learn how to draw in the early and middle grades. Their self-criticism becomes permanent, and they very rarely try to learn how to draw later in life. Like the doctoral candidate mentioned above, they might grow up to be highly skilled in a number of areas, but if asked to draw a person,

they will produce the same childlike image they were drawing at age ten.

From infancy to adolescence

For most of my students, it has proven beneficial to go back in time to try to understand how their visual imagery and childhood symbols developed from infancy to adolescence. With this understanding, students seem better able to "unstick" their artistic development and move on to adult skills.

The scribbling stage

Making marks on paper begins at about age one and a half, when you as an infant were given a pencil or crayon, and you, by yourself, made a mark. It's hard for us to imagine the sense of wonder a child experiences on seeing a black line emerge from the end of a stick, a line the child controls. You and I, all of us, had that experience.

After a tentative start, you probably scribbled with delight on every available surface, perhaps including your parents' best books and the walls of a bedroom or two. Your scribbles were seemingly quite random at first but very quickly began to take on definite shapes. One of the basic scribbling movements is a circular one, probably arising simply from the way the shoulder, arm, wrist, hand, and fingers work together. A circular movement is a natural movement—more so, for instance, than the movements required to draw a square. (Try both on a piece of paper, and you'll see what I mean.)

The stage of symbols

After some days or weeks of scribbling, infants—and apparently all human children—make the basic discovery of art, the discovery first made by prehistoric humans: a drawn image can stand for something out there in the world. The child makes a circular mark, looks at it, adds two marks for eyes, points to the drawing, and says, "Mommy," or "Daddy," or "That's me," or "My

"When I was a child, I spake as a child, I thought as a child: but when I became a man, I put away childish things."
—1 Corinthians 13:11

"By the time the child can draw more than a scribble, by age three or four years, an already well-formed body of conceptual knowledge formulated in language dominates his memory and controls his graphic work … Drawings are graphic accounts of essentially verbal processes. As an essentially verbal education gains control, the child abandons his graphic efforts and relies almost entirely on words. Language has first spoilt drawing and then swallowed it up completely."
—Written in 1930 by German psychologist Karl Buhler (1879–1963)

Fig. 5-3. Scribble drawing by a two-and-a-half-year-old.

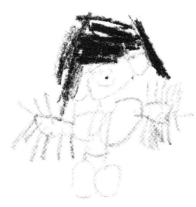

Fig. 5-4. Drawing by a three-and-a-half-year-old.

dog," or whatever (see Figure 5-3). Thus, we all made the uniquely human leap of insight that is the foundation for all art, from the prehistoric cave paintings up through the centuries to the art of da Vinci, Rembrandt, and Picasso.

With great delight, infants proceed to draw circles with eyes, mouth, and lines sticking out to represent arms and legs, as in Figure 5-3. This form, a symmetrical, circular form, is a basic form universally drawn by infants. The circular form can be used for almost anything: with slight variations, the basic pattern can stand for a human being, a cat, a sun, a jellyfish, an elephant, a crocodile, a flower, or a germ. For you as a child, the picture was whatever you said it was, although you probably made subtle and charming adjustments of the basic form to get the idea across. I believe that one of the main functions of the symbolic drawing of childhood is to enhance language acquisition.

By the time children are about three and a half, the imagery of their art becomes more complex, reflecting growing awareness and perceptions of the world. A body is attached to the head, though it may be smaller than the head. Arms may still grow out of the head, but more often they emerge from the body—sometimes from below the waist. Legs are attached to the body.

By age four, children are keenly aware of details of clothing—buttons and zippers, for example, appear as details of the drawings. Fingers appear at the ends of arms and hands, and toes at the ends of legs and feet. Numbers of fingers and toes vary imaginatively. I have counted as many as thirty-one fingers on one hand and as few as one toe per foot (Figure 5-4).

Although children's drawings of figures are similar in many ways, through trial and error each child works out favorite images, which become refined through repetition. Children draw their special images over and over, memorizing them and adding details as time goes on. Eventually, the sets of symbols become embedded in memory and are remarkably stable over time (Figure 5-5).

Fig. 5-5. Notice that the features are the same in each figure—including the cat—and that the little hand symbol is also used for the cat's paws.

Fig. 5-7. The arm is huge because it holds up the umbrella.

"You must be Billy's parents. I'd recognize you anywhere!"

Fig. 5-6.

Fig. 5-6. Children's repeated images become known to fellow students and teachers, as shown in this wonderful cartoon by Brenda Burbank.

Pictures that tell stories

Around age four or five, children begin to use drawings to tell stories and to work out problems, using small or large adjustments of the basic forms to express their intended meaning. For example, in Figure 5-7, the young artist has made the arm that holds the

Fig. 5-8

Using his basic figure symbol, he first drew himself.

He then added his mother, using the same basic figure configuration with adjustments—long hair, a dress.

He then added his father, who was bald and wore glasses.

He then added his sister, with teeth.

umbrella huge in relation to the other arm, because the arm that holds the umbrella is the important point of the drawing.

Another instance of using drawing to portray feelings is a family portrait, drawn by a shy five-year-old whose every waking moment apparently was dominated by his older sister (Figure 5-8).

Even a Picasso could hardly have expressed a feeling with greater power than that. Once the feeling was drawn, giving form to formless emotions, the child who drew the family portrait may have been better able to cope with his overwhelming sister.

The landscape

By around age five or six, children have developed a set of symbols to create a landscape. Again, by a process of trial and error, children usually settle on a single version of a symbolic landscape, which is endlessly repeated. Perhaps you can remember the landscape you drew around age five or six.

Fig. 5-9. Landscape drawing by a six-year-old. The bottom edge of the paper functions as the ground, and the house therefore sits on the paper's bottom edge. The empty spaces of the drawing function as air through which smoke rises, the sun's rays shine, and a bird flies.

Figure 5-10. Recalled Childhood Landscape from about age seven. The ground line has risen from the bottom edge. Fish swim in a pond. The path grows narrower as it rises on the page—a first attempt at depicting space. Notice that the adult who did this charming recalled drawing left off the doorknob, which, as a child, she would not have forgotten.

What were the components of that landscape? First, the ground and sky. Thinking symbolically, a child knows that the ground is at the bottom and the sky is at the top. Therefore, the ground is the bottom edge of the paper, and the sky is the top edge. Children emphasize this point, if they are working with color, by painting a green or brown stripe across the bottom, blue across the top.

Most children's landscapes contain some version of a house. Try to call up in your mind's eye an image of the house you drew. Did it have windows? With curtains? And what else? A door? What was on the door? A doorknob, of course, because that's how you get in. I have never seen an authentic, child-drawn house with a missing doorknob.

You may begin to remember the rest of your landscape: the sun (did you use a corner sun or a circle with radiating rays?), the clouds, the chimney, the flowers, the trees (did yours have a convenient limb sticking out for a swing?), the mountains (were

Young children seem to start out with a nearly perfect sense of composition—the way shapes and spaces are arranged within the four edges of the paper. A few years later, they lose this compositional sense, perhaps because they become focused on separate objects rather than whole scenes bounded by the edges of the paper.

This cheerful Recalled Childhood Drawing with its sun smiling down (Figure 5-11) is a perfectly balanced composition. In Figure 5-12, I have removed one element, a tree, from the drawing, to demonstrate how the change completely throws off the balance of the composition.

Test this with your own Recalled Landscape by covering one element of your drawing and observing the effect on the composition.

Figure 5-11

Figure 5-12

yours like upside-down ice cream cones?). And what else? A road going back? A fence? Birds?

Redraw your childhood landscape

At this point, before you read any further, please take a sheet of paper and draw the landscape that you drew as a child. Label your drawing "Recalled Childhood Landscape." You may remember this image with surprising clarity as a whole image, complete in all its parts; or it may come back to you more gradually as you begin to draw.

While you are drawing the landscape, try also to recall the pleasure drawing gave you as a child, the satisfaction with which each symbol was drawn, and the sense of rightness about the placement of each symbol within the drawing. Recall the sense that nothing must be left out and, when all the symbols were in place, your sense that the drawing was complete.

If you can't recall the drawing at this point, don't be concerned. You may recall it later. If not, it may simply indicate that you've blocked it out for some reason (possibly a criticizing or ridiculing remark by some unthinking person). Usually about 10 percent of my adult students are unable to recall their childhood drawings.

Before we go on, let's take a minute to look at some recalled childhood landscapes drawn by adults, Figures 5-10 and 5-11. First, you will observe that the landscapes, while similar, are personal images, each different from the others. Observe also that in every

case the composition—the way the elements of each drawing are composed or distributed within the four edges—seems exactly right, in the sense that not a single element could be added or removed without disturbing the rightness of the whole.

After you have looked at the examples, observe your own drawing. Think back on how you did the drawing. Did you do it with a sense of sureness, knowing where each part was to go? For each part, did you find that you had an exact symbol that was perfect in itself and fit perfectly with the other symbols? You may have been aware of feeling the same sense of satisfaction that you felt as a child when the forms were in place and the image completed.

The stage of complexity

Now, like the ghosts in Dickens's *A Christmas Carol*, we'll move you on to observe yourself at a slightly later age, at nine or ten. Possibly you may remember some of the drawings you did at that age—in the fifth, sixth, or seventh grade.

During this period, children try for more detail in their artwork, hoping by this means to achieve greater realism, which is a prized goal. Concern for composition diminishes, the forms often being placed almost at random on the page. Children's concern for where things are located in the drawing is replaced with concern for how things look, particularly the details of forms (Fig. 5-13). Overall, drawings by older children show greater complexity and, at the same time, less assurance than do the landscapes of early childhood.

Also around this time, children's drawings become differentiated by gender, probably due to cultural factors. Boys begin to draw automobiles—hot rods and racing cars—and war scenes with dive bombers, submarines, tanks, and rockets. They draw legendary figures and heroes—bearded pirates, Viking crewmen and their ships, television stars, mountain climbers, and deep-sea divers. They are fascinated by block letters, especially monograms, and some odd images such as (my favorite) an eyeball complete with piercing dagger and pools of blood (Fig. 5-13).

Fig. 5-13. Gruesome eyeballs are a favorite theme of adolescent boys. Meanwhile, girls are drawing tamer subjects such as this bride.

Fig. 5-14. Recent drawings by girls sometimes present a more contemporary view, as in this drawing titled "Wolfgirl" by Nova Johnson, age 10. On the back of the drawing, Nova wrote: "I made up Wolfgirls on my own. Obviously, they're part wolf, part human girl. They will always be there in my imagination, and I love thinking about them and what they might be like. So I decided to draw a picture of one."

Fig. 5-15. Complex drawing by Naveen Molloy, then ten years old. This is an example of the kind of drawing by adolescents that teachers often deplore as "tight" and uncreative. Young artists work very hard to perfect images like this one of electronic equipment. Note the keyboard and mouse. The child will soon reject this image, however, as hopelessly inadequate.

Meanwhile, girls are drawing tamer things—flowers in vases, waterfalls, mountains reflected in still lakes, pretty girls standing or sitting on the grass, and fashion models with incredible eyelashes, elaborate hairstyles, tiny waists and feet, and hands held behind the back because hands are "too hard to draw."

Figures 5-14 through 5-17 are some examples of these early adolescent drawings. I've included a cartoon drawing. Both boys and girls draw cartoons. I believe that cartooning appeals to children at this age because cartoons employ familiar symbolic forms but are used in a more sophisticated way, thus enabling adolescents to avoid the dreaded criticism that their drawings are "babyish."

The stage of realism

By around age ten or eleven, children's passion for realism is in full bloom. When their drawings don't come out "right"—meaning that things don't look real—children often become discouraged and ask their teachers for help. The teacher may say, "You must look more carefully," but this doesn't help, because the child doesn't know what to look more carefully for. Let me illustrate that with an example.

Fig. 5-16. Complex drawing by a nine-year-old girl. Transparency is a recurrent theme in the drawings of children at this stage. Things seen under water, through glass windows, or in transparent vases—as in this drawing—are all favorite themes. Though one could guess at a psychological meaning, it is quite likely that young artists are simply trying this idea to see if they can make the drawings "look right."

Fig. 5-17. Complex drawing by a ten-year-old boy. Cartooning is a favorite form of art in the early adolescent years. As art educator Miriam Lindstrom notes in *Children's Art,* the level of taste at this age is at an all-time low.

Say that a ten-year-old wants to draw a picture of a cube, perhaps a three-dimensional block of wood. Wanting the drawing to look "real," the child tries to draw the cube from an angle—not just a straight-on side view that would show only a single plane, and thus would not reveal the true shape of the cube.

To do this, the child must draw the oddly angled shapes just as they appear—that is, just like the image that falls on the retina. Those shapes are not square. In fact, the child must suppress knowing that the cube is square and draw shapes that are "funny." The drawn cube will look like a cube only if it is comprised of oddly angled shapes (see the diagrams in Figure 5-18). Put another way, the child must draw unsquare shapes to draw a

Fig. 5-18. Realistic depiction of a cube requires drawing uncubelike shapes.

Fig. 5-19. Children's unsuccessful attempts to draw a cube that "looks real."

square cube, and the child must accept this paradox, this illogical process that conflicts with verbal, conceptual knowledge. (Perhaps this is one meaning of Picasso's famous 1923 statement that "Art is a lie that makes us realize the truth.")

If verbal knowledge of the cube's real shape overwhelms the student's purely visual perception, "incorrect" drawing results—drawing with the kinds of problems that make adolescents despair (see the diagrams in Figure 5-19). Knowing that cubes have square corners, students usually start a drawing of a cube with a square corner. Knowing that a cube rests on a flat surface, students draw straight lines across the bottom. Their errors compound themselves as the drawing proceeds, and the students become more and more confused.

Though a sophisticated viewer, familiar with the art of Cubism and abstraction, might find the "incorrect" drawings in Figure 5-19 more interesting than the "correct" drawings in Figure 5-18, young students find praise of their wrong forms incomprehensible. In this case, the child's intent was to make the cube look "real." Therefore, to the child, the drawing is a failure. To say oth-

"I must begin, not with hypothesis, but with specific instances, no matter how minute."
— Paul Klee

erwise seems to students as absurd as telling them that "two plus two equals five" is a creative and praiseworthy solution to a math problem.

On the basis of "incorrect" drawings such as the cube drawings, students may decide that they "can't draw." But they can draw. The forms indicate that manually they are perfectly able to draw the lines. The dilemma is that previously stored knowledge—useful in other contexts—prevents their seeing the thing-as-it-is, right there in front of their eyes.

The teacher could solve the problem by showing the students how—that is, by demonstrating the process of drawing the cube. Learning by demonstration is a time-honored method of teaching art, and it works if the teacher knows how to draw and has confidence enough to demonstrate realistic drawing in front of a class. Unfortunately, since many teachers at the crucial elementary and middle school levels are themselves not able to draw, they often have the same feelings of inadequacy as the children they wish to teach.

Also, many teachers wish children at this age would be freer, less concerned about realism in their artwork. But however much some teachers may deplore their students' insistence on realism, the children themselves are relentless. They will have realism, or they will give up art forever. They want their drawings to match what they see, and they want to know how to do that.

I believe that children at this age love realism because they are trying to learn how to see. They are willing to put great energy and effort into the task if the results are encouraging. A few children are lucky enough to accidentally discover the secret: how to see things in a different (R-mode) way. I think I was one of those children who, by chance, or perhaps by having a somewhat quirky brain, stumbles on the process. But the majority of children need to be taught how to make that cognitive shift.

Lewis Carroll described an analogous shift in Alice's adventures:

"Oh, Kitty, how nice it would be if we could only get through into Looking Glass House! I'm sure it's got, oh! such beautiful things in it! Let's pretend there's a way of getting through into it, somehow, Kitty. Let's pretend the glass has got all soft like gauze, so that we can get through. Why, it's turning to a mist now, I declare! It'll be easy enough to get through…"
—Lewis Carroll, *Through the Looking-Glass, and What Alice Found There,* 1871

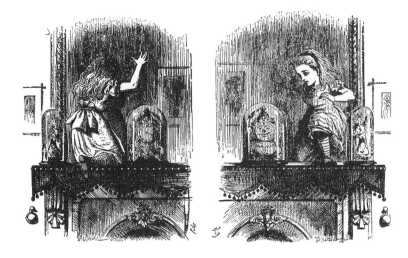

How the symbol system, developed in childhood, influences seeing

Now we are coming closer to the problem and its solution. First, what prevents a person from seeing things clearly enough to draw them?

The left hemisphere has no patience with detailed, complicated, and paradoxical perception and says, in effect, "It's a cube, I tell you. That's enough to know. You don't need to look at it, because we know it is square. Here, I have a symbol for that; add a few details if you want, but don't bother me with this looking-real business."

And where do the symbols come from? From the years of childhood drawing during which every person develops a set of symbols that becomes embedded in memory. The symbols are ready to be called out, just as you recalled them to draw your childhood landscape. The symbols are also ready to be called out when you draw a face. The efficient left brain says, "Oh yes, eyes. Here's a symbol for eyes, the one we've always used. A nose? Yes, here's the way we do it." Mouth? Hair? Eyelashes? There is a symbol for each. There are also symbols for birds, grass, rain, hands, trees, and on and on.

What is the solution to this dilemma? The most efficient solution is our main strategy: *present the brain with a task the left brain*

either can't or won't handle. You have already experienced this strategy, slightly with the Vase/Faces drawings, and more strikingly with the Upside-Down Drawing. And you have already begun to recognize and experience the alternate state of right-hemisphere mode. You are beginning to know that while you are in that slightly different subjective state of mind, you slow down so that you can see more clearly. There is an unawareness of time in the sense of time passing. You do not attend to people talking. You may hear the sounds of speech, but you do not decode the sounds into meaningful words. If someone speaks directly to you, it seems as though it would take a great effort to cross back, think again in words, and answer. Furthermore, whatever you are doing seems immensely interesting. You are attentive and concentrated, and feel "at one" with the thing you are concentrating on. You feel energized but calm, alert without anxiety. You feel self-confident and capable of doing the task at hand. Your thinking is not in words, and your mind is "locked on" to the object you are drawing. On leaving the R-mode state, you feel not tired, but refreshed.

Our job now is to bring this state into clearer focus and under greater conscious control, in order to take advantage of the right hemisphere's superior ability to see and draw.

Figure 5-20. *Hare*, 1502 (watercolor on paper) by Albrecht Dürer (1471–1528). Graphische Sammlung Albertina, Vienna, Austria/The Bridgeman Art Library.

From childhood onward, we have learned to see things in terms of words: We name things, and we know facts about them. The dominant left verbal system doesn't want too much information about things it perceives—just enough to recognize and to categorize.

In ordinary life, we screen out a large proportion of incoming perceptions, a necessary process to enable us to focus our thinking and one that works very well for us most of the time. But *drawing* requires that you look at something for a long time, perceiving lots of details and how they fit together to form wholes, registering as much information as possible—ideally, *everything*, as did Albrecht Dürer in his drawing of a hare.

CHAPTER 6
PERCEIVING EDGES

Attributed to Mir Musavvir, *A Portly Courtier*, c. 1530. Ink and reed pen on paper, 13.5 x 10.4 cm (5 5/16 x 4 1/8 in.). Harvard Art Museums/Arthur M. Sackler Museum, Gift of Henry B. Cabot, Walter Cabot, Edward W. Forbes, Eric Schroeder, and the Annie S. Coburn Fund, 1939.270. Photo: Katya Kallser / © President and Fellows of Harvard College

This is a superb example of a flowing contour line and the "lost-and-found" line that grows darker and lighter as it moves along the edge of the forms.

Figure 6-1. Jigsaw puzzles share edges of shapes and spaces.

Your Vase/Faces drawing and Upside-Down Drawing have demonstrated our main strategy for "setting aside" the dominant left verbal hemisphere and allowing the visual, perceptual R-mode to come forward:

Present your brain with a task that the left brain either can't or won't accept.

Now we'll try another version of the strategy to force an even stronger cognitive shift.

A quick review of the five perceptual skills of drawing

In this chapter, we are working on the perception of edges—one of the basic component skills of drawing. Recall that there are four others, and together these five components make up the global skill of drawing:

1. The perception of edges (the "shared" edges of contour drawing)
2. The perception of spaces (in drawing called *negative spaces*)
3. The perception of relationships (known as perspective and proportion)
4. The perception of lights and shadows (often called "shading")
5. The perception of the whole (the gestalt, the "thingness" of the thing)

For most people, these basic component skills require the kind of direct teaching that you are experiencing here because the skills are difficult to discover on one's own.

The first component skill: the perception of edges

In drawing, the term *edge* has a special meaning, different from its ordinary definition as a border or outline. In drawing, an edge is where two things come together, and the line that depicts the shared edge is called a *contour line*. A contour line is always the border of two things simultaneously—that is, a shared edge. The Vase/Faces exercise illustrates this concept. The line you drew

was simultaneously the edge of the profile and the edge of the vase. In the Upside-Down Drawing of Stravinsky, the contour lines depicting, for example, the edges of the shirt, tie, vest, and jacket are all shared edges. Turn back to the drawing on page 55 to check this out.

The child's jigsaw puzzle, Figure 6-1, also illustrates this important concept. The edge of the boat is shared with the water. The edge of the sail is shared with the sky and the water. Put another way, the water stops where the boat begins—a shared edge. The water and the sky stop where the sail begins—shared edges. If you draw one, you have also drawn the other. Note also that the outer edge of the puzzle—its frame or format, meaning the bounding edge of the composition (which is surprisingly important in all artworks)—is also the outer edge of the sky-shape, the land-shapes, and the water-shape. You will see the advantage of this concept in this chapter's exercises, but especially when we take up the second basic component skill of seeing and drawing: negative spaces (Chapter 7).

Nicolaides's contour drawing

Contour drawing, introduced as a teaching method by the revered art teacher Kimon Nicolaides in his 1941 book, *The Natural Way to Draw*, is still widely used by art teachers. The term *contour* means "edge." Nicolaides recommended that students imagine that they were touching the edge of a form as they drew it, thus activating the sense of touch along with the sense of sight. This suggestion greatly helped his students see and draw, perhaps because it enhanced their focus on the particular edge they were drawing and distracted them from symbolic drawing. Brilliantly, Nicolaides also insisted that his students keep their eyes on the subject of the drawing most of the time, not on the drawing itself.

I use a variation of Nicolaides's contour drawing method that is somewhat more drastic. I've called the method "Pure Contour Drawing," and your left hemisphere is probably not going to enjoy it. The exercise requires that you slow way down to see and draw

Woman in a Hat, Kimon Nicolaides. Collection of the author.

"Merely to see, therefore, is not enough. It is necessary to have a fresh, vivid, physical contact with the object you draw through as many of the senses as possible—and especially through the sense of touch."
— Kimon Nicolaides, *The Natural Way to Draw*, 1941

everything, while *never* looking at the drawing. Disliking the task because the perceptions are too meticulous, too slow—and, in left-brain terms, boring and useless—the L-mode soon drops out, allowing the R-mode to come forward. In short, Pure Contour Drawing is a task the left brain rejects—again, just what we want.

The paradox of the Pure Contour Drawing exercise

For reasons that are still unclear, Pure Contour Drawing is one of the key exercises in learning to draw. But it is a paradox: Pure Contour Drawing, which doesn't produce a "good" drawing (in students' estimations), is the best exercise for effectively and efficiently enabling students to later achieve good drawing. In our five-day classes, we have experimented with skipping this exercise, mainly because many students dislike it so much. Later in the course, however, we found that students did not progress as well or as quickly. Perhaps with this somewhat drastic exercise, the left brain understands that we are serious about this skill of drawing. Equally important, this is the exercise that revives childhood wonder and the sense of beauty found in ordinary things.

Using Pure Contour Drawing to see things differently

In my classes, I demonstrate Pure Contour Drawing, describing how to use the method as I draw—that is, if I can manage to keep talking (an L-mode function) while I'm drawing. Usually I start out all right but begin trailing off in midsentence, losing language completely after a few minutes. By that time, however, my students have the idea.

Following the demonstration, I show examples of previous students' Pure Contour Drawings, such as those on pages 90 and 91. As you see, they do not depict whole hands, only complex wrinkles and creases in the palms of the hands.

What you'll need:

- Several pieces of bond paper, stacked and taped to your drawing board
- Your #2 writing pencil, sharpened
- An alarm clock or kitchen timer
- About thirty minutes of uninterrupted time

What you'll do:

(Please read through the following instructions before you begin your drawing.)

1. Look at the palm of your hand—the left hand if you are right-handed and the right if you are left-handed. Close your hand slightly to create a mass of wrinkles in your palm. Those wrinkles are what you are going to draw—all of them. I can almost hear you saying, "You must be joking!" or "No way!"

2. Set the timer for five minutes. In this way, you won't have to keep track of time, an L-mode function.

3. Sit in a comfortable position with your drawing hand on the drawing paper, holding the pencil and ready to draw.

4. Then, face all the way around in the opposite direction, keeping your hand with the pencil on the drawing paper, and gaze at the palm of the other hand. (See Figure 6-2 for the drawing position.) Be sure to rest the posing hand on some support—the back of a chair or perhaps on your knee—because you will be holding this rather awkward position for the allotted five minutes. Remember, once you start to draw, you will not turn to look at the drawing until the timer goes off.

5. Gaze closely at a single wrinkle or crease in your palm. Place your pencil on the paper and begin to draw just that edge, where two bits of flesh come together to form an edge. As your eyes track the direction of the edge very, very slowly, one millimeter at a time, your pencil will *simultaneously* record your perceptions as a very slow line. If the edge changes direction, so does your pencil. If the edge intersects with another edge, follow that new information slowly with your

Fig. 6-2. This is the position for Pure Contour drawing. Before you start, be sure to tape your paper to your drawing board to prevent it from shifting while you draw, which is very distracting.

Pure Contour Drawing is so effective at producing this strong cognitive shift that some artists routinely begin work with a short session of this or some similar practice, in order to start the process of entering working mode.

If perhaps you did not attain a shift to the R-mode in your first Pure Contour Drawing, please be patient with yourself. You may have a very determined verbal system.

I suggest that you try again. You might try drawing a crumpled piece of paper, a flower, or any complex object that appeals to you. My students sometimes have to make two or even three tries in order to "win out" against their strong verbal modes.

eyes, while your pencil simultaneously records every detail. An important point: your pencil can record only what you see—nothing more, nothing less—at the moment of seeing. Your hand and pencil function like a seismograph, responding only to your actual perceptions.

The temptation will be very strong to turn and look at the drawing. Resist the impulse! Don't do it! Keep your eyes focused on your hand.

Match the movement of the pencil exactly with your eye movement. One or the other may begin to speed up, but don't let that happen. You must record everything at the very instant that you see each point on the contour. Do not pause in the drawing, but continue at a very slow, even pace. At first you may feel uneasy or uncomfortable: some students even report sudden headaches or a sense of panic. This will quickly pass.

6. Do not turn around to see what the drawing looks like until your timer signals the end of five minutes.

7. Most important, you must continue to draw until the timer signals you to stop.

8. If you experience painful objections from your verbal mode ("What am I doing this for? This is really stupid! It won't even be a good drawing because I can't see what I'm doing," and so forth), try your best to keep on drawing. In a minute or so, the protests from the left will fade out and your mind will become quiet. You will find yourself becoming fascinated with the wondrous complexity of what you are seeing, and you will feel that you could go deeper and deeper into the complexity. Allow this to happen. You have nothing to fear or be uneasy about. Your drawing will be a beautiful record of your deep perception. We are not concerned about whether the drawing looks like a hand—in fact, it will not look like a hand. We want only the record of your perceptions of the creases in your palm.

9. Soon the mental chatter will cease, and you will find yourself becoming intensely interested in the complexity of the edges you see in your palm and intensely aware of the beauty of that complex perception. When that change takes place, you will have shifted to the visual mode and you will be "really drawing."

10. When the timer signals the allotted time, turn and see your drawing.

After you have finished

Looking at your drawing, a tangled mass of pencil marks, perhaps at first glance, you will say, "What a mess!" But look more closely and you will see that these marks are strangely beautiful. Of course, they do not represent the hand, only its details, and details within details. You have drawn complex edges from actual perceptions. These are not quick, abstract, symbolic representations of the wrinkles in your palm. They are painstakingly accurate, excruciatingly intricate, entangled, descriptive, and specific marks—just what we want at this point. I believe that these drawings are visual records of the R-mode state of consciousness. As writer Judi Marks, a witty friend of mine, remarked on viewing a Pure Contour Drawing for the first time, "No one in their left mind would do a drawing like that!"

A possible explanation of the profound effect of Pure Contour Drawing

Pure Contour Drawing may function as a mild sort of "shock treatment" for the brain, forcing both modes to do things differently. Apparently, in our habitual use of brain modes, the L-mode seeks to quickly recognize, name, and categorize, while the R-mode wordlessly perceives whole configurations and how the details fit together. This "division of labor" works fine in ordinary life.

I believe Pure Contour Drawing causes L-mode to "drop out," perhaps, as I mentioned, through simple boredom. ("I've already

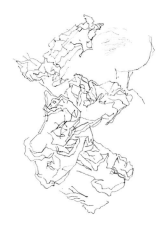

These strange marks on the wall of a cave were made by Paleolithic humans. In their intensity, the marks seem to resemble Pure Contour Drawing.
— *Shamans of Prehistory*, J. Clottes and D. Lewis-Williams (New York: Harry N. Abrams, Inc.), 1996

named it—it's a wrinkle, I tell you. They're all alike. Why bother with all this looking?") Because of the way the exercise is set up, it seems possible that the R-mode is also forced to perceive in a new way. Each wrinkle—normally regarded as a detail—becomes a whole configuration, made up of even smaller details. Then each detail of each wrinkle becomes a further whole, made up of ever-smaller parts, and so on, going deeper and deeper into ever-expanding complexity. There is some similarity, I believe, to the phenomenon of fractals, in which whole patterns are constructed of smaller detailed whole patterns, which are constructed of ever-smaller, detailed whole patterns.

Whatever the actual reason may be, I can assure you that Pure Contour Drawing will permanently change your ability to perceive. From this point onward, you will start to see things differently and your skills in seeing and drawing will progress rapidly. Look at your Pure Contour Drawing one more time and appreciate the quality of the marks you made in R-mode. Again, these are not the quick, glib, stereotypic marks of the symbolic L-mode. These marks are true records of perception.

A record of an alternative state

Observe again some examples of Pure Contour Drawings in Figure 6-3. What strange and marvelous markings are these! It is the

"Blind swimmer, I have made myself see. I have seen. And I was surprised and enamored of what I saw, wishing to identify myself with it …"
— Max Ernst, 1948

Fig. 6-3. Some examples of Pure Contour Drawing.

quality of the marks and their character that we care about. These living hieroglyphs are records of perceptions: rich, deep, intuitive marks made in response to the thing-as-it-is, the thing as it exists out there, marks that delineate the is-ness of the thing perceived. Blind swimmers have seen! And seeing, they have drawn. Never mind that the drawings don't resemble in any way the overall configuration of a hand—that's to be expected. We'll attend to the overall configuration, the image of the whole hand, in the next exercise, "Modified Contour Drawing."

To set the experience, I hope you will do one or two more Pure Contour Drawings. Any complex object will work as a model: a feather, the center cluster of stamens of a flower, the bristles of a toothbrush, a section of a sponge, a single piece of popped corn. Once you have shifted to the R-mode, the most ordinary things become inordinately beautiful and interesting. Can you remember the sense of wonder you had as a child, poring over some tiny insect or dandelion?

Modified Contour Drawing of your hand

In the next exercise, you will use your technical aids (your plastic picture plane and your viewfinders) to enable you to do a realistic drawing of your own hand—a first "real" drawing depicting a three-dimensional form.

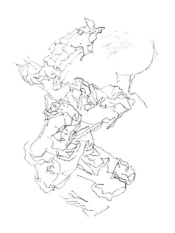

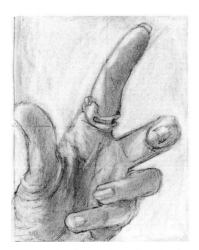

Fig. 6-4. A foreshortened view of your hand.

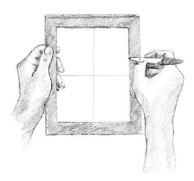

Fig. 6-5. Draw a format line on the plastic picture plane.

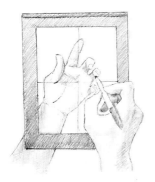

Fig. 6-6. Draw the contours of your hand on the picture plane.

The first step: drawing directly on the picture plane

You will need:

* Your clear plastic picture plane
* Your non-permanent felt-tip marker
* Your viewfinder and clips
* Your #2 writing pencil, sharpened
* A slightly moistened tissue to use as an eraser

Please read through all of the instructions before starting. I define and fully explain the picture plane later, but for now, you will simply be using it. Just follow the instructions. I realize that the instructions look long and tedious, but that is the nature of verbal instructions—they look long and tedious. If I could *show* you, we wouldn't need words. You will find that the actions I am asking you to take, one by one, are not difficult.

What you'll do:

1. Rest your hand on a desk or table in front of you (the left hand if you are right-handed, and the right, if you are left-handed) with the fingers and thumb curved upward, pointing toward your face. (See Figure 6-4 for a possible position.) This is a foreshortened view of your hand. Imagine now that you are about to draw that foreshortened form—not just the palm, but the whole hand.

2. If you are like most of my beginning students, you would simply not know how to go about drawing this three-dimensional form, with its parts moving toward you in space. The viewfinders and plastic picture plane will solve the problem. Try out each of the viewfinders to decide which size fits most comfortably over your hand, which you should still be holding in a foreshortened position with the fingers coming toward you. Men often need the larger, women the smaller-sized viewfinder. Choose one or the other.

3. Clip the chosen viewfinder onto your clear-plastic picture plane.

4. Use your felt-tip marker to draw a "format" line on the plastic picture plane, running the marker around the inside of the opening of the viewfinder. A format line forms the outer boundary of your drawing. See Figure 6-5.

5. Now, holding your hand in the same foreshortened position as before, balance the viewfinder/plastic picture plane on the tips of your fingers and thumb. Move it about a bit until the picture plane seems balanced comfortably.

6. Pick up your uncapped marking pen, gaze at the hand under the plastic picture plane, and *close one eye*. (I explain in the next segment why it is necessary. For now, please just do it.)

7. Choose an edge to start your drawing. Any edge will do. With the marking pen, begin to draw slowly on the plastic picture plane the edges of the shapes just as you see them. See Figure 6-6. Don't try to "second guess" any of the edges. Do not name the parts. Do not wonder why the edges are the way they are. Your job, just as in Upside-Down Drawing and in Pure Contour Drawing, is to draw exactly what you see with as much detail as you can manage with the marking pen (which is not as precise as a pencil).

8. Be sure to keep your head in the same place and keep one eye closed. Don't move your head to try to "see around" the form. Keep it still. (Again, I explain why in the next segment.)

9. Correct any lines you wish by just wiping them off with the moistened tissue on your forefinger. It is very easy to redraw them more precisely.

Fig. 6-7. Vincent van Gogh, *Sketches with Two Sowers*. St. Remy, 1890. Courtesy the Van Gogh Museum, Amsterdam (Vincent van Gogh Foundation).

After you have finished

Place the plastic picture plane on top of a plain sheet of paper so that you can clearly see what you have drawn. I can predict with confidence that you will be amazed. With relatively little effort, you have accomplished one of the truly difficult tasks in drawing—drawing the human hand in foreshortened view. Great artists in the past have practiced drawing hands over and over (see the example by Vincent van Gogh, Figure 6-7).

How did you accomplish this so easily? The answer, of course, is that you did what a trained artist does: you "copied" what you saw on the picture plane—in this instance, an actual plastic plane. (I fully define and explain the artist's *imaginary* picture plane in the next section. I have found that the explanation makes more sense after students have used the actual plastic plane itself.)

For further practice: I suggest that you erase your felt-tip pen drawing from the picture plane with a damp tissue and do several more, with your hand in a different position each time. Try for the really "hard" views—the more complicated the better. Oddly, the flat hand is the hardest to draw. A complex position is actually easier and certainly more interesting to draw. Therefore, arrange your hand with the fingers curved, entwined, or crossed; clench your fist, holding an eraser or other small object. For each pose, include some foreshortening. Remember, the more you practice each of these exercises, the faster you will progress. Save your last (or best) drawing for the next step, as this will be a wonderful drawing of your hand.

Let's pause here to answer an all-important question in terms of your understanding: what is the link between realistic drawing and the picture plane?

To reiterate a quick, short answer: *realistic drawing is "copying" what you see on the picture plane.* In the drawing you did just now (with one eye closed, removing binocular vision), you "copied" the image of your hand that you saw "flattened" on the plastic picture plane.

But here is a more complete answer to the question. Realistic drawing is reproducing on a two-dimensional surface (usually paper) a *perceived* actual three-dimensional object, still life, landscape, or figure(s).[17] Incredibly, prehistoric cave artists reproduced their remembered realistic images of animals on the stone walls of deep caves, but it wasn't until Greeks and Romans worked out ways of drawing three-dimensional forms that realistic art revived. The skill was lost again during the Dark Ages, and

A good definition of "picture plane" from *The Art Pack*, Key Definitions/Key Styles, 1992: "Picture plane: Often used—erroneously—to describe the physical surface of a painting, the picture plane is in fact a mental construct—like an imaginary plane of glass ... Alberti (the Italian Renaissance artist) called it a 'window' separating the viewer from the picture itself ..."

17. The term *Realism* often refers to a nineteenth-century art movement that celebrated naturalistic depictions. I am using the term to describe a basic stage in artistic training that stands between children's art and whatever direction a mature artist may develop. Learning to draw one's perceptions is still regarded as basic to all visual arts, although some contemporary abstract, non-objective, or conceptual artists dispute its usefulness in light of current art trends. As stated earlier, my view is that knowledge never hurts.

until the early fifteenth century Renaissance in Italy, artists struggled with the problems of accurately drawing their perceptions.

Then the great early Renaissance artist Filippo Brunelleschi worked out a way to portray linear perspective, and Leon Battista Alberti discovered that he could draw in perspective the cityscape beyond his window by drawing directly on a glass pane the view he saw beyond the pane. Inspired by Alberti's 1435 book on perspective and painting and also by Leonardo da Vinci's later writing on the subject, sixteenth-century German artist Albrecht Dürer developed the picture plane concept further, building actual picture plane devices. (See Figure 6-11 on page 97.) Dürer's writings and drawings inspired Dutch artist Vincent van Gogh in the nineteenth century to construct his own "perspective device," as he called it, when he was laboriously teaching himself to draw. (See Figure 6-12 on page 97). Later on, after van Gogh had mastered the concept of using the imaginary picture plane, he discarded his device, just as you will. Note that van Gogh's iron and wood device must have weighed thirty pounds or more. I can picture him in my mind's eye laboriously dismantling the parts, tying them up, and carrying the bundle—along with his painting materials—on his long walk to the seashore, unbundling and setting the device up, and then repeating the whole sequence to get home at night. This gives us some insight into how resolutely van Gogh labored to improve his drawing skills.

Another renowned artist, the sixteenth-century Dutch master Hans Holbein, who had no need for help with his drawing, also used an actual picture plane. Art historians recently discovered that Holbein used a glass pane on which he directly drew images of his sitters in order to speed up the overwhelming number of portrait drawings required of him when he lived in the English court of Henry VIII (see Figure 6-8). Art historians speculate that Holbein, one of the great draftsmen of art history, did this only to save time—the overworked artist could quickly sketch his model on a glass plane, then quickly transfer the drawing on glass to paper, work it up, and get on to the next portrait.

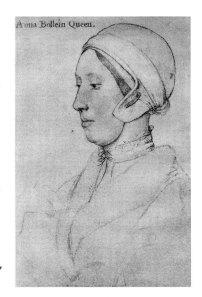

Fig. 6-8. *Queen Anne Boleyn (1507–1536), the wife of King Henry VIII of England* from the drawing by Hans Holbein, circa 1533. (Photo by Hulton Archive/Getty Images.)

John Elsum, in his 1704 book *The Art of Painting After the Italian Manner*, gave instructions for making "a handy device"—an early picture plane:

"Take a Square Frame of wood about one foot large, and on this make a little grate [grid] of Threads, so that crossing one another they may fall into perfect Squares about a Dozen at least, then place [it] between your Eye and the Object, and by this grate imitate upon your Table [drawing surface] the true Posture it keeps, and this will prevent you from running into Errors. The more work is to be [fore]shortened the smaller are to be the Squares."
— Quoted in *A Miscellany of Artists' Wisdom*, compiled by Diana Craig (Philadelphia: Running Press), 1993

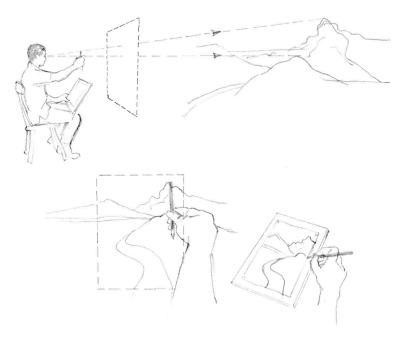

Fig. 6-9. The picture plane is an imaginary vertical surface, like a window, through which you look at your subject. In this way, you copy your three-dimensional view of the world onto your two-dimensional surface onto your drawing paper.

Fig. 6-10. Dozens of picture planes and perspective devices are recorded in the U.S. Patent Office. Here are two examples.

It might help your understanding of the picture plane to realize that photography grew directly out of drawing.

In the years before photography was invented, nearly all artists understood and used the concept of the picture plane. You can imagine the artists' excitement (and, perhaps, dismay) to see that a photograph could, in an instant, capture an image on the camera's glass plate—an image that would have taken an artist hours, days, or even weeks to render in a drawing.

After photography became common in the mid-nineteenth century and artists were no longer needed for realistic depiction, they began to explore other aspects of perception, such as capturing the fleeting quality of light in Impressionism. Gradually, the concept of the picture plane faded away.

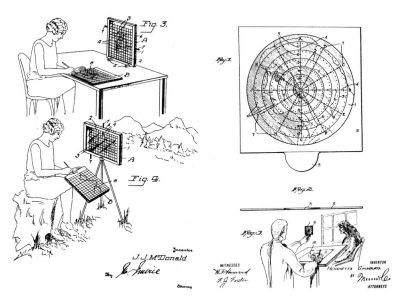

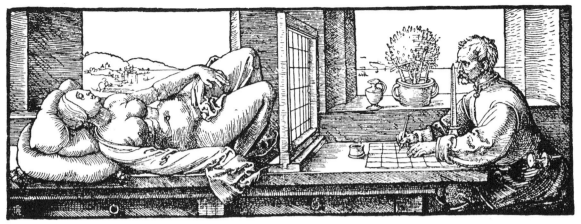

Fig. 6-11. Albrecht Dürer, *Draughtsman Making a Perspective Drawing of a Woman* (1525). Courtesy of The Metropolitan Museum of Art, New York. Gift of Felix M. Warburg, 1918.

"Dear Theo, In my last letter you will have found a little sketch of that perspective frame I mentioned. I just came back from the blacksmith, who made iron points for the sticks and iron corners for the frame. It consists of two long stakes; the frame can be attached to them either way with strong wooden pegs.

"So on the shore or in the meadows or in the fields one can look through it *like a window* [the artist's emphasis]. The vertical lines and the horizontal line of the frame and the diagonal lines and the intersection, or else the division in squares, certainly give a few pointers which help one make a solid drawing and which indicate the main lines and proportion …of why and how the perspective causes an apparent change of direction in the lines and change of size in the planes and in the whole mass.

"Long and continuous practice with it enables one to draw quick as lightning—and once the drawing is done firmly, to paint quick as lightning, too."

— From Letter 223, *The Complete Letters of Vincent van Gogh* (Greenwich, CT.: The New York Graphic Society), 1954, pp. 432–33

Left: Fig. 6-12. Vincent van Gogh's perspective device. Above: Fig. 6-13. The artist using his device at the seashore. From *The Complete Letters of Vincent van Gogh.* Greenwich, CT: The New York Graphic Society, 1954. The drawings are reproduced by permission of The New York Graphic Society.

The imaginary picture plane: a mental construct

Like van Gogh and Holbein, we are using an actual picture plane, but once you have learned the process, you will discard the actual plane for an *imaginary plane*. The concept of the imaginary or "mental" picture plane is abstract and somewhat difficult to explain. But this concept is one of the most important keys to learning to draw, so stay with me.

In your "mind's eye," see this: the picture plane as an *imaginary* transparent plane, like a framed window, that is always hanging in front of the artist's face, always parallel to the plane of the artist's two eyes. If the artist turns, the plane also turns. What the artist sees "on the plane" actually extends back into the distance. But the plane enables the artist to "see" the scene as though it were magically smashed flat on the back of the clear glass plane—like a photograph, in a sense. Put another way, the 3-D (three-dimensional) view behind the framed "window" is converted to a 2-D (flat) image *on the plane*. The artist then "copies" what is seen *on the plane* onto the flat drawing paper. The flat drawing paper and the flattened image on the plane are thought of as one and the same, and the artist's task is to transfer the image on the plane to the paper. The result is a realistic drawing.

This trick of the artist's mind, so difficult to describe in words, is even more difficult for beginning students to discover on their own and I think is one of the reasons that learning to draw requires teaching. In this course, your actual plastic picture plane and actual window frames (the viewfinders) are devices that seem to work like magic to enable students to "get" what drawing is—that is, to understand the fundamental nature of drawing perceived objects or persons.

To further help beginners in drawing, I asked you to draw crosshairs on your sheet of plastic (the plastic picture plane). These two "grid" lines represent vertical and horizontal, the two constants on which the artist absolutely depends to assess relationships. (Early in my teaching, I used a grid of many lines, but

I found that students were counting up—"two spaces over and three down." This is just the kind of L-mode activity we didn't want. I reduced the "grid" lines to one vertical and one horizontal and found that that was sufficient.)

Later on, you will need neither the plastic picture plane with its gridlines nor the viewfinders. You will replace these technical devices with the imaginary, internalized mental picture plane that every artist uses, whether consciously or subconsciously. The actual plane (your plastic picture plane) and the actual viewfinders are simply very effective aids during the time you are learning how to draw.

Try this: clip your large viewfinder to your picture plane. Close one eye and hold the picture plane/viewfinder up in front of your face. (See Figure 6-13.) Look at whatever "framed" image is in front of your eye (singular). You can change the "composition" by bringing the picture plane/viewfinder closer to or farther away from your face, much as a camera viewfinder works. Check out the angles of the edges of the ceiling, or perhaps of a table, relative to the crosshairs—that is, relative to vertical and horizontal. These angles may surprise you. Next, imagine that you are drawing with your felt-tip marker what you see on the plane, just as you did in drawing your hand. (See Figure 6-14.)

Then turn to see another view, and then another, always keeping the picture plane parallel to the front of your face and closing one eye to convert 3-D to 2-D on the plane. Now, put down the picture plane, close one eye, and try using the imaginary picture plane, adjusting your seeing to the mind-set of the artist at work.

One more important point: "drawing" means drawing a single view. Recall that when you drew your hand directly on the plastic picture plane, I asked you to keep your posing hand still and your head still in order to see one view only on the picture plane. Even a slight movement of your posing hand or a slight change in the position of your head will give you a different view of your hand. I sometimes see students bend their heads to the side in order to see something they couldn't see with their head in the

Fig. 6-13. Using your Picture Plane.

Fig. 6-14. You draw the angles just as you see them on the Picture Plane.

original position. Don't do it! If you can't see that fourth finger, you don't draw it. To repeat: keep your hand and your head in an unchanged position and draw just what you see. For the same reason—to see one view only—you kept one eye closed. By closing one eye, you removed binocular vision, the slight variance in images, called "binocular disparity," that occurs when we view an object with both eyes open. Binocular vision—sometimes called "depth perception"—allows us to see the world as three-dimensional. When you close one eye, the single image is two-dimensional—that is, it is flat, like a photograph, and therefore can be "copied" onto flat paper.

You may be wondering, "Is it always necessary to close one eye while drawing?" Not always, but most artists do quite a lot of one-eye closing while drawing. The closer the viewed object, the more eye-closing. The farther away the object, the less eye-closing, because binocular disparity diminishes with distance.

And here we arrive at yet another of the many paradoxes of drawing. The flat, two-dimensional image that you saw and drew (with one eye closed) directly on the picture plane, when copied onto your drawing paper, miraculously "looks" three-dimensional to the person who views your drawing. One necessary step

Fig. 6-15. Brian Harking.

in learning to draw is to believe that this miracle will happen. Often students struggling with a drawing will ask, "How can I make this finger look like it is curving toward me?" or "How do I make this table look like it is going back in space?" The answer, of course, is to draw—to copy!—just what you see flattened on the picture plane. Only then will the drawing convincingly depict these "movements" through three-dimensional space (Figure 6-15).

Why draw?

The idea that basic realistic drawing is copying what is seen on the picture plane may seem simplistic to you. "If that is so," you may object, "why not just take a photograph?" One answer is that the purpose of realistic drawing is not simply to record data, but rather to record your unique perception—how you personally see something and, moreover, how you understand the thing you are drawing. By slowing down and closely observing something, personal expression and comprehension occur in ways that cannot occur simply by taking a snapshot. (I am referring, of course, to casual photography, not the work of artist-photographers.)

Also, your style of line, choices for emphasis, and subconscious mental processes—your personality, so to speak—enter the drawing. In this way, again paradoxically, your careful observation and depiction of your subject give the viewer both the image of your subject and an insight into you. In the best sense, you will have expressed yourself in a uniquely human activity that has its origin in our remote prehistoric past.

The next step: Modified Contour Drawing and your first fully realized drawing

What you will need:

+ Your plastic picture plane with your felt-tip marker drawing of your hand
+ Your pad of drawing paper
+ Your graphite stick and some paper napkins or paper towels

Fig. 6-16. The position for Modified Contour Drawing is the normal drawing position for drawing your hand.

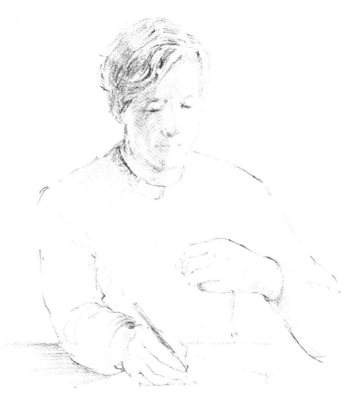

Fig. 6-17. Apply graphite to your paper.

Fig. 6-18. Rub the graphite to an even tone.

+ Your #2 writing pencil and your #4b drawing pencil, sharpened
+ Your three erasers
+ An hour of uninterrupted time

Before you begin: please read through all the instructions.

In this drawing, we are modifying the instructions for Pure Contour Drawing. You will sit in a normal position and therefore be able to glance at your drawing to monitor its progress (see Figure 6-16). Nevertheless, I hope you will use the same focused concentration that you used in Pure Contour Drawing.

1. Tape a stack of several sheets of paper to your drawing board. Tape all four corners securely, so that the paper will not shift. One of your hands will be "posing" and must remain still. The other will be drawing and perhaps erasing. If the paper

shifts under your hand while you are drawing or erasing, it is very distracting.

2. Draw a format line on your drawing paper, using the inside edge of your viewfinder as a template.

3. The next step is to tone your paper. Make sure you have a stack of several sheets of paper to pad your drawing. Begin to tone your paper by rubbing the edge of your graphite stick very lightly over the paper, staying inside the format line. You want to achieve a pale, even tone—don't worry too much about staying within the lines. You can clean up the edges at a later time (Figure 6-17).

4. Once you have covered the paper with a light application of graphite, begin to rub the graphite into the paper with your paper towel. Rub with a circular motion, applying even pressure right up to the edge of the format line. You want to achieve a very smooth, silvery tone (Figure 6-18).

5. Next, lightly draw horizontal and vertical crosshairs on your toned paper. The lines will cross in the center just as they do on your plastic picture plane. Use the crosshairs on the plastic plane to mark the position of the crosshairs on the format of your toned paper. A caution: don't make the lines too dark. They are only guidelines and later you may want to eliminate them.

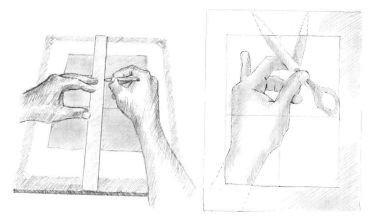

Fig. 6-19. Lightly draw crosshairs on your toned paper.

Fig. 6-20. You may wish to do a new drawing.

Fig. 6-21. Place the new drawing on a piece of paper to see the drawing clearly.

Fig. 6-22. Transfer the main points and edges from your drawing on plastic to your toned drawing paper.

Most of my students greatly enjoy this process of toning their paper, and the physical action of "working up" the tone seems to help them get started with a drawing. A possible reason is that, having marked the paper and made it their own, so to speak, they escape the intimidation of that blank sheet of white paper staring at them.

6. Retrieve your picture plane with the felt-tip drawing that you did at the start of this section, or, if you wish, do a new drawing (Figure 6-21). Then place the plane on a light surface, perhaps a sheet of paper, so that you can clearly see the drawing on the plastic. This image will act as a guide for you when you next draw your hand on the paper.

7. An important next step: you will transfer the main points and edges of your drawing on plastic to your drawing paper (Figure 6-22). The formats are the same size, so it is a one-to-one scale transfer. Using the crosshairs, locate a point where an edge of your hand drawing contacts a crosshair. Transfer several of these points. Then begin to connect the edges of your hand, fingers, thumb, palm, creases, and so on with the points you have established. This is just a light sketch to help you place the hand within the format. Recall that drawing is copying what you see on the picture plane. For this drawing, you will take this actual step, in order to get used to the process. If you have to correct a line, don't worry about erasing the ground. Erase, then just rub the erased area with your finger or a paper towel or tissue and the erasure disappears. A toned ground is very forgiving of erasures.

8. Once this rough, light sketch is on your paper, you are ready to start drawing.

9. Set aside your drawing-on-plastic, but place it where you can still refer to it. Reposition your "posing" hand, using the drawing-on-plastic to guide the positioning.

10. Then, closing one eye, focus on a point on some edge in your posing hand. Any edge will do. Place your pencil point on this same point in the drawing. Then gaze again at this point on your hand in preparation to draw. This will start the mental shift to the R-mode and help quiet any objections from the L-mode.

11. When you begin to draw, your eyes—or, rather, eye—will move slowly along the contour and your pencil will record

your perceptions at the same slow speed that your eye is moving. Just as you did in Pure Contour Drawing, try to perceive and record all the slight undulations of each edge (Figure 6-23). Use your eraser whenever needed, even to make tiny adjustments in the line. Looking at your hand (with one eye closed, remember), you can estimate the angle of any edge by comparing it to the crosshairs. Check these angles in your drawing-on-plastic that you did earlier, but also try to see these relationships by imagining a picture plane hovering over your hand, with its helpful crosshairs and the edge of the format to guide you.

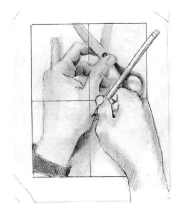

Fig. 6-23. Try to see and record all the slight undulations of each edge.

12. About 90 percent of the time, you should be looking at your hand. That is where you will find the information that you need. In fact, all the information you need to do a wonderful drawing of your hand is right in front of your eyes. Glance at the drawing only to monitor the pencil's recording of your perceptions, to check for relationships of sizes and angles, or to pick a point to start a new contour. Concentrate on what you see, wordlessly sensing to yourself, "How wide is this part compared to that? How steep is this angle compared to that?" and so on.

13. Move from contour to adjacent contour. If you see spaces between the fingers, use that information as well: "How wide is that space compared to the width of that shape?" (Remember, we are not naming things—fingernails, fingers, thumb, palm. They are all just edges, spaces, shapes, relationships.) Be sure to keep one eye closed at least a good portion of the time. Your hand is quite close to your eyes, and the binocular disparity can confuse you with two images. When you come to parts that impose their names on you—fingernails, for example—try to escape the words. One good strategy is to focus on the shapes of the flesh around the fingernails. *These shapes share edges with the fingernails. Therefore, if you draw the shapes around the nails, you will have also drawn the edges of the fingernails—but you'll get both right!*

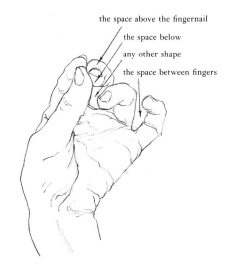

the space above the fingernail
the space below
any other shape
the space between fingers

Fig. 6-24. Drawing the hand by using shapes and spaces.

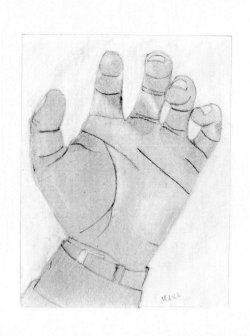

(See Figure 6-24.) In fact, if mental conflict sets in over any part of the drawing, move to the next adjacent space or shape, remembering the "shared edge" concept. Then return later with "new eyes" to the part that seemed difficult.

14. You may want to erase the spaces around your hand. This makes the hand "stand out" from the negative spaces. You can work up the drawing with a little shading by observing where you see areas of light (highlights) and areas of shadow appear on your posing hand. Erase the highlights and darken the shadows.

15. Finally, when the drawing begins to become intensely interesting, like a complicated and beautiful puzzle gradually taking shape under your pencil, you will be deep in the R-mode and really drawing.

After you have finished

This is your first "real" drawing, and I can assume with some confidence that you are pleased with the results. I hope you now see what I meant about the miracle of drawing. Because you drew what you saw on the flat picture plane, your drawing appears authentically three-dimensional.

Furthermore, some very subtle qualities will show in your drawing. For example, a sense of the volume—the three-dimensional thickness—of the hand will be there, as well as the precise effort of holding the pose, or the slight pressure of a finger on the thumb. And all of this comes from simply drawing what you see on the plane.

In the group of drawings on pages 106 and 107, some are student drawings, some are demonstration drawings by instructors. In all of the drawings, the hands are three-dimensional, believable, and authentic. They seem to be made of flesh, muscles, skin, and bones. Again, very subtle qualities are depicted, such as the tension of certain muscles or the precise texture of the skin. Notice also the individuality of styles of drawing.

Before we move on to the next step, think back on your mental state during the drawing of your hand. Did you lose track of time? Did the drawing at some point become interesting, even fascinating? Did you experience any distraction from your verbal mode? If so, how did you escape it?

Also, think back on this basic conception of the picture plane and our working definition of drawing: "copying" what you see on the picture plane. From now on, each time you pick up the pencil to draw, the strategies learned in this drawing will become better integrated and more "automatic."

It will be helpful to do a second Modified Contour Drawing of your hand, perhaps this time holding some complex object: a twisted handkerchief, a flower, a pinecone, a pair of eyeglasses. For this drawing, you can again work on a lightly "toned" ground, or you might try a "line" drawing, without the toned ground (Figure 6-24, page 105). Remember, as in learning any skill, the more you practice, the faster those new neural maps in your brain will become permanent.

The next step: tricking the L-mode with empty space

So far, we have found several ways to set aside the dominant left hemisphere. It has problems with mirror images (the Vase/Faces Drawing) and refuses to deal with upside-down information (the drawing of Stravinsky). It rejects ultra-slow, complex perceptions (Pure and Modified Contour Drawing). The next lesson on Negative Spaces expands our main strategy and restores the compositional unity of early childhood art.

CHAPTER 7
PERCEIVING SPACES

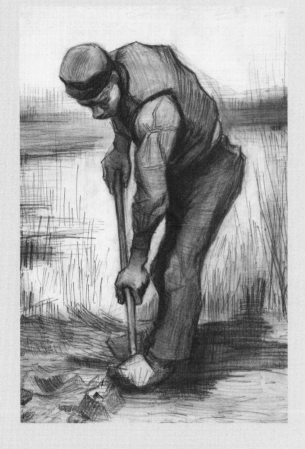

Vincent van Gogh (1853–1890), *Digger*,
1885. Courtesy the Van Gogh Museum,
Amsterdam (Vincent van Gogh Founda-
tion). In his drawing of *Digger*, Vincent van
Gogh strongly emphasized negative spaces,
especially near the figure. Notice how
varied and interesting the spaces are, how
essentially *simple* they are, and how they
unify the figure with the ground.

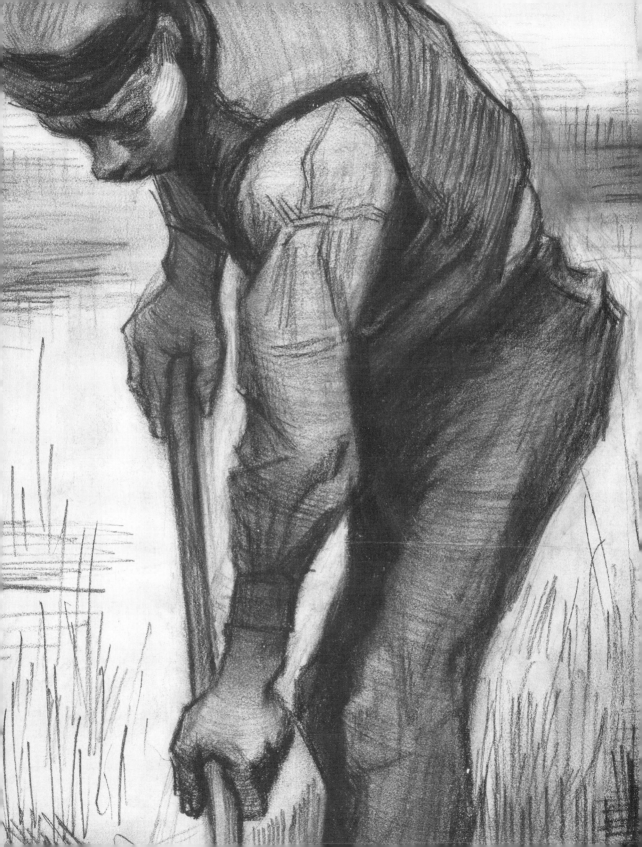

"Nothing is more real than nothing."
— Irish writer Samuel Beckett (1906–1989)

The second basic component skill of drawing, the perception of negative spaces, is new learning for most of our students and pure joy because of its antic, whimsical quality. In a sense, you will be seeing and drawing what is not there in order to portray what *is* there. Realizing the importance of spaces is rare in American life. We tend to focus on objects; we are an *objective* culture. In other cultures, many Asian cultures, for example, working "within the spaces" is common practice and well understood. My aim is to make spaces become as "real" for you as are positive forms, and to provide a new experience in seeing and drawing.

Negative spaces and positive forms

Two terms traditionally used in art are *negative spaces* and *positive forms*. The word *negative* is a bit unfortunate because it carries, well, a negative connotation. I have searched in vain for a better term, so we'll stick with this one. The two terms have the advantage of being easy to remember and, after all, are commonly used in the whole field of art and design.

An analogy to clarify the concept of Negative Spaces

In drawing, negative spaces are real. They are not just "the empty parts." The following analogy may help you see that. Imagine that you are watching a Bugs Bunny cartoon. Imagine that Bugs Bunny is running at top speed down a long hallway, at the end of which is a closed door. He smashes through the door, leaving a Bugs Bunny–shaped hole in the door. What is left of the door is negative space. Note that the door has an outside edge. This edge is the outside edge of the negative space (its format). The hole in the door is—was—the positive form (Bugs Bunny) now gone poof! The point of the analogy is that negative spaces in drawings are just as solid, just as important as the positive forms. For the person just learning to draw, they are perhaps more important, because *negative spaces make drawing difficult things easy.*

Let me explain. In the last chapter, you learned that edges

Fig. 7-1. In drawing the sheep, the "hard" parts would be drawing the horns and legs.

Fig. 7-2. Don't draw the horns! Draw the negative spaces.

Fig. 7-3. Once you have drawn the spaces, the positive shapes are much easier to see and draw.

are shared. The edges of the positive forms share edges with the negative spaces. If you draw one, you will have also drawn the other. In the drawings of the bighorn sheep, for example, the sheep is the positive form and the sky behind and ground below the animal are the negative spaces. The first drawing (Fig. 7-1) is focused on the sheep, the second and third on the negative spaces. In drawing the sheep, a "hard" part would be drawing the horns, which are foreshortened and curve off into space in unexpected ways that make the horns difficult to see and draw. Another hard part would be the arrangement of the legs in the foreshortened view of the animal. What to do? Don't draw the horns or the legs at all. Close one eye, focus on the negative spaces of the horns and the legs, draw those (see Figure 7-2), and you get the horns and legs—for free! Moreover, you will get them right, because you have no names for those shapes, no pre-existing symbols to rush in, and no knowledge of why they are the way they are. They are just shapes.

This is where the joy and whimsy of negative spaces come in.

Fig. 7-4. Notice signs of struggle in this student's drawing.

Fig. 7-5. Focusing on negative spaces makes drawing easier.

Using this unlikely and unexpected method, you will be able to draw the most difficult forms—drawings that will cause viewers to wonder, "How did you make that look so real?" A person experienced in drawing is always ignoring the "hard parts" and drawing the easy parts, the negative spaces, thereby getting difficult positive forms as free gifts.

This method, of course, fits our main strategy for easing the left brain out of the task. Finding you focused on *nothing*, and then drawing nothing, the L-mode says, in effect, "I do not deal with nothing. It isn't *anything!* If you are going to keep on with that, I'm out of it." Excellent! Just what we want. To the R-mode, it makes no difference: negative spaces or positive forms, it is all interesting—the more unusual the shapes, the better.

The cognitive battle of perception

Figures 7-4 and 7-5 show an interesting graphic record of a student's mental struggle and its resolution in two drawings of a cart and projector. In Figure 7-4, the first drawing, the student had great difficulty reconciling his stored knowledge of what the objects were "supposed to look like" with what he actually saw. Notice the signs of mental struggle throughout the drawing, along with signs of surrender to verbal knowledge: the legs of the cart are all the same length, and the same symbol is used for all the wheels, even though they are in different positions.

When the student shifted to drawing only the shapes of the negative spaces, he was far more successful (Figure 7-5). The visual information apparently came through clearly; the drawing looks confident and as though it was done with ease. And, in fact, it *was* done with ease, because using negative spaces enables one to escape the mental crunch that occurs when perceptions don't match conceptions.

It's not that the visual information gathered by regarding spaces rather than objects is really less complex or is in any way easier to draw. The spaces, after all, share edges with the forms. But by focusing on the spaces, we free the R-mode from the dom-

ination of the L-mode. Put another way, by focusing on information that does not suit the style of the verbal system, we cause the job to be shifted to the mode appropriate for seeing and drawing what is really out there. Thus, the conflict ends, and in R-mode, the brain processes spatial, relational information with ease.

Besides making drawing easier, why is learning to see and draw negative spaces important?

In Chapter 5, we saw that young children have a strong grasp of the importance of the bounding edges of the paper. This strong awareness of the format controls the way they distribute forms and spaces, and young children often produce nearly flawless compositions. The composition by a six-year-old in Figure 7-7 compares favorably with Spanish artist Joan Miró's composition in Figure 7-6.

As you have seen, this ability unfortunately lapses as children approach adolescence, perhaps due to lateralization and the left

Figure 7-6. Joan Miró, *Personages with Star*, 1933. Courtesy The Art Institute of Chicago.

Figure 7-7. This composition by a six-year-old could be compared with Spanish artist Joan Miró's composition in Figure 7-6.

hemisphere's penchant for recognizing, naming, and categorizing *things.* Concentration on single objects seems to supersede the young child's more holistic or global view of the world, where everything is important, including the negative spaces of sky, ground, and air. Usually it takes years of training to convince students, in the way experienced artists are convinced, that negative spaces, bounded by the format, require the same degree of attention and care that positive forms require. Beginning students generally lavish all their attention on the objects, persons, or forms in their drawings, and then more or less "fill in the background." It may seem hard to believe at this moment, but if care and attention are lavished on the negative spaces, the forms will take care of themselves, and your composition will be immensely strengthened.

Defining composition

In art, the term *composition* means the way an artist arranges the key elements of an artwork, the positive shapes (the objects or persons) and negative spaces (the empty areas) within the format (the bounding edges of an artwork). To compose a work, the artist starts by first deciding on the *shape* of the format (see Figure 7-8 for a variety of formats) and then places and fits together the positive shapes and the negative spaces within the format with the goal of unifying the composition.

The importance of composing shapes and spaces within the format

The format controls composition. Put another way, the shape of the drawing surface (most often rectangular) will greatly influence how an artist distributes the shapes and spaces within the bounding edges of that surface. To clarify this, use your R-mode ability to image a tree, let's say a Christmas tree, and fit it into each of the formats in Figure 7-8. You will find that the shape nicely fits one or two of the formats but is all wrong for others. In this course, in order to simplify instruction, you are using one format

Figure 7-8. A variety of formats.

only, a familiar vertical rectangle that is approximately the shape of ordinary bond paper. The format is repeated in your picture plane, viewfinders, and drawing pad of paper. This particular format, which varies only in size, is suitable for all the exercises, but later on, you will enjoy experimenting with other formats.

Experienced artists fully comprehend the importance of the shape of the format. Beginning drawing students, however, are often curiously oblivious to the shape of the paper and the boundaries of the format. Because their attention is directed almost exclusively toward the objects or persons they are drawing, they seem to regard the edges of the paper almost as nonexistent, almost like the real space that surrounds objects and has no bounds. This causes problems with composition for nearly all beginning art students. For this reason, I suggest that you always start a drawing by first using a viewfinder to decide on a composition, then drawing a format on your paper, using one of the viewfinders or the outside edge of your picture plane as a template. In this way, you focus your attention on the bounding edges of the format before starting to draw.

You saw in the last chapter that because edges in a drawing are always shared edges, the objects and the spaces around them fit together like the pieces of a puzzle (Figure 7-9). Every piece is important, both positive forms and negative spaces. Together they fill up all the area within the four edges of the format. Excellent examples of this fitting together of the spaces and shapes are the figure drawing *Digger* by Vincent van Gogh (Figure 7-10) and the still-life painting by Paul Cézanne (Figure 7-11 on page 118.). Notice how varied and interesting the negative spaces are, and how essentially *simple* they are. And because the spaces are emphasized very strongly in the van Gogh drawing, especially near the figure, and more subtly in the Cézanne, the positive forms are made *one* (unified) with the spaces.

Figure 7-9. Negative spaces and positive forms fit together with shaved edges—like the pieces of a puzzle.

Figure 7-10. Vincent van Gogh, *Digger*, 1885. Courtesy the Van Gogh Museum, Amsterdam. In this powerful drawing, negative spaces are particularly strong close to the figure.

Figure 7-11. Paul Cézanne (1839–1936), *The Vase of Tulips*. Courtesy The Art Institute of Chicago. By making the positive forms touch the edge of the format in several places, Cézanne enclosed and separated the negative spaces, which contribute as much to the interest and balance of the composition as do the positive forms.

Summing up, then, negative spaces have three important functions:

1. Negative spaces make difficult drawing tasks easy—for example, areas of foreshortening or complicated forms that, when flattened on the plane, don't "look like" what we know about them. These parts of a drawing become easy to draw by shifting to negative spaces because the spaces and the shapes share edges. If you draw one, you have also drawn the other. The chair drawing in the margin and the horns of the sheep on page 113 are good examples.

2. Emphasis on negative spaces *unifies* your drawing and *strengthens* your composition. Emphasis on negative spaces automatically creates unity, and, conversely, ignoring negative spaces inevitably *dis-unifies* an artwork. For reasons that are hard to put into words, we just like to look at artworks with strong emphasis on negative spaces. Who knows—perhaps it is our human longing to be unified with our world, or perhaps because in reality we *are* one with the world around us.

3. Most important, learning to pay attention to negative spaces will enrich and expand your perceptual abilities. You will find yourself intrigued by seeing negative spaces all around you.

The next exercise: drawing a chair

Our students are sometimes surprised that the subject chosen for this key exercise is a chair. We tried other subjects: still life objects (fruit, vases, bottles, potted plants, and flowers), but we found that with these subjects inaccuracies are hard to detect. If the negative spaces of a potted plant are drawn inaccurately, hardly anyone will notice—or care. Using a chair as the subject solved the problem. If the negative spaces are incorrect, any inaccuracies quickly show up by distorting the chair, causing both the teacher and student to notice—and to care.

In addition, drawing a chair is a great opportunity to experience again our main strategy: left-brain knowledge of chairs

must be set aside. A beginner in drawing knows too much, in an L-mode sense, about chairs. For example, seats have to be deep enough and wide enough to sit on; all four chair legs are about the same length; chair legs sit on a flat surface; the back of the chair is as wide as the seat, and so forth. This language-based information does not help, and in fact can greatly hinder drawing a chair.

The reason: when a chair is seen from different angles, the visual information does not conform to what we know. Visually—that is, as seen flattened on the plane—a chair seat may appear as a narrow strip, not nearly wide enough to sit on (see Figure 7-12). The curve of the chair's back may appear to be entirely different from what we know it must be. Moreover, the legs may appear to be all of different lengths, and if there are rungs below the chair seat, they form angles—sometimes triangles!—when we know the rungs to be parallel to the chair's seat.

What are we to do? The answer: don't draw the chair at all! Instead, draw the easy parts, the negative spaces. Why are the negative spaces easier? Because you don't know anything, in a verbal sense, about these spaces. You have no pre-existing memorized knowledge of spaces, and therefore, you can see them clearly and draw them correctly. And, even more important, by focusing on negative spaces, you can cause the L-mode again to drop out of the task, perhaps after the usual protest, and again see things clearly.

Now, take your plastic picture plane with a clipped-on viewfinder and look at a chair, preferably a chair with rungs and slats. Close one eye and move the viewfinder backward and forward, up and down, as though framing a snapshot. When you have found a composition that pleases you, hold the viewfinder very still. Now, keeping one eye closed to flatten the image and gazing at a space in the chair, perhaps the space between two back slats, imagine that the chair is magically pulverized and, like Bugs Bunny, disappears, leaving only the negative spaces, the one you are gazing at and all the rest of the spaces. They are real. They have real shapes, just like the remains of the door in the Bugs

Fig. 7-12. A negative space drawing of a chair by student Jeanne O'Neil. Seen from the side, what we know about chairs doesn't fit the visual image—for example, chair seats need to be wide enough to sit on. Drawing the negative spaces solves this cognitive dissonance.

Unity: A most important principle of art.

If negative spaces are given equal importance to the positive forms, all parts of a drawing seem interesting and all work together to create a unified image. If, on the other hand, the focus is almost entirely on the positive forms, the drawing may seem uninteresting and disunified—even boring—no matter how beautifully rendered the positive form may be. A strong focus on negative spaces will make these basic instructional drawings strong in composition and beautiful to look at.

Bunny analogy. Most fortuitously, when you draw the edges of the spaces (those are shared edges), you will have simultaneously drawn the chair—and the chair will emerge, correctly drawn.

Note that because the bounding format edge is the outer edge of the chair's negative spaces, and together the chair-form and the space-shapes fill the format completely, you will end with a strong composition. Art teachers often laboriously try to teach their students "the rules of composition," but I have discovered that if students pay close attention to negative spaces in their drawings, many compositional problems are automatically solved.

I realize that it is counterintuitive—that is, it goes against common sense—to think that focusing on the spaces within and around objects will improve your drawing of the objects. But this is simply another of the paradoxes of drawing and may help explain why it is so difficult to teach oneself to draw. So many of the strategies of drawing—using negative spaces to make drawing easier, for example—would never occur to anyone "in their left mind."

Our next bit of preparation is to define the "Basic Unit." What is it and how does it help with drawing?

Choosing a Basic Unit to start a drawing

On looking at a finished drawing, beginning drawing students often wonder how the artist decided where to start. This is one of the most serious problems that plague students. They ask, "After I've decided what to draw, how do I know where to begin?" or "What happens if I start too large or too small?" Using a Basic Unit to start a drawing answers both these questions, and ensures that you will end with the composition you so carefully chose before you started a drawing.

Once, many years ago when I was teaching a high school drawing class, I asked a student to model by sitting on a chair in side view for the students. It happened that she was wearing some beautiful boots with fanciful designs on the leather, which were in fashion at the time. The class got started with their draw-

ings, and the room went quiet. A half hour later, I heard sighing and a few groans. I asked what the problem was, and one student blurted out, "I can't get to the boots." I walked around the room and saw that almost every student had started their drawing with the head too large and too low in the format. The boots couldn't be included—with the head and upper body so large, the boots went off the page (though one student just ignored the problem and squeezed the boots up into the drawing anyway, completely distorting the proportions of the model—which we all found very amusing, even the student who did the distorting).

This is such a frequent problem: when students are first learning to draw, they almost desperately want to get something down on the paper. Often, they just plunge in, drawing some part of the scene in front of them without paying attention to the size of that first shape (in the incident above, the model's head) in relation to the size of the format. But the size of the first shape *controls the subsequent size of everything in the drawing.* If that first shape is inadvertently drawn too small or too large, the resulting drawing may be an entirely different composition from the one you intended at the beginning.

Students find this frustrating (causing sighs and groans), because it often happens that the very thing that interested them in the scene (the boots) turns out to be "off the edge" of the paper. They don't get to draw that part at all simply because the first shape they drew was too large. Conversely, if the first shape is too small, students find that they must include much that is of no interest to them in order to "fill out" the format.

After years of teaching classes and workshops, struggling to find words to explain how to start a drawing, my fellow teacher Brian Bomeisler and I finally worked out a method that enabled us to communicate how a trained artist does this. We had to carefully introspect what we were doing when starting a drawing and then figure out how to teach the process, which is fundamentally nonverbal, extremely rapid, and "automatic." We called this method "Choosing a Basic Unit." The Basic Unit becomes the key

Fig. 7-13. Henri Matisse (1869–1954), *Young Woman in White, Red Background*, 1946. Musee des Beaux-Arts, Lyon, France.

that unlocks all the relationships within a chosen composition: all proportions are found by comparing everything to a "starting shape," the Basic Unit.

An anecdote about French artist Henri Matisse illustrates this point and also illustrates the almost subconscious process of finding a Basic Unit. John Elderfield, former chief curator of painting and sculpture at The Museum of Modern Art in New York City, in his wonderful catalog of the Matisse retrospective exhibition of 1992, states: "There is a 1946 film of Matisse painting *Young Woman in White, Red Background* (see Figure 7-13). When Matisse saw the slow-motion sequence of the film, he said that he felt 'suddenly naked,' because he saw how his hand 'made a strange journey of its own' in the air before drawing the model's head. It was not hesitation, Matisse insisted: 'I was unconsciously establishing the relationship between the subject I was about to draw and the size of my paper.'" Elderfield goes on to say, "This can be taken to mean that he had to be aware of the entire area he was composing before he could mark a particular section of it."

Clearly, Matisse was finding his "starting shape" (his Basic Unit), the head of the model, to make sure it would be the right size to show the whole figure in his painting. The curious thing about Matisse's remark is that he felt "suddenly naked" when he saw himself apparently figuring out how big to make that first shape. I believe this indicates the almost entirely subconscious nature of this process.

What is the Basic Unit?

All parts of a composition (negative spaces and positive forms) are locked into a relationship that is bounded by the outside edge of the format. For realistic drawing, the artist is tied to that relationship in which all the parts fit together. The artist is not at liberty to change the proportional relationships (as my high school student did, in order to draw the boots). I'm sure you can see that if you change one part, something else necessarily gets changed.

Vincent van Gogh's drawing *Van Gogh's Chair* (Figure 7-14

on page 124) will help me explain the use of a Basic Unit. It is a "starting shape" or "starting unit" that you choose from within the scene you are viewing through the viewfinder. You need to choose a Basic Unit of medium size—neither very small nor very large, relative to the format. It can be either a positive form or a negative space. For *Van Gogh's Chair*, for example, you could choose the top negative space in the back of the chair (Figure 7-14). A Basic Unit can be a whole shape (the shape of the model's head, as in the two anecdotes above, or a whole negative space, as in van Gogh's chair), or it can be just a single edge from point to point (the top edge of that negative space). The choice depends only on what is easiest to see and easiest to use as your Basic Unit.

The next step is to place that first shape into your format. If you imagine crosshairs on the van Gogh painting, you will easily see where to place that first negative space, and what size to make it (Figure 7-16). Once your Basic Unit is placed and drawn, all other proportions are determined relative to the Basic Unit. The Basic Unit is always called "One." You can lay your pencil down on Vincent's chair to compare the relationships. For example, you can now ask yourself, "Are all three negative spaces in the chair back the same width?" Check it out. Note that for each proportion, you go back to your Basic Unit to measure it on your pencil and then you make the comparison with the other negative spaces in the chair back. These measurements are expressed as relationships to "One," or, more technically, as *ratios*:

- The negative space just below our Basic Unit is *about* one to seven-eighths, or 1:7/8.
- The next space below is *about* one to three-quarters, or 1:3/4.

Check it yourself by measuring on van Gogh's painting with your pencil. (Notice that these are approximations, not ruler measurements.)

I'm sure you can see the (visual) logic of this method and how it will enable you to draw in proportion. Starting with your Basic Unit, you can draw all the negative spaces in the van Gogh

Fig. 7-14. Vincent van Gogh (1853–1890), *Van Gogh's Chair*, 1888. Oil on canvas, 91.8 × 73 cm © National Gallery, London/Art Resource. NY. D0089271 ART 373307. Bought, 1924 (NG3862). All proportions in this famous painting are in correct relationship, achieved by referring every part of the composition to the size, placement, and proportion of the initial shape set down by the artist.

Fig. 7-15. *Gauguin's Chair*, 1888. This is the companion piece to *Van Gogh's Chair*, for the French painter Paul Gauguin. Notice the different "personalities" of the chairs. Oil on canvas, 90.5 × 72.5 cm. Van Gogh Museum, Amsterdam (Vincent van Gogh Foundation).

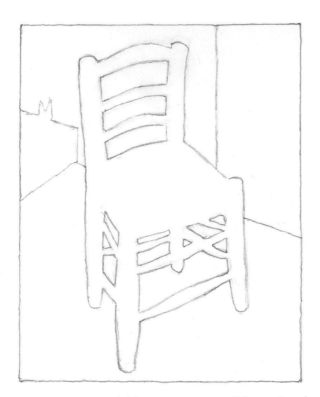

Fig. 7-16. Negative space drawing of *Van Gogh's Chair*. Observe that the negative spaces in the lower part of the chair are like pieces of a jigsaw puzzle. Fitted together they form the rungs of the chair, but drawing the spaces is the easy way to draw the rungs.

composition, and, like magic, you will have also drawn the chair (Figure 7-16).

This method of starting may seem a bit tedious and mechanical at first. But it solves many problems, including problems of starting and of composition as well as problems of proportional relationships. Soon it becomes quite automatic. In fact, this is the method most experienced artists use, but they do it so rapidly that someone watching would think that an artist "just starts drawing" after, perhaps, a slight beginning pause, as in the Matisse anecdote.

Later on, you too will rapidly find a Basic Unit or your "starting shape," or your "One," or whatever you may eventually call it. The method becomes very quick and easy with a bit of practice. Later, when you have discarded all your drawing aids—the viewfinders and plastic picture plane—you will use your hands to form a rough "viewfinder" (as in Figure 7-17), quickly choose a starting shape (Basic Unit), take note of its size and placement

Fig. 7-17.

relative to the format, and then, within your format, size and place the starting shape correctly for your chosen composition. And someone watching you will think that you "just started drawing."

Getting off to a good start: your Negative Space drawing of a chair

What you'll need:

- Your viewfinder with the larger opening
- Your picture plane
- Your felt-tip marker
- Your masking tape
- Your pad of drawing paper
- Your drawing board
- Your pencils, sharpened
- Your erasers
- Your graphite stick and several paper towels or paper napkins
- About an hour of uninterrupted time—more, if possible, but at least an hour

The general procedure for setting up to draw

You will be taking some preliminary steps, so please read all the instructions before you start. The following is a summary of the preliminary steps for every exercise in this course. The steps take only a few minutes, once you have learned the routine.

- Choose a format and draw it on your paper.
- Tone your paper (if you choose to work on a toned ground).
- Draw your crosshairs.
- Compose your drawing using a viewfinder/picture plane.
- Choose a Basic Unit.
- Draw the chosen Basic Unit on the picture plane with a felt-tip marker.

- Transfer the Basic Unit to your paper.
- Then, start the drawing.

Here are the steps for this particular negative space drawing of a chair:

1. The first step is to draw a format on your drawing paper. For your Negative Space drawing of a chair, use the *outside* edge of your viewfinder or the plastic picture plane. The drawing will be slightly larger than the opening of your viewfinder.

2. The second step is to tone your paper. Begin by rubbing the edge of the graphite stick very lightly over the paper, staying inside the format. Once you have covered the paper with a light application of graphite, begin to rub the graphite into the paper with your paper towels. Rub with a circular motion, applying pressure evenly and going right up to the edge of the format. You want to achieve a very smooth, silvery tone.

3. Next, lightly draw horizontal and vertical crosshairs on your toned paper. The lines will cross in the center, just as they do on your plastic picture plane. Use the crosshairs on the plastic plane to mark the position of the crosshairs on the format of your toned paper. A caution: don't make the lines too dark. They are only guidelines, and later you may want to eliminate them.

4. Choose a chair to use as the subject of your drawing. Any chair will do—an office chair, a plain straight chair, a stool, a cafeteria chair, whatever. If you prefer, you may find a rocking chair or a bentwood chair or something else very complicated and interesting. But the simplest kind of chair will be fine for your drawing.

5. Place the chair against a fairly plain background, perhaps an empty room corner. A blank wall is just fine and will make a beautiful drawing, but the choice of setting is entirely up to you. A lamp placed nearby may throw a wonderful shadow of the chair on the wall or floor—a shadow that can become part of your composition.

- The toned format on your paper is larger than the format of the opening of your viewfinder. Though the sizes are different, the proportion of the two formats—meaning the relationship of width to length—is the same.
- Your felt-tip drawing of your Basic Unit on the plastic picture plane and your drawing on the toned paper will be the same, but the one on your paper will be slightly larger.
- Stated another way, the images are the same, but the scale is different. Note that in this instance, you are "scaling up." At other times, you may "scale down."

6. Sit in front of your "still life"—the chair and setting you have chosen—at a comfortable distance of about six to eight feet. Take the cap off your felt-tip marker and place it close beside you.

7. Next, use your viewfinder to compose your drawing. Clip the viewfinder onto your picture plane. Then, holding the viewfinder/picture plane up in front of your face, close one eye and, moving the device forward or backward, up or down, "frame" the chair in a composition that you like. (Many students are very good at this. They seem to have an intuitive "feel" for composition, possibly stemming from experiences with photography.) If you wish, the chair can nearly touch the format so that the chair pretty much "fills the space" (see *Gauguin's Chair*, Figure 7-15), or you can leave a bit of space around the chair (see *Van Gogh's Chair*, Figure 7-14).

8. Hold the viewfinder very still. Now, gazing at a space in the chair, perhaps between two back slats, imagine that the chair is magically pulverized and, like Bugs Bunny, disappears. What are left are the negative spaces. They are real. They have real shapes, just like the remains of the door in the analogy. These negative space-shapes are what you are going to draw.

Choosing a Basic Unit

1. Pick up the felt-tip marker. Still framing your chosen composition with the viewfinder/plastic picture plane, choose a negative space within the drawing—perhaps a space-shape between two rungs or between two back slats. This space-shape should be fairly simple if possible, and neither too small nor too large. You are looking for a manageable unit that you can clearly see for its shape and size. This is your Basic Unit, your "starting shape," your "One." See Figure 7-18 for an example.

2. With one eye closed, focus on that particular negative space—your Basic Unit. Keep your eye focused there until

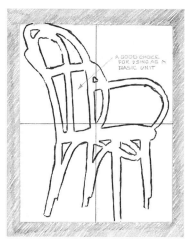

Fig. 7-18. Using your picture plane, focus on the negative spaces of the chair.

it "pops" into focus as a shape. (This always takes a moment—perhaps it is the L-mode's protesting time. There is also a little pop of pleasure, perhaps the R-mode stepping into the task.)

3. With your felt-tip marker, carefully draw your Basic Unit on the plastic picture plane. This is your starting shape (Figure 7-19).

4. The next step is to transfer your Basic Unit onto the paper you have toned. You will use your crosshairs to place it and size it correctly. (This is called "scaling up." See the sidebar for an explanation.) Looking at your drawing on the plastic plane, say to yourself: "Relative to the format and to the crosshairs, where does that edge start? How far over from that side? From the crosshair? From the top?" These assessments will help you draw your Basic Unit correctly. Check it three ways: The shape on your toned paper, the actual space-shape in the chair-model, and the shape in the picture plane drawing should all be proportionally the same.

5. Check each angle in your Basic Unit the same way, by comparing three ways as above. To determine an angle, say to yourself, "Relative to the crosshairs (vertical or horizontal), what is that angle?" You can also use the edges of the format (vertical and horizontal) to assess any angles in your Basic Unit. Then, draw the edges of the space just as you see them. (Simultaneously, of course, you are drawing the edge of the chair.) (See Figure 7-20.)

6. One more time, check your drawing of your Basic Unit, first with the actual chair, then with the rough sketch on the plastic picture plane, and then in your drawing. Even though the scale is different in each, the relative proportions and angles will be the same.

7. It is worth taking time to make sure your Basic Unit is correct. Once you have this first negative space-shape correctly sized and placed within the format in your drawing, all the rest of the drawing will be in relationship to that first shape.

Fig. 7-19. Focus on the negative space you have chosen for your Basic Unit. Then, draw that shape on the picture plane. Next, you will transfer that shape to your toned paper.

Fig. 7-20. Demonstration drawing by instructor Brian Bomeisler.

You will experience the beautiful logic of drawing and you will end with the composition you so carefully chose at the start.

Drawing the rest of the negative spaces of the chair

1. Remember to focus only on the shapes of the negative spaces. Try to convince yourself that the chair is gone, pulverized, absent. Only the spaces are real. Try also to avoid talking to yourself or questioning why things are the way they are—for example, why any space-shape is the way it is. Draw it just as you see it. Try not to "think" at all, in terms of L-mode arguments. Remember that everything you need is right there in front of your eyes and you need not "figure it out." Note also that you can check out any problem area by returning to your plastic picture plane and, remembering to close one eye, drawing the troublesome part directly on the plastic plane.

2. Draw the spaces of the chair, one after another. Working outward from your Basic Unit, all the spaces and shapes will fit together like a jigsaw puzzle (Figure 7-21).

3. Again, if an edge is at an angle, say to yourself: "What is that angle compared to vertical (or horizontal)?" Then, draw the edge at the angle you see it.

4. As you draw, try to take conscious note of what the mental state of drawing feels like—the loss of the sense of time passing, the feeling of "locking on" to the image, and the wonderful sense of amazement at the beauty of your perceptions. During the process, you will find that the negative spaces will begin to seem interesting in their strangeness and complexity. If you have a problem with any part of the drawing, remind yourself that everything you need to know is right there, perfectly available to you.

5. Continue working your way through the drawing, searching out relationships, both angles (relative to vertical or horizontal) and proportions (relative to each other). Remind yourself that the image before you is *flattened on the plane.*

Fig. 7-21. Working outward from your Basic Unit, the negative spaces will fit together like a jigsaw puzzle.

Fig. 7-22.

Fig. 7-23. You may want to erase the negative spaces, leaving the chair in a darker tone.

Fig. 7-24. Alternatively, you may want to erase the chair and leave the negative spaces in the dark tone of the paper.

Demonstration drawing by the author.

Demonstration drawing by the author.

Close one eye as often as is necessary. If you talk to yourself at all during the drawing, use only the language of relationships: "How wide is this space compared to the one I have just drawn?" "What is this angle compared to horizontal?" "How far does that space extend relative to that whole edge of the format?" Soon you will be "really drawing," and the drawing will seem like a fascinating puzzle, the parts fitting together in an entirely satisfying way (Figure 7-21).

6. When you have finished drawing the edges of the spaces, you may want to "work up" the drawing a bit by using your eraser to lighten the tone in some areas, leaving the chair in tone (Figures 7-22 and 7-24), or erasing the chair and leaving the negative spaces in tone. If you see shadows on the floor or on the wall behind, you may want to add them to your drawing, perhaps adding in some tone with your pencil, or erasing the negative spaces of the shadows. You may also want to "work up" the positive form of the chair itself, adding some of the interior contours (see some examples on the left and on page 133).

After you have finished

I feel confident that your drawing will please you. One of the most striking characteristics of negative-space drawings is that no matter how mundane the subject—a chair, a wire whisk, a stepladder—the drawing will seem beautiful. Don't you agree? For whatever reason, we simply like to look at drawings that give equal emphasis to spaces and shapes, presenting a strong composition and a unified whole image.

With only this brief lesson, you will begin to see negative spaces everywhere. My students often regard this as a great and joyful discovery. Have you noticed the negative-space arrow on the side of FedEx trucks? Have negative spaces between tall buildings popped into focus? Practice seeking negative spaces as you go through your everyday routine and imagine yourself drawing those beautiful spaces. This mental practice at odd moments

is extremely helpful in putting perceptual skills "on automatic," ready to be integrated into a learned skill that you own.

Showing all manner of negative spaces

The drawings here and on page 132 are intriguingly pleasurable to look at, even when the positive form is as mundane as a basketball net, Figure 7-25. One could speculate that the reason is that the method raises to a conscious level the unity of positive and negative shapes and spaces. Another reason may be that the technique results in excellent compositions with particularly interesting divisions of shapes and spaces within the format.

In the next chapter, we'll take up the perception of relationships, a skill you can put to use in as many directions as your mind can take you. Learning to see clearly through drawing can surely enhance your capacity to take a clear look at problems and be better able to see things in perspective.

Student drawing by Masako Ebata.

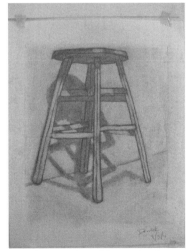

Derrick Cameron's stool drawing, April 5, 2011, New York City.

Fig. 7-25. Even forms as mundane as a basketball net seem beautiful when drawn using negative spaces.

Winslow Homer (1836–1910), *Child Seated in a Wicker Chair*, 1874. Courtesy the Sterling and Francine Clark Art Institute, Williamstown, Massachusetts.

Observe how Winslow Homer used negative spaces in his drawing of a child in a chair. Try copying this drawing.

Peter Paul Rubens (1577–1640). *Studies of Arms and Legs.* Courtesy Museum Boymans-Van Beuningen, Rotterdam.

Copy this drawing. Turn the original upside down and draw the negative spaces. Then turn the drawing right-side up and complete the details inside the forms. These "difficult" *foreshortened* forms become easy to draw if attention is focused on the spaces around the forms.

Chapter 8
Perceiving
Relationships

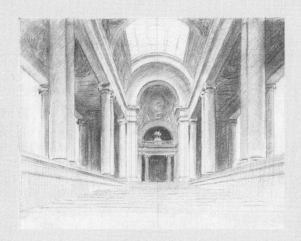

Photograph © 2012 Museum of Fine Arts, Boston. John Singer Sargent, American, 1856–1925. *Architectural Sketch for Rotunda and Stairway*, Museum of Fine Arts Boston. Charcoal and graphite pencil on paper. Sheet: 47.5 x 62 cm (18 $^{11}/_{16}$ x 24 $^{7}/_{16}$ in.). Museum of Fine Arts, Boston. Sargent Collection. Gift of Miss Emily Sargent and Mrs. Violet Ormond in memory of their brother John Singer Sargent, 28.636

In the early 1920s, renowned American artist John Singer Sargent redesigned the colonnade of the Rotunda of the Museum of Fine Arts, Boston, replacing evenly spaced, heavy columns with more widely spaced pairs of lighter columns, thus providing room for the artist's murals, which were restored and conserved in 1999. This is one of his architectural sketches, a wonderful example of a one-point perspective drawing.
If you look closely at the detail on the opposite page, you will see a tiny circle on the stairs. That tiny circle marks his vanishing point, the artist's single point of view, and his eye-level line (his horizon line).

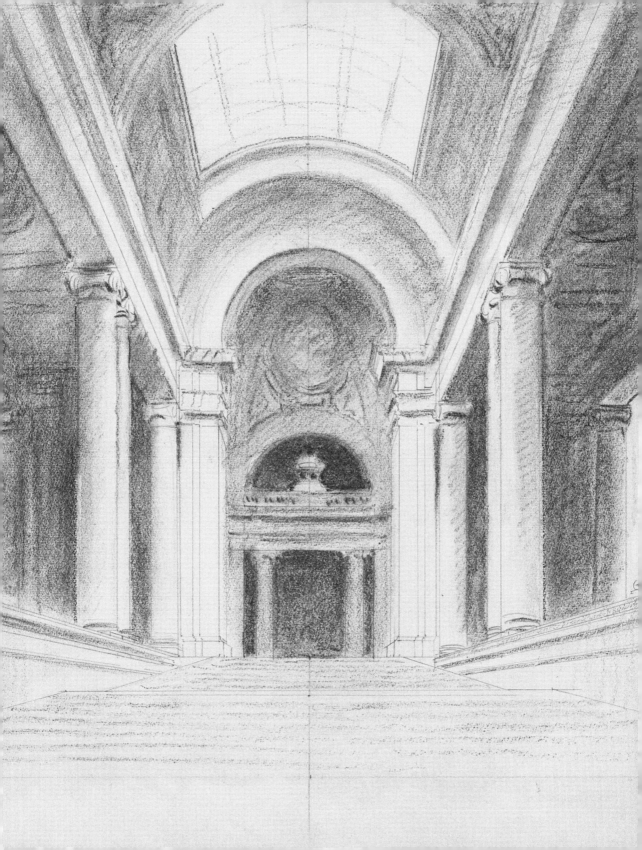

Drawing is a global skill made up of five component skills—the perception of:
 • Edges (Contours)
 • Spaces (Negative Spaces)
 • Relationships of Angles and Proportions (The two-part skill of perspective)
 • Lights and Shadows (Values)
 • The *Gestalt* (The Whole, which is greater than the sum of the parts)

The Main Strategy for drawing:

In order to access the right hemisphere mode, you must present your brain with a task that your left brain will turn down.

18. *The Complete Letters of Vincent Van Gogh,* Letter 136, September 2, 1880.

19. Letter 138, November 1, 1880.

In September 1880, as he was about to enroll in art classes in Brussels, Vincent van Gogh was struggling with drawing in perspective, about which he said, "You have to know it just to be able to draw the least thing." Discouraged by poverty and his difficulties with drawing but determined to improve, he wrote in a letter to his brother, Theo, "In spite of everything, I shall rise again: I will take up my pencil, which I have forsaken in my great discouragement, and I will go on with my drawing."[18]

Enrolled in classes two months later, the artist in another letter to Theo expressed his determination to master the basic skills of drawing: "There are laws of proportion, of light and shadow, of perspective, which one *must know* (van Gogh's emphasis) in order to be able to draw well; without that knowledge, it always remains a fruitless struggle, and one never creates anything."[19] The artist was not alone in his struggle with drawing, especially the skill we focus on in this chapter. But van Gogh did master drawing in perspective, and soon, hard worker that he was, even took pleasure in the effort.

You, too, will learn to "draw in perspective," a goal, I'm sorry to say, that has become the Waterloo of many an art student and often carries a huge charge of dread that is quite unnecessary. Hearing the phrase "the science of perspective," with its aura of lengthy, tedious, and boring lessons, can wilt the ambition of even a determined drawing student.

It does not have to be that way. You must trust me on this. Yes, there are some concepts of formal perspective that are essential to know: Point of View, the picture plane, eye-level line (Horizon Line), Vanishing Points, and Converging Lines. But most artists, once they understand the basic concepts, use what is called "informal perspective," or "intuitive perspective," or more simply, just "sighting." I will teach you first the concepts of formal perspective, followed by instruction in how to use those concepts in informal perspective.

This is not to say that a thorough knowledge of one-point, two-point, and three-point perspective is not important. I will say it again: in my view, knowledge never hurts! But even artists who are completely trained in formal perspective rarely bother to set up complicated diagrams of Vanishing Points and Converging Lines in perspective drawing. While keeping the basic concepts in mind, they simply sight angles and proportions the way I will teach you to do.

Going by the rules

Almost every skill requires a component similar to perspective drawing. Most sports have fairly complicated game rules, and learning to drive a car requires that you learn the rules of the road, which at first seem overly complicated and too detailed. Who of us has not swallowed hard over the driver's license test at the Department of Motor Vehicles? But when adequately learned, the rules provide a mind-set that guides driving a car. With practice, the rules go on automatic, and driving becomes legal, pleasurable, and (most of the time) stress-free.

Learning to draw in perspective is also comparable to learning the rules of grammar in reading and writing. Just as good grammar allows words and phrases to communicate ideas clearly and to hang together logically, skillful perceptions of angles and proportions allow drawings to come together with clarity and logic. Mastering this skill will enable you to depict the three-dimensional world on a flat sheet of paper, and will give your drawings power through the illusion of space.

Once learned, practiced, and put on automatic, you will use your skill in sighting relationships of angles and proportions for all your drawings, not just drawings of interiors, buildings, or street scenes. Sighting is essential to drawing portraits, still lifes, figures, and landscapes—in fact, every subject. In this chapter, however, we'll focus on drawing an interior, because correct sighting plays a large role in that subject matter, and the many paradoxes involved are useful for understanding the skill. Once

"Perspective should be learned—and then forgotten. The residue—a sensitivity to perspective—helps perception, varying with each individual and determined by his responsive needs."
— Nathan Goldstein, American artist, author, and professor of painting and drawing at The Art Institute of Boston at Lesley University

you have learned the basics of formal perspective, you will find informal perspective quite engaging and even fascinating—that is the experience that my students report.

Perspective and paradox

In learning perspective drawing, you will again apply the main strategy of this course, which I cited in the reminder on page 138. The reason is this: perspective drawing requires that you overcome your left brain's dislike of paradox. It knows what it knows and does not like contradiction. Let me explain, again using the example of drawing a cube. A cube is comprised of squares and right angles. That is a matter of accepted, broad knowledge. But to draw a cube *in perspective*, while it is sitting at an angle on a table in front of you, requires you to draw the cube *as you see it on the picture plane.* That image of the cube includes some oblique angles and some sides of varying widths that your left brain will protest cannot be part of a cube (Figure 8-1). It will protest—and protest some more: "All sides of a cube must be equal in height and width, and all angles must be right angles. Moreover, a cube *always* has these properties: they are unchangeable."

But if you ignore these protestations and draw the angles and proportions *as you perceive them*, your drawing, paradoxically, will look like a cube made up of equal squares and right angles. Because you have drawn the cube *in perspective*, it will be *perceptually correct.* I believe that the necessity to accept paradox is largely the reason learning perspective in drawing causes anxiety and distress. In a left-brained sense, perspective requires that you

Fig. 8-1. Cubes drawn in perspective contradict the known properties of cubes.

draw "lies" in order to portray "truth," to recall Picasso's famous comment. But in a right-brain sense, perspective requires that you draw what you actually see in order to portray perceptual reality. It's a difference of point of view.

Formal perspective: a few key concepts

+ Point of View
+ The Picture Plane
+ The Horizon Line
+ Vanishing Points
+ Converging Lines

First, Point of View. In a one-point perspective drawing, the artist regards the scene to be drawn from a single point of view, ideally with one eye intermittently closed to remove the depth perception of binocular vision. This point of view is *fixed*, and you should think of it as an actual point out there, upon which your eye is fixed. To stay fixed on this point, the artist does not lean to one side or the other, or turn the head to one side or another.

Second, the Picture Plane. I described the concept of the Picture Plane in some detail in Chapter 6. To recap: with eyes (or eye) fixed on the point of view, the artist views the scene through the picture plane, the imaginary vertical, transparent plane (like a pane of glass), which is always parallel to the plane of the artist's eyes. By closing one eye, the artist sees the scene *flattened* on the transparent picture plane—like a photograph. Try to permanently absorb the rule that the picture plane always stays parallel to the plane of the eyes. If you turn your head to another view, the picture plane also turns, and you have a new point of view, resulting in a different drawing. In order for you to learn perspective, we'll continue to use our actual picture plane, made of clear plastic, with its black printed or taped edges and crosshairs for vertical and horizontal, the constants to which all angles are compared. Keep in mind, however, that in time and with practice, the imaginary picture plane takes over.

"Art is a lie that makes us realize the truth."
— Pablo Picasso, 1923

"Point of view is worth 80 points of IQ."
— Alan Kay, president of Viewpoints Research Institute, Kyoto Prize winner 2004, and renowned expert in computer science

Third, the Horizon Line. From the artist's fixed point of view, looking straight ahead through the transparent vertical picture plane, with a gaze that is parallel with the ground, the artist "sees" an imaginary Horizon Line, which is at the level of the artist's eye. That line is also called the *eye-level line*. The two terms are interchangeable, and, in drawing, mean the same thing: *the Horizon Line is always at eye level.*

A strangely little-known fact is that the Horizon Line is not fixed. It is variable, depending on where the artist/viewer is standing. For example, if the artist happens to be standing at the edge of the ocean, with an unobstructed view of the sea, the actual Horizon Line where the sea meets the sky is at the artist's eye level. If the artist climbs a cliff beside the shore, the Horizon Line will have "risen" to the artist's new eye level. If the artist climbs down from the cliff and crouches down by the shore, the Horizon Line will have "lowered" to yet another eye level (See Figures 8-2, 8-3, and 8-4).

> **The thing to remember is this:** *Imaginary or actual Horizon Lines are always at your eye level, no matter where you are, whether you are sitting or standing, whether you are on the ground or at the top of a mountain, and whether or not you can actually see an actual Horizon Line.*

From here on, I use the two terms interchangeably, but it is important to remember that for most drawings, the actual Horizon Line is not visible, and you will use your eye level to determine an imaginary Horizon Line.

Something that often confuses students beginning in drawing is that *you can choose where to place the Horizon Line in your drawing.* You can decide to place it anywhere—near the top edge, near the middle of the paper, near the bottom edge, at any location between the top and bottom edges of the paper, or even beyond the top, as in the Vija Celmins drawing (Figure 8-5). It depends on what you want to show in your drawing—that is, what you choose to include within the frame of your picture

In visualizing a Horizon Line that is not actually in view, it sometimes helps to imagine that you are standing (or sitting) where water is rising until it reaches your eyes and extends out all the way to the horizon. That is your eye-level line (your Horizon Line).

Fig. 8-2. The horizon line is *always* at the viewer's eye level. Standing by the shore, the horizon line is at the viewer's eye level.

Fig. 8-3. Standing at a higher elevation, the horizon line "rises" to the viewer's eye level.

Fig. 8-4. Sitting down, the horizon level "moves down" to the viewer's new eye level.

Woman by the Sea Taking a Sight of the Ocean, © Robert J. Day/The New Yorker Collection/ www.cartoonbank.com. This *New Yorker* cartoon in an art-field inside joke. Sighting always involves comparing one thing to another. In this scene, there is nothing to compare.

FIG. 8-5. You are free to decide where you want to place the Horizon Line in your drawing: high in the format, in the middle of the format, or low in the format—or even outside the format, as in American artist Vija Celmins's drawing of the ocean's surface.

plane. This is your *composition*.

In the example above of looking at the ocean, deciding to place the horizon near the top of your drawing will result in a composition that emphasizes the water, waves, and shoreline. A Horizon Line in the middle will give equal emphasis to water and sky. A low horizon will emphasize sky, clouds, sunset, etc., and de-emphasize the ocean. Framing the view with your viewfinder or with your hands, then raising and lowering the frame, will help you make this compositional choice.

Fourth, Vanishing Points. The classic image to illustrate one-point perspective is an empty landscape with a road retreating in the distance to a Vanishing Point on the Horizon Line (Figure 8-6). That point, the Vanishing Point, is the artist's Point of View fixed on the Horizon Line. (Two-point perspective, obviously, has two Vanishing Points for each object, and three-point perspective has three.) For the moment, we'll stick to one-point perspective, to better understand the basic concepts.

Fifth, Converging Lines. The rule is: for a one-point perspective drawing, with a single Vanishing Point on the Horizon Line, *parallel edges that are parallel to the ground appear to converge at that point on the Horizon Line* (see Figure 8-6).

If we add to the scene some buildings and trees, all the edges that are parallel to the ground will converge toward the same single Vanishing Point (Figure 8-6).

An important note: Observe that vertical edges of human-built objects or buildings *remain vertical* (Figure 8-6). In one- and two-point perspective drawings, you draw vertical edges straight up and down, parallel to the vertical edges of your drawing paper, and they do not vary. There are some exceptions—for example, in three-point perspective, looking up at a tall building or looking down from a tall building, but the exceptions are too rare to address here. See Figure 8-10, page 149.

Fig. 8-6. The classic perspective illustration. Note that vertical lines remain vertical; horizontal edges converge at a vanishing point on the horizon line (which is always at the artist's eye level). That's one-point perspective in a nutshell. Two-point and three-point perspective are complex systems, involving multiple vanishing points that often extend far beyond the edges of the drawing paper and requiring a large drawing table, T-squares, straight-edges, etc., to draw. Informal sighting is much easier and is sufficiently accurate for most drawing.

I am sure you are asking yourself, "But if I focus on a single fixed point on the Horizon Line, how can I see the other parts of the total view without shifting my eyes off of the Vanishing Point?" Well, obviously, you can't, and, also obviously, you need to shift your gaze to the part that you want to draw. At the same time, you must keep in mind where the Vanishing Point lies on the Horizon Line, and you should mark the point with your pencil, thus making sure that your Converging Lines aim for that point.

Now, a most important point that again seems simplistically obvious, but often gets lost in the midst of a drawing:

 ⁘ Horizontal edges that are *below* the Horizon Line (like the edges of the road) converge *going up* to the Vanishing Point on the Horizon Line.

 ⁘ Horizontal edges that fall *on the Horizon Line* remain horizontal.

 ⁘ Horizontal edges that are *above* the Horizon Line (like the horizontal edges of the buildings in Figure 8-6) converge *going down* to the Vanishing Point on the Horizon Line.

Once you understand this last bit and make it a permanent part of your mind-set, you are well on your way to drawing in perspective. To help with that understanding, please do the following quick observation exercise in one-point perspective.

1. Find a hallway, the longer the better, either in your house or in another building—a hallway that has one or more doors along the sides. Have your picture plane and a pencil with you.

2. Stand at one end of the hallway, at an equal distance from each side wall. Look straight ahead and find your eye-level Horizon Line on the end wall of the hallway. Fix your gaze on a single point (the Vanishing Point) on your Horizon Line (Figure 8-7).

3. Next, hold up your picture plane with both hands, so that it is parallel to the plane of your eyes. For clarity, line up the horizontal crosshair on your picture plane with your eye-

Our lead workshop teacher, Brian Bomeisler, uses an inventive method that helps students see clearly how all edges converge at the Vanishing Point on the Horizon Line in one-point perspective views.

Looking down a hallway, hold up your picture plane with both hands, with both thumbs holding the pencil lengthwise and flat on the plane. The pencil should cross the Vanishing Point on your Horizon. Hold it there as a fulcrum for rotation. Begin to rotate one end of the pencil on the right side of the plane, and *observe* that, as you rotate the pencil from top to bottom, it "lines up" with every horizontal edge in the hallway, from the ceiling angle to the angle of the floor.

Then, move the pencil to the left side of the plane and repeat the rotation, observing again that the pencil lines up with every horizontal edge.

This technique seems to work well to convince students of how one-point perspective "works." See Figure 8-8.

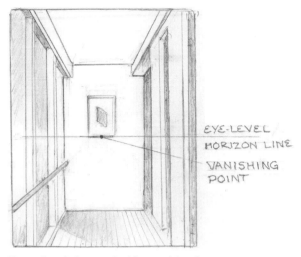

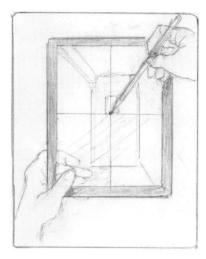

Fig. 8-7. First, find your eye level/horizon. Then, fix your eye on your vanishing point.

Fig. 8-8. Then, hold up your picture plane and line up your eye level/horizon with the horizontal crosshair and the vanishing point with the crossing point on the picture plane. Closing one eye, align your pencil with the edge where the wall meets the ceiling.

level Horizon Line. Then, closing one eye, look straight ahead at the Vanishing Point on your Horizon Line. Again, for clarity, you can use the crossing point of the two grid lines to mark your Vanishing Point.

4. Now, with one hand holding the picture plane parallel to your eyes, with the other hand, line up your pencil on the picture plane with the edge where the wall on the left-hand side meets the ceiling. You will find that it *descends* (angles downward) toward the Vanishing Point on your Horizon Line (Figure 8-8).

5. Repeat this maneuver with the wall-meets-ceiling edge on the right-hand side of the hallway. You will find that this edge *descends* to the same Vanishing Point on your Horizon Line. These two edges have *converged at the Vanishing Point.*

6. Next, observe the top edges of the doorway or doorways. They also descend and converge toward the Vanishing Point, but at a slightly lesser angle than the ceiling/wall edge.

7. Now repeat these maneuvers with the lower edges where the

walls meet the floor. You will find that these edges *rise* (angle upward) and converge at the Vanishing Point on your Horizon Line.

8. Finally, observe that all of the vertical edges of doors, openings, etc., *remain vertical.* Test this observation with your pencil on your picture plane.

This observational exercise illustrates the basic concepts of formal perspective, and the mind-set that you need in order to draw in informal perspective. Again, you must confront and deal with paradoxical information. You know, of course, that the horizontal edges at the ceiling and floor of the hallway are, in truth, not angles, descending or rising. They are horizontal, at a constant height all along the hallway. But to draw the hallway in perspective, you must draw the paradoxically angled lines just as you see them on the picture plane (See Figure 8-9).

Let's take a further step in observation

1. Sit in a chair at the same spot at one end of the hallway, or, if you are able, sit on the floor, still holding your picture plane and pencil.

2. Gaze straight ahead through your picture plane. You will see that your Horizon Line is now much lower on the end wall of the hallway.

3. Again, looking through your picture plane, observe that the angled horizontal edges are now *different* angles from those you observed while standing. The upper edges angle *more* steeply downward, and the lower edges are angled *less* steeply upward. Same edges, different angles, because you have *lowered your eye level* and that changed your Horizon Line/ Vanishing Point.

If you had a stepladder to raise your Horizon Line, you again would find new and different angles for the horizontal edges. If you stepped slightly to one side, still looking straight ahead, your

Fig. 8-9. When sighting angles of receding forms (where the hallway walls meet the ceiling, for example), the temptation is to "poke through the picture plane." These angles must be sighted *on the plane*. Paradoxically, the receding forms will then appear to "go back in space" in your drawing.

When we see students sighting with their pencils pointed outward, we caution them, "Stay on the plane!" or "Don't poke through the plane!" Later, when you have learned to sight and have discarded the actual picture plane, you must still remember not to "poke through" the imaginary plane.

Point of View would change, and all the angles would also change. It all depends on your Point of View. But the constant rules are:

· *Horizontal edges above eye level converge going down toward the Horizon Line/Vanishing Point.*
· *Horizontal edges that fall at eye level remain horizontal.*
· *Horizontal edges below eye level converge going up.*

I think that this infinitely possible variation of eye-level line and angled edges converging at Vanishing Points is the complication that most disturbs the left brain in perspective drawing. Infinitely possible variations of the same objects do not fit the left brain's preferred mode of thinking. It expects that things it knows to be stable, dependable, and constant will stay that way. Two plus two is always four, the ceiling and floor of the hallway are always horizontal, and the height of the hallway is always the same for the whole length of the hallway. "Don't tell me that this hallway diminishes in size from one end to the other, because I know it doesn't."

This is the paradox that perspective drawing confronts. And because perspective angles are infinitely variable, *they must each be sighted.* In time and with practice, many can be quickly and more or less successfully "eyeballed," but successful eyeballing depends on a clear perspective mind-set and a right-brain mode that accepts and even delights in the paradoxes of perspective drawing.

Summing up the whole mind-set for one-point perspective drawings:

· An imaginary Horizon Line on the imaginary picture plane.
· A single Point of View/Vanishing Point.
· An expectation that horizontal edges above the Horizon Line will descend, converging on the Vanishing Point; those below will rise, converging on the same Vanishing Point; and those at eye level will remain horizontal.
· An awareness that vertical edges of human-built structures remain vertical.

Whole mind-sets are not unfamiliar. For example, in driving a car, one has a similarly controlling whole mind-set: the rules of the road, which start with which side of the road to drive on.

In the United States, part of the mind-set is that we drive on the right side. If one moves, say, to England, where people drive on the left side, one must quickly modify the controlling mind-set.

Once you have that whole mind-set, you are ready for one-point perspective drawing. The best way to practice the perspective mind-set is to simply observe the main concepts step by step, consciously and deliberately, wherever you happen to be and whatever scene is in front of your eyes (any hallway, for example).

Observe, step by step:

Regard the scene in view, flattened on the imaginary picture plane (close one eye!): check

Find your eye level/Horizon Line: check

Find your Vanishing Point: check

Observe that horizontal edges above the Horizon Line descend and converge: check

Observe that horizontal edges on the Horizon Line remain horizontal: check

Observe that horizontal edges below the Horizon Line rise and converge: check

Observe that vertical edges remain vertical: check

You will still encounter mental arguments. I recall one student who had gone through the hallway observation exercise, had grasped the fundamentals I have outlined above, and had practiced the one-point perspective mind-set. When she sat down to draw the hallway, however, the argument began. I watched as she correctly took a sight on the angle of the edge where the wall met the ceiling. She started to transfer the angle to her drawing paper, and I heard her say, "It can't be." She correctly took the sight again, looking straight ahead, her pencil held along the angle she saw on her picture plane. Again, starting to draw the angle, I heard her say, "It *can't* be." Again, she took the sight, and again the argument came. Finally, I heard her say, "Oh, all *right!*" She drew the angle, then proceeded with the next, and the next. Finally, she leaned back, regarding her drawing, and said, "Oh, my gosh, it works!"

Your one-point perspective drawing

To set the concepts in your mind, please draw the hallway you

Fig. 8-10. Three-point perspective views are fairly rare, involving looking up at tall buildings or down, say from the top of a tall building. These views are often exploited by cartoonists for the dynamic sense of space they engender.

The third Vanishing Point is an imaginary point in the sky or below the ground where the vertical edges of tall buildings seem to converge.

have observed in a one-point perspective drawing. We'll then proceed to the next step.

Two-point and three-point perspective

In the complex world we live in, one-point perspective views, like the hallway view, are relatively rare, and three-point perspective views are even rarer. The single Vanishing Point of one-point perspective makes for a relatively simple composition, with all lines converging on a Vanishing Point within the four edges of the drawing paper. But the most common views that artists see and draw are two-point perspective views. These views have at least two Vanishing Points, but may have four, five, six, eight, or more depending on how many objects or buildings are in the composition.

To illustrate: If you have two cubes (say, two square tissue boxes) on your table, lined up with one side of one box parallel to one side of the other, and both boxes parallel to the leading edge of the table, you will have a single Vanishing Point and a one-point perspective drawing (Figure 8-11).

If the same two cubes are on your table but are placed at random angles, each will have its own *two* Vanishing Points on the Horizon Line. You will have a two-point perspective drawing, and some or all of the four Vanishing Points may be off the page (Figure 8-12).

If there are three cubes, placed at random (also a two-point perspective drawing), each cube will have its own two Vanishing Points, some or all off the page.

As you see in the sketches, the complication of two-point perspective is that the multiple Vanishing Points are nearly always *outside*—sometimes *far* outside—the edges of the drawing paper, where they can be marked only with great difficulty—with long strings, thumbtacks, yard-long rulers, etc. No one wants to deal with this! And this is where informal perspective—sighting—makes more sense. With a firm grasp of the main concepts of formal perspective, the artist simply *sights* the angles of converging

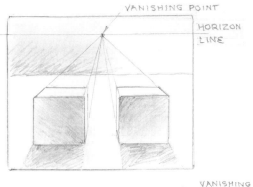

Fig. 8-11. Two cubes in one-point (formal) perspective.

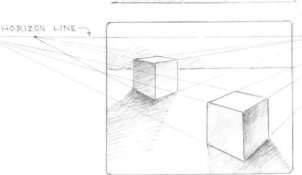

Fig. 8-12. Two cubes placed at random require two-point (formal) perspective and four vanishing points, all outside the format. All the angles, however, can be sighted on the plane, using informal perspective ("sighting").

edges, always assessing the angles *relative to vertical and horizontal*, the artist's constants, and using the concepts of the Picture Plane, the Horizon Line, Vanishing Points, and Converging Lines as mental guides.

This mind-set helps the artist by setting up *expectations of convergence.* To repeat, in two-point perspective, upper and lower horizontal edges of a single form will converge toward an imaginary vanishing point (your eye level). Angled edges above the Horizon Line will descend toward the imaginary Vanishing Point (which is somewhere off the page) on the imaginary Horizon Line (which extends beyond the format). Angled edges below the Horizon Line will rise toward the same Vanishing Point/Horizon Line. Vertical edges will remain vertical. These expectations are enormously helpful, and, with practice, sighting goes "on automatic" and the stress of perspective drawing gives way to pleasurable engagement. The critical task of the artist is to

Fig. 8-13.

Fig. 8-14.

Verticals in human-built structures remain vertical. Horizontals—that is, edges parallel to the face of the earth—appear to change and converge and must be sighted. But you can pretty much count on verticals remaining vertical. In your drawing, they will be parallel to the edges of your paper. There are exceptions, of course. If you stand at street level, looking up, to draw a tall building, those vertical edges will converge and must be sighted. This situation (three-point perspective) is fairly rare in drawing.

sight the angles as accurately as possible, guided by the expectation of convergence.

Informal perspective: the artist's way of seeing and drawing angles and proportions

Keeping the fundamental concepts of formal perspective in mind, informal perspective, usually simply called "sighting," is the method used by almost all artists. *Sighting is a two-part skill.* For both parts, your pencil is the "sighting tool" for unlocking the information you need in order to correctly draw both angles and proportions, but for each, you are seeking different information. You will be sighting:

+ Angles in relation to horizontal and vertical.
+ Proportions in relation to a Basic Unit.

First, sighting angles

Angles are always sighted *in relation to vertical and horizontal,* the two constants that the artist clings to "as to a life raft," as one of my students put it. To assess any angle "out there," you can always close one eye and hold up your pencil *on the plane* in vertical or horizontal position. You also have the edges of your picture plane and its crosshairs to represent vertical and horizontal and help you assess an angle. Furthermore, *the edges of the paper on which you are drawing represent the same vertical and horizontal and enable you to transfer any angle into your drawing. The side edges represent vertical, and the top and bottom edges represent horizontal. Thus, the artist is always anchored to the "life raft" constants: vertical and horizontal.*

A brief practice sighting angles in two-point perspective

1. Take up your viewfinder/picture plane, your pencil, and your felt-tip marker. Seat yourself ten or twelve feet from a room corner, perhaps one with a doorway, ideally one that is free of furniture so that you will be able to see the edges where the ceiling meets the walls. See Figures 8-13 and 8-14.

2. Hold up the picture plane and compose your view (find a composition you like by moving your picture plane forward or back, up or down, or side to side).

3. Find your Horizon Line/eye-level line. Line up the horizontal crosshair with your eye-level line.

4. Look at the angle formed where the ceiling meets the two walls. Be sure to keep the picture plane vertical in front of your face and parallel to the plane of your two eyes. Don't tilt the plane in any direction.

5. Use your marker on the picture plane to draw the vertical corner (a straight up-and-down edge).

6. Then, on the plane, draw the angled edges where the ceiling meets the two walls, and, if the corner is free of furniture, the angled edges where the floor meets the walls.

7. Put your picture plane down on a piece of paper so you can see the drawing and transfer those lines to a piece of drawing paper.

8. You have just drawn a corner in two-point perspective. The Vanishing Points lie outside your drawing paper. If you extend the angled lines of the ceiling and floor on each side of your drawing, those angled lines will converge on your eye-level line at two Vanishing Points *outside the format of your drawing.*

Next, let's do a drawing by sighting the angles of a corner with just your pencil.

1. Sit again in front of the corner, or move to a different corner. Tape a piece of paper to your drawing board. Now, take a sight on the vertical corner. Close one eye and hold your pencil at the corner perfectly vertically. Having checked, you can now draw a vertical line for the corner.

2. Next, determine where your eye-level line is on the corner line and make a mark.

3. Then, hold up your pencil perfectly horizontally, staying on the plane, to see what the angles of the ceiling are relative to horizontal (Figure 8-13). In sighting angles, you must stay *on*

Two suggestions:

1. I usually recommend that students not try to designate an angle by degrees: a 45-degree angle, a 30-degree angle, etc. It really is best to simply remember the "pie" shape the angle makes when compared to vertical and horizontal and then carry that visual triangle in your mind to draw it. You may have to double-check angles a few times at first, but my students learn this skill of envisioning angles very quickly.

2. The decision whether to use vertical or horizontal as the constant against which to see a particular angle occasionally puzzles students. I recommend that you choose whichever will produce the smaller angle.

the imaginary plane. Do not *poke your pencil through the plane!* This is a solid plane. You cannot "poke through it" to align your pencil with an edge as it moves toward you or away from you through space. You determine the angle as it appears on the plane (See Figure 8-9, page 147).

4. As you close one eye and hold your pencil horizontally at the top of your vertical corner line, you will see the edges of the ceiling as angles above your horizontal pencil. Snap a mental photograph of one of these angles as a *triangular shape* (Figure 8-13).

5. Then, draw the angle into your drawing, matching (estimating, actually) the triangle you saw "out there." Use the same procedure for the other ceiling edge, then the floor angles (Figure 8-14), holding onto the mind-set *that the ceiling and floor angles* will *converge at a Vanishing Point on your eye-level line.* This expectation helps you to see the angles correctly.

These are fundamental sighting movements and procedures in drawing. They are not difficult to master, once you have a real understanding of the purpose of the procedure.

Part two of sighting: proportions

Remember, sighting is a two-part skill. You have just learned the first part: sighting angles. In sighting proportions, your pencil, again used as your sighting device, enables you to see "How wide is this compared to my Basic Unit?" "How tall is this compared to my Basic Unit?" Proportions, especially tricky ones that are hard to perceive correctly, as in foreshortened forms, are always sighted *on the plane* relative to your Basic Unit.[20] Proportions that are not so difficult can be "eyeballed" (estimated) more or less successfully, especially as you become practiced at sighting on the imaginary picture plane.

In seeing and drawing proportions, therefore, the artist must find out the perceptually correct proportions and draw them just as they are out there. In this way, the drawn proportions will "look right."

We have tried working with various tools for assessing angles and proportions: protractors, calipers, etc. Some are helpful, and you may enjoy trying them.

The problem is that in the midst of drawing, the tools must be picked up, focused on, and then put down in order to retrieve your pencil and continue drawing.

The charm of the pencil as a simple sighting tool for both angles and proportions is that it just stays in your hand to take a sight and then to continue drawing—there is no interruption for picking up and putting down another tool.

20. See page 120 in Chapter 7 if you wish to review using a Basic Unit.

The question is, how does the artist "find out"? The answer is by measuring and comparing sizes. How does the artist measure? Quite simply, by "taking a sight" on one form and comparing it to another. How do you take a sight and compare a size? Simply by using that all-purpose drawing tool, the pencil, to measure a form and compare it to another. In sighting proportions, the pencil is *always held at arm's length with the elbow locked*.

Remember! All sights of proportions are taken *on the imaginary picture plane*, which is always parallel to the plane of your eyes. (I am repeating myself, I realize, but in our workshops we do a lot of repeating, "Stay on the plane! Stay on the plane!" "Lock your elbow!" "Close one eye!") At first, it *is* hard to remember. This is new learning, after all.

The formal gesture of sighting proportions

In drawing, you are always comparing two proportions: the width (or height) of your Basic Unit to the width (or height) of each form you need to sight. For every sight you take, you must go back to the Basic Unit and measure that first, because that is your constant, your "One." Every proportion in the drawing is in relationship to the Basic Unit. Every proportional relationship is "One to (something)," expressed as a ratio, 1:(something).

To take a proportional sight requires a rather formal gesture. Holding your pencil, raise your arm and extend it at full arm's length, *with your elbow locked*. The purpose of locking the elbow is to ensure using a single scale in sighting proportions. Relaxing the elbow even slightly can cause errors by changing the scale of the sights.

Close one eye, extend your arm with your elbow locked (staying on the imaginary plane), and set one end of the pencil at one edge of the first form (your Basic Unit) and mark with your thumb the other edge: the width (or length) of the Basic Unit. Next, with your thumb still marking the width of your "One," and keeping your elbow locked and one eye closed, move your pencil to the other form and repeat the measurement, taking mental

note of the relationship as a simple ratio. Perhaps it will be 1:1 (one to one, the widths are the same), or let's say you find that it is 1:2 (the second form is twice as wide).

You can now transfer the "sight" to your drawing: keeping the ratio 1:2 in mind, *wipe that first measurement off the pencil!* You have found the proportional relationship "out there." The next step is to get that ratio into your drawing, which has its own scale—different from "out there."

Return to your drawing. Measure your Basic Unit *in the drawing*, using your pencil and thumb—that is your "One" in the drawing. Then, moving the measure to the second form, count "One, two" and mark on the drawing the width of the second form. Remember, all forms are flattened on the picture plane, like a photograph, so all proportional measurements in drawing are widths or lengths. You'll recall that depths are flattened, as in a photograph, because you are measuring *on the picture plane* and you cannot "poke through the plane." Things going back in space or coming toward you are measured as *flat* on the plane.

A summary of sighting proportions

+ Close one eye and extend your arm full length, elbow locked, holding your pencil *on the plane*. Out there, sight first your Basic Unit, and then compare it to a second form. *Hold the proportional ratio in mind: let's say it is 1:2.*

+ Wipe that measure *off your pencil!*

+ Return to your drawing. Now measure your Basic Unit *in the drawing* and move to the second form. Measure "One, two," make a mark, and continue with your drawing, confident that the second form is *in proportion.*

A two-point perspective drawing

What you'll need:

+ Your drawing board
+ Your pad of drawing paper
+ Your masking tape

One of our students invented the commandment "Wipe it (that first measurement) off the pencil!" accompanied by a wiping-off gesture on the pencil.

The commandment is brilliant! The most frequent error students make is taking a sight "out there" and bringing it straight down into the drawing, forgetting that they must re-measure in the drawing because the scale is different from the scale "out there."

- Your drawing pencils, sharpened, and your erasers
- Your graphite stick and several paper towels or paper napkins
- Your plastic picture plane and your felt-tip marker
- Your larger viewfinder

Before you start

1. Follow the steps in "Setting up to draw" on page 126 (Chapter 7). The format should be drawn by using the outside edge of your picture plane.
2. Choose your subject. The best way to choose a site is to walk around, using your viewfinder to find a composition that pleases you—much in the same way as composing with a camera's viewfinder. Choose a view or a site that you think would be really interesting to draw, not necessarily one that looks easy to draw. You will want to prove to yourself that you can achieve this skill, and, surprisingly, a complicated site with lots of angles is quite achievable at this stage. See the student drawings on page 164.

Possible sites:

- A kitchen corner
- A view through an open doorway
- A corner of any room in your house
- A porch or balcony
- Any street corner where you can sit in your car or on a bench and draw
- An entrance to any public building, seen from the inside or outside (A caution: oddly, people who would never approach a stranger just to chat often feel perfectly free to talk with someone who is drawing or painting in a public place. This can be pleasant, but it is not conducive to R-mode concentration.)

Your two-point perspective drawing

1. Set yourself up to draw at your chosen site. You will need two chairs, one to sit on and one on which to lean your drawing board. If you are drawing outside, folding chairs are convenient. Make sure that you are directly facing your chosen view.

2. Clip your larger viewfinder and the plastic picture plane together. Draw a format edge on the plastic plane by running the felt-tip marker around the inside edge of the viewfinder opening. Closing one eye, move the viewfinder/plastic picture plane backward and forward, up and down, to find the best composition, the one you prefer.

3. Having found a composition you like, choose your Basic Unit. It should be of medium size and of a shape that is not too complicated. It might be a window or a picture on the wall or a doorway. It can be a positive form or a negative space. It can be a single line or a shape. Draw your Basic Unit directly on your plastic picture plane with your felt-tip marker (Fig. 8-15).

4. Set aside your viewfinder/plastic picture plane on a piece of white paper so that you can see what you have drawn on it.

Fig. 8-15.

Fig. 8-16. Draw the top of the doorway on your plastic Picture Plane. This is your Basic Unit.

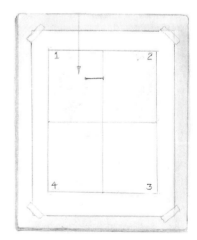

Fig. 8-17. Transfer your Basic Unit to your drawing paper, scaling it up because your drawing paper is slightly larger than your picture plane.

5. Transfer your Basic Unit onto the toned paper using your crosshairs as a guide. On both the picture plane and on your toned paper, the crosshairs divide the drawing area into four quadrants. Your drawing area will be the same shape but slightly larger, because your toned format is larger than the viewfinder opening. (You are scaling up.) See Figure 8-16.

If necessary, refer to Figures 8-15 and 8-16 for how to transfer your Basic Unit from your picture plane to your toned paper by using these quadrants.

A few remarks and reminders before you begin your drawing

For most people just learning to draw, the hardest part of drawing is believing their own sights of both angles and proportions. Many times I have watched students take a sight, shake their heads, take the sight again, shake their heads again, and, like my student doing the one-point drawing, even say out loud, "It (an angle) can't be that steep," or "It (a proportion) can't be that small."

With a little more experience in drawing, students are able to accept the information they obtain by sighting. You just have to swallow it whole, so to speak, and make a decision not to second-guess your sights. I say to my students, "If you see it, draw it. Don't argue with yourself about it."

Of course, the sights have to be taken as correctly and carefully as possible. When I demonstrate drawing in a workshop, students see me making a very careful, deliberate movement to extend my arm, lock my elbow, and close one eye in order to carefully check a proportion or an angle on the plane. But you will find that these movements very quickly become quite automatic, just as one quickly learns to brake a car to a smooth stop or to make a difficult left-hand turn.

Sometimes it is useful to go back to the picture plane to check on an angle or proportion "out there." To refind your composition, simply hold up your viewfinder/plastic picture plane, close one eye, and move the plane forward or backward until your Basic Unit "out there" lines up with the felt-tip drawing of your Basic

Strong emphasis on negative spaces strengthens drawings because it *unifies* spaces and shapes within the format. Unity is the premier element of good composition.

Strong emphasis only on *shapes* tends to disunify a composition, and, oddly, results in a boring image. It seems that we long for unity in artworks.

Fig. 8-18. Looking at the view you are drawing, with your thumb, mark on your pencil the width of your Basic Unit, the top of the doorway. This is your "One."

Unit on the plastic plane. Then check out any angle or proportion that may be puzzling you.

Now, complete your perspective drawing

1. Again, you will fit the pieces of your drawing together like a fascinating puzzle. Work from part to adjacent part, always checking the relationships of each new part to the parts already drawn. Also, remember the concept of edges as shared edges, with the positive forms and negative spaces fitted into the format to create a composition. Remember that all the information you need for this drawing is right there before your eyes. You now know the strategies artists use to "unlock" that visual information, and you have the correct tools (your picture plane and pencil) to help you.

2. Make sure that you use negative spaces as an important part of your drawing, as in Figure 8-22. You will add strength to your drawing if you use negative spaces to see and draw small items such as lamps, tables, signs with lettering, and so on. If

Fig. 8-19. Turn your pencil to vertical and measure "One to one ..."

Fig. 8-20. Drop your pencil down and measure again: "One to two ..."

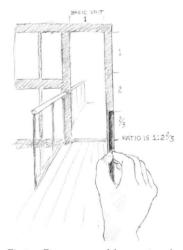

Fig. 8-21. Drop your pencil down again and measure again: "And two-thirds." Now you know the relationship of the width to length of the doorway. It is one to two and two-thirds, or 1:2⅔. Next, you need to get that relationship into your drawing.

Fig. 8-22. Demonstration drawing by the author.

Fig. 8-23. Lupe Ramirez

Fig. 8-24. Drawing by instructor Brian Bomeisler.

An open doorway is an excellent subject for a sighting drawing.

you focus only on the positive shapes, this will tend to weaken your drawing. If you are drawing a landscape, trees and foliage in particular are much stronger when their negative spaces are emphasized.

3. If you are working on a toned ground, you can focus on the lights and shadows once you have completed the main parts of the drawing. "Squinting" your eyes a bit will blur the details and allow you to see large shapes of lighted and shadowed areas. Again using your new sighting skills, you can erase out the shapes of lights and use your pencil to darken in the shapes of shadows. These shapes are sighted in exactly the same way that you have sighted the other parts of the drawing: "What is the angle of that shadow relative to horizontal? How wide is that streak of light relative to the width of the window?"

4. If any part of the drawing seems "off" or "out of drawing" (as such errors are called), check the troublesome area with your clear plastic picture plane. Look at the image on the plane (with one eye closed, of course) and alternately glance down at your drawing to double-check angles and proportions. Make any corrections that seem reasonably easy to make.

Fig. 8-25. From *The New York Times*,
© November 10, 2010, *The New York Times*.
All rights reserved. Used by permission and
protected by the copyright laws of the United
States. The printing, copying, redistribution,
or retransmission of the material without
express written permission is prohibited.

One can imagine artist Alex Eben Meyer
enjoying working on this challenging one-
point perspective drawing.

After you have finished

Congratulations! You have just accomplished a task that many
college art students would find daunting if not impossible.
Sighting is an aptly named skill. You take a sight and you see
things as they really appear on the picture plane. This skill will
enable you to draw anything you can see with your own eyes.
You need not search for "easy" subjects. You will be able to draw

anything at all. As Vincent van Gogh put it so well about learning perspective, "You need to know it just to draw the least thing."

The skill of sighting takes some practice to master, but very soon you will find yourself "just drawing," taking sights automatically, at times even without needing to measure proportions or assess angles. That is to say, you will find yourself successfully "eyeballing" some proportions—some of the easier ones, at least. But when you come to the difficult foreshortened parts, you will have just the skills needed to unlock those difficult angles and proportions.

The visible world is replete with foreshortened views of people, streets, buildings, trees, and diverse objects. Beginning students sometimes avoid these "difficult" views and search instead for "easy" views. With the skills you now have, this limiting of subject matter is unnecessary. Edges, negative spaces, and sightings of relationships work together to make drawing foreshortened forms not just possible—they become downright enjoyable. As in learning any skill, learning the "hard parts" is challenging and exhilarating. See Figure 8-25.

Looking ahead

Realistic drawing of perceived subjects is always the same, always requiring the same rock-bottom basic perceptual skills you are learning in this course, no matter what the subject. Differences are matters of mediums, subjects, surfaces, and sizes. The sighting techniques you have just learned are the same that artists use for difficult foreshortened views in figure drawing, still lifes, drawings of foreshortened animals, and so on. It is all the same, always requiring the same skills, no matter what the subject happens to be. Of course, this is true of other global skills. Once you can read, you can read anything in your native language. Once you learn to drive, you can drive any make of car. Once you can cook, you can follow any recipe. And once you can draw, you can draw anything that you see with your eyes.

Fig. 8-26. A fairly boring view of an industrial hallway becomes an intriguing one-point perspective drawing with a strong feeling of receding space.

We have now explored three important basic perceptual skills: seeing and drawing edges, spaces, and relationships of angles and proportions. Next, you will be drawing a profile portrait, putting to use your skills of perceiving edges, spaces, angles, and proportional relationships in drawing the human head, a most intriguing and challenging subject.

Fig. 8-27. You will find interesting two-point perspective compositions in unexpected places, as did student Cindy Ball-Kingston in this bedroom scene with its unmade bed.

Fig. 8-28. By toning your paper before you start, you can include some lights and shadows in your sighting drawing, as instructor Brian Bomeisler did in this two-point perspective exterior scene.

CHAPTER 9
DRAWING A PROFILE
PORTRAIT

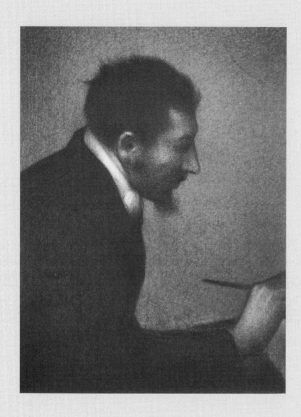

Georges Seurat (1859–1891), *Aman-Jean*, 1882–83. Conté crayon, 24 ½ x 18 ¹¹⁄₁₆ in. (62.2 x 47.5 cm). Bequest of Stephen C. Clark, 1960 (61.101.16). The Metropolitan Museum of Art, New York, NY, U.S.A. Image copyright © The Metropolitan Museum of Art/Art Resource, NY.

French artist Georges Seurat was just twenty-three when he drew this acclaimed profile portrait of his friend Aman-Jean, who was a fellow art student at the Ecole des Beaux-Arts in Paris. In his use of conté crayon, Seurat achieved tones from blackest black to pale gray, and then left the white of the paper untouched at the collar to complete a full range of values. The drawing is suffused with a sense of Aman-Jean's deep concentration, his expression one of silent focus as he worked with brush in hand. We also sense Seurat's empathy and tender regard for his friend.

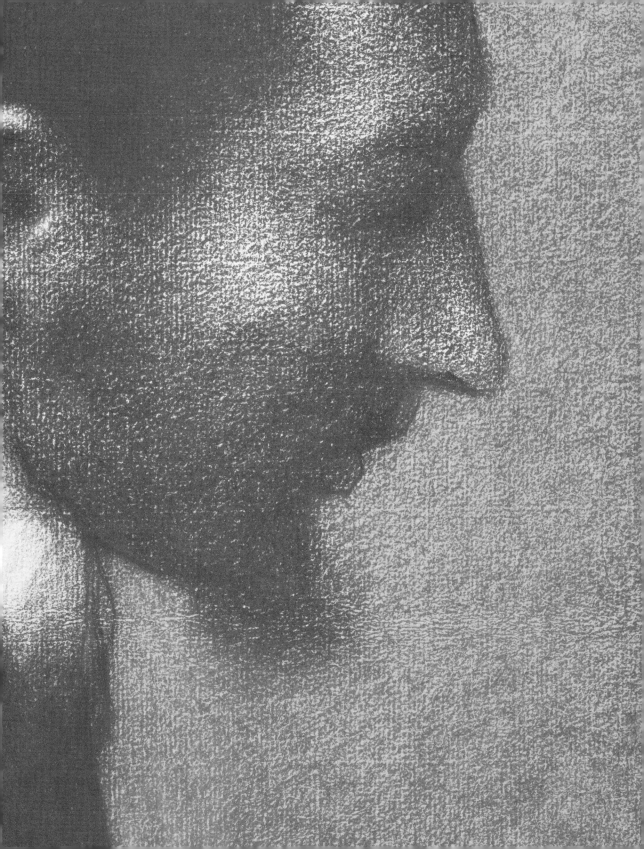

Drawing a perceived object or person is a global skill composed of five component sub-skills. So far, you have learned to see and draw:

- Edges, the shared contours of drawing
- Spaces, the negative spaces that share edges with the positive forms
- Relationships, of angles to vertical and horizontal, and proportions to each other

In this chapter, these three skills come together in a profile portrait drawing.

And the skill that doesn't require instruction:

- The *gestalt*, the perception that happens as a result of close observation—that the whole is greater than the sum of its parts, the aha of comprehension

A reminder of our main strategy: In order to set aside the dominant verbal left hemisphere, it is necessary to focus on visual information that does not fit the L-mode style of processing: upside-down images, complex edges, negative spaces, paradoxical angles, proportions, and lights and shadows.

Human faces have always fascinated artists. It is a challenging, inviting prospect to catch a likeness, to show the exterior in such a way that the inner person can be seen. Moreover, a portrait can reveal not only the appearance and personality (the *gestalt*) of the sitter but also the soul of the artist. Paradoxically, the more clearly the artist sees the sitter, the more clearly the viewer can see through the likeness to perceive the artist.

These revelations beyond the likeness are not intentional. They are simply the result of close, sustained observations, sifted through the persona of the artist. Therefore, because we are searching for your unique expression through the images you draw, you will be drawing human faces in the next exercises. The more clearly you see, the better you will draw and the more you will express yourself to others.

Since portrait drawing requires very precise perceptions in order to capture a likeness, faces are effective for teaching beginners in seeing and drawing. The feedback on the correctness of perception is immediate and certain, because we all know when a drawing of a human head is correct in its general proportions. And if we know the sitter, we can make even more precise judgments about the accuracy of the perceptions.

Because the right hemisphere is specialized for the recognition of faces, particularly for the melding of overall configuration with fine details, portrait drawing is particularly suitable for our strategy of gaining conscious access to right-hemisphere functions. People with right-hemisphere injury caused by a stroke or accident often have difficulty recognizing their friends or even recognizing their own faces in the mirror. Left-hemisphere-injured patients usually do not experience this deficit. Portrait drawing, therefore, may be particularly appropriate for accessing right-hemisphere functions.

Beginners often think that drawing people is the most difficult of all kinds of drawing. It isn't, actually. As with any other subject matter, the visual information is right there in front of your eyes. Again, however, the problem is in knowing how to see.

To restate a major premise of this book: drawing is always the same task—that is, every drawing requires the basic *seeing* skills you are learning. Aside from complexity, one subject is not harder or easier than another to draw.

Certain subjects, however, often *seem* harder than others, possibly because embedded symbol systems, which interfere with clear perceptions, are stronger for some subjects than for others. Portraits fall into this category. Most people have a very strong, persistent symbol system, retained since childhood, for drawing the human head. For example, a common symbol for an eye is two curved lines enclosing a small circle (the iris). Your own unique set of symbols for features, as we discussed in Chapter 5, was developed and memorized during childhood and is remarkably stable and resistant to change. These symbols actually seem to override seeing, and therefore few people can draw a realistic human head. Even fewer can draw recognizable portraits.

Summing up, then, portrait drawing is useful to our goals for four reasons. First, it is a suitable subject for accessing the right hemisphere, which is specialized for recognition of human faces and for making the fine visual discriminations necessary to achieve a likeness. Second, drawing faces will help you strengthen your ability to perceive edges, spaces, angles, and proportions, since all are integral to portraiture. Third, drawing faces is excellent practice in bypassing embedded symbol systems. And fourth, the ability to draw portraits with credible likenesses is a convincing demonstration to your ever-critical left hemisphere that you have—dare we say it?—innate drawing capability.

You'll find that drawing portraits is not difficult once you shift to your new way of seeing. By focusing intently on the skills you have learned so far, you will perceive and draw a likeness and the *gestalt* of your model—the unique character and personality behind the drawn image.

The importance of proportion in portrait drawing

All drawing involves proportional relationships, whether the subject is a still life, landscape, figure drawing, or portrait drawing. Proportion is important whether an artwork's style is realistic, abstract, or completely nonobjective (that is, without recognizable forms from the external world). But portrait drawing in particular depends heavily on proportional correctness. Therefore, realistic drawing is especially effective in training the eye to see the thing-as-it-is in its relational proportions. Individuals whose jobs require close estimations of size relationships—carpenters, dentists, dressmakers, carpet-layers, and surgeons—often develop great facility in perceiving proportion, just as you will as a result of learning to draw.

On believing what you think you are seeing: size constancy

One of the most surprising aspects of learning to draw is the discovery that your brain is changing incoming visual information to fit its preconceptions, and it isn't telling you what it is doing. You have to find out for yourself what is really out there. This phenomenon is called "visual constancy." There are several "constancies," but perhaps the most important for drawing are *size constancy* and

Fig. 9-1. The four figures are the same size.

shape constancy. Due to this phenomenon, we see familiar objects as having familiar sizes and shapes, regardless of whether they are nearby or far away. The actual perceptual truth that distance diminishes sizes and shapes can be accessed by "throwing a glitch into the system," meaning to insert an intervening device in order to assess the true sizes or shapes. For drawing, the intervening "glitch" is the artist's method of sighting, using our all-purpose tool, the pencil, to carefully measure and compare sizes and shapes on the picture plane.

Let me give you some examples of size and shape constancy. In each example, we'll use a measuring device as a "glitch" to unlock actual sizes and shapes. Figure 9-1 shows a diagrammatic landscape with four men. The man at the far right appears to be the largest of the four, but all four figures are exactly the same size. Cut a little measuring device (Figure 9-2) and test the validity of that statement. Even after measuring and proving to yourself that the figures are all the same size, however, you will probably find that the man on the right will still look larger (Figure 9-3).

If you turn this book upside down and view the drawing in the inverted orientation that sets aside the L-mode, you will find that you can more easily see that the figures are the same size. Upside down, the same visual information triggers a different

(Above) Fig. 9-2. Mark the size of one figure on a piece of paper.

(Right) Fig. 9-3. Cut out a notch the size of one figure and measure each of the figures by fitting it into the cut-out notch.

response. The brain, apparently now less influenced by the verbal concept of diminishing size in distant forms, allows us to see the proportion correctly. But when you turn the book right-side up, that far right figure will grow again, against your will.

The likely reason for this misperception comes from our past experience of the way distance affects the apparent size of forms: Given two objects of the same size, one nearby and one at a distance, the distant object will appear smaller. If they look the same size, the far object must be a great deal larger than the near object. This makes sense, and we don't quarrel with the concept. But coming back to the four-man image, it seems that the brain *enlarges* the far object to make the concept truer than true. This is overdoing it! And this is precisely the kind of overdoing—of changing the actual image into something different and not letting us know of the change—that causes beginning drawing students to have problems with proportion.

Two tables

One of the most jarring examples of the misperception of size *and* shape constancy is shown in Figure 9-4, a drawing of two tables by Roger N. Shepard, the renowned psychologist of perception

and cognition. If I say to you that the two tabletops are exactly the same shape and size, you no doubt will find that hard to believe. The best way to test that assertion is to trace with your felt-tip marker the tabletop on the left onto your clear plastic picture plane, and then slide the plane over the table on the right, shifting the position until the two tabletops line up. You will find that they are exactly the same size and shape. (Incidentally, Roger Shepard's *Two Tables* drawing is one of the rare illusion drawings that retains the illusion, whether right-side up or upside down.)

I have demonstrated this phenomenon of misperception to various groups. I show the drawing of the two tables using a projector and lay a precisely matching transparent plastic cutout (the "glitch") over the tabletop on the left. I then slide the clear plastic cutout over to the tabletop on the right, where it fits exactly, inevitably eliciting loud moans of disbelief from the audience. I once demonstrated this mind-bending illusion to a group of Disney animators. After the lecture, two of the artists came down to tell me (joking, of course) that they wanted to check out "that little piece of magic plastic" I had used.

Head sizes

Here is another example of the baffling misperceptions of size constancy. The next time you are in a crowd of people—in a lecture hall or a theater—look around and ask yourself if people's heads appear to be more or less all the same size. Then, roll up a piece of paper into a tube about an inch in diameter. Look through the tube (which has become an ad hoc measuring device) at a person fairly near you. Reroll the tube, if necessary, so that the person's head just fits the diameter of the tube. Then, keeping the tube at the same diameter, turn and look through the tube at a person's head far across the room. It may appear to be as small as one-quarter the size of the head near you. Yet, when you take the tube away and look at that person across the room, the head will instantly "jump up" in size to what we take for "normal."

Because the brain is actually changing the apparent size of things to match what the brain knows them to be, you cannot depend on what you think you are seeing. The brain knows that human heads are mostly about the same size, and it refuses to accept the actual reduction in perceptual size that distance causes. But here we confront a double paradox:

> *If you accept the brain's version and draw all the heads, near or distant, about the same size, the brain will sense that something is wrong with the drawing. But if you draw the proportions of heads perceptually correct—diminishing in size with distance—the brain will see them as usual, that is, all pretty much the same size.*

On not believing what you see

One last example: stand in front of a mirror at about an arm's distance away. How large would you say is the image of your head in the mirror? About the same size as your head? Using your felt-tip marker, extend your arm and make two marks on the mirror—one at the top of the reflected image (the outside contour of your head) and one at the bottom contour of your chin (Figure 9-5). Step to one side to see the size you have marked on the mirror. You'll find that it's about 4½ to 5 inches—half the true size of your head. Yet, when you remove the marks and look again at yourself in the mirror, it seems that the image must be life-size! Again, you are seeing what you believe and not believing what you have just discovered.

Drawing closer to reality

Once we have accepted that the brain is changing information and not telling us that it has done so, some of the problems of drawing become clearer, and learning to see what is actually out there in the real world becomes very interesting. Note that the perceptual phenomenon of constancy is probably essential to ordinary life. It reduces the complexity of incoming data and enables us to have stable concepts. The problems start when we try to see

Figure 9-5. Standing in front of a mirror at about arm's distance, the actual size of the image of your head in the mirror is only about half size, but this reduction in size is very difficult to see. Due to size constancy, your head convincingly appears to be its normal size.

what is really out there for purposes of checking reality, solving real problems, or drawing realistically. And it turns out that the brain is also changing visual sizes depending on whether what it is looking at seems interesting or important—or not! Again, this is overdoing it, and we need a way to discern reality.

The mystery of the chopped-off skull and the misplaced ear

In this introduction to drawing the profile, I concentrate on two critical relationships that are persistently difficult for beginning drawing students to perceive correctly: the location of eye level in relation to the length of the whole head, and the location of the ear in the profile view. I believe these are two examples of perceptual errors caused by the brain's propensity to change visual information to better fit its concepts.

In landscape drawing, the term "eye-level line" is used synonymously with "horizon line." In portrait drawing, "eye-level line" refers to where the eyes are located relative to the total length of the head. In adults, the eye-level line is almost invariably located *halfway* between the topmost visual edge of the skull/hair and the bottom edge of the chin bone. This proportion is very difficult to see because of a perceptual error related to size constancy.

Fig. 9-6. Instead of a 1-to-1 proportion of the lower half of the head to the upper half, the proportion in this student's drawing is about 1-to-¼.

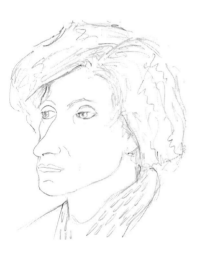

Fig. 9-7. With the student's permission, I traced only the lower half of the student's drawing. Then I enlarged the upper part of the head to the normal 1-to-1 proportion. As you see, along with a few other very minor corrections, the entire look of the drawing has changed.

The "chopped-off skull" error

Looking at human faces, most people think that the eyes are about one-third of the way down from the top of the head. The actual measure is one-half. I think this misperception occurs because the important visual information is in the features, not in foreheads and hair areas. Apparently, because the top half of the head is less compelling than the features, the features are perceived as larger and the top half is diminished. This error in perception results in what I've called the "chopped-off-skull error," my term for the most common perceptual error made by beginning drawing students (Figures 9-6, 9-7).

I stumbled on this problem at the university many years ago, while teaching a group of beginning drawing students. They were working on portrait drawing and one student after another had drawn the model with a "chopped-off" skull. I went through my usual questioning: "Can't you see that the eye-level line (an imaginary horizontal line that passes through the inside corners of the eyes) is halfway between the top edge of the hair and the bottom of the chin?" The students said, "No. We can't see that." I asked them to use their pencils to measure the location of eye level on the model's head, then on their own heads, and then on each other's heads. "Is the measure one to one?" I asked. "Yes," they said. "Well," I said, "now you can see on the model's head that the proportional relationship is one to one, isn't that true?" "No," they said, "we still can't see it." One student even said, "We'll see it when we can believe it."

This went on for a while until finally the light dawned and I said, "Are you telling me that you really can't see that relationship?" "Yes," they said, "we really can't see it." At that point I realized for the first time that brain processes were actually preventing accurate perception and causing the "chopped-off-skull" error. Once we all agreed on this phenomenon, the students were able to accept their measurements of the actual proportion, and soon the problem was solved. Now we must use our intervening "glitch," that is, *measurement by sighting*, to put your own brain into a logi-

cal box. You need to show it irrefutable evidence that will help it accept your sightings of the proportions of the head.

The top half of the head is important after all

Contrary to what one would expect, most students have few serious problems in learning to see and draw features on a human head. I have done some drawings (Figures 9-8 a, b, and c and 9-9 a, b, and c) to demonstrate how important it is to provide the full skull for the features—to *not* cut off the top of the head because

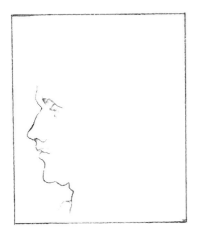

Fig. 9-8a. The features only.

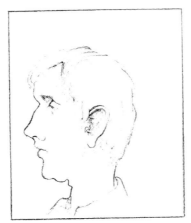

Fig. 9-8b. The cut-off skull error, using the same features.

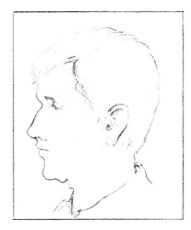

Fig. 9-8c. The same features again, this time with the full skull.

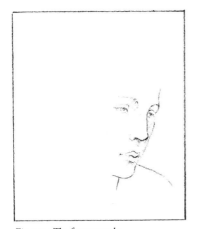

Fig. 9-9a. The features only.

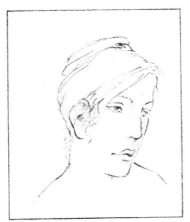

Fig. 9-9b. The cut-off skull error, using the same features.

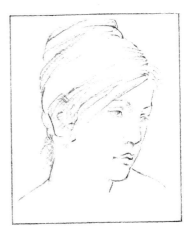

Fig. 9-9c. The same features again, this time with the full skull.

Fig. 9-10. Vincent van Gogh (1853–1890), *Carpenter*, 1880. Courtesy Rijksmuseum Kröller-Müller, Otterlo.

Van Gogh worked as an artist only during the last ten years of his life, from the age of 27 until he died at 37. During the first two years of that decade, van Gogh did drawings only, teaching himself how to draw. As you can see in the drawing of the carpenter, he struggled with problems of proportion. By 1882, however—two years later—in his *Old Man Reading*, van Gogh had overcome his difficulties with proportions.

your brain finds it less important and makes you see it as smaller. On the left side, I have drawn features only, without the rest of the skull. In the middle are the identical features with the cut-off-skull error. On the right are the identical features again, this time with the full skull in correct proportion to the features and the lower half of the head.

You can see that it's not the features that cause the problem of wrong proportion; it's the size of the features in relation to the

Fig. 9-11. Vincent van Gogh (1853–1890),
Old Man Reading, 1882. Van Gogh Museum
Amsterdam (Vincent van Gogh Foundation),
The Netherlands.

By December of 1882, two years later, the
artist had solved most of his problems with
proportion, including the proportions of
the head.

Fig. 9-12. Draw an oval (called a "blank") and divide it vertically with a line representing the "central axis."

skull. Turn to Figure 9-10 to see a clear example of the "chopped-off-skull" error in Vincent van Gogh's drawing (September 1881) of a carpenter. The drawing is from the period when the artist was struggling to learn to draw. By December of 1882, in his drawing "Old Man Reading," van Gogh had solved his many proportional problems, including the proportions of the head (Figure 9-11). Please take a few minutes to closely compare the two drawings.

Are you convinced? Is your logical left hemisphere convinced? Good. You will save yourself from making many basic mistakes in drawing!

1. Drawing a blank to help overcome the effects of size constancy. Please copy the oval shape as shown in Figure 9-12. This shape is called a "blank," used by artists in diagrams representing the front-view human skull. Draw a vertical line through the center of the blank, dividing the shape in half. This dividing line is called the *central axis*.

2. Next, locate the horizontal "eye-level line," which crosses the central axis at a right angle and places the eyes at half of the whole form. Check this correct placement of the eyes on your own head, as shown in Figure 9-13. Use your pencil to measure the distance from the inside corner of one eye to the bottom of your chin. Do this by placing the eraser end (to protect your eye) at the inside corner of one eye and

Fig. 9-13. On your own head, with your pencil, measure eye level to the bottom of your chin.

Fig. 9-14. Next, measure from your eye level to the top of your head. You will find that the axiom is valid: "Eye level to chin *equals* eye level to top of head."

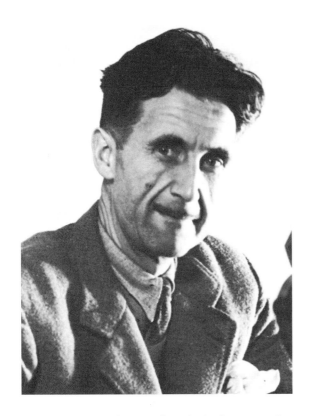

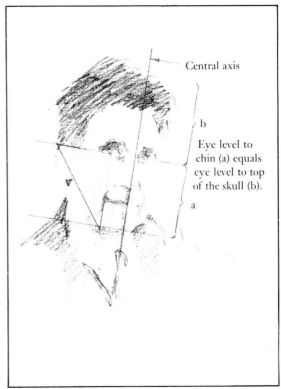

Central axis

b

Eye level to
chin (a) equals
eye level to top
of the skull (b).

a

Fig. 9-15.

marking with your thumb the bottom of your chin bone.
Next, holding that measurement as in Figure 9-14, raise the
pencil and compare the first measurement (eye level to chin)
with the measurement from your eye level to the top of your
head. It may help to feel across from the end of the pencil to
the topmost part of your head. You will find that those two
measurements are the same.

3. Repeat the measurement in front of a mirror. Regard
the reflection of your head. Try to see the one-to-one
relationship. Then use your pencil to repeat the measure-
ment one more time.

4. If you have newspapers or magazines handy, check the
proportion in photographs of people's heads, or check out
the photo of English writer George Orwell, Figure 9-15. Use
your pencil to measure. You will find that: *Eye level to chin*
equals *eye level to top of skull.* I suggest that you memorize

this as a rule. This is a proportion that almost never varies.

5. Turn on the television to a news program and measure the talking head right on the TV screen by placing your pencil flat on the screen, measuring first the eye level to chin, then the eye level to the top edge of the head. Now, take the pencil away and look again. Can you see the proportion clearly now?

When you finally believe what you see, you will find that on virtually every head you observe, the eye level is about the halfway mark. It is almost never less than half—that is, almost never nearer to the top of the skull than to the bottom of the chin. And if the hair is thick, as in the Orwell photograph, or is dressed high, the top half of the head—eye level to the topmost edge of the hair—is proportionally even *larger* than the bottom half.

The "chopped-off skull" creates the masklike effect so often seen in children's drawings, abstract or expressionistic art, and so-called primitive or ethnic art. This masklike effect of enlarging the features relative to the skull size, of course, can have tremendous expressive power, as seen, for example, in works by Picasso, Matisse, and Modigliani, and great works of other cultures. The point is that master artists, caricaturists, and cartoonists, especially of our own time and culture, use the device by choice and not by mistake. Later on, you may decide to make use of deliberately changed proportions, but for now you are training your eye to see what is really out there.

Drawing another blank and getting a line on the profile

Next, please copy a second blank, this time for the human head in profile (Figure 9-16). The profile blank is a somewhat different shape—like an oddly shaped egg—because the human skull, seen from the side, is a different shape than the skull seen from the front. In profile, the human skull is wider than in front view. It is easier to draw the blank correctly if you observe that the negative spaces are different from side to side in the lower half (Figure 9-16).

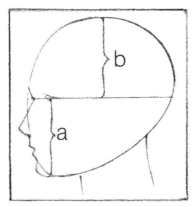

Fig. 9-16. A diagrammatic blank for the human head in profile.

Making sure that you have first drawn the eye-level line at the halfway point on the blank (measure it!), you may want to sketch in the features (see Figure 9-16). First, however, notice how *small* the features are relative to the whole shape of the head in profile. To compare the relationship, cover the features with one finger or with your pencil. You will see that the features are a tiny portion of the whole skull. This is a surprisingly difficult perception when observing people, and I believe the brain enlarges the features because they transmit the most important information.

The other most common error in drawing the profile: the misplaced ear

The next measurement is extremely important in helping you correctly perceive the placement of the ear, which in turn will help you correctly perceive the width of the head in profile and prevent chopping off the back of the skull.

When drawing a profile, most beginning students draw the ear too close to the features, and then misperceive the width of the skull, which is once more chopped off, this time at the back. (Look again at the van Gogh drawings, Figures 9-10 and 9-11, to see an example of the misplaced-ear problem in *Carpenter*, and its solution in *Old Man Reading*.) Again, the cause of this very common problem may be linked to the size constancy problem. Perhaps the brain views the expanse of cheek and jaw as uninteresting and boring, and therefore misperceives the width

I have personal knowledge of a case, many years ago, of a boy who was born without an ear on one side of his head. A plastic surgeon built an ear, but, incredibly, made the error of placing the ear too far forward—the same common perceptual error that so many of our beginning students make.

Also incredibly, to this day, training for most cosmetic plastic surgeons does not include basic perceptual skills in drawing.

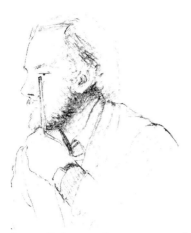

Fig. 9-17. To determine the correct position of the ear, start by measuring from your eye level to your chin with your pencil.

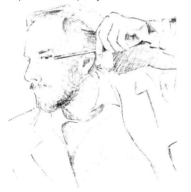

Fig. 9-18. Holding that measurement, next measure from the back of your eye to the back of your ear. These are equal measurements.

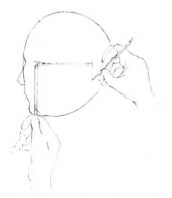

Fig. 9-19. By measuring, you have correctly placed the back of the ear. Placing the ear too far forward is a very common error.

of the space between the eye and the ear.

As before, intervening with measurement (sighting) and then *believing your sights* is the solution to this common problem. On your own head, use your pencil to again measure the length from the inside corner of one eye to the bottom of your chin (Figure 9-17). Now, holding that measurement, lay the pencil horizontally along your eye-level line (Figure 9-18) with the eraser end at the *outside corner of your eye.* You will find that the measurement coincides with the back edge of your ear. The position of the ear doesn't vary much from head to head. The *size* of ears varies quite a lot, but the position is almost invariable.

Memorize this mnemonic: *Eye level to chin equals back of eye to back of ear.* If you will learn this verbal reminder, it will save you from another stubborn problem in drawing the human head. It is not just that the distance is hard to see; it is that you *can't* see it because of (presumed) brain processes that are out of your control (Figure 9-19).

Visualizing an equal-sided right-angle triangle (an isosceles triangle) is another useful technique (and a more visual R-mode-style method) for correct placement of the ear. Since you now know that two measurements are equal—from eye level to chin equals back of eye to back of ear—you can visualize connecting these three points into an isosceles triangle, as shown in Figure 9-20. This is an easy way to place the ear correctly. The isosceles triangle can be visualized on the model. Going back to your profile blank, draw the isosceles triangle that marks the back of the ear. This visual reminder will also help to prevent many problems and errors in your profile drawings.

We need to make two additional measurements on the profile blank. Holding your pencil horizontally, just under one ear, slide the pencil forward as in Figure 9-21. You come to the space between your nose and mouth. This is the level of the bottom of your ear. Make a mark on the blank. (This is an approximate measurement, since ears vary in size.)

Next, we need to locate the bending point where the back of the neck meets the skull. This point is higher than you expect it to be (see Figure 9-22). In childhood drawing, a tiny neck is usually drawn directly under the oval of the head. This will cause problems in your drawing: the neck will be too narrow—look again at the middle drawings in Figure 9-8b and 9-9b on page 177. Check where the back of your neck meets your skull by holding your pencil horizontally just under your ear and sliding the pencil to the back of your neck. Nod your head up and down. You will come to the place where your skull and neck connect—the place that bends (see Figure 9-22). Mark this point on the blank.

You will need to practice these perceptions. Look at people. Try to see beyond the perceptual changes your brain is making. Practice perceiving the real proportions, the real relationships. Soon you will see that individual faces have almost identical pro-

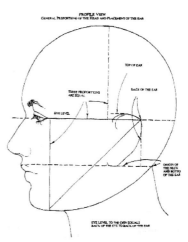

Fig. 9-20. Imaging an isosceles triangle ("Eye level to chin equals back of eye to back of ear.") will help you place the ear correctly.

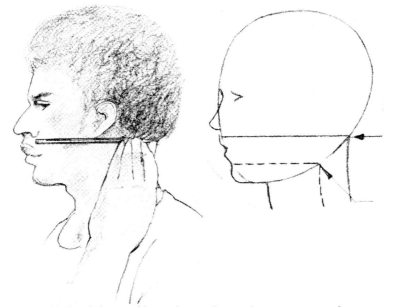

Correct point in relation to the facial features.

Fig. 9-21. To place the bottom of the ear relative to the features, put your pencil at the bottom of one ear and then slide it forward to determine where that point is relative to the features. This proportion varies greatly from person to person and must be checked on each model.

Fig. 9-22. A common error: misplacement of the point where the neck joins the skull. To place the bending point where the skull meets the neck, use your pencil to determine that point and then slide the pencil forward horizontally to determine the location of the bending point relative to the upper lip.

portions, yet are amazingly unique and varied in their details and overall configuration.

You are now well prepared to draw a profile portrait. You will be using all the skills you have learned so far:

· Focusing on complex edges and negative spaces until you feel the shift to an alternative state of consciousness, one in which your right hemisphere leads and your left hemisphere is quiet. Remember that this process requires an uninterrupted block of time.

· Assessing angles *on the plane* in relation to the vertical and horizontal crosshairs and the edges of the paper.

· Measuring relationships of sizes, also *on the plane*—how big is this form compared to that one?

· Believing your measurements and drawing what you see, without second-guessing your sights. Try to avoid mental judgments or labels about the face you are drawing.

· Setting aside any stored-and-memorized symbols from your childhood drawing.

· And finally, perceiving details such as features without changing or revising visual information to fit preconceptions about what parts are important. They are all important, and each part must be given its full proportion in relation to the other parts. This requires bypassing the brain's propensity to change incoming information without letting you know what it has done. Your sighting tool—your pencil—will enable you to "get at" the true perceptions. But you must agree to believe them.

If you feel that you need to review any of the techniques before you start to draw, turn to the previous chapters to refresh your memory. Reviewing some of the exercises, in fact, will help strengthen your new skills. A short session of Pure Contour Drawing is particularly useful in strengthening your newfound method of gaining access to your right hemisphere and quieting the left.

Making verbal judgments about your model's appearance can influence your perceptions and therefore your drawing.

I recall a student who was drawing a profile portrait of a male model. I came around to check her drawing and saw that the proportions were off: the lower part of the head was much too long relative to the upper part. I suggested that she sight the proportions and correct her drawing. I watched as she took the sights correctly. Then she erased the errors and started to redraw.

When I returned to check her drawing, I found that she had redrawn the same incorrect proportions. I asked, "Are you saying something to yourself about this model?"

She answered, "Well, he does have such a long face."

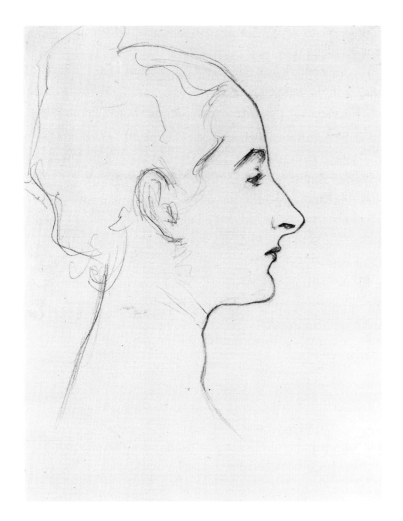

Figure 9-23. John Singer Sargent, *Mme. Pierre Gautreau*, 1883. The drawing for this exercise was a preparatory sketch by John Singer Sargent for a full-length portrait painting, titled "Madame X," of Virginie Avegno Gautreau, an American expatriate married to a Paris banker. She was considered a great beauty among the socialites of Paris in the 1880s.

When exhibited, the portrait created a scandal for reasons that seem quite tame now (a strap on her gown was shown as slightly fallen off her shoulder).

The scandal ended Sargent's career in Paris and soon after, he moved to London. Nevertheless, the artist considered the portrait his greatest masterpiece. In 1916, he sold it to the Metropolitan Museum of Art in New York, where it remains today.

A warm-up exercise

To illuminate for yourself the importance of edges, spaces, and relationships in portrait drawing, I suggest that you copy (make a drawing of) John Singer Sargent's beautiful profile portrait of Mme. Pierre Gautreau, which the artist drew in 1883 (Figure 9-23).

For centuries, copying masterworks was recommended as an aid to learning to draw. Beginning around the middle of the twentieth century, many art schools began to reject traditional teaching methods and copying master drawings went out of favor. Now, copying is coming back into favor as an effective means of

training the eye. It is, after all, the method by which the old masters themselves, as apprentices, learned to draw and paint.

I believe that copying great drawings is very instructive for beginning students. Copying forces one to slow down and really see what the artist saw. I can practically guarantee that carefully copying any masterwork of drawing will forever imprint the image in your memory. Therefore, because copied drawings become an almost permanent file of memorized images, I recommend that you copy only the work of major and minor masters of drawing. We are fortunate these days to have reproductions of great works readily available in books or for downloading from the Internet.

Please read all the instructions before you begin your exercise copy of Sargent's profile portrait of Mme. Pierre Gautreau, also known as "Madame X."

What you'll need:

- Your pad of drawing paper
- Your #2b writing pencil and #4b drawing pencils, sharpened, and your erasers
- Your plastic picture plane to use as a template for your format
- An hour of uninterrupted time

You will use your skills of seeing edges, spaces, and relationships in this drawing

1. As always in starting a drawing, first draw a format. Center your picture plane on your drawing paper and use your pencil to draw around the outside edges. Then, lightly draw crosshairs on your paper.
2. Since the original is a line drawing, do not tone your paper. Lights and shadows are not relevant in this exercise. Lightly draw the crosshairs.
3. Lay your clear plastic picture plane directly on top of the Sargent drawing and note where the crosshairs fall on the

portrait drawing. You will immediately see how this will help you in deciding on a Basic Unit and starting your copy of the drawing. You can check proportional relationships right on the original drawing and transfer them to your copy.

4. Choose your Basic Unit (the length of the ear, or the nose, or eye level to chin) as a starting shape or size and transfer it to your drawing. This will ensure that your drawing will be correctly sized within the format, and your Basic Unit will be your constant unit for comparing measurements.

In Figure 9-24, check the following perceptions, which are keyed to numbers 1 through 9 below. Remember that all edges, spaces, and shapes are located in relation to the crosshairs and the format edges, and all are sighted *on the plane*.

1. Where is the point where the forehead meets the hairline?
2. Where is the outermost curve of the tip of the nose?
3. What are the angles/curves of the forehead?

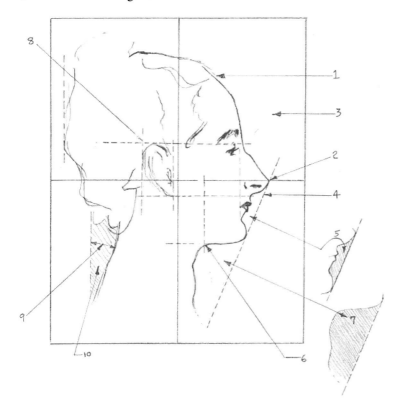

Fig. 9-24. Suggestions for steps in sighting proportions in Sargent's profile portrait of Madame Gautreau.

4. What is the negative shape next to the forehead/nose?
5. If you draw a line between the tip of the nose and the outermost curve of the chin, what is the angle of that line relative to vertical (or horizontal)?
6. What is the negative shape defined by that line?
7. Relative to the crosshairs, where is the curve of the front of the neck?
8. What is the negative space made by the chin and neck?
9. What is the position of the back of the ear, the bend of the neck, and the slant of the back?

Continue in this fashion, putting the drawing together like a jigsaw puzzle: where is the ear? How big is it relative to the crosshairs or to your Basic Unit? What is the angle of the back of the neck? What is the shape of the negative space made by the back of the neck and the hair? And so on. Compare all sizes to your Basic Unit. Draw just what you see, nothing more.

Observe how small an eye is relative to the nose, and then observe the size of the mouth relative to the eye. When you have unlocked the true proportions of the features relative to the whole form of the skull, I feel quite sure you will be surprised. In fact, if you lay down your pencil over the features, you will see what a small proportion of the whole form is occupied by the main features.

When you have finished, turn both the book and your drawing upside down. Compare the two drawings. Check for any errors in your copy of Sargent's drawing (you can see them more easily upside down), and make any necessary corrections.

Now, the real thing: a profile portrait of a person

Now you are ready to draw a real portrait of a person. You'll be seeing the wondrous complexity of contours, watching your drawing evolve from the line that is your unique, creative invention, and observing yourself integrating your skills into the drawing process. You will be seeing, in the artist's mode of seeing, the astounding thing-as-it-is, not a symbolized, categorized, ana-

lyzed, memorized shell of itself. Opening the door to see clearly what is before you, you will draw the image by which you make yourself known to viewers of your drawing.

If I were demonstrating the process of drawing a portrait profile, I would not be naming parts. I would point to the various areas and refer to features, for example, as "this form, this contour, this angle, the curve of this form," and so on. Unfortunately, however, for the sake of clarity in writing, I'll have to name the parts. The process may seem cumbersome and detailed when you read these written out as verbal instructions. The truth is that your drawing will seem like a wordless, antic dance, an exhilarating investigation, with each new perception miraculously linked to the last and to the next.

With that caution in mind about avoiding naming parts as you draw, read through all the instructions before you start and then try to do the drawing without interruption.

What you'll need:

1. Most important, you'll need a model—someone who will pose for you in profile view. Finding a model is not easy. Many people strenuously object to sitting perfectly still for any period of time. One solution is to draw someone who is watching television or reading a book. Another possibility is to catch someone sleeping—preferably upright in a chair, though that doesn't seem to happen very often!
2. Your clear plastic picture plane and your felt-tip marking pen.
3. Two or three sheets of your drawing paper, taped in a stack onto your drawing board.
4. Your drawing pencils and erasers.
5. Two chairs, one to sit on and one on which to lean your drawing board. See Figure 9-25 for setting up to draw. Note that it's also helpful to have a small table or a stool or even another chair on which to put your pencils, erasers, and other gear.
6. An hour or more of uninterrupted time.

What you'll do:

1. As always, start by drawing a format, using as a template the outside edge of your picture plane.

2. Lightly tone your paper. This will allow you to erase lighted areas and to add graphite for shadowed areas. (I give complete instructions for the fourth perceptual skill, perceiving lights and shadows, in the next chapter. You have already had some experience with "shading," however, and I find that my students greatly enjoy adding at least some lights and shadows to this exercise.) On the other hand, you may prefer to do a line drawing without toning the paper, as John Singer Sargent did in his profile portrait of Mme. Gautreau. Whether you tone the paper or not, be sure to add the crosshairs.

3. Pose your model. The model can be facing either right or left, but in this first profile drawing, I suggest that you place your model facing to your left if you are right-handed and to your right if you are left-handed. With this arrangement, you will not be covering up the features as you draw the skull, hair, neck, and shoulders.

4. Sit as close to your model as possible. Two to four feet is ideal, and this distance can be managed even with the intervening chair for propping up your drawing board. Check the setup again in Figure 9-25.

5. Next, use your plastic picture plane to compose your drawing. Close one eye and hold up the picture plane with a clipped-on viewfinder; move it backward and forward, up and down, until the head of your model is placed pleasingly within the format—that is, not too crowded on any edge and with enough of the neck and shoulders to provide "support" for the head. One composition you certainly don't want is one in which the model's chin is resting on the bottom edge of the format.

6. When you have decided on your composition, hold the plastic picture plane as steadily as possible. Next, choose a

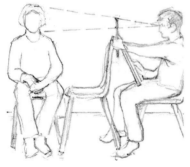

Fig. 9-25. A seating arrangement for doing a profile drawing.

Basic Unit—a convenient size and shape to guide proportions as you draw. I usually use the span from the model's eye level to the bottom of the chin. You, however, might prefer to use another Basic Unit—perhaps the length of the nose or the span from the bottom of the nose to the bottom of the chin (Figure 9-26).

7. When you have chosen your Basic Unit, use your felt-tip pen to mark the top and bottom of the unit on your plastic picture plane. Then, transfer those two marks of the Basic Unit to your drawing paper, using the same procedure that you have learned in previous exercises. You may need to review the instructions on page 158, Figures 8-15, 8-16, and 8-17. You may also want to mark on the plane the topmost edge of the hair and the back of the head at the point opposite eye level. You can transfer these marks to your paper as a rough guide for drawing the whole head (Figure 9-27).

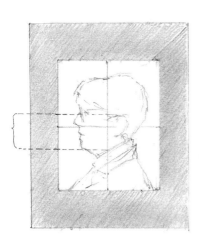

Fig. 9-26. Choose your Basic Unit, perhaps the distance from eye level to the bottom of the chin, or, for a smaller Basic Unit, from under the nose to the bottom of the chin.

Fig. 9-27. With your felt-tip pen, mark your Basic Unit on your picture plane and, if you wish, mark a few of the major proportions of the head of your model, such as the topmost edge of the hair, the back edge of the hair, and the back of the neck. Next, transfer the marks for your Basic Unit and any additional guiding marks to your drawing paper.

Fig. 9-28. By closing one eye and holding your pencil (on the plane), you can see the angle from the tip of the nose to the chin. This forms a small negative space that will help you see and draw the contours of the lower part of the face.

Figure 9-29. At this point, you can begin your drawing, confident that you will end up with the composition you have carefully chosen.

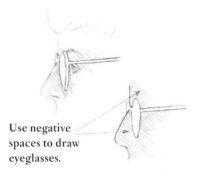

Use negative spaces to draw eyeglasses.

Fig. 9-30. To draw eyeglasses, see and draw the negative spaces surrounding the glasses. In profile view, glasses are an entirely different shape from the round shape you know them to be.

8. At this point, you can begin to draw, confident that you will end up with the composition you have so carefully chosen (Figure 9-29).

Again, I must remind you that although this starting process seems cumbersome now, later on it becomes so automatic and so rapid that you will hardly be aware of how you start a drawing. Allow your mind to roam over the many complicated processes you accomplish without thinking of the step-by-step methods: cracking and separating an egg yolk from the white; crossing a busy intersection on foot where there is no stoplight; setting a table for dinner. Imagine how many step-by-step instructions would be required for any of those skills.

In time, and with practice, starting a drawing becomes almost completely automatic, allowing you to concentrate on the model and on composing your drawing. You will hardly be aware of choosing a Basic Unit, sizing it, and placing it on the drawing paper. I recall an incident when one of my students realized that she "just started drawing." She exclaimed, "I'm doing it!" The same thing will happen to you—in time, and with practice.

9. Gaze at the negative space in front of the profile and begin to draw that negative shape. Check the angle of the nose relative to vertical. It may help to hold up your pencil vertically to check that shape, or you may want to use one of your viewfinders. Remember that the outside edge of the negative shape is the outer edge of the format, but to make a negative space easier to see, you may want to make a new, closer edge. See Figure 9-28 for how to check the angle formed by holding your pencil on the plane against the tip of the nose and the outermost curve of the chin.

10. You may choose to erase the negative space around the head. This will enable you to see the head as a whole, separated from the ground. On the other hand, you may decide to darken the negative spaces around the head or to leave the tone as it is, working only within the head. (See the demonstration drawings at the end of the chapter for examples.)

These are aesthetic choices—some of the many that you'll make in this drawing.

11. If your model wears glasses, use the *negative shapes* around the outside edges of the glasses (remembering to close one eye to see a 2-D image of your model). The glasses, seen from the side and *flattened* on the plane, appear to be totally different shapes than you know them to be (Figure 9-30).

12. Use the shape under the nostril as a negative shape (Figure 9-31).

13. Place the eye in relation to the innermost curve of the bridge of the nose. Check the angle of the eyelid relative to horizontal (Figure 9-32).

14. Check the angle of the centerline of the mouth (the edge where the lips meet). This is the only true edge of the mouth—the outside contours of the upper and lower lips only mark a color change. It's usually best to draw this color-change boundary lightly, especially in portraits of males. Note that, in profile, the angle of the centerline of the mouth—the true edge—often descends relative to horizontal. Don't hesitate to draw this angle just as you see it (Figure 9-32).

15. Using your pencil to measure (Figure 9-33), you can check the position of the ear (if it is visible). To place the ear in profile portrait, recall our mnemonic: *Eye level to chin equals back of eye to back of ear.* Remember also that this measure forms an isosceles triangle, which can be visualized on the model (Figure 9-34).

Fig. 9-32. Holding your pencil horizontally, check the descending angle of the upper lid and the angle of the centerline of the mouth, which in profile view often also descends.

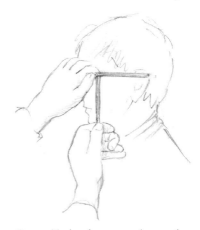

Fig. 9-33. To place the ear correctly, remember our mnemonic: "Eye level to chin *equals* eye level to back of ear."

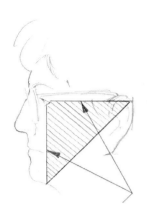

Fig. 9-34. Remember also that imaging the rule as an isosceles triangle is a reliable way to place the back of the ear.

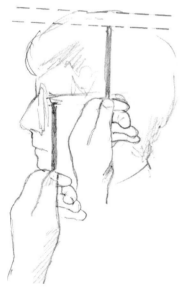

Fig. 9-35. Check the topmost height of the hair in relation to our other axiom, "Eye level to chin *equals* eye level to top of skull." Hair has thickness, which varies from model to model and therefore must be sighted for each model.

16. Check the length and width of the ear. Ears are nearly always bigger than you expect them to be. Check the size against the features of the profile (Figure 9-34).

17. Check the height of the topmost curve of the head—that is, the topmost edge of the hair or of the skull if your model happens to have a shaved head or thin hair (Figure 9-35).

18. In drawing the back of the head, sight as follows:

• Close one eye, extend your arm holding your pencil perfectly vertically, lock your elbow, and take a sight on eye level to chin.

• Next, holding that measure, turn your pencil to horizontal and check how far it is from the back of the eye to the back of the head. It will be 1 (to the back of the ear) and something more—perhaps 1:1.5 or even 1:2 if the hair is very thick. *Keeping that ratio in your mind, wipe the measurement off your pencil.*

• Then, turn back to your drawing to transfer the ratio. Using the pencil, *remeasure eye level to chin in the drawing.* Holding that measure with your thumb, turning your pencil to the horizontal position, measure from the back of the eye to the back of the ear, then to the back of the head (or hair). Make a mark. Perhaps you will not believe your own sights. If carefully taken, they are true, and your job is to believe what your eyes tell you. Learning to have faith in one's perceptions is one of the principal keys to drawing well.

19. In drawing your model's hair, what you want *not* to do is to draw hairs. Students often ask me, "How do you draw hair?" I think the question really means, "Tell me a quick and easy way to draw hair that looks good." But the answer to the question is, "Look carefully at the model's (unique) hair and draw what you see." If the model's hair is a complicated mass of curls, the student is likely to answer, "You can't be serious! Draw all of that?"

But it really isn't necessary to draw every hair and every curl. Your viewer wants you to express the character of the hair, particularly

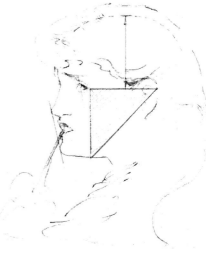

Fig. 9-37. Practice visualizing the isosceles triangle with Sandys's drawing, and note how far back the back edge of *Proud Maisie's* hair is. The ratio relative to the eye-level-to-chin measurement is about 1 to 1⅔.

Fig. 9-36. The artist's perception and depiction of *Proud Maisie's* hair are important to the drawing and contribute greatly to the viewer's enjoyment. Don't hesitate to take a bit of time in drawing your model's hair. Remember, the right brain has no sense of time passing and responds favorably to complexity.

Anthony Frederick Augustus Sandys (1832–1904), *Proud Maisie*. Courtesy Victoria and Albert Museum, London.

the hair closest to the face. Look for the dark areas where the hair separates and use those areas as negative spaces. Look for the major directional movements, the exact turn of a strand or wave. The right hemisphere, which loves complexity, can become entranced with the perception of hair, and the record of your perceptions in this part of a portrait can have great impact, as in *Proud Maisie* (Figure 9-36). To be avoided are the thin, glib, symbolic marks that spell out h-a-i-r on the same level as if you lettered the word across the skull of your portrait. Given enough

clues, the viewer can extrapolate and, in fact, enjoys extrapolating the general texture and nature of the hair.

Here are a few specific suggestions:

Take notice of the overall shape of the skull/hair and make sure that you have matched that shape in your drawing. Gaze at your model's hair with your eyes squinted to obscure details and to see where the larger highlights lie and where the larger shadows fall. Notice particularly the characteristics of the hair (wordlessly, of course, though I must use words for the sake of clarity). Is the hair crinkly and dense, smooth and shiny, randomly curled, short and stiff? Begin to draw the hair in some detail where the hair meets the face, transcribing the light-shadow patterns and the direction of angles and curves in various segments of the hair. (See the demonstration drawings at the end of this chapter for examples.)

20. Finally, to complete your profile portrait, draw the neck and shoulders, which provide a support for the profile head. The amount of detail of clothing is another aesthetic choice with no strict guidelines. The major aims are to provide enough detail to fit—that is, to be congruent with—the drawing of the head, and to make sure that the drawing of details of clothing adds to and does not detract from your drawing of the head. For an example, see Figure 9-36, *Proud Maisie.*

Some further tips

Fig. 9-38. Note that the eyelids have thickness. Also, the iris of the eye often triggers a strong, circular symbolic shape, even in a profile drawing. To avoid this error, first draw the white of the eye as a negative shape.

Fig. 9-39. Observe that eyelashes grow downward from the lid, then (sometimes) curve upward. Also, the upper lid slants back at an angle relative to horizontal. This angle varies from model to model.

Eyes: Observe that the eyelids have thickness. The eyeball is behind the lids (Figure 9-38). To draw the iris (the colored part of the eye), *don't* draw it. Instead, draw the shape of the white (Figure 9-38) as a negative space that shares edges with the iris. By drawing the (negative) shape of the white part, you'll get the iris right because you'll bypass your memorized symbol for iris. Note that this bypassing technique works for everything that you might find "hard to draw." Shift to the next adjacent shape or space and draw that instead, thus taking advantage of the "shared-

edges" method of drawing the "easy parts" and getting the hard parts for free.

Observe that the upper lashes grow first downward and then (sometimes) curve upward. Observe that the whole shape of the eye slants back at an angle from the front of the profile (Figure 9-39). This is because of the way the eyeball is set in the surrounding bony structure. Observe this angle on your model's eye (it will vary from model to model). This is an important detail.

Fig. 9-40. Use negative space in front of the neck to see the angle of the neck. The tendency is to draw the neck as a vertical edge, whereas the contour usually slants.

Neck: Use the negative space in front of the neck to perceive the contour under the chin and the contour of the neck (Figure 9-40). Check the angle of the front of the neck in relation to vertical. Make sure to check the point where the back of the neck joins the skull. This is often at about the level of the nose or mouth.

Collar: Don't draw the collar. Collars, too, are strongly symbolic. Instead, use the neck as negative space to draw the top of the collar, and use negative spaces to draw collar points, open necks of shirts, and the contour of the back below the neck, as in Figures 9-40 and 9-41. (This bypassing technique works, of course, because shapes such as the spaces around collars cannot be easily named and generate no symbols to distort perception.)

Fig. 9-41. Collars often trigger symbolic pointed forms. To avoid this error, draw the negative spaces around and under the collar.

After you have finished

Congratulations on drawing your first profile portrait! You are now using the perceptual skills of drawing with some confidence. Don't forget to practice seeing and sighting on faces that you encounter. Television is wonderful for supplying models for practice, and the TV screen is, after all, a "picture plane." Even if you can't draw these free models because they rarely stay still (unless you have the ability on your TV to "freeze frame"), you can practice eyeballing edges, spaces, angles, and proportions. Soon these perceptions will occur automatically, and you will be able to "see through" the size-constancy changes made by your brain.

Fig. 9-42. Another example of two styles of drawing. Instructor Brian Bomeisler and I sat on either side of Grace Kennedy, who is also one of our instructors, and drew these demonstration drawings for our students. We were using the same materials, the same model, and the same lighting.

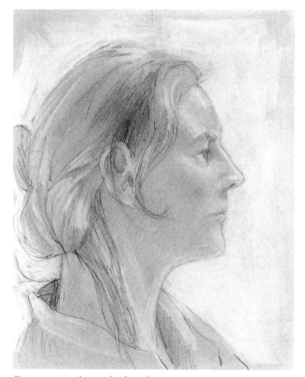

Demonstration drawing by the author.

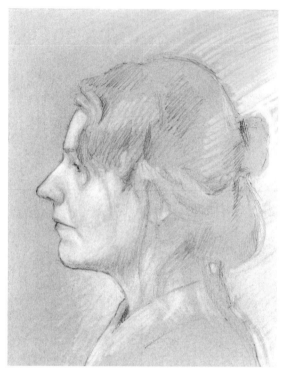

Demonstration drawing by instructor Brian Bomeisler.

Showing of profile portraits

Study these drawings. Notice the variations in styles of drawing. Check the proportions by measuring with your pencil.

Next, you will learn the fourth skill of drawing, the perception of lights and shadows. The main exercise will be a fully modeled, tonal, volumetric self-portrait and will bring us full circle to your "Before Instruction" self-portrait for comparison.

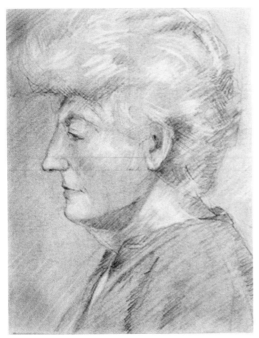

A drawing by Douglas Ritter.

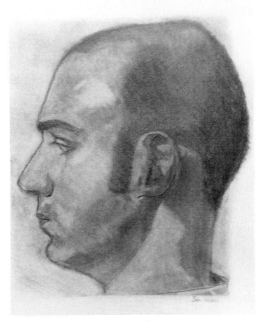

A drawing of Peter Boivin by Jennifer Boivin.

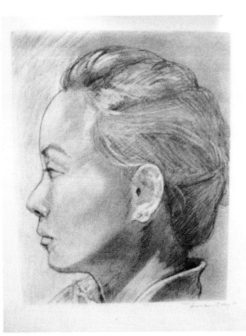

A student drawing by Tricia Goh.

A student drawing of Robin by Stephanie Bell.

Chapter 10
Perceiving Lights, Shadows, and the Gestalt

Rembrandt, *Self-Portrait with Loose Hair,* c. 1631, 145 × 117 mm. Collection Rijksmuseum, Amsterdam.

This self-portrait by Dutch artist Rembrandt van Rijn is an etching made by scratching lines on a metal plate that is then inked and used to make a print. The artist depicted the lights and shadows of his image almost entirely by using hatched lines. As you see, Rembrandt has portrayed his eyes as different in alignment, which some recent research suggests might have enhanced his exceptional powers of observation. Harvard researchers* have recently suggested that the misalignment might have had the same effect as closing one eye in order to remove binocular vision. The asymmetry of Rembrandt's eyes appears in nearly half of the artist's numerous self-portraits (over 80 paintings, etchings, and drawings), where both eyes are clearly depicted. These exceptional self-portraits reflect Rembrandt's unsparing self-observation and penetrating self-contemplation, so evident in this riveting etching.

Researchers found that in Rembrandt's painted and drawn self-portraits, the misaligned eye appears to be the right eye, but in the etchings, the left eye. The reason for the discrepancy is that an etching, printed from an etched plate, reverses the original drawing on the plate, which, like the paintings and drawings, results from looking in a mirror.

* Margaret S. Livingstone and Bevil R. Conway, "Was Rembrandt Stereoblind?" (Correspondence), *New England Journal of Medicine* 351 (12) (September 16, 2004), 1264–1265.

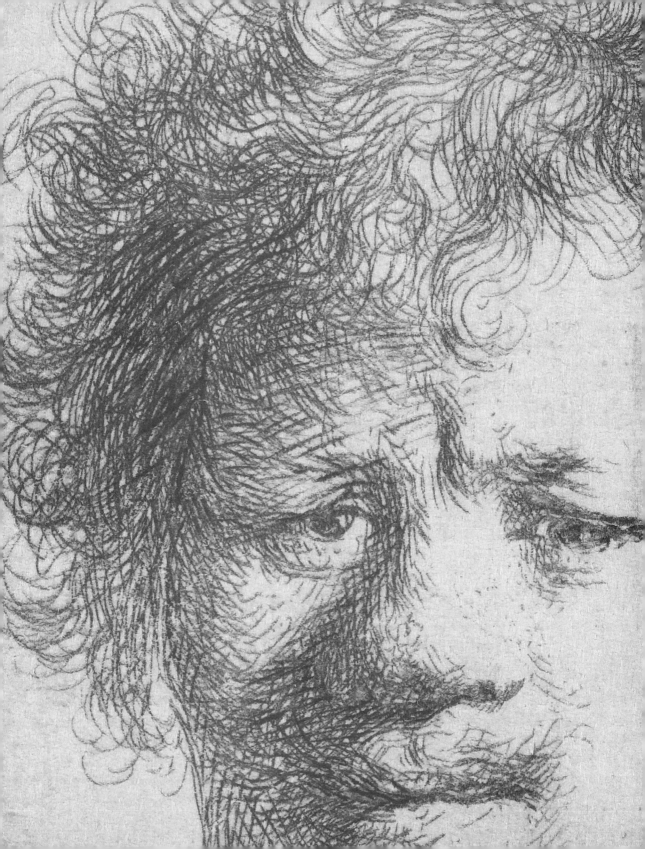

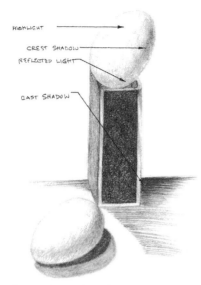

HIGHLIGHT

CREST SHADOW

REFLECTED LIGHT

CAST SHADOW

Fig. 10-1. Drawing by student Elizabeth Arnold.

Light logic. Light falls on objects and (logically) results in the four aspects of light/shadow:

1. *Highlight:* The brightest light, where light from the source falls most directly on the object.

2. *Cast shadow:* The darkest shadow, caused by the object's blocking of light from the source.

3. *Reflected light:* A dim light, bounced back onto the object by light falling on surfaces around the object.

4. *Crest shadow:* A shadow that lies on the crest of a rounded form, between the highlight and the reflected light. Crest shadows and reflected lights are difficult to see at first, but are the keys to "rounding up" forms for the illusion of 3-D on the flat paper.

Ideally (in my view), learning in art should proceed as follows: the perception of edges (line) leads to the perception of shapes (negative spaces and positive shapes), drawn in correct proportion and perspective (sighting). These skills lead to the perception of values (light logic), which leads to the perception of colors as *values*, which leads to painting.

Now that you have gained experience with the first three perceptual skills of drawing—**the perception of edges, spaces, and relationships**—you are ready to put them together with the fourth skill, **the perception of lights and shadows.** After the mental stretch and effort of sighting relationships, you will find that drawing lights and shadows is especially rewarding. This is a skill often most desired by drawing students. It enables them to depict three-dimensionality through the use of a technique students often call "shading," but in art terminology is called "light logic" (Figure 10-1).

This term means just what it says: Light falling on forms creates lights and shadows in a logical way. Look for a moment at Henry Fuseli's self-portrait (Figure 10-2). Clearly, there is a source of light, perhaps from a lamp. This light strikes the side of the head nearest the light source (the side on your left, as Fuseli faces you). Shadows are logically formed where the light is blocked, for example, by the nose. We constantly use this R-mode visual information in our everyday perceptions because it enables us to recognize the three-dimensional shapes of objects we see around us. But, like much R-mode processing, seeing lights and shadows remains below conscious level. We use the perceptions without "knowing" what we are seeing.

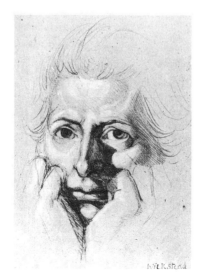

Fig. 10-2. Henry Fuseli (1741–1825), *Portrait of the Artist.* Courtesy Victoria and Albert Museum, London.

Find the four aspects of light logic in Fuseli's self-portrait.
1. *Highlights:* Forehead, cheeks, etc.
2. *Cast shadows:* Cast by the nose, lips, hands.
3. *Reflected lights:* Side of the nose, side of the cheek.
4. *Crest shadows:* Crest of the nose, crest of the cheek, temple.

The fourth basic component of drawing requires learning to consciously see and draw lights and shadows with all their inherent logic. This is new learning for most students, just as learning to see complex edges, negative spaces, and the relationships of angles and proportions are newly acquired skills, requiring new neural pathways in the brain. In this chapter, I will teach you how to see and draw lights and shadows to achieve "depth" or three-dimensionality in your drawings.

Seeing values

Light logic also requires that you learn to see differences in tones of light and dark. These tonal differences are called "values." Pale, light tones are called "high" in value, dark tones "low" in value.

A complete value scale goes from pure white at the top to pure black at the bottom,[21] with literally thousands of minute gradations between the two extremes of the scale. Artists usually use an abbreviated scale, sometimes with eight, sometimes with ten or twelve tones in evenly graduated steps between light and dark.

In pencil drawing, the lightest possible light is the white of the paper. (See the white areas on Fuseli's forehead, cheeks, and

21. Value scales are sometimes horizontal, usually with white at the left and black at the right.

In 2010, three researchers at University College London published a paper titled "Art Students Who Cannot Draw."* In the last paragraph, the authors suggest a solution to the problem:

"The teaching of complex tasks often requires the breaking down of rich, multidimensional tasks, such as singing, into their separate components (pitch, rhythm, reading of music, voice control, and breathing, etc.). A possibility raised by the present study is that art students may benefit from the explicit teaching of techniques for carrying out very low level copying skills, such as accurately representing angles and proportions."

I absolutely agree, since this way to teach drawing has been my life's work, starting with my 1979 edition of this book. The authors cite my book, but perhaps didn't read it.

In this chapter, we focus on the fourth "very low level" component skill of seeing and drawing lights and shadows. We add this to the first three basic component skills you have learned—how to see and draw:

+ Edges—shared contours
+ Spaces—negative spaces
+ Relationships—of angles and proportions
 And next:
+ Lights and shadows—"light logic"

The fifth and last basic component, the perception of the *gestalt*, does not require instruction. The *gestalt* simply emerges as comprehension of *the thing itself* or *the thingness of the thing*, resulting from intense focus on the parts that make up the whole, and the whole, which is greater than the sum of its parts.

Since the verbal, symbolic, analytic skills

mainly attributed to the left hemisphere are not appropriate for realistic drawing, *our main strategy* for accessing the visual, spatial skills of the right hemisphere is: **To present the brain with a task that the left hemisphere will turn down.**

* C. McManus, Rebecca Chamberlain, and Phik-Wern Loo, Research Department of Clinical, Educational and Health Psychology. In *Psychology of Aesthetics, Creativity, and the Arts*, 2010, Vol. 4, No. 1, 18–30.

nose.) The darkest dark appears where the pencil lines are packed together in a tone as dark as the graphite will allow. (See the dark shadows cast by Fuseli's nose and hand.) Fuseli achieved the many tones between the lightest light and the darkest dark by various methods of using the pencil: solid shading, crosshatching, and combinations of techniques. He actually erased many of the white shapes, using an eraser as a drawing tool (for instance, see the highlights on Fuseli's forehead).

The role of the R-mode in perceiving shadows

In the same curious way that the L-mode apparently will not deal with negative spaces, upside-down information, or the paradoxes of sighting, it seems also to turn down perceiving lights and shadows. I believe the reason for this refusal is that lights and shadows are ephemeral—if the model moves even slightly, all the lights and shadows change to *new and different* shapes. This makes them unnamable, and they cannot be categorized or generalized in any useful L-mode way. Thus, a focus on lights and shadows is another effective means for setting aside the left brain.

You will therefore need to learn to see lights and shadows at a conscious level. To illustrate for yourself how we *interpret* rather than *see* lights and shadows, look at Gustave Courbet's *Self-portrait*, Figure 10-3, presented both upside down and right-side up. Upside down, the drawing looks entirely different—primarily a pattern of dark areas and light areas. Now, look at it right-side up. You will see that the dark/light pattern seems to change and, in a sense, disappear into the three-dimensional shape of the head. This is another of the many paradoxes of drawing: if you draw the shapes of lighted areas and shadowed areas just as you perceive them, a viewer of your drawing will not notice those shapes. Instead, the viewer will wonder how you were able to make your subject so "real," meaning three-dimensional.

These special perceptions, like all drawing skills, are easy to attain once you have made a cognitive shift to the artist's mode of seeing. Research on the brain indicates that the right hemisphere,

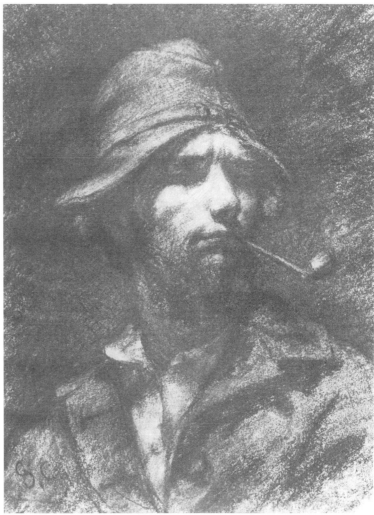

as well as being able to perceive the shapes of particular shadows, is also specialized for deriving meaning from patterns of shadows. Apparently, this derived meaning is communicated to the verbal system, which then names the image.

How does the R-mode accomplish the leap of insight required to know what these patterns of light and dark areas mean? Apparently, the R-mode is able to extrapolate from incomplete information to envision a complete image. The right brain seems undeterred by missing pieces of information and appears

Fig. 10-4.

to delight in "getting" the picture, despite its incompleteness. Look, for example, at the patterns in Figure 10-4. In each of the drawings, notice that first you see the black/white pattern, then you perceive what it is.

Patients with right-hemisphere brain injuries often have great difficulty making sense of complex, fragmentary shadow patterns such as those in Figure 10-4. They see only random light and dark shapes. Try turning the book upside down to approximate seeing the patterns as these patients do—as unnamable shapes. Your task in drawing is to see the shadow-shapes in this way even when the image is right-side up, while holding at arm's length, so to speak, your knowledge of what the shapes mean.

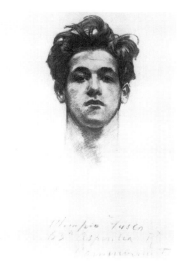

Figure 10-5. John Singer Sargent, (1856–1925), *Olimpio Fusco, c. 1905–15.* Courtesy The Corcoran Gallery of Art, Washington, D.C. A full-face or frontal view.

Fig. 10-6. Berthe Morisot (1841–1895), *Self-Portrait, c. 1885.* Courtesy The Art Institute of Chicago. A full-face or frontal view.

The three basic portrait poses

In portrait drawing, artists have traditionally posed their models (or themselves in self-portraits) in one of three traditional views:

 * Full face or frontal view: The artist faces the model directly (or, for a self-portrait, faces a mirror) with both sides of the face fully visible to the artist. See the Sargent portrait of Olimpio Fusco, Figure 10-5, and the Morisot self-portrait, Figure 10-6.

 * Profile or side view: This is the view you drew in the last chapter. The model faces toward the artist's left or right and only one side (one half) of the model's face is visible to the artist. Profile self-portraits are relatively rare, perhaps due to the complication of setting up multiple mirrors.

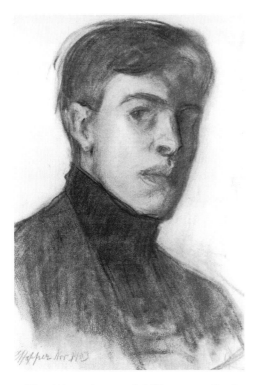

Fig. 10-7. Edward Hopper (1882–1967), *Self-Portrait*, 1903. Conté crayon on white paper. Courtesy National Portrait Gallery, Smithsonian Institution. A three-quarter view. The artist shadowed the left side of his head to an almost even tone, yet the viewer "sees" the left eye that is barely suggested.

Figure 10-8. Dante Gabriel Rossetti (1828–82), *Jane Burden, Later Mrs. William Morris, as Queen Guinevere*. Courtesy The National Gallery of Ireland, Dublin. A three-quarter view that is almost a profile view, but is still termed a three-quarter view.

• Three-quarter view: The model makes a half-turn toward the left or right, making visible three-quarters of the model's face—the profile (one half) plus the quarter-face visible on the turned side, thus the "three-quarter" designation. See the Hopper self-portrait, Figure 10-7.

Note that the full-face and profile views are relatively invariant, while the three-quarter view can vary from an almost profile to an almost full-face pose and still be called a "three-quarter view." See the Rossetti portrait of Jane Burden, Figure 10-8.

Taking the next step

We are relying on the skills you've developed with the first three components to learn the fourth, lights and shadows. For this process to work, you will call on your skills of seeing edges, where lights change into shadows, seeing shapes of lights and shadows as positive and negative shapes, and seeing the angles and proportions of lights and shadows. In this lesson, all of the basic skills work together as a whole, or "global," skill.

More than the other components, this fourth skill apparently strongly triggers the brain's ability to envision a complete form from incomplete information (as you saw in the black/white patterns in Figure 10-4). By suggesting a form with light/shadow shapes, you can cause a viewer to see something that is not actually there, and the viewer's brain apparently always gets it right. If you provide the right clues, your viewers will see marvelous things that you don't even have to draw!

For a wonderful example of this phenomenon, look again at the *Self-Portrait* by Edward Hopper (Figure 10-7). In this three-quarter pose, the artist strongly lighted one side of his face and left the other side in deep shadow. If you turn the image upside down, you will see that there is almost no change in the even tone of the shadowed side. Yet, right-side up, the eye in shadow seems to be there, and we even see the expression in that eye that isn't there.

An even more striking example of this light/shadow magic is Edward Steichen's 1901 photographic *Self-Portrait with Brush*

Fig. 10-9. Edward Steichen (1879–1973), *Self-Portrait with Brush and Palette*, 1901, printed 1903. Photograph, Photogravure, Unframed, 8 7/16 x 6 3/8 in., Los Angeles County Museum of Art, The Audrey and Sydney Irmas Collection, permission of the Estate of Edward Steichen, digital image © Museum Associates/LACMA/Art Resource, NY. A superb example of light/shadow magic.

and Palette, Figure 10-9. The logic of light tells us that Steichen arranged a focused light above and to his left, leaving the right side of his face and his left eye, shadowed by his brow ridge, in deep shadow. The shapes of these shadows carve the features in three dimensions. Even though we see no details, we are able to *envision* the features and the expression on the face. They seem more real than real, because the interpretation is triggered in the brain.

The truth is, by giving only the slightest clues in a light/shadow drawing, you can cause your viewer to complete the

Fig. 10-10. A detail of the Steichen *Self-Portrait*.

There is an amusing saying in art circles that every artist needs someone standing behind them with a sledgehammer to let the artist know when to stop.

image, and your viewer's right hemisphere will be delighted to enter this collaboration. Learning this "trick of the artist" involves imaging: as you are drawing, you will occasionally squint your eyes to see if you can yet "see" the form you intend. And when you "see" it—that is, when the clues are sufficient to trigger the envisioned image—stop! So many times in workshops, watching a student draw lights and shadows, I find myself urgently saying, "Stop! It's there. You've got it!"

To practice this game of lights and shadows, I suggest that you make a copy of a detail of the Steichen three-quarter self-portrait—just the head, as shown in Figure 10-10. But first, I need

Fig. 10-11. The full-face view diagram. Note that this diagram is only a general guide to proportions that vary from head to head. The differences, however, are often very slight and must be carefully perceived and drawn to achieve a likeness.

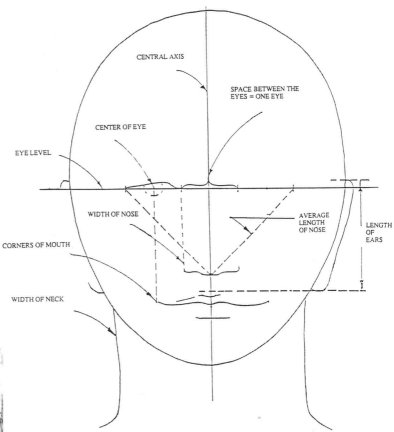

FULL VIEW
GENERAL PROPORTIONS OF THE HUMAN HEAD - USE AS A GUIDE TO PROPORTIONS

CENTRAL AXIS

SPACE BETWEEN THE
EYES = ONE EYE

CENTER OF EYE

EYE LEVEL

WIDTH OF NOSE

AVERAGE
LENGTH
OF NOSE

LENGTH
OF
EARS

CORNERS OF MOUTH

WIDTH OF NECK

EYE TO THE CHIN = EYE TO THE TOP OF THE SKULL

Fig. 10-12. Note that even though the head is tilted and the central axis is tilted, the eye-level line is horizontal, skewing the features. Vincent van Gogh (etching, 1890). Courtesy National Gallery of Art, Washington, D.C., Rosenwald Collection. An interesting example of the expressive effect of skewed features.

2

Fig. 10-13. No matter how you may tilt your head, the central axis and eye-level line remain at right angles.

Fig. 10-14. A diagram of the skewing in the Van Gogh drawing.

to provide you with some brief instructions on the proportions of the head in full frontal view and in three-quarter view. All the proportions laid out below can be simply sighted, of course, but our students have found it helpful to have some guidance. It is important to remember that size constancy and shape constancy are in play here, and some of these proportions are difficult to see correctly.

The frontal view

Keeping this book open to the diagram, Figure 10-12, sit in front of a mirror with the book, a piece of paper, and a pencil. You are going to observe and diagram the relationships of various parts of your own head. *Note that the mirror becomes your picture plane.* Stop a moment to think that through—I'm sure you will see the logic of it. Your image is flattened on the surface of the mirror, and if you are sitting close enough, you can take sights of angles and proportions directly on the mirror.

1. Looking at your own face in the mirror, visualize a central axis that divides your face and observe that your eye-level line is at right angles to the central axis. Tip your head to one side, as in Figure 10-13. Notice that the central axis and the eye-level line remain at right angles no matter what direction you tip your head. (This is only logical, I know, but many people ignore this fact and skew the features, as in the van Gogh etching, Figures 10-12 and 10-14.)

2. First, draw a blank (an oval shape) on your paper and draw the central axis dividing the diagram (see Figure 10-11). Then, observe and use your pencil to measure on your own head the eye-level line (see Figures 9-13 and 9-14 on page 180). The measurement will be halfway. On the blank, draw an eye-level line. Be sure to measure to ensure that you make this placement accurately in your drawing.

3. Observe in the mirror: what is the width of the space between your eyes, compared to the width of one eye? Yes, it's the width of one eye. Divide the eye level approximately into fifths, as shown in Figure 10-11. Mark the inside and outside

corners of each eye. The space between the eyes varies slightly from face to face, but only slightly. A discrepancy of only ¼ inch can be judged as "very close-set" or "very wide-set" eyes.

4. Observe your face in the mirror. Between eye level and chin, where is the end of the nose? This is the most variable of all the features of the human head. You can visualize an inverted triangle on your own face, with the wide points at the outside corners of your eyes and the center point at the bottom edge of your nose. This method is quite reliable. The inverted triangle of your nose length may be different (shorter or longer) from the generic one shown in Figure 10-11. Draw the triangle.

5. Where is the level of the centerline of the mouth? About a third of the way between the nose and chin. Make a mark on the blank. Again, this proportion will vary from face to face.

6. Observe your face in the mirror. If you drop a line straight down from the inside corners of your eyes, what do you come to? The outside edges of your nostrils. Noses are wider than you expect. Mark the blank.

7. If you drop a line straight down from the center of the pupils of your eyes, what do you come to? The outside corners of your mouth. This proportion also varies, but in general, mouths are wider than you expect. Mark the blank.

8. If you move your pencil along a horizontal line on the level of your eyes, what do you come to? The tops of your ears. Mark the blank.

9. Coming back from the bottoms of your ears, in a horizontal line, what do you come to? In most faces, the space between your nose and mouth. Ears are bigger than you expect. Mark the blank.

10. Feel on your own face and neck: how wide is your neck compared to the width of your jaw just in front of your ears? You'll see that your neck is almost as wide—in some men, it's as wide or wider. Mark the blank. Note that necks are also wider than you expect.

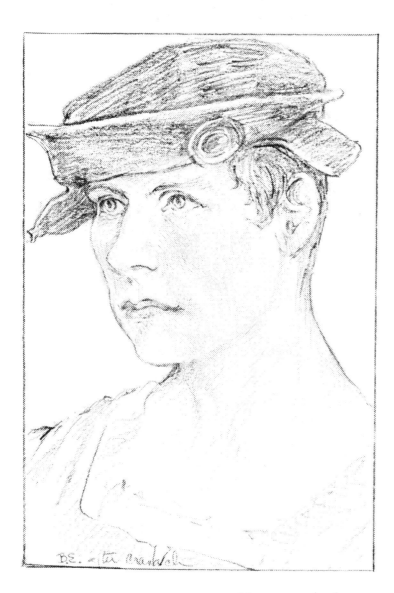

Fig. 10-15. A sketch by the author from a three-quarter-view portrait by the German artist Lucas Cranach (1472–1553), *Head of a Youth with a Red Cap.*

11. Now test each of your perceptions on people, photographs of people, and images of people on the television screen. Practice observing often—first without measuring and then, if necessary, corroborating by measuring. Practice perceiving relationships between this feature and that, perceiving the unique, minute differences between faces. Seeing, seeing, seeing. Eventually, you will have memorized the general measurements given above and you won't have to analyze in the

left-hemisphere mode as we have been doing. But for now, it's best to practice observing specific, individual faces while keeping in mind the general guide to proportions.

Now we'll turn to the three-quarter view

Artists of the Renaissance loved the three-quarter view, once they had finally worked through the problems of the proportions. I hope you will choose this view for your self-portrait. It's somewhat complicated, but fascinating to draw.

Young children rarely draw people with heads turned to the three-quarter view. Nearly always, they draw either profiles or the full, frontal view. Around the age of ten or so, children begin to attempt three-quarter-view drawings, perhaps because this view can be particularly expressive of the personality of the model. The problems young artists encounter with this view are the same old problems. The three-quarter view brings visual perceptions into conflict with the symbolic forms for profile and full-face views developed throughout early childhood, views which by age ten are embedded in memory.

What are those conflicts? First, as you see in Figure 10-15, the nose is not the same as a nose seen in frontal view. In three-quarter view, you see the top and the side of the nose, making it seem *very* wide at the bottom. Second, the two sides of the face are different widths—one side narrow, one side wide. Third, the eye on the turned side is narrower and shaped differently from the other eye. Fourth, the mouth from its center to the corner is shorter on the turned side and shaped differently from the mouth on the near side of the central axis. These perceptions of *non-matching* features conflict with memorized symbols for features, which are nearly always symmetrical.

The solution to the conflict is, of course, to draw just what you see on the mirror/picture plane, without questioning why it is thus or so and without changing the perceived forms to fit with a memorized-and-stored set of symmetrical symbols for features. The key is always to see the thing-as-it-is in all its unique and

Fig. 10-16. First, see this whole area as a shape.

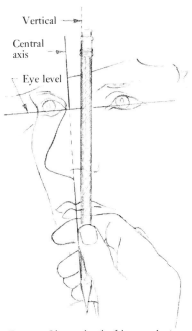

Fig. 10-17. Observe the tilt of the central axis compared to vertical (your pencil). The eye-level line is at a right angle compared to the central axis.

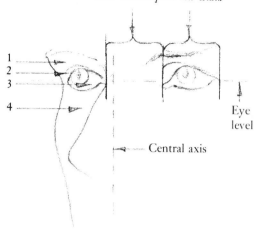

This width *equals this width*

1
2
3
4

Eye
level

Central axis

Fig. 10-18. A step-by-step diagram for drawing the eye on the turned side, and a diagram of the equal width of the near-side eye to the distance to the edge of the nose.

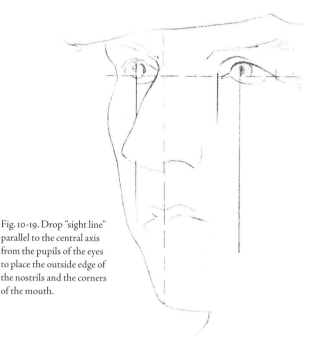

Fig. 10-19. Drop "sight line" parallel to the central axis from the pupils of the eyes to place the outside edge of the nostrils and the corners of the mouth.

marvelous complexity. But my students have found it helpful if I point out some specific aids to seeing the three-quarter proportions. Let me again take you through the process step-by-step, giving you some methods for keeping your perceptions clearly in mind. Again, note that if I were demonstrating the three-quarter-view drawing, I would not be naming any of the parts, only pointing to each area. When you are drawing, do not name the parts to yourself. In fact, try not to talk to yourself at all while drawing.

Using the mirror as the picture plane

1. Again, sit in front of a mirror with paper and a pencil. Sit close enough that you can sight measurements right on the mirror surface. Pose your head by starting with a full, frontal view and then turning (either left or right) until the tip of your nose nearly coincides with the outer contour of the turned cheek, as in Figure 10-18. You can see that this forms an enclosed shape. You are now seeing one full half plus one-

quarter of your face—in other words, a classic three-quarter view seen flattened on the mirror/picture plane.

2. Observe your head. Perceive the central axis—that is, an imaginary line that passes through the very center of the face. In three-quarter view (and also in frontal view), the central axis passes through two points: a point at the center of the bridge of the nose and a point at the middle of the upper lip. Imagine this as a thin wire that passes right through the form of the nose (Figure 10-17). By holding your pencil vertically at arm's length toward your reflection in the mirror, check the angle or tilt of the central axis of your head. You may have a characteristic tilt to your head, or the axis may be perfectly vertical.

3. Next, observe that your eye-level line is at right angles to the central axis. This observation will help you avoid skewing the features (Figure 10-17). Measure the position of eye level on your head and observe again that your eye-level line is at the halfway point of your whole head. Remember, your reflected image is *flattened* on the mirror/picture plane, so you needn't close one eye.

4. Now, practice making a line drawing of a three-quarter view on your scratch paper. You will be using the method of modified contour drawing: drawing slowly, directing your gaze at edges, and perceiving relational sizes, angles, etc. Again, you can start anywhere you wish. I tend to start with the shape between the nose and the contour of the turned side of the cheek because that shape is easy to see, as in Figures 10-16 and 10-17. Note that this shape can be thought of as an "interior" negative shape—a shape you have no name for.

5. Direct your eyes to the shape and wait until you can see it clearly. Draw the edges of that shape. Because the edges are shared, you will have also drawn the edge of the nose. Inside the shape you have drawn is the eye with the odd configuration of the three-quarter eye. Remember: to draw the eye, don't draw the eye. Draw the shapes around the eye. You may

want to use the order 1, 2, 3, 4 as shown in Figure 10-18, but any order will work as well. First the shape over the eye (1), then the shape next to it (2), then the shape of the white part of the eye (3), then the shape under the eye (4). Try not to think about what you are drawing. Just see and draw each shape.

6. Next, locate the correct placement of the eye on the side of the head closest to you. In the mirror, observe on your head that the inside corner lies on the eye-level line. Note espe cially how far away this eye is from the edge of the nose. This distance is nearly always equal to the full width of the eye on the near side of your head. Be sure to look at Figure 10-19 for this proportion. The most common error students make in the three-quarter view is to place the eye too close to the nose. This error throws off all the remaining proportions and can spoil the drawing. Make sure that you see (by sighting) the width of that space and draw it as you see it. Incidentally, it took the early Renaissance artists half a century to work out this particular proportion. We benefit, of course, from their hard-won insights (See Figures 10-7 and 10-8).

7. Next, the nose. Check on your image in the mirror where the edge of the nostril is in relation to the inside corner of the eye. Drop a line straight down (this is called a "sight line"), parallel to the central axis (Figure 10-19). Remember that noses are bigger than you think—just draw the bottom of the nose and the nostril as you see it.

8. Observe where the corners of your mouth lie in relation to the eye (Figure 10-19). Then observe the centerline of the mouth and the exact curve. This curve is important in catch- ing your expression. Don't talk to yourself about this. The visual perceptions are there to be seen. Try to draw precisely what you see—exact edges, spaces, angles, proportions, lights, and shadows. Accept your perceptions without second- guessing them.

9. Observe the upper and lower edges of your lips, remember-

ing that the slight color change defining the upper and lower lips is usually depicted with a light line because these are not true edges or strong contours.

10. On the turned side of your head, observe the shapes of the spaces around the mouth. Again, note the exact curve of the centerline where the lips part. This contour will be different on each side of the central axis (Figure 10-15).

11. Placing the ear. The mnemonic for placing the back edge of the ear in profile view must be slightly changed to account for the turn of the head in three-quarter view.

Mnemonic for the Profile View:
*Eye level to chin = **back** of eye to back of ear*

becomes

Mnemonic for the Three-quarter View:
*Eye level to chin = **front** of eye to back of ear*

You can perceive this relationship by measuring it on your reflection in the mirror. Next, note the location of the top of the ear, and then the bottom (see Figure 10-15).

A warm-up exercise: a copy of a detail of the Steichen self-portrait

Imagine that you are honored by a visit from the famous photographer Edward Steichen and that he has agreed to sit for a portrait drawing. The artist is in a rather serious mood, quiet and thoughtful (see Figure 10-10, page 211).

Imagine further that in a darkened room, you have arranged a spotlight so that it shines from above and slightly to the left of Steichen, illuminating the top of his forehead, but leaving the eyes and more than half of the face in deep shadow. Take a moment to consciously see how the lights and shadows logically fall relative to the source of light. Then turn the book upside down to see the shadows as a pattern of shapes. The wall behind is slightly lighted, silhouetting the dark head and shoulders of your model.

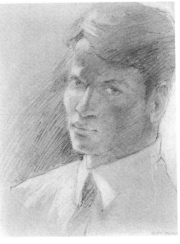

Fig. 10-20. A three-quarter demonstration portrait of model R. Bandalu by the author. Check out the proportions, placement of the features, and placement of the ear, and note the tilted central axis and the eye level at right angles.

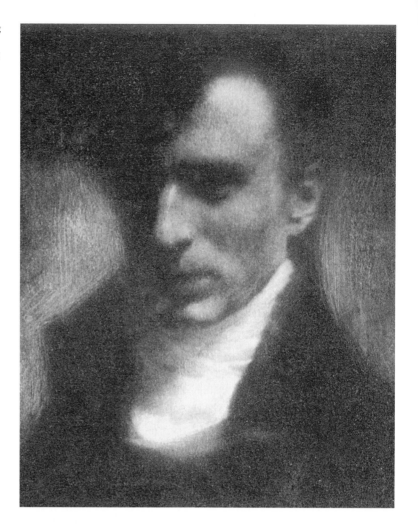

Fig. 10-21. For practice in working with strong light-shadow patterns, before drawing your own self-portrait, I suggest that you copy this detail of the Steichen *Self-Portrait*.

What you'll need:

1. Your #4b drawing pencil
2. Your erasers
3. Your clear plastic picture plane
4. A stack of three or four sheets of drawing paper taped to your drawing board
5. Your graphite stick and some paper napkins

What you'll do:

Please read through all the instructions before starting.

1. As always, draw a format edge on your drawing paper, using the outside edge of one of your viewfinders. This format is in the same proportion, width to height, as the detail reproduction.

2. Tone your paper with a rubbed graphite ground to the darkest dark you can achieve.

3. Set your picture plane on top of the detail reproduction. The crosshairs will instantly show you where to locate the essential points of the drawing. If you wish, you could work upside down for at least the first "blocking in" of the lights and shadows.

4. Add crosshairs to your toned format, but this time use a straight edge and a trimmed eraser (see Figure 10-22) to add thin *erased* lines rather than trying to draw crosshairs on the dark tone. Just run the trimmed eraser along the straight edge of your picture plane. The erased crosshairs are easy to remove later by rubbing them into the base tone.

5. Decide on a Basic Unit, perhaps the length of the nose, or the length of the light shape from the top of the nose to the bottom of the chin, or perhaps from the bottom of the nose to the bottom of the chin. Remember that everything in the Steichen image is locked into a relationship. For this reason, you can start with any Basic Unit and end up with the correct relationships.

6. Transfer your Basic Unit to the drawing paper, following the instructions on page 158 and in Figures 8-15, 16, and 17.

Fig. 10-22. Prepare your paper with a dark ground and trim your eraser for precise erasing. Use a #4B or #6B pencil to darken deeply shadowed areas.

The step-by-step procedure I offer below is only a suggestion about how to proceed. You may wish to use an entirely different sequence. Also note that I am naming parts of the drawing only for instructional purposes. As you draw, try your best to see the shapes of lights and darks wordlessly. I realize that this is like trying not to think of the word "elephant," but as you continue to draw, thinking wordlessly becomes second nature.

7. You will be "drawing" with your trimmed eraser. Begin by lightly erasing the major shapes of light on the face, the white neck scarf, and the soft shapes behind the collar and shoulders, always checking the size, angles, and position of those shapes against your Basic Unit. You might think of these light-shapes as negative shapes that share edges with the dark forms. By correctly seeing and erasing the light shapes, you'll have the dark shapes "for free."

8. Squint your eyes to see where the lightest lights are: the top of the forehead, the white scarf, and the highlight on the nose. Erase these areas to the lightest light you can achieve.

9. Using your #4b pencil, darken the area around the top of the head. Observe the shapes of the shadows under the brow, the shadowed side of the face, under the nose, under the lower lip, and the shadow that shapes the chin.

10. Keep your tones quite smooth. Notice that there is almost no information in the shadowed areas. They are nearly uniform tones. Yet the face and features emerge out of the shadows. These perceptions are occurring in your own brain, imaging and extrapolating from incomplete information. The hardest part of this drawing will be resisting the temptation to give too much information! Let the shadows stay shadowy, and have faith that your viewer will extrapolate the features, the expression, the eyes, everything (Figure 10-23).

11. At this point, you have the drawing "blocked in." The rest is all refinement, called "working up" the drawing to a finish. Note that because the original is a photograph and you are working in pencil, the exact textures and tones are difficult to reproduce in pencil. But even though you are copying Steichen's self-portrait, your drawing is *your* drawing. Your unique style of drawing and choice of emphasis will show through.

12. At each step, pull back a little from the drawing, squint your eyes a bit, and slightly move your head from side to side to see if the image is beginning to emerge. Try to see (that is, to

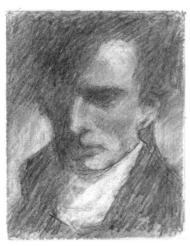

Fig. 10-23. Start by lightly erasing the major shapes of light, always checking the size, angles, and position of those shapes against your Basic Unit. Use a #4b or #6B pencil for the darkest shapes. The hardest part of this drawing will be to resist giving your viewer too much information. Let the shadows remain shadows, so that your viewer can "see" the features and facial expression.

image) what you have not yet drawn. Use this emerging, imagined image to add to, change, and reinforce what is there in the drawing. You will find yourself shifting back and forth: drawing, imaging, drawing again. Be sparing! Provide only enough information to the viewer to allow the correct image to occur in the viewer's imagined perception. Do not overdraw.

13. As you are working up the drawing, try to focus your attention on the original. For any problem that you encounter, the answer is in the original. For example, you will want to achieve the same facial expression: the way to accomplish that is to pay careful attention to the exact shapes, for example, of the shadow under the cheekbone and the lighter shape around the upper lip. Notice that small shadow at the corner of the mouth. Try not to talk to yourself about the facial expression: it will emerge from the shapes of the lights and shadows.

14. Draw just what you see: no more, no less. You may be tempted to draw the eyes. Don't do it! Allow the viewer of your drawing to play the game of "seeing" what is not there. Your job is to barely suggest, just as the artist/photographer did.

After you have finished

In copying the Steichen self-portrait, you were bound to be impressed by this work, its subtlety and strength, and how the personality and character of the photographer-model emerge from the shadows. I hope that this exercise has provided you with a taste for the power of light/shadow drawing. An even greater satisfaction, of course, will come from doing your own self-portrait.

Crosshatching a lighter shadow

Before we advance to the next drawing, your self-portrait, I want to show you how to "crosshatch." This is a technical term that

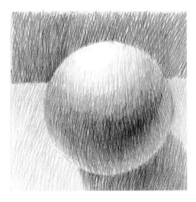

Fig. 10-24. This tonal drawing of a sphere is built almost entirely of crosshatches.

artists use for creating a variety of tones or values in a drawing, by laying down a "carpet" of pencil strokes (called "hatches), often crossing the strokes at angles ("crosshatching"). Figure 10-24 is an example of a tonal drawing of a sphere built almost entirely of crosshatches.

When I first started teaching drawing, I thought that hatching and crosshatching were natural activities and did not require teaching. But I learned that that was not the case. The ability to hatch or crosshatch is a mark of a trained artist, and for most students, the technique must be taught and learned. If you glance through this book at the many reproductions, you will see that almost every drawing has some area of hatching. You will also notice that crosshatching has almost as many forms as there are artists to use them. Each artist, it seems, develops a personal style of hatching, almost a "signature," and, very quickly, so will you. I show you the technique and a few of the traditional styles of hatching and crosshatching.

You will need paper and a carefully sharpened pencil, either your #2 writing pencil or your #4B drawing pencil.

1. Hold your pencil firmly and make a group of parallel marks, called a "set" (shown in Figure 10-25), by placing the pencil point down firmly, fingers extended. Swing off each mark by moving the whole hand from the wrist. The wrist remains in place while your fingers pull the pencil back just a bit for each successive hatch. When you have finished one "set" of eight to ten hatch marks, move your hand and wrist to a new position and hatch a new set. Try swinging the mark toward you, and also try swinging it away from you in an outward movement to see which seems more natural for you. Try also changing the angle and the length of the marks.

2. Practice making sets until you have found the direction, speed, spacing, and length of marks that seem right for you.

3. The next step is to make the "cross" sets. In classical hatching, the cross set is made at an angle only slightly different from the original set, as shown in Figure 10-26. This slight angle

Fig. 10-25. A "set" of hatches.

Fig. 10-26. In classical cross-hatching, sets of hatches cross at a slight angle.

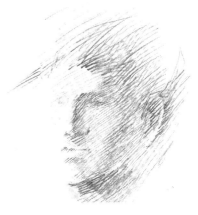

Fig. 10-27. Using only crosshatching without contour edges can convincingly depict three-dimensional forms.

Fig. 10-28. Some examples of various styles of crosshatching.

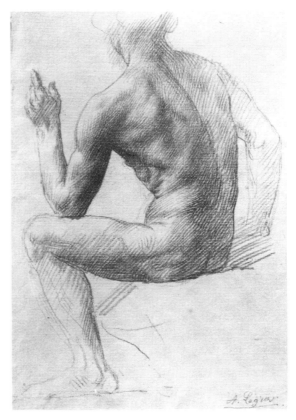

Fig. 10-29. To create dark passages, simply pile up sets of hatches, as in the back and left arm of Legros's drawing. Alphonse Legros, red chalk on paper. Courtesy The Metropolitan Museum of Art, New York.

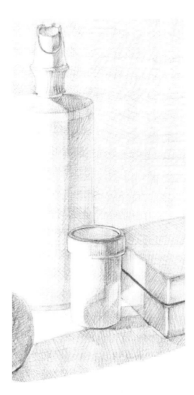

Fig. 10-30. Practice using crosshatching to draw three-dimensional forms.

If, as occasionally happens, your verbal system remains active as you start to draw, the best remedy is to do a short session of Pure Contour Drawing, using any complex object as a model—a crumpled piece of paper is fine. Pure Contour Drawing seems to force the shift to R-mode and therefore is a good warm-up exercise for drawing any subject.

produces a very pretty moiré pattern that causes a drawing to seem to shimmer with light and air. Try this. Figure 10-27 shows how to use crosshatching to create a three-dimensional form.

4. By increasing the angle of crossing, a different style of cross-hatch is achieved. In Figure 10-28, see various examples of styles of hatching: full cross (hatch marks crossing at right angles), cross-contour (usually curved hatches), and hooked hatches (where a slight hook inadvertently occurs at the end of the hatch), as in the topmost example of hatching styles in Figure 10-28. There are myriad styles of hatching.

5. To increase the darkness of tone, simply pile up one set of hatches onto others, as shown in the left arm of the figure drawing by Alphonse Legros (Figure 10-29).

6. Practice, practice, practice. Instead of doodling while talking on the phone, practice crosshatching—perhaps shading geometric forms such as spheres, or cylinders (see the examples in Figure 10-30).

As I mentioned, hatching is not a naturally occurring skill for most individuals, but it can be rapidly developed with practice. I assure you that skillful, individualized use of hatching and cross-hatching in your drawings will be gratifying to you and much admired by your viewers.

Shading into a continuous tone

Areas of continuous tone are created without using the separate strokes of crosshatching. The pencil is applied in either short, overlapping movements or in elliptical movements, going from dark areas to light and back again, if necessary, to create a smooth tone. Most students have little trouble with continuous tone, although practice is usually needed for smoothly modulated tones. Charles Sheeler's complex light/shadow drawing of the cat sleeping on a chair (Figure 10-31) superbly illustrates this technique.

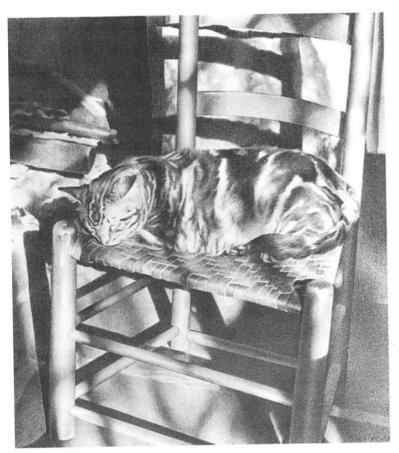

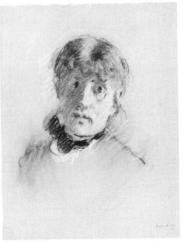

Fig. 10-31. A superb example of smoothly modulated continuous tone. Charles Sheeler (1883–1965), *Feline Felicity*, 1934. Conté crayon on white paper. Courtesy The Fogg Art Museum, Harvard University. Purchase-Louise E. Bettens Fund.

Fig. 10-32. A soft, delicately loose style of drawing. Berthe Morisot (1841–1895), *Self-Portrait*, c. 1885. Courtesy The Art Institute of Chicago. A full face or frontal view.

Drawing on the logic of light for a fully modeled, tonal, volumetric self-portrait

In these lessons, we began with line drawing and we end with a fully articulated drawing. "Modeled," "tonal," and "volumetric" are the technical terms that describe the drawing you will do next. From this exercise onward, you will practice the five perceptual skills of drawing with constantly changing subject matter. The basic skills will soon become melded into a global skill, and you will find yourself "just drawing." You will shift flexibly from edges to spaces to angles and proportions to lights and shadows. Soon the skills will be on automatic and someone watching you draw may be baffled by how you do it. I feel sure that you will find yourself seeing things differently, and I hope that, for you as for

many students, life will seem much richer by having learned to see and draw.

As you continue to draw after completing these lessons, you will begin to find your own unique style of using these fundamental components. Your personal style may evolve into a rapid, vigorous calligraphy (as in the Morisot *Self-Portrait*, Figure 10-32), a beautifully pale, delicate style of drawing, or a strong, dense style, as in the Courbet *Self-Portrait*. Or your style may become more and more precise, as in the Sheeler drawing (Figure 10-31).

Remember, you are always searching for your unique way of seeing and drawing. No matter how your style evolves, however, you will always be using edges, spaces, and relationships, and usually but not always lights and shadows, and you will depict the thing itself (the *gestalt*) in your own way.

Ready to draw!

What you'll need for your Self-Portrait:

- Your drawing paper—three or four sheets (for padding), taped to your drawing board
- Your pencils, sharpened, and your erasers
- A mirror and tape for attaching the mirror to a wall, or you may want to sit in front of a bathroom mirror or dressing table mirror
- Your felt-tip marker
- Your graphite stick
- A paper tissue or paper towel for rubbing in a ground
- A floor lamp or a table lamp to illuminate one side of your head (Figure 10-34 shows an inexpensive spot lamp)
- A hat, scarf, or headdress, if that idea appeals to you

Fig. 10-33. Set yourself up for drawing your self-portrait. Your (picture plane) mirror should be at arm's length so that you can sight measurements directly on the mirror.

What you'll do:

1. First, prepare your drawing paper with a format edge and a ground. You may choose any level of tone. You may want to do a "high-key" drawing by starting with a pale ground, or you may decide to use the drama of a dark ground for a "low-

key" drawing. Or perhaps you prefer a middle value. Be sure to lightly draw in the crosshairs, or erase them if your tone is dark. Note that again in this drawing, you will not need your plastic picture plane because the mirror becomes the picture plane.

2. Once your ground is prepared, set yourself up to draw. Check the setup in Figure 10-33. You will need a chair to sit in and a chair or small table to hold your drawing tools. As you see in the diagram, you will lean your drawing board against the wall. Once you are seated, adjust the mirror on the wall so that you can comfortably see your image. Also, the mirror should be just at arm's length from where you are sitting. You want to be able to take sightings directly on the mirror as well as directly on your face and skull as you observe the measurements in the mirror (Figure 10-35).

3. Adjust the lamp and test out various poses by turning your head, raising or lowering your chin, and (if you are wearing one) adjusting your hat or headdress, until you see in the mirror a composition in lights and shadows that you like. Decide whether to draw a full-face view or a three-quarter view, and decide which way you will turn, left or right, if you choose the three-quarter view.

4. Once you have carefully chosen your composition in the mirror and the pose is "set," try to keep all your gear in place until the drawing is finished. If you stand up to take a break, for example, try not to move your chair or the lamp. Students often find it very frustrating if they can't recapture exactly the same view when they sit down again.

5. You are now ready to draw. The instructions that follow are really only a suggestion for one procedure among myriad possible procedures. I suggest that you read through all the remaining instructions and follow the suggested procedures before you begin drawing. Later on, you'll find your own way to proceed.

Fig. 10-34. A moveable lamp will help adjust the lights and shadows on your image in the mirror.

Fig. 10-35. Use your pencil directly on the mirror as your sighting tool.

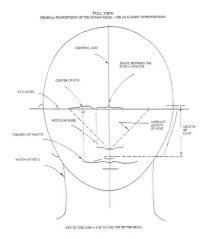

CENTRAL AXIS

SPACE BETWEEN THE
EYES = ONE EYE

CENTER OF EYE

EYE LEVEL

WIDTH OF NOSE

AVERAGE
LENGTH
OF NOSE

LENGTH
OF
EARS

CORNERS OF MOUTH

WIDTH OF NECK

EYE TO THE CHIN = EYE TO THE TOP OF THE SKULL

Fig. 10-36. The frontal-view diagram.

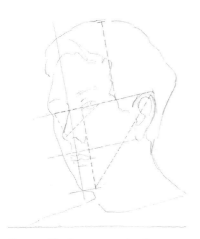

Fig. 10-37. The three-quarter-view diagram.

A self-portrait in pencil

1. Gaze at your reflection in the mirror, searching for negative spaces, interesting edges, and the shapes of lights and shadows. Try to suppress language entirely, particularly verbal criticism of your face or features. This is not easy to do, because this is a new use of a mirror—not for checking or correcting, but to reflect an image in an almost impersonal way. Try to regard yourself the way you would regard a still-life setup or a photograph of a stranger.

2. If you decide on a full-face view, please review the proportions on page 213. Remember that due to the size constancy phenomenon, your brain may not be helping you see certain proportions, and I encourage you to take sights on everything, using your pencil as a sighting tool (Figure 10-35). Also, please review the full-face blank (Figure 10-36).

3. If you have decided on a three-quarter view, please review the proportions for that view on pages 217 and 218. One caution: students sometimes begin to widen the narrow side of the face and then, because that makes the face seem too wide, they narrow the near side of the face. Often the drawing ends up a frontal view, even though the person was posing in three-quarter view. This is very frustrating for students, because they often can't figure out what happened. The key is to accept your perceptions. Draw just what you see! Sight everything, and don't second-guess your sightings.

4. Choose a Basic Unit. This is entirely up to you. I generally use eye level to chin, and I often use a felt-tip marker to draw a central axis and the eye-level line directly on my image in the mirror, and then mark the top and bottom of my Basic Unit. You may prefer to start your drawing another way, perhaps relying only on the crosshairs you have drawn on the mirror. Please feel free to do so. You must, however, be sure to mark the top and bottom of your Basic Unit directly on the mirror.

5. The next step, of course, is to transfer your Basic Unit to your

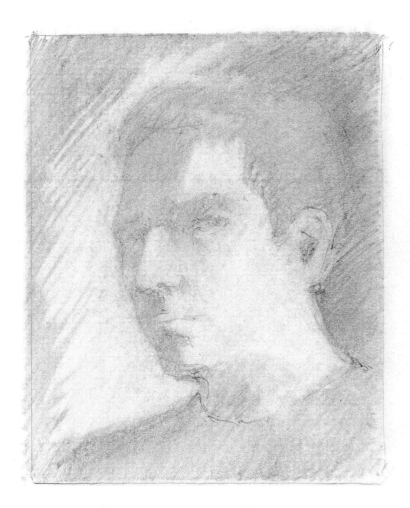

Fig. 10-38. Begin by erasing the largest lighted shapes.

"The object, which is back of every true work of art, is the *attainment of a state of being*, a state of high functioning, a more than ordinary moment of existence.... We make our discoveries while in the state because then we are clear-sighted."
— Robert Henri, *The Art Spirit*, 1923

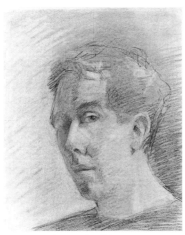

Fig. 10-39. The completed three-quarter-view self-portrait by instructor Brian Bomeisler, at a somewhat rough or "unfinished" stage.

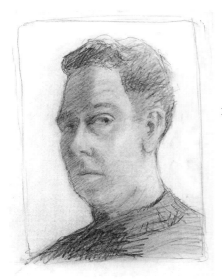

Figure 10-40. Another three-quarter-view self-portrait, worked up to a more finished state.

drawing paper with its crosshairs and toned ground. Just make marks at the top and bottom of your Basic Unit. You may wish to add marks for the top edge and side edges of the image of your head in the mirror. Transfer these marks to your drawing.

6. Next, squint your eyes a bit to mask some of the detail in your mirror image and find the large lighted shapes. Note where they are located relative to your Basic Unit, to the crosshairs in your drawing, and to the central axis/eye-level lines, if you are using them.

7. Begin your drawing by erasing the largest lighted shapes, as in Figure 10-38. Try to avoid any small forms or edges. Right now, you are trying to see the large lights and shadows.

8. You may wish to erase the ground around the head, leaving the toned ground as the middle value of the head. You may, on the other hand, want to lower the value (darken) the negative spaces. These are aesthetic choices. Figure 10-39 shows both.

9. You may want to add some graphite to the shadowed side of the face. For this, I recommend your #4b pencil, not the graphite stick, which is somewhat hard to control and becomes rather greasy if pressed hard on the paper.

10. I'm sure you've noticed that I have said nothing about eyes, nose, or mouth up to this point. If you can resist the impulse to draw the features first, and allow them to "come out" of the light/shadow pattern, you will be able to exploit the full power of this kind of drawing.

11. Rather than drawing the eyes, for example, I recommend that you rub your #4b pencil point on a scrap of paper, rub your forefinger over the graphite and, checking back in the mirror for the location of the eyes, rub your graphite-covered fingertip where the eyes should be. Suddenly you will be able to "see" the eyes, and you need only to slightly reinforce that ghostly perception.

12. Once you have the large shapes of lights and shadows drawn,

begin to look for some of the smaller shapes. For example, you may find a shadowed shape under the lower lip, the chin, or the nose. You may see a shadow-shape on the side of the nose or under the lower lid. You can slightly tone the shadow-shape with your pencil, using crosshatching, or, if you wish, rub the tone in with your finger to smooth it. Be sure that you place and tone the shadow-shapes exactly as you see them. They are the shapes they are because of the bone structure, the flesh, and the particular light that falls on the shape.

13. At this point, you are ready to decide whether you want to leave the drawing at this somewhat rough or "unfinished" stage (See Figure 10-39), or whether you want to work the drawing up to a "high finish." Throughout this book, you will find numerous examples of drawings at various degrees of finish (Figure 10-40).

Drawing hair

The portrait drawings throughout this book demonstrate various ways of drawing different types of hair. There is obviously no one way of depicting hair, just as there is no one way to draw eyes, noses, or mouths. As always, the answer to any drawing problem is to draw what you see. Start with drawing the larger shapes of lights and shadows in the hair, then add enough detail to show the nature of the hair.

Now that you have read all the instructions, you are ready to begin. I hope you will find yourself quickly shifting into R-mode. Every once in a while, it is helpful to stand up and regard your drawing from a greater distance. In this way, you regard the drawing more critically, more analytically, perhaps noting slight errors or slight discrepancies in proportions. This is the artist's way. Shifting out of the working R-mode and back to L-mode, the artist assesses the next move, tests the drawing against the critical left brain's standards, plans the required corrections, and notes where areas must be reworked. Then, by taking up the pencil and starting in again, the artist shifts back into the working R-mode.

This on-off procedure continues until the work is done—that is, until the artist decides that no further work is needed.

After you have finished: a personal before-and-after comparison

This is a good time to retrieve your pre-instruction drawings and compare them with the drawing you have just completed. Please lay out the drawings for review.

I fully expect that you are looking at a transformation of your drawing skills. Often my students are amazed, even incredulous, that they could actually have done the pre-instruction drawings they now find in front of them. The errors in perception seem so obvious, so childish, that it even seems that someone else must have done the drawing. And in a way, I suppose, this is true. The L-mode, in drawing, sees what is "out there" in its own way—linked conceptually and symbolically to ways of seeing, naming, and drawing developed during childhood.

Your recent drawings, on the other hand, are more complex, more linked to actual perceptual information from "out there," drawn from the present moment, not from memorized symbols of the past. These drawings are therefore more realistic. A friend might remark upon looking at your drawings that you had uncovered a hidden talent. In a way, I believe this is true, although I am convinced that this talent is not confined to a few, but instead is as widespread as, say, talent for reading.

Your recent drawings aren't necessarily more expressive than your "Before-Instruction" drawings. Conceptual L-mode drawings can be powerfully expressive. Your "After-Instruction" drawings are expressive as well, but in a different way: They are more specific, more complicated, and more true to life. They are the result of newfound skills for seeing things differently, of drawing from a different point of view. The true and more subtle expression is in your unique style of drawing and your unique "take" on the model—in this instance yourself.

At some future time, you may wish to partly reintegrate simplified, conceptual forms into your drawings. But you will do so by design, not by mistake or inability to draw realistically, if that is your intent. For now, I hope you are proud of your drawings as signs of victory in the effort of learning basic perceptual skills. And now that you have seen and drawn your own face with great care, surely you understand what artists mean when they say that every human face is beautiful.

A showing of portraits

As you look at the post-instruction self-portraits in Chapter 2, go through the measurement process yourself. This will help reinforce your skills and train your eye.

A suggestion for a next drawing

A suggestion for a follow-up exercise that has proven to be amusing and interesting is to draw your self-portrait as a character from art history. Such drawings might include "Self-Portrait as the Mona Lisa" or "Self-Portrait as a Renaissance Youth."

Chapter 11
Using Your New
Perceptual Skills
for Creative Problem
Solving

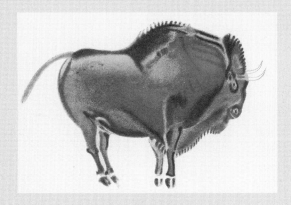

A prehistoric painting of a standing bison
from the cave at Altamira in northern Spain.
(12,000 B.C.) Pigments are manganese diox-
ide (red), charcoal (black), and kaolin or
mica (white). Getty Images 799610-002.

Now that you have learned the five basic perceptual skills of drawing, I hope you will try to do a bit of drawing every day. New neural pathways in your brain form as a result of repeating new learning. That means practice. The best way to keep your skills growing is to carry a small sketchbook and, whenever you have a few spare minutes, draw anything—anything at all!—that you see nearby (a cup, a stapler, a pair of scissors, a potted plant, or even just a leaf). Another suggestion is to copy newspaper photographs upside down, as this is the quickest and best way to shift your brain mode. Sports or dance photos often have wonderful negative spaces for drawing upside down.

The very best practice, of course, is to draw any subject from life, or to copy master drawings. Even *mental* practice can help keep open your new access to right hemisphere visual perceptual skills, by looking for negative spaces in your surroundings, finding eye level and determining angles relative to vertical and horizontal, or checking out facial proportions on people you meet or faces on television. Whether you are drawing or practicing mentally, the key to accessing visual skills is always the same strategy: focusing on visual information that the left hemisphere will reject.

Another productive way to practice your new perceptual skills is to apply them to general thinking and problem solving, and for some, this may prove to be the main value of learning to draw. A basic review of the creative process will add power to this use of the basic skills.

Applying perceptual skills to creative problem solving

In our highly verbal, digital, and technological twenty-first century American culture, it might seem odd or foolish to propose that learning to draw would be of any practical value whatsoever, aside from interest, curiosity, or self-improvement. My hope is that in time it will make sense. I suggest ways that the five basic perceptual skills, learned through drawing, can add insight to

verbal, analytic problem solving, and I connect perceptual skills to the traditional stages of creativity. In addition, I recommend programming your own brain—that is, to deliberately set up your brain for the stages of creativity and problem solving.

There is no question that we must solve our pressing problems: an inadequate educational system, a deteriorating environment, and competitive economic pressures from around the world, among many others. According to American psychologist Abraham Maslow, a sense that we need another way of thinking seemed to be "in the air" even in the mid-1970s, and the perceived need has steadily increased since then. Although left-brained styles of thinking still clearly dominate our American life, the right-brain response of seeing "the whole picture," seeing the forest and not just the trees, and posing intuitive questions is becoming better known and more common. While our language-dominated brains are still engaged in linear plans and purposes, the other half of the brain is seeing what is out there and (wordlessly) protesting with what I think is the iconic right-brain question: "Hey, wait a minute! What about . . . ?" More frequently than in the past, the question is gaining serious attention.

Philosopher, psychiatrist, jazz pianist, and corporate innovator John Kao, on creativity: "The crucial variable in the process of turning knowledge into value is creativity."
— John Kao, *Jamming: The Art and Discipline of Business Creativity* (New York: HarperCollins, 1996)

Computers and the left brain

For some time now, powerful computers have been able to perform most left-hemisphere functions better and faster than the human brain. And, according to Moore's Law,[22] computing power will continue to increase exponentially in the near future and perhaps beyond.

It is not surprising that computers first mastered left-hemisphere functions of the brain. The step-by-step progression of L-mode thought is well suited to computer functions. Computers mirror the linear nature of language itself, composed as it is of one letter following another to form a word, and words following words to form a sentence. These "bits" progress over time, things strung out in strings that, in L-mode style, are resistant to allowing in new, incoming information until a conclusion is reached, because new data might be disruptive. A clear human example

22. Moore's Law is named for Gordon E. Moore, who predicted in 1965 that the number of components that can be placed inexpensively on an integrated circuit would double approximately every two years. His prediction has been uncannily correct, and the increase is expected to continue until 2020 or later.

of this aspect of L-mode thought appeared in the news after the oil crisis of the 1970s. The then-president of one of the largest American automakers was asked by a reporter, "Couldn't you see that continuing to produce huge, gas-guzzling cars while people were spending long hours in line for high-priced gas was not in your best interest?" The president replied, "Yes, we did see that, but we were in the middle of our five-year plan."

Recent research has shown that the language-based brain hemisphere (the L-mode) can cause some problems in human thinking. Roger Sperry himself said that the left brain is aggressive and competitive with its silent partner—and often with other people's brains as well. The question of which brain mode will be first to respond in most situations is which hemisphere gets there first, and most often it is the quick, verbal, competitive left brain—whether it is suited to the task or not. Furthermore, if a question comes up to which the left hemisphere does not know the answer, it sometimes simply makes up an answer, or it will even prevaricate with great aplomb.[23]

This can leave the silent right brain, which may see something critically relevant to the subject, sputtering in its inability to prevail over—or even help out—its verbal partner. Television is amazingly effective for seeing this L-mode domination in operation, simply by observing eye dominance, which is determined by language location in the brain and is fairly easy to detect. Looking at a person's face, simply focus your direct gaze first on one eye and then shift your gaze to the other eye. In general, the eye controlled by the dominant verbal hemisphere (it may be the left *or* the right eye, depending on the individual's brain organization) is wider open, brighter, and appears to be listening to the words being spoken.

To try out this observation, find a person's face shown in frontal view on the television screen—someone who is talking, perhaps answering questions. Focus for a moment on the dominant eye (most often, the right eye, controlled by the left brain), and then shift your direct gaze to the other eye, controlled by the right

"The first principle is that you must not fool yourself—and you are the easiest person to fool."
— Richard Feynman, California Institute of Technology Commencement Address, 1974

23. Michael S. Gazzaniga, *The Mind's Eye* (University of California Press, Berkeley, 1997)

hemisphere. In many cases, you will clearly see a difference. The subdominant eye often appears to be more hooded by the eyelid, less bright, and, in a sense, unavailable. If the person speaking is dogmatically committed to his/her pronouncements, the subdominant eye (usually the left eye) can appear to be almost oblivious to the words being spoken, as though it has given up trying. With other speakers, it is comforting to observe nondominant eyes that are still alert and participating.

Computers emulating the R-mode

In terms of computer emulation of R-mode visual perceptual functions, progress has been slower than emulation of the L-mode. Since the 1960s, for example, computer scientists have pursued human facial recognition, a province of the brain's right hemisphere. Computer-aided facial recognition is generally possible today, especially for frontal and profile views, although partial turns between full front view and profile view still cause problems for the machines. Scientists are also working on deciphering human facial *expression*, another function of the right brain. Here also, progress is slow. Presently, computers can differentiate between a smiling face and a non-smiling face. But what kind of smile? Welcoming? Snide? Pitying? Patient? Tentative? In a split second, the right brain can sense the *meaning* of an infinite variety of smiles. Computers cannot—at least not yet. Professor Lijun Yin of Binghamton University, a leading researcher in this field, has said, "Computers only understand zeroes and ones. Everything is about patterns. We want to recognize each emotion using only the most important features."[24] Facial expression patterns, however, are almost incalculable in number, and the tiniest shift in expression can communicate an entirely different meaning—easily read by a ten-year-old child but still invisible to computers.

Parallel processing, the linking of multiple computers to work together on various aspects of a problem, has solved some computer limitations concerning more R-mode-appropriate

Renaissance portrait artists often placed the dominant eye on the vertical midline of a painting to help establish the dominant eye.

You can clearly see eye difference in the drawing by Leonardo da Vinci reproduced on the cover of this book. The riveting, dominant right eye of Leonardo's beautiful model contrasts with the left eye, which seems to be dreaming away.

The eyeballs do not differ, of course, except in cases of stereoblindness, a condition where the two eyes do not work in concert. It is the facial muscles controlled by the opposite brain hemisphere that cause the difference in appearance.

In ordinary life, we tend not to notice this, because, in face-to-face conversation, our own dominant eye searches out the speaker's dominant eye, perhaps to better understand the speaker.

Try this, but carefully: when face-to-face in conversation with someone, locate and gaze into the subdominant eye. The person is likely to turn away slightly to deflect your gaze back to the dominant eye. If you persist, the person will likely end the conversation and walk away.

24. Lijun Yin is Associate Professor in the Department of Computer Science, Thomas J. Watson School of Engineering and Applied Science, State University of New York, Binghamton.

multifaceted or ambiguous problems. A recent example is IBM's "Watson," a massively parallel computer collection of 2,880 processor cores, capable of conversing in human language, which has outperformed expert human *Jeopardy!* game-show contestants by rapidly and correctly answering questions that require leaps across unrelated data. This was rightly hailed as a victory in the search for intuitive computing power, and Watson marks a huge potential advance in solving human problems. It is important to remember, however, that in order to compete with human intuition, Watson took years to develop, cost millions of dollars, and requires immense power input and a very large space to accommodate the multiple computers, while Watson's two human opponents were using human brains weighing only three pounds, powered by about 4½ ounces of glucose a day, and occupying the small inner space of human skulls—and they nearly beat Watson. Possibly one day we will devote equal amounts of time, money, and effort to properly train *both* halves of human brains and thereby help advance intuitive human solutions to human problems.

Computing and R-mode functions

In light of computer superiority in left-hemisphere functions and the thus-far slow computer development of right-hemisphere visual functions, it is astounding that American education is putting more and more stress on teaching and testing children on the very skills that are growing more redundant every year, while nearly completely eliminating any attempt to nurture powerful human right-hemisphere skills. Decades ago, Professor David Galin[25] proposed that we revise education in the following ways:

+ First, teach children about their own brains and the differences between the major thinking modes of the brain.

+ Second, teach children to be able to look at a problem and decide if one or the other brain mode would be most appropriate, or both modes working alternatively or cooperatively.

"Watson represents a major leap forward for computer science. With its combination of sheer data processing power, natural language recognition and machine learning, the system demonstrates that the technology has the potential to help humans improve performance of many endeavors—everything from medicine to education, law, and environmental protection."
— Press release, IBM: *First Watson Symposium*, Carnegie Mellon University and University of Pittsburgh, March 30, 2011

25. Professor David Galin, M.D., Langley Porter Neuropsychiatric Institute, University of California San Francisco

• Third, teach children how to access the appropriate mode or modes and how to prevent interference by the inappropriate mode.

Unfortunately, we are nowhere near achieving Dr. Galin's proposed revision.

The L-mode, the R-mode, and the stages of creativity

In my 1986 book on creativity, *Drawing on the Artist Within*, I explored the five stages of creativity in relation to drawing and brain-hemisphere functions. I suggested that the stages may occur because of shifts in right- and left-hemisphere emphasis:

- First Insight: R-mode leading
- Saturation: L-mode leading
- Incubation: R-mode leading
- Illumination (*The Aha!*): R-mode and L-mode celebrate the solution
- Verification: L-mode guided by R-mode visualization

Except for Illumination, which is generally very brief, the stages can occupy widely varying lengths of time. Note also that the first four stages can occur serially, with sub-*ahas* for early segments of a complex problem, leading to a grand finale *aha* and to Verification.

First Insight: R-mode leading

I propose that this first stage of creativity is largely a visual, perceptual right-hemisphere stage during which individuals visually search out or by chance discover problems. This requires surveying an area of interest, looking around to see what is "out there," scanning the whole area wordlessly, alert to parts that don't seem to fit, or parts that seem to be missing, or something that appears to "stand out" by being the wrong size or in the wrong place. This stage is suited to the right brain, which can take in huge amounts of visual data all at once, then review repeatedly in great gulps, seeing, comparing, and checking things out. This survey triggers

The Five Stages of Creativity

In the late nineteenth century, German psychologist and physicist Hermann von Helmholtz described his discoveries in terms of three stages, "Saturation," "Incubation," and "Illumination."

In 1908, French mathematician Henri Poincaré added a fourth stage, "Verification."

In 1960, American psychologist Jacob Getzels added a new first stage of *Problem Finding*, later named by another American psychologist, George Kneller, "First Insight."

"Creativity moves through different phases. Trying to produce a finished version in one move is usually impossible. Not understanding this can make people think that they are not creative at all."
— Ken Robinson, *Out of Our Minds: Learning to be Creative* (Capstone Publishing, 2011), p. 158

"To think creatively, we must be able to look afresh at what we normally take for granted."
— George Kneller, *The Art and Science of Creativity*, 1965

a spike of interest and a question: "I wonder why…?" "I wonder if…?" Or, my favorite, "I wonder how come…?"

Saturation: L-mode leading

The R-mode's creative First Insight question triggers, I believe, a largely L-mode response: finding out to the extent possible what is already known relative to the question, focusing on the puzzling parts, and trying to determine whether the problem has already been solved. This is called "research," and this is the left brain's cup of tea. Guided by the right brain's insightful questions, the L-mode saturates the brain with information and data, ideally with everything currently known about the problem (though this is increasingly impossible due to proliferating knowledge). The R-mode's role in Saturation is to view incoming research relative to the First Insight question, looking for whether, or how, the information might fit the question.

As the investigation continues and no solution is found, frustration rises. The gathered bits of information refuse to coalesce, while the question remains unanswered, and the key that would reveal the solution stays hidden. Logical links remain elusive, and exasperation, unease, and anxiety set in. The person, tired of the whole thing and perhaps wondering if there even *is* an answer, decides to take a break—to go on vacation and quit thinking about it for a few days.

Incubation: R-mode leading

I believe that at this point the whole problem is handed back to the right brain, so to speak, and—outside of conscious awareness of the person—the right hemisphere goes to work on the problem. The right brain, drawing on the L-mode's research while keeping the First Insight question in view, perhaps rotates the whole in visual space, wordlessly envisioning missing parts, extrapolating from known to unknown information, seeking the pattern where all the parts will fit together into a coherent whole with the right relationships of parts-to-whole. Note that this wordless process

Heuristic:

Derived from the Indo-European *wer* (I have found); in Greek *heuriskein* (to discover), from which came Archimedes's cry, "Eureka!" (I have found it!).

general meaning: serving to guide, discover, or reveal

specific meaning: a rule valuable for research but unproved or incapable of proof

does not follow algorithms of logical analysis, but instead works by the heuristics of visual perceptual logic. This stage can be brief or extended, but it generally seems to happen *while the person does something else.* I'm guessing that this is because the L-mode prefers to stay out of the messy, complicated, (verbally) illogical visual R-mode process, perhaps sensing that its style of thinking is inappropriate for the task. Or, perhaps, protesting, as in Upside-Down Drawing, "If you're going to do that stuff, I'm out of it."

Ilumination (*The Aha!*): R-mode and L-mode celebrate the solution

Then comes the *Great Aha!* of creativity. Suddenly, without warning, the moment of insight occurs, often while the person is in the middle of ordinary activities. Individuals have reported sudden rapid heartbeats and a profound sense of "things coming together," even before conscious verbal awareness of the solution. It is perhaps a moment when the whole human brain is suffused with joy.

Verification: L-mode guided by R-mode visualization

This is the stage that most of us do not do well, the real work of putting creative insight into final form: constructing the architectural model, testing the scientific theory, reorganizing the company, writing the business plan, composing the opera, delivering the finished solution for public assessment. Verification requires both modes of the brain working cooperatively, the left brain structuring the discovery step-by-step and recording the discovery in accessible form, while guided by the right hemisphere's grasp of the whole and its well-fitted parts. This stage is simply a lot of work and often is not nearly as captivating or joyful as other stages. When I was teaching at the university, I often asked groups of students how many had experienced the stages of creativity, including the *Great Aha!* Most of the students raised their hands. Then I asked, "How many of you followed up Illumination with Verification and put your insight into final form?" This question brought on much rueful laughter and shaking of heads.

"In 1907, Albert Einstein recorded the creative moment when he grasped that the effect of gravity was equivalent to a non-uniform motion as 'the happiest moment of my life.'"
— Quoted in Hans Pagels, *The Cosmic Code,* 1982

"I can remember the very spot in the road, whilst in my carriage, when to my joy the solution occurred to me."
— From *The Life and Letters of Charles Darwin,* 1887

"The classic example of the arduousness of verification is the search of the Curies for the undiscovered element in pitchblende. The excitement they felt at discovering a new source of energy was buried under years of exhausting toil."
— George Kneller, *The Art and Science of Creativity,* 1965

Art historian Milton Brener, in his brilliant book *Vanishing Points*, proposes a gradual evolution of the right hemisphere over the centuries:

"Because it (the right hemisphere) minimizes repetitions and maximizes the focus on uniqueness of information, the right hemisphere has, through the course of evolution, developed the capacity to remain broadly receptive to the outside world. It has ... a parallel method of processing information, combining all perceptions from outside at once, instead of in a linear, one-step-at-a-time processing. Hence, it may have no access to any linguistic capability, controlled by the sequential mode of the left hemisphere, and one of the results of that right hemispheric method is what we consequently call intuition."

— Milton Brener, *Vanishing Points: Three-dimensional Perspective in Art and History* (McFarland & Company, Inc., 2004), p. 102

26. I will designate the designer with the generic "he," to avoid the awkward "he/she" construction.

Using your new perceptual skills for general problem solving and creativity

This is my major premise: having learned to *know* perceptual skills through actually using them in drawing will enhance your success in transferring your visual skills to thinking and problem solving. *You will see things differently.* For example, once you have actually *seen and drawn* negative spaces, shared edges, angles and proportions, or lights and shadows, the mental concepts become real, and one of the best ways to use the skills is to actually visualize—*see in your mind's eye*—the edges of a problem, the spaces, relationships, lights and shadows, and the *gestalt.*

These visual skills are useful for problem solving of all kinds, in every field of human endeavor, from solving business or personal problems to enhancing general thinking about world problems (large scale) or local problems (smaller scale). More important, they can help you produce new and unique innovations of social value.

A hypothetical problem

As an illustration of general problem solving, I will use an unspecified design problem as a model, since the art field is the one I know best, but the same ideas can be extrapolated to any other field. For each stage of this general problem-solving example, I will suggest uses for the five basic perceptual skills from the perceptual point of view of the designer.[26]

Each progressive stage might be thought of as a new drawing of the same subject, and while I speak separately, in linear language, of the five basic seeing skills within each stage, they actually occur simultaneously, as happens in drawing.

The designer's dilemma

A designer has conceived and worked out a wonderful and innovative plan for a major project, and he is ready to put his plan into final form. He needs a partner to help execute the project (Verification) and has submitted his plan to several clients. One

has accepted his proposal, but the designer has some doubts. His problem is whether to agree to the offer or look for a more suitable client. The project will involve great amounts of time and effort, and this decision is crucial to its success. To solve his problem, the designer needs to look around, survey the whole situation, and be receptive to all information, positive or negative. His question about the client is "I wonder if…?" The main rule for the designer is to see clearly and to believe the reality he perceives "out there" without revising the information to fit any hopes, wishes, fears, or preconceptions.

I believe that the right brain, even against its will, sees and confronts reality—what is really "out there." Being without language, it is not capable of "explaining things away" (a very interesting phrase).

The First Stage of Creativity: First Insight, R-mode leading

⋆ **Seeing the edges of the problem**

In looking at the problem, the designer finds a significant edge where his concern for the integrity of the projected design shares an edge with the client's need to control the outcome. The designer needs to clearly perceive the nature of that edge. Is it soft and pliable; sharp, heavy, and decisive; simple and visible; or complicated and obscure?

Another edge is financial—the shared edge of the designer's need for adequate pay and high-quality materials and the client's need to control costs. Again, what is the specific nature of that edge? Jagged and clashing, or smooth and fluid?

Another edge is time—the shared edge of the designer's need for adequate time and the client's need for a quick result. Is that edge frozen in place, or is it erasable and adjustable?

Another edge is aesthetic—the shared edge of the designer's need for personal aesthetic congruency (his "style") and the client's need for expressing design preferences and contributing to the outcome. This edge could be the most difficult to perceive.

⋆ **First Insight: seeing the spaces of the problem**

The designer needs to see the context of the problem. Within the bounding edge of the project (its format), the spaces share edges with the "shapes," the known parts of the problem. What is in the

negative spaces? (In business writing, these spaces are sometimes called "white spaces.") In the spaces, are there competing designs unknown to the designer? Are there other decision makers involved? Are there other unknowns that can be perceived by extrapolating from the shared edges of spaces and shapes (as in the Vase/Faces exercise)?

◆ **First Insight: seeing the relationships of the problem**

Taking a long view, where is the Horizon Line? Is it at the designer's eye level or at the client's eye level? If both, can the two horizons be reconciled or will they remain unresolved, each with a different perspective on the project?

What are the proportional relationships of the project? How big is the designer's need for autonomy in working out the design relative to the client's need to closely supervise? Is that proportional relationship adjustable or unchangeable? Are the proportional relationships clear? And what is the Basic Unit against which all the proportions will be calculated? Time? Money? Aesthetics? Power? Reputation?

What are the angles of the project? Is the project a one-point perspective problem where all plans come together at a single Vanishing Point? Or are there multiple Vanishing Points complicating the project?

Under this client's supervision, how sharply angled, fast moving, and dynamic will the project be as a whole, or will it be slow, stable, and steady (vertical and horizontal)?

◆ **First Insight: seeing the lights and shadows of the problem**

Under this client, is the future of the project "high key" (largely in the light) or "low key" (largely in the dark)?

What is in the light at the present moment, and what lies in shadow? Can the designer extrapolate from what is lighted to the parts in shadow, or are the unknowns too dark to "see into?" (Think back to the Steichen *Self-Portrait*.)

Do the lights and shadows logically reveal the project in three dimensions, or are the lights and shadows confused and illogical?

A famous university science professor was once asked why it was that he had received so many awards. He answered that it was because he was always looking around him, looking for things that didn't fit, or seemed odd or out of place. "When I find myself with a question, I know I am on to something."

♦ First Insight: seeing the *gestalt* of the problem

Having explored many aspects of First Insight in R-mode, the designer visually gathers all the parts into the overwhelming question and looks at it as a whole. He mentally turns the image upside down to gain a new perspective on the question, looking for what he might have missed in normal orientation. This provides a new take on the whole problem, but much remains to be seen before the solution will be available. At this point, the L-mode steps in, ready to do the needed research.

The Second Stage of Creativity: Saturation, L-mode leading

Now, the designer hands over the problem (instructs his brain) to research all of the questions that surfaced in First Insight. This means investigating what is "out there" by calling on his analytic language abilities to research the history of the client's previous projects, gathering all of the available information relative to the First Insight questions. One task is to determine the constants of the situation: what things can't be changed, and what things can.

This stage may be brief or lengthy, depending on the nature of the questions and the transparency or opacity of the situation. As the search goes on, the designer longs for closure, but the gathered information is contradictory and difficult to fit into a coherent pattern. Also, there is a time restriction (a deadline) for a decision, all of which causes the designer anxiety, frustration, and lost sleep.

"It seems, then, to be one of the paradoxes of creativity that in order to think originally, we must familiarize ourselves with the ideas of others."

— George Kneller, *The Art and Science of Creativity*, 1965

♦ The end of Saturation: After gathering and cataloging all available information relative to the complex first insight, trying to fit it together, and apprehensive of making a wrong decision, the designer decides to clear his mind by taking a long weekend to go skiing, hoping to forget the impasse for a day or two. Before he leaves, however, he takes a few minutes to do something that has worked for him in the past with similar difficult problems. He says aloud to himself (to his brain, actually), "I can't see the solution. *You'll* have to work it out. By Tuesday, I need to know what to do. And now, I'm going skiing."

The American poet Amy Lowell spoke of dropping a subject she had in mind for a poem, "much as one drops a letter into a mailbox." From that point, she said, she simply waited for the answer to come "by return post." Sure enough, six months later she would find the words of the chosen subject coming into her head.

— From *American Poetry: The Twentieth Century*, Vol. 1, Robert Haas, compiler, 2000

Historian David Luft, in his 1980 biography of the Austrian writer, *Robert Musil and the Crisis of European Culture 1880–1942*, said: "Robert Musil joined Lichtenberg, Nietzsche and Mach in his preference for the formulation 'it thinks' rather than the conventional 'I think' of Western thought since Descartes."

The Third Stage of Creativity: Incubation, R-mode leading

• Having been programmed, so to speak, to solve the problem, I propose that the designer's brain then thinks on its own, in a way quite different from his ordinary cognition. Following the lead of historian David Luft, I suggest the formulation "It thinks." The designer's deliberate halt to ordinary thinking about the problem at the end of Saturation and his programming ("You solve it!") puts his thinking out of conscious control, thus enabling the R-mode (or perhaps *allowing* is a better word) to think in its way, dealing with enormous complexity, "looking at" densely packed information from the Saturation stage, seeking "fit," meaning, aesthetic unity, and an organizing principle. And the deadline, "by Tuesday," can sometimes even structure the Incubation process in time (surely an L-mode contribution). The American writer Norman Mailer, encountering a problem in his writing, would say to himself, "I'll meet you there tomorrow," and the next day, he said, "there was the solution."

The Fourth Stage of Creativity: Illumination— the *Great Aha!*, R-mode and L-mode together celebrate the solution

• After his skiing weekend, while driving home on the freeway thinking of something else, the designer's brain without warning suddenly breaks into his train of thought and bathes his brain with the solution—the *aha*. The solution has been communicated to the designer's conscious mind, arriving perhaps visually, perhaps verbally, or both, causing a sudden surge of joy and relief—the euphoria of the *Great Aha!* A few minutes later, the designer says aloud to himself, with feeling, "*Thank* you."

The French poet and critic Paul Valéry said of Verification:
"The master provided the spark; it is your job to make something of it."
— Quoted by Jacques Hademard, *The Psychology of Invention in the Mathematical Field*, 1945

• Because the solution fits and reconciles all the parts of his decision-problem, he knows as a "gut feeling" that it is the right solution. Perhaps, in a sense, the whole brain is satisfied with the solution and is suffused with relief and joy. (To take a guess at one of many possible solutions, perhaps the designer's

conscious brain was handed a complex and innovative plan for how to structure a project contract and protocol that resolve all questions, apprehensions, and reservations, thus freeing him to accept the client's proposal and move on to the last stage of Verification—completing the project and putting the whole into final form for public judgment.)

The Fifth (and last) Stage of Creativity: Verification—L-mode step-by-step strategy guided by R-mode visualization

* Now the hard work begins: first, putting the solution into concrete form by carefully constructing and then obtaining the client's agreement on the proposal, the contract, and a detailed protocol. This step must be completed before starting the even harder work of completing the whole undertaking.

* During this last stage, the designer will rely on his left-hemisphere skills for planning a logical step-by-step procedure for the project, while at the same time relying on his right hemisphere to guide the work and "see" any incoming problems or information that he should incorporate along the way, thus ensuring against unpleasant surprises at completion. There are bound to be many unexpected stumbles in the long process, and he and the client must still plan and prepare for public presentation and evaluation, but the designer's careful groundwork—and insights—will help ensure a good final outcome.

True Creativity and Innovation

My example of the Designer's Dilemma illustrates the use of R-mode perceptual skills, learned through drawing, for general thinking and problem solving. Usually, however, we think of true creativity and innovation as being on a different and higher plane: creating something original, innovative, socially valuable, and important. I believe that the same perceptual skills used for general problem solving can also apply to rare, original, high-level

British educator and expert on creativity Ken Robinson provides a clear definition in his remarkable book on the subject which, he states, involves three related ideas:

"*Imagination*, which is the process of bringing to mind things that are not present to our senses;

creativity, which is the process of developing original ideas that have value;

and *innovation*, which is the process of putting new ideas into practice."

— Ken Robinson, *Out of Our Minds: Learning to Be Creative* (Capstone Publishing, Ltd., 2011), pp. 2–3

innovative creativity. I absolutely agree with Ken Robinson, who proposes in his book *Out of Our Minds* that we might be able to increase this higher level of creativity by radically reforming our educational system and returning the arts to their rightful place in education—not in order to produce more artists (our nation does not support the artists we now have), but to improve thinking.

High-value creativity at work

An admirable example of a socially valuable and important creative innovation in the field of open-heart surgery was recently reported in the news. In this brief account, you will be able to track the stages of creativity.

One of the innovators, Charles Pell, holds a master's degree in sculpture but over time became deeply interested in biomechanics, the study of how living creatures and their body parts move. Two decades ago, the other innovator, Hugh Crenshaw, Ph.D., whose specialty is biomechanics, joined Pell as business partners, and together they developed a number of robots and other devices based on biomechanics.

Looking around recently for a new project, they turned to the field of surgery. They noticed that in open-heart operations, surgeons were still using a rib spreader that had been invented in 1936. The device did work, but a survey showed that due to the rib spreader, up to 34 percent of an estimated two million open-heart surgery patients every year ended up with broken ribs, crushed nerves, and long-lasting pain, which complicated and lengthened their recovery.

Surprised that little research had been done on the clearly adverse force of the rib spreaders, even though contemporary strain gauges could easily measure the force, the entrepreneurs saw a problem ready to be solved. "Well, there's a biomechanics project if I ever saw one," said Pell. He and Crenshaw set out to design "a kinder, gentler rib spreader." They investigated the mechanical force exerted on ribs by the 1936 spreader, which was jerked open by a hand crank with a force that could not be

adjusted to the nature of bones, which are hard but not brittle and, with care, can flex and bend.

To guide their thinking, the entrepreneurs used the metaphor of a branch *bending* before it breaks, if force is delivered slowly enough. They set out to develop a prototype rib spreader that was smoothly opened by a motor while measuring the strain force on the ribs. Experimenting with animal bones, they discovered that a few seconds before a rib broke there were tiny popping sounds, which could be used as a signal to adjust the force, reduce strain, and avoid breakage. This must have been an *aha!* moment. "We hit all the important endpoints that we were going for," said Crenshaw. They moved forward with development of their prototype, and thorough testing showed that the new rib spreader effectively worked as they had planned.

The inventors are now at work building and testing their new device, for which they will seek premarket approval and which they hope to bring to market in 2012. Then they plan to look at other surgical tools that can inadvertently damage patients' bodies. Said Pell, "We've got years of products to bring out."[27]

Creativity and human history

Human creativity, for good or for ill, has inexorably shaped human life on our planet. At every incremental stage of human history, countless examples of socially valuable creative discoveries similar to the Pell-Crenshaw invention have contributed to improving human life. We have benefitted even more from rarer, truly momentous discoveries. Paul Strathern, in his book *The Big Idea Collected: Six Revolutionary Ideas That Changed the World*, examines some of the world's greatest creative ideas and the wondrous thinkers who brought them to life:

- Isaac Newton and gravity
- Marie Curie and radioactivity
- Albert Einstein and relativity
- Alan Turing and the computer
- Stephen Hawking and black holes
- Francis Crick and James Watson and DNA[28]

27. Reported in the *New York Times* Science section, May 17, 2011, "Turning to Biomechanics to Build a Kinder, Gentler Rib Spreader," by Carl Zimmer, and in www.outpatientsurgery.net/news/2011/05/16,. "Inventors Aim to Transform 'Entire Surgical Tray' With Biomechanics," by Irene Tsikitas.

28. Quality Paperback Books, Doubleday, 1999.

Few humans aspire to this rarified level of creative thought. Nevertheless, large numbers of more ordinary visionaries have made enormous contributions to human progress over the centuries, and we are greatly indebted to them. Note that Paul Strathern's six are all in the fields of mathematics and science. We could compile an equally awesome short list of creative visual artists: Praxiteles, Leonardo da Vinci, Michelangelo, Raphael, Rembrandt, Goya, Cézanne, Matisse, and Picasso.

Prehistoric creativity

Among the earliest creative innovations by prehistoric humans were shaped stone tools (2.5 million years ago) and controlled use of fire (around 400,000 B.C.), later followed by such inventions as bone needles with eyes for threading, leading to animal-hide clothing. Recently, a 45,000-year-old Neanderthal flute was discovered, suggesting a more advanced creative level in Neanderthal culture than previously thought. And certainly we must include as momentous the creation of cave drawings and paintings discovered in many parts of our world, from Europe to Africa to Australia. Recently discovered magnificent cave art in Chauvet, France, is as ancient as 32,000 B.C. What these genuinely creative works of art signify in terms of human brain development is still a mystery. Theories abound, to no avail. For many scientists, they are simply mind-bogglingly inexplicable.

The difficulties overcome by the cave artists were enormous. They created highly realistic, astonishingly beautiful drawings and paintings of animals in huge caves that extend deep into mountainsides (see page 257). The caves were profoundly dark, and the artists worked by dim light from unreliable torches or crude lamps using animal fat. For their drawings and paintings, the artists used lumps of charcoal or paint made from iron oxide for red, manganese dioxide or charcoal for black, and kaolin or mica for white, and they used vegetable and animal oils for binders—the first oil paint. The artworks were often so high on the cave walls or even ceilings that the cave artists had to build elaborate

Fig. 11-1. Leaping Boar

Fig. 11-1, 2, 3. From an antique German plate of scientifically accurate depictions by Henri Breuil of prehistoric paintings from the cave at Altamira, Spain. Published in a German journal, title unknown, 1925.

Henri Breuil (1877–1961) amazingly combined the world outlook of a Catholic priest, an interest in drawing and painting, and a scientific approach to the study of the most ancient periods of human history, with a special passion for Paleolithic art. By his own account, starting in 1903, Breuil spent over 700 days in prehistoric caves, studying, drawing, and painting scientifically accurate copies of cave art. The magnificent drawings he did in so many caves under difficult conditions made the world aware of the treasures in the caves.

The Breuil paintings on these pages are from his work in the Altamira caves in northern Spain. Altamira was the first cave in which prehistoric paintings were discovered. It was 1880, and a bitter controversy ensued because many experts declared that prehistoric humans did not have the intellectual capacity to produce any art, much less art of high aesthetic value. Finally, in 1902, the authenticity of the cave paintings was acknowledged, forever changing our perception of prehistoric human beings.

Fig. 11-2. Crouching Bison

scaffolding, like that used by Michelangelo to paint the Sistine Chapel ceiling in Renaissance Rome more than thirty thousand years later. Often, contours on the cave walls themselves seem to have suggested animal shapes, on which the cave artists, by imaging the complete animal, reinforced the wall shapes with amazing realism, sophistication, and beauty. As author Gregory Curtis says in his 2007 book, *The Cave Painters: Probing the Mysteries of the World's First Artists,*[29] "I was astounded by the way the cave artists used the contours of the cave wall to enhance their work."

29. First Anchor Books Edition, 2007, p. 6.

"The cave paintings possess classical ideas, classical grace, classical confidence, and classical dignity, and that is why they feel familiar and appear to be a direct part of our heritage."
— Gregory Curtis, *The Cave Painters: Probing the Mysteries of the World's First Artists* (First Anchor Books Edition, 2007), p. 238

30. Formerly termed "Cro-Magnon."

These Early Modern Humans[30] drew *from memory*, envisioning the animals *in their mind's eye* and proceeding to draw the imaged creatures—with astounding skill and accuracy. A well-trained artist today, working under similar difficult conditions, would be hard put to duplicate the aesthetic quality of the cave artists' magnificent renderings of lively mammoths, bison, lions, and horses. They are portrayed as powerful but also elegant, with delicate legs and hooves, sometimes even accurately shown in perspective and shaded to enhance the appearance of three dimensions. In the whole and in the details, the drawings clearly derive from superb observation and memorization of living animals. They would have required, as in Ken Robinson's definition of creativity, the most highly developed *"imagination, which is the process of bringing to mind things that are not present to our senses."* These enormous difficulties of portraying multiple animal species under such daunting conditions imply intense resolve to execute the artworks and perceptual skills beyond expectation, considering the primitive context of the cave artists' world.

The implication of cave art, it seems to me, is that Early Modern Humans somehow came to possess immense powers of visualization. The question arises: do we still have that capability as a

Fig. 11-3. Wild Horse

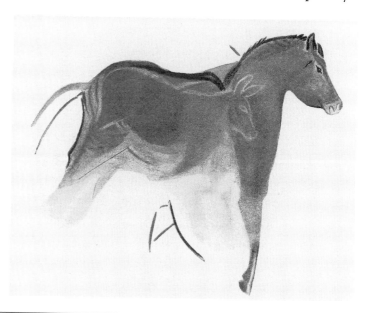

general attribute of our contemporary human brain, or has it been pushed aside and overwhelmed by other momentous creations, such as the invention of written language, now culminating in vast computer language, and digital capabilities?

Could we retrieve that degree of visual power? What would it take? In time and with effort, could we harness human creativity, imagination, and innovation to envision the future and foresee dangers coming from inventions that are *not* of social value, such as terrible weapons created for human injury or annihilation on an unthinkable scale, and disastrous inventions that are harming our planet's ecosystem and our very future existence? We must recognize that socially harmful inventions are genuinely creative: they fit the long tradition of human creativity, *except for the crucial requirement for social value.* Can we regain our observational and envisioning abilities enough to perceive hazards ahead, and ask the iconic creative question, "Wait a minute! What about…?"

History gives promise and hope. The innovative visual power of the Early Modern Humans reappeared with the "Greek miracle," subsided during the Middle Ages, and revived again in the Renaissance. Could it be that our growing understanding of our human brain and its capabilities might lead us to a *re*-rebirth, a new Renaissance?

In 1946, Albert Einstein said:

"The unleashed power of the atom has changed everything save our mode of thinking."

And in the same article:

"A new type of thinking is essential if mankind is to survive and move toward higher levels."

— From "Atomic Education Urged by Einstein," *New York Times*, May 25, 1946

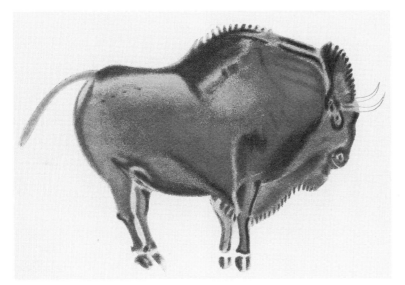

Standing Bison from the cave at Altamira, Spain. There is nothing primitive or amateurish about this high art. The cave artist has forcefully portrayed the bulk of the animal, its delicate balance and elegance, along with accurate anatomy and the sense of a living animal, pausing before movement. About the cave art at Altamira, Picasso famously said, "After Altamira, all is decadence."

Chapter 12
Drawing on the Artist in You

Leonardo da Vinci, (1452–1519), *Face of the Angel from the Virgin of the Rocks* (facsimile, original in Turin, Royal Library). Gabinetto dei Disegni e delle Stampe, Uffizi Florence, Italy. Scala/Art Resource, NY.

This tiny drawing, 18.1 × 15.9 cm (about 7 × 6 inches), is in silverpoint with white highlights on prepared paper. It was a preparatory sketch for the head of the angel in Leonardo's painting *The Virgin of the Rocks*. In his 1896 book *The Italian Painters of the Renaissance*, eminent art expert Bernard Berenson (1865–1959) called it "the most beautiful drawing in the world."

At the beginning of this book, I said that drawing is a magical process. When your brain is weary of its verbal chatter, drawing is a way to quiet the chatter and to grasp a fleeting glimpse of another way of looking at the world. By the most direct means, your visual perceptions stream through the human system—through retinas, optic pathways, brain hemispheres, and motor pathways—to magically transform an ordinary sheet of paper into a direct image of your unique response to the subject of your drawing. By this means, the viewer of your drawing—no matter what the subject—can find you, see you.

Furthermore, drawing can reveal much about you to yourself, some facets of yourself that might be obscured by your verbal self. Your drawings can show you how you see things and feel about things. All drawings convey meaning—in art terms, called "content." First, you draw in R-mode, wordlessly connecting yourself to the subject. Then shifting back to your verbal mode, you can interpret your feelings and perceptions by using the powerful skills of your left brain—words and logical thought. If the pattern is incomplete and not amenable to words and rational logic, a shift back to R-mode can bring intuition and metaphoric insight to bear on the process.

The exercises here, of course, encompass only the very beginning steps toward the goal of knowing your two minds and how to use their capabilities. From here on, having caught a glimpse of yourself in your drawings, you can continue the journey on your own.

Once you have started on this path, there is always the sense that in the next drawing you will more truly see, more truly grasp the nature of reality, express the inexpressible, find the secret beyond the secret. As the great Japanese artist Hokusai said, learning to draw never ends.

With the power of both halves of the brain available to you and myriad possible combinations of the separate powers of the hemispheres, the door is open to your becoming more intensely aware, more capable of controlling some of the verbal processes

that can distort thinking—sometimes even to the extent of causing physical ailments. Logical, systematic thinking is surely essential for survival in our culture, but if our culture is to survive, understanding how the human brain molds behavior is our urgent need.

Through introspection, you can embark on that study, becoming an observer and learning, to some degree at least, how your unique brain works. By observing your brain, you will widen your powers of perception and take advantage of the capabilities of both its halves. Presented with a subject for drawing, you will have the possibility of seeing things two ways: abstractly, verbally, and logically; but also wordlessly, visually, and intuitively. Use your twofold ability. Draw anything and everything. No subject is too hard or too easy, nothing is unbeautiful. Everything is your subject—a few square inches of weeds, an artichoke, an entire landscape, a human being.

Continue to study. The great masters of the past and present are readily available at reasonable cost in books of drawings and on the Internet. Copy the masters, not to copy their styles, but to read their minds. Let them teach you how to see in new ways, to see the beauty in real things, to explore new forms and open new vistas.

Observe your style developing. Guard it and nurture it. Provide yourself with time so that your style can develop and grow, sure of itself. If a drawing goes badly, calm yourself and quiet your mind. End for a time the endless talking to yourself. Know that what you need to see is right there before you.

Put your pencil to paper every day. Don't wait for a special moment, an inspiration. As you have learned in this book, you must set things up, position yourself, in order to evoke the shift to the other-than-ordinary state in which you can see clearly. Through practice, your mind will shift ever more easily. By neglect, the pathways can become blocked again.

Teach someone else to draw. The review of the lessons in this book will be invaluable to both of you. The lessons you give will

deepen your insight about the process of drawing and may open the world of drawing for someone else.

Clearly, these skills have other applications, such as problem solving. Look at a problem from several viewpoints and different perspectives. See the parts of the problem in their true proportions. Instruct your brain to work on the problem while you sleep or take a walk or do a drawing. Scan the problem to see all its facets without censoring or revising or denying. Play with the problems in the antic/serious intuitive mode. The solution is very likely to present itself nicely when you least expect it.

Drawing on the capabilities of the right side of your brain, develop your ability to see ever more deeply into the nature of things. As you look at people and objects in your world, imagine that you are drawing them, and then you will see differently. You will see with an awakened eye, with the eye of the artist within you.

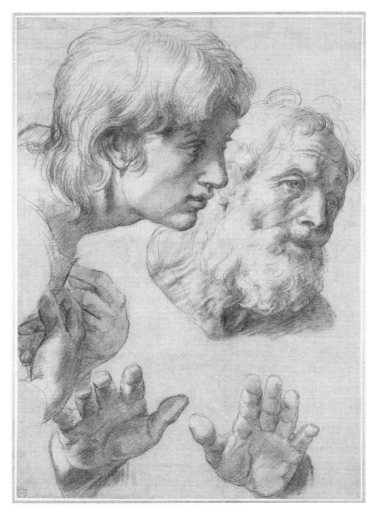

Raphael (1483–1520), *Studies of Heads and Hands of Two Apostles*, c. 1517. WA1846.209.
Ashmolean Museum, University of Oxford, Great Britain.

Glossary

Abstract art A translation into drawing, painting, sculpture, or design of a real-life object or experience. Usually implies the isolation, emphasis, or exaggeration of some aspect of the artist's perception of reality. Should not be confused with nonobjective art.

Basic unit A "starting shape" or "starting unit" chosen from within a composition for the purpose of maintaining correct size relationships in a drawing. The Basic Unit is always termed "One" and becomes part of a ratio, as in "1:2."

Blank An egg-shaped oval, drawn on paper to represent the basic shape of the human head. Because the human skull, seen from the side, is a different shape than the skull seen from the front, the side-view blank is a somewhat differently shaped oval than the front-view blank.

Brain plasticity; neuroplasticity Scientists have not yet reached a universally agreed-upon definition of neuroplasticity. The term means different things to different researchers in different subfields. In general, the term refers to the ability of the brain and nervous system to change structurally and functionally as a result of input from the environment. Recent research shows that the brain can, and does, change both its physical structure and its functional organization, actually creating new neural maps in response to new information, experiences, or learning.

Central axis Human features are more or less symmetrical and are bisected by an imaginary vertical line in the middle of the face. This line is called the central axis. It is used in drawing to determine the tilt of the head and placement of the features.

Cerebral hemispheres The brain is divided into left and right hemispheres that are connected by the corpus callosum and by other smaller commisures or connections.

Cognitive shift A hypothesized transformation from one mental state to another—for example, from L-mode to R-mode or vice versa.

Composition An ordered relationship among the parts or elements of a work of art; the arrangement of forms and spaces within the format.

Conceptual images Imagery from internal sources (the "mind's eye") rather than from external, perceived sources; usually simplified images; often abstract rather than realistic.

Contour line In drawing, a line that represents the shared edges of a form, a group of forms, or forms and spaces.

Corpus callosum A wide, flat bundle of neural fibers, numbering 200–250 million, that connects the left and right cerebral hemispheres. The corpus callosum enables and facilitates interhemispheric communication. Recent research indicates that the corpus callosum may also be able to inhibit communication between the hemispheres.

Creativity The ability to find new solutions to problems or bring into existence something new to the individual or to the culture. Writer Arthur Koestler added the requirement that the new creation should be socially useful.

Crosshairs In drawing, vertical and horizontal lines that divide a format into quadrants. Crosshairs are useful in correctly placing parts of a composition.

Crosshatching A series of intersecting sets of parallel lines used to indicate shading or volume in a drawing.

Edge In drawing, the place where two things meet (for example, where the sky meets the ground); the line of separation between two shapes or a space and a shape.

Expressive quality The slight individual differences in the way each of us perceives and represents our perceptions in a work of art. These differences express an individual's inner reactions to the perceived stimulus as well as the unique "touch" arising from individual physiological motor differences.

Eye level In perspective drawing, a horizontal line on which lines above and below it in the horizontal plane appear to converge. In portrait drawing, the proportional line that divides the head in half horizontally; the location of the eyes at this halfway mark on the head.

Foreshortening A way to portray forms on a two-dimensional surface so that they appear to project from or recede behind a flat surface; a means of creating the illusion of spatial depth in figures or forms.

Format The particular shape of a drawing or painting surface—rectangular, circular, triangular, etc.; the proportion of the surface, e.g., the relationship of the length to the width in a rectangular surface.

Framing lines Lines drawn at the border of a composition to contain an image or design. Alternatively called "the format edge" or simply "the format."

Grid Evenly spaced lines, running horizontally and vertically at right angles, that divide a drawing or painting into small squares or rectangles. Often used to enlarge a drawing or to aid in seeing spatial relationships.

Ground A base layer added to a sheet of paper to darken it, tone it, or color it.

Heightening In drawing, the use of a white or light crayon, pastel, or white pencil to emphasize highlights or light areas of a drawing.

Hemispheric lateralization A process over the first ten years of life of differentiation of the two cerebral hemispheres with respect to function and mode of cognition.

Holistic In terms of cognitive functions, the simultaneous processing of an array of information in a total configuration as opposed to sequential processing of its separate parts.

Horizon Line: See **Eye level** In art, the terms horizon line and eye-level line are synonymous and refer to the projection of the artist's view parallel to the ground all the way to the horizon (where the sky meets the ocean or a flat surface of the earth meets the sky), if such a long view were available. In more usual instances, the horizon line/eye-level line is an imaginary line that anchors imaginary vanishing points, where horizontal edges of forms appear to converge on the horizon line. The familiar illustration is a railroad track whose edges appear to converge at a vanishing point on the horizon line.

Image *Verb*: to call up in the mind a mental copy of something not present to the senses; see in the "mind's eye." *Noun*: a retinal image; the optical image of external objects received by the visual system and interpreted by the brain.

Imagination A recombination of mental images from past experiences into a new pattern.

Intuition Direct and apparently unmediated knowledge; a judgment, meaning, or idea that occurs to a person without any known process of reflective thinking. The judgment is often reached as a result of minimal cues and seems to "come from nowhere."

Key In drawing, the lightness or darkness of an image. A high-key drawing is light or high in value; a low-key drawing is dark or low in value.

Learning Any relatively permanent change in behavior as a result of experience or practice.

Left Hemisphere The left half (oriented according to your left) of the cerebrum. For most right-handed individuals and a proportion of left-handed individuals, verbal functions are mainly in the left hemisphere.

L-Mode A state of information processing characterized as linear, verbal, analytic, and logical.

Negative Spaces The areas around positive forms that share edges with the forms. Negative spaces are bounded by the outer edges by the format. "Interior" negative spaces can be part of positive forms. For example, the whites of the eyes can be regarded as interior negative spaces useful for correctly drawing the irises.

Nonobjective art Art that makes no attempt to reproduce the appearance of real-life objects or experiences or to produce the illusion of reality. Also called "non-representational art."

Perception The awareness, or the process of becoming aware, of objects, relations, or qualities—either internal or external to the individual—by means of the senses and under the influence of previous experiences.

Picture plane An imaginary construct of a transparent plane, like a framed window, that always remains parallel to the vertical plane of the artist's face. The artist draws on paper what he or she sees beyond the plane as though the view were flattened on the plane. Inventors of photography used this concept to develop the first cameras.

Prepared paper An art historical term for paper that has been toned or grounded with various substances such as graphite to prepare it for drawing.

Realistic art The objective depiction of objects, forms, and figures attentively perceived. Also called "naturalism."

Right hemisphere The right half (oriented according to your right) of the cerebrum. For most right-handed individuals and a proportion of left-handed individuals, visual, spatial, relational functions are mainly in the right hemisphere.

R-Mode A state of information processing characterized as visual, perceptual, spatial, and relational.

Scaling up In art, proportionately enlarging an artwork from an earlier, smaller version.

Scanning In drawing, checking points, distances, degrees of angles relative to vertical or horizontal, relative sizes, etc.

Sighting Measuring relative sizes by means of a constant measure (the Basic Unit). The pencil held at arm's length is the most usual measuring device. Sighting is used to determine relative points—the location of one part relative to some other part. Also, to determine angles relative to the constants vertical and horizontal. Sighting often requires closing one eye to remove binocular vision.

Split-brain patients Individuals who had been suffering from intractable epileptic seizures and whose medical problems were relieved by a surgical operation. The procedure separates the two hemispheres by severing the corpus callosum. The procedure is rarely done and split-brain patients are few in number.

States of consciousness A largely unresolved concept, consciousness is used in this book to mean the awareness, continually changing, of what passes in one's own mind. An alternate state of consciousness is one that is perceived as noticeably different from ordinary, waking consciousness. Familiar alternate states are daydreaming, sleep dreaming, and meditation.

Style In drawing, the distinctive "handwriting" that reveals the "artistic personality" of the person who is drawing. Individual style arises from both psychological and physiological factors, such as preferences for pale lines or bold, dark lines. Personal styles may change over time, but are often remarkably stable and recognizable, even through changes in mediums and subject matter.

Symbol system In drawing, a set of symbols that are consistently used together to form an image, for example, a figure. The symbols are usually used in sequence, one appearing to call forth another, much in the manner of writing familiar words, in which writing one letter leads to writing the next. Symbol systems in drawn forms are usually set in childhood and often persist throughout adulthood unless modified by learning new ways to see and draw.

Value In art, the darkness or lightness of tones or colors. White is the lightest, or highest, value; black is the darkest, or lowest, value.

Vanishing point(s): See **Horizon line** Horizontal edges of forms that are parallel to each other and to the horizontal surface of the earth appear to converge (or "vanish") at points on an imaginary horizon line. In one-point perspective compositions, all horizontal edges above and below the horizon line appear to converge at one vanishing point. Two-point and three-point perspective compositions have multiple vanishing points that often lie outside the composition's edges.

Visual Information Processing The use of the visual system to gain information from perceived external sources and the interpretation of that sensory data by means of cognition.

Bibliography

Arguelles, J. *The Transformative Vision*. Berkeley: Shambhala Publications, 1975.

Arnheim, R. *Art and Visual Perception*. Berkeley: University of California Press, 1954.

———. *Visual Thinking*. Berkley: University of California Press, 1969.

"Atomic Education Urged by Einstein." *New York Times*, May 25, 1946 (author unknown).

Ayrton, M. *Golden Sections*. London: Methuen, 1957.

Berger, J. *Ways of Seeing*. New York: Viking Press, 1972.

Bergquist, J. W. *The Use of Computers in Educating Both Halves of the Brain*. Proceedings: Eighth Annual Seminar for Directors of Academic Computational Services, August 1977. P.O. Box 1036, La Cañada, Calif.

Blakemore, C. *Mechanics of the Mind*. Cambridge: Cambridge University Press, 1976.

Bliss, J., and J. Morella. *The Left-Handers' Handbook*. New York: A & W Visual Library, 1980.

Bogen, J. E. "The Other Side of the Brain." *Bulletin of the Los Angeles Neurological Societies* 34 (1969): 73–105.

———. "Some Educational Aspects of Hemispheric Specialization." *UCLA Educator* 17 (1975): 24–32.

Bolles, Edmund. *A Second Way of Knowing: The Riddle of Human Perception*. Upper Saddle River, N.J.: Prentice Hall, 1991.

Brener, Milton. *Vanishing Points: Three-dimensional Perspective in Art and History*. Jefferson: McFarland & Company, Inc., 2004.

Brooks, Julian. *Master Drawings Close Up*. J. Paul Getty Museum, 2010.

Bruner, J. S. "The Creative Surprise." In *Contemporary Approaches to Creative Education*, edited by H. E. Gruber, G. Terrell, and M. Wertheimer. New York: Atherton Press, 1962.

———. *On Knowing: Essays for the Left Hand*. New York: Atheneum, 1965.

Buswell, Guy T. *How People Look at Pictures*. Chicago: Chicago University Press, 1935.

Buzan, T. *Use Both Sides of Your Brain*. New York: E. P. Dutton, 1976.

Carey, Benedict. "Brain Calisthenics for Abstract Ideas." *New York Times* Science Section, June 7, 2011.

Carra, C. "The Quadrant of the Spirit." *Valori Plastici* I (April–May 1919): 2.

Carroll, L., pseud. See Dodgson, C. L.

Cennini, Cennino. *Il Libro Dell'Arte* (The Craftsman's Handbook), c. 1435.

Collier, G. *Form, Space, and Vision*. Englewood Cliffs, N.J.: Prentice-Hall, 1963.

Complete Letters of Vincent van Gogh, The New York Graphic Society, 1954. Letter 184, p. 331.

Corballis, M., and I. Beale. *The Psychology of Left and Right.* Hillsdale, N.J.: Lawrence Erlbaum Associates, 1976.

Cottrell, Sir Alan. "Emergent Properties of Complex Systems." In *The Encyclopedia of Ignorance*, edited by R. Duncan and M. Weston-Smith. New York: Simon & Schuster, 1977.

Crick, F. H. C. *The Brain.* A Scientific American Book. New York: W. H. Freeman, 1979.

Curtis, Gregory. *The Cave Painters: Probing the Mysteries of the World's First Artists.* New York: First Anchor Books, 2007.

Darwin, F. *The Life and Letters of Charles Darwin.* London: John Murray, 1887.

Davis, Stuart. Quoted in "The Cube Root." In *Art News* XLI, 1943, 22–23.

Delacroix, Eugene. In *Artists on Art*, edited by Robert Goldwater and Marco Treves. London: Pantheon Books, 1945.

Dodgson, C. L. [pseud. Carroll, L.] *The Complete Works of Lewis Carroll*, edited by A. Woollcott. New York: Modern Library, 1936.

Doidge, Norman. *The Brain that Changes Itself.* New York: Penguin Books, 2007.

Edwards, B. "Anxiety and Drawing." Master's thesis, California State University at Northridge, 1972.

———. "An Experiment in Perceptual Skills in Drawing." Ph.D. dissertation, University of California, Los Angeles, 1976.

———. *Drawing on the Artist Within.* New York: Simon and Schuster, 1989.

———. *Drawing on the Right Side of the Brain Workbook.* New York: Tarcher, 2002.

Edwards, B., and D. Narikawa. *Art, Grades Four to Six.* Los Angeles: Instructional Objectives Exchange, 1974.

Encarta World English Dictionary. New York: St. Martin's Press, 1999.

English, H. B., and Ava C. English. *A Comprehensive Dictionary of Psychological and Psychoanalytical Terms.* New York: David McKay Company, Inc., 1974.

Ernst, M. *Beyond Painting.* Translated by D. Tanning. New York: Wittenborn, Schultz, 1948.

Ferguson, M. *The Brain Revolution.* New York: Taplinger Publishing, 1973.

Feynman, Richard, California Institute of Technology Commencement Address, 1974.

Flam, J. *Matisse on Art.* New York: Phaidon, 1973.

Franck, F. *The Zen of Seeing.* New York: Alfred A. Knopf, 1973.

Franco, L., and R. W. Sperry, "Hemisphere Lateralization for Cognitive Processing of Geometry," *Neuropsychologia*, 1977, Vol. 15, 107–14.

Freud, Sigmund. "The Origins of Psychoanalysis." *American Journal of Psychology*, 21. Champaign: University of Illinois Press, 1910.

Gardner, H. *The Shattered Mind: The Person After Damage.* New York: Alfred A. Knopf, 1975.

———. *Creating Minds.* New York: Basic Books, 1993.

Gazzaniga, M. "The Split Brain in Man." In *Perception: Mechanisms and Models*, edited by R. Held and W. Richards, p. 33. San Francisco, Calif.: W. H. Freeman, 1972.

Gladwin, T. "Culture and Logical Process." In *Explorations in Cultural Anthropology*, edited by W. H. Goodenough, pp. 167–77. New York: McGraw-Hill, 1964.

Goldstein, N. *The Art of Responsive Drawing.* Englewood Cliffs, N.J.: Prentice-Hall, 1973.

Gregory, R. L. *Eye and Brain: The Psychology of Seeing.* 2nd ed., rev. New York: McGraw-Hill, 1973.

Grosser, M. *The Painter's Eye.* New York: Holt, Rinehart and Winston, 1951.

Haas, Robert et. al. (compiler), *American Poetry: The Twentieth Century*, Vol. 1. Library of America, 2000.

Hademard, J. *An Essay on the Psychology of Invention in the Mathematical Field.* Princeton, N.J.: Princeton University Press, 1945.

Hardiman, Mariale M., Ed.D. and Martha B. Denckla, M.D. "The Science of Education," "Informing Teaching and Learning through the Brain Sciences." *Cerebrum, Emerging Ideas in Brain Science,* The Dana Foundation, 2010.

Hearn, Lafcadio. *Exotics and Retrospectives.* New Jersey: Literature House, 1968.

Henri, R. *The Art Spirit.* Philadelphia, Pa.: J. B. Lippincott, 1923.

Herrigel, E. *Zen in the Art of Archery.* Germany, 1948.

Hill, E. *The Language of Drawing.* Englewood Cliffs, N.J.: Prentice-Hall, 1966.

Hockney, D. *David Hockney,* edited by N. Stangos. New York: Harry N. Abrams, 1976.

Hoffman, Howard. *Vision & the Art of Drawing.* Englewood Cliffs, N.J.: Prentice-Hall, 1989.

Hughes, Robert. *Nothing If Not Critical.* New York: Alfred A. Knopf, 1991.

Huxley, A. *The Art of Seeing.* New York: Harper and Brothers, 1942.

———. *The Doors of Perception.* New York: Harper and Row, 1954.

IBM: First Watson Symposium, Carnegie Mellon University and University of Pittsburgh, Press Release. March 30, 2011.

Jaynes, J. *The Origin of Consciousness in the Breakdown of the Bicameral Mind.* Boston: Houghton Mifflin, 1976.

Johnson, Hugh. *Principles of Gardening.* London: Mitchell Beazley Publishers Limited, 1979.

Jung, C. G. *Man and His Symbols.* Garden City, N.Y.: Doubleday, 1964.

Kandinsky, W. *Concerning the Spiritual in Art.* New York: Wittenborn, 1947.

———. *Point and Line to Plane.* Chicago: Solomon Guggenheim Foundation, 1945.

Kao, John. *Jamming: The Art and Discipline of Business Creativity.* New York: HarperCollins, 1996.

Keller, Helen. *The World I Live In.* New York: The Century Company, 1908.

Kimmelman, Michael. "An Exhibition about Drawing Conjures a Time when Amateurs Roamed the Earth." *New York Times,* July 19, 2006.

Kipling, R. *Rudyard Kipling's Verse.* London: Hodder & Stoughton, 1927.

Kneller, George. *The Art and Science of Creativity.* New York: Holt, Rinehart and Winston, 1965.

Krishnamurti, J. *The Awakening of Intelligence.* New York: Harper and Row, 1973.

———. "Self Knowledge." In *The First and Last Freedom,* p. 43. New York: Harper and Row, 1954.

———. *You Are the World.* New York: Harper and Row, 1972.

Levy, J. "Differential Perceptual Capacities in Major and Minor Hemispheres," *Proceedings of the National Academy of Science,* Vol. 61, 1968, 1151.

———. "Psychobiological Implications of Bilateral Asymmetry." In *Hemisphere Function in the Human Brain,* edited by S. J. Dimond and J. G. Beaumont. New York: John Wiley and Sons, 1974.

Levy, J., C. Trevarthen, and R. W. Sperry. "Perception of Bilateral Chimeric Figures Following Hemispheric Deconnexion," *Brain,* 95, 1972, 61–78.

Lindaman, E. B. *Thinking in Future Tense.* Nashville, Tn.: Broadman Press, 1978.

Lindstrom, M. *Children's Art: A Study of Normal Development in Children's Modes of Visualization.* Berkeley, Calif.: University of California Press, 1957.

Lowenfeld, V. *Creative and Mental Growth.* New York: Macmillan, 1947.

Luft, David. *Robert Musil and the Crisis of European Culture, 1880–1942.* Berkeley: University of California Press, 1984.

Maslow, Abraham. *The Farther Reaches of Human Nature.* Big Sur: Esalen Institute, 1976.

Matisse, H. *Notes d'un peintre.* In *La grande revue.* Paris, 1908.

McFee, J. *Preparation for Art.* San Francisco, Calif.: Wadsworth Publishing, 1961.

McGilchrist, Iain. *The Master and His Emissary.* New Haven, Ct.: Yale University Press, 2009.

McManus, C., Rebecca Chamberlain and Phik-Wern Loo, Research Department of Clinical, Educational and Health Psychology. *Psychology of Aesthetics, Creativity, and the Arts,* Vol. 4 No. 1.

Milne, A.A. *The House at Pooh Corner.* London: Methuen & Co. Ltd., 1928.

Newton, Isaac. *Opticks,* Book 1, Part 2. 1st ed., London, 1704.

Nicolaides, K. *The Natural Way to Draw.* Boston: Houghton Mifflin, 1941.

Ornstein, R. *The Psychology of Consciousness.* 2nd ed., rev. New York: Harcourt Brace Jovanovich, 1977.

Orwell, G. "Politics and the English Language." In *In Front of Your Nose,* Vol. 4 of *The Collected Essays of George Orwell,* edited by S. Orwell and I. Angus, p. 138. New York: Harcourt Brace and World, 1968.

Paivio, A. *Imagery and Verbal Processes.* New York: Holt, Rinehart and Winston, 1971.

Paredes, J., and M. Hepburn. "The Split-Brain and the Culture-Cognition Paradox." *Current Anthropology* 17 (March 1976): 1.

Piaget, J. *The Language and Thought of a Child.* New York: Meridian, 1955.

Pirsig, R. *Zen and the Art of Motorcycle Maintenance.* New York: William Morrow, 1974.

Reed, William. *Ki: A Practical Guide for Westerners.* Tokyo: Japan Publications, 1986.

Robinson, Ken. *Out of Our Minds: Learning to be Creative.* Mankato, Minn.: Capstone, 2011.

Rock, I. "The Perception of Disoriented Figures." In *Image, Object, and Illusion,* edited by R. M. Held. San Francisco: W. H. Freeman, 1971.

Rodin, A. Quoted in *The Joy of Drawing.* London: The Oak Tree Press, 1961.

Rose, Kian, and Ian Piumarta, editors. *Points of View: A Tribute to Alan Kay.* Glendale, Calif.: Viewpoints Research Institute, 2010.

Samples, B. *The Metaphoric Mind.* Reading, Mass.: Addison-Wesley Publishing, 1976.

———. *The Wholeschool Book.* Reading, Mass.: Addison-Wesley Publishing, 1977.

Samuels, M., and N. Samuels. *Seeing with the Mind's Eye.* New York: Random House, 1975.

Shankar, Thom and Matt Richtel. "In New Military, Data Overload Can be Deadly." *New York Times,* January 17, 2011.

Shepard, R.N. *Visual Learning, Thinking, and Communication,* edited by B.S. Randhawa and W.E. Coffman. New York: Academic Press, 1978.

Sperry, R. W. "Hemisphere Disconnection and Unity in Conscious Awareness." *American Psychologist* 23 (1968): 723–33.

———. "Lateral Specialization of Cerebral Function in the Surgically Separated Hemispheres," in *The Psychophysiology of Thinking,* edited by F. J. McGuigan and R. A. Schoonover. New York: Academic Press, 1973, 209–29.

Sperry, R. W., M. S. Gazzaniga, and J. E. Bogen, "Interhemispheric Relationships: the Neocortical Commissures; Syndromes of Hemisphere Disconnection," *Handbook of Clinical Neurology,* edited by P. J. Vinken and G. W. Bruyn. Amsterdam: North-Holland Publishing Co., 1969, 273–89.

Strathern, Paul. *The Big Idea Collected: Six Revolutionary Ideas that Changed the World*. New York: Doubleday, 1999.

Suzuki, D. "Satori." In *The Gospel According to Zen*, edited by R. Sohl and A. Carr. New York: New American Library, 1970.

Tart, C. T. "Putting the Pieces Together." In *Alternate States of Consciousness*, edited by N. E. Zinberg. New York: Macmillan, 1977, 204–6.

———. *States of Consciousness*. New York: E. P. Dutton, 1975.

Taylor, J. *Design and Expression in the Visual Arts*. New York: Dover Publications, 1964.

Tsikitas, Irene. "Inventors Aim to Transform 'Entire Surgical Tray' with Biomechanics." *Outpatient Surgery Magazine* (Online), May 17, 2011. www.outpatientsurgery.net/news/2011/05/16

Walter, W. G. *The Living Brain*. New York: W. W. Norton, 1963.

Zaidel, E., and R. Sperry. "Memory Impairment after Commisurotomy in Man." *Brain* 97 (1974): 263–72.

Zimmer, Carl. "Turning to Biomechanics to Build a Kinder, Gentler Rib Spreader." *New York Times* Science Section, May 17, 2011.

Index

Page numbers in italics refer to sidebar information or illustrations.

application of perceptual skills, xiv, xxiv, 240–41, 248–53, 264

high-level innovation, 253–58

in human history, 255–58

intuition and insight, 35–36, 38, 248, 262

new combinations of information, 37

sketches of inventions, xviii

stages of, 245–47

Crenshaw, Hugh, 254–55

Crick, Francis, 28

crosshatching, 225–28

Crowe, Dana, *165*

cubes, 75–76, 140, 150–51

Curtis, Gregory, 257

Darwin, F., *247*

Day, Robert J., *143*

Death of Seneca, The (Tiepolo), 52

Degas, Edgar, *10, 26*

Denckla, Martha B., *xxii*

depth perception, 100

Designer's Dilemma problem, 248–53

Digger (van Gogh), *110*

Doidge, Norman, *xxviii*

Doors of Perception, The (Huxley), 4

Draughtsman Making a Perspective Drawing of a Woman (Dürer), 97

drawing

advantages of learning, 7

Basic Unit, 120–26, 128–29

copying of masterworks, 187–88, 263

disengagement of right brain from task, xxvii–xxxii

glossary of terms, 265–67

as magical process, 2–3, 262

materials for, 12–13, 14

as method for perceptual training, xix

practice, 240, 263

pre-instruction drawings, 13–21, 236

realistic subjects, 5–6

shift of consciousness during, 3–4

subskills, xv–xvi, xxiv–xxv

as teachable skill, 3

warm-up exercise, 88, 228

Drawing Hands (Escher), *xxxiv*

Duncan, Arne, *xxiii*

Dürer, Albrecht, 7, *80, 95, 97*

Ebata, Masako, *133*

edges

bounding edges of format, 72, 115–17

contour lines, 84–85

disengagement of left brain from task, xxix, 86, 89–90

juncture of positive forms and negative spaces, 112–13, *117*

Modified Contour Drawing, 91–94, 101–9

picture plane and, 94–101

Pure Contour Drawing, 85–91

Edison, Thomas A., *xviii*

educational system

emphasis on left-brain functions, 244–45

failures, xxiii

focus of art classes, 66

opposition to arts education, xxii–xxiii

perceptual learning, xviii–xix

potential benefit of perceptual training, xxiv

teachers' inability to draw, 2, 77

Einstein, Albert, xv, xxiii, *247, 258*

Elderfield, John, 122

Elgart, Elliot, *100*

Elsum, John, 95

Ernst, Max, *90*

Escher, M. C., *xxxiv*

eye dominance, 242–43

eye level

Horizon Line, 142–44, 147

in portraits, *175, 176, 180, 213, 214*

style
 development of, 230, 263
 line qualities, 25
 self-expression, 21–24, 101
 signature, 22–23
supplies for drawing, 12–13, 14
symbol system. *See* childhood symbol
 system

talent versus brain plasticity, xx–xxi
Tart, Charles, 48
Teater, David, 4
"Thanksgiving Dining" (Meyer), 162
thinking. *See* creativity and problem
 solving
Thinking in Future Tense
 (Lindaman), 225
Thinking with a Pencil (Nelms), xviii
Three Hands, Two Holding Forks
 (van Gogh), 8–9
three-point perspective, 144, 149, 152
*Through the Looking Glass, and What
 Alice Found There* (Carroll), 78
Tiepolo, Giovanni Battista, 51
tonal values, 205–6
transfer of learning, xiv, xix, xxiv
Twain, Mark, xv
Twombly, Cy, 90
two-point perspective, 150–54, 156–61,
 164, 165
"Two-Sided Man, The" (Kipling), 29

Umboh, Merilyn, 19
unity and strength of composition, 118,
 119, 120, 133, 159
"Upon the Lonely Moor" (Carroll), 43
Upside-Down Drawing, xxviii, 51–59

Valéry, Paul, 252
values of light and dark tones,
 205–6
van Gogh, Vincent. *See* Gogh,
 Vincent van
Van Gogh's Chair (van Gogh),
 122–23, *124*
Vanishing Points, 144, *149*,
 150–51
Vanishing Points (Brener), 248
Vanreusel, James, *xxx–xxxi*
Varieties of Religious Experience, The
 (James), 59
Vase/Faces exercise, xxviii, 46–51
Vase of Tulips, The (Cézanne), 118
viewfinders, to construct, 14
visual constancy, 170–74
*Visual Learning, Thinking, and
 Communication* (Shepard), 4
visual skills. *See* perception skills

Winter Landscape (Rembrandt), 25
*Woman by the Sea Taking a Sight of the
 Ocean* (Day), 143
Woman in a Hat (Nicolaides), 85
Woodward, Terry, 20
Wyeth, Andrew, *13*

Yin, Lijun, 243
Young Hare (Dürer), 80
Young Woman in White, Red Background
 (Matisse), *122*

Zen in the Art of Archery
 (Herrigel), 24
Zen of Seeing (Franck), 6
Zvovu, Frank, 20